Bio-Inspired Computation and Applications in Image Processing

Bio-Inspired Computation and
Applications in Image Processing

Bio-Inspired Computation and Applications in Image Processing

Edited by

Xin-She Yang
School of Science and Technology,
Middlesex University, London, United Kingdom

João Paulo Papa
Department of Computing,
São Paulo State University, Bauru, São Paulo, Brazil

AMSTERDAM • BOSTON • HEIDELBERG • LONDON
NEW YORK • OXFORD • PARIS • SAN DIEGO
SAN FRANCISCO • SINGAPORE • SYDNEY • TOKYO

Academic Press is an imprint of Elsevier

Academic Press is an imprint of Elsevier
125 London Wall, London EC2Y 5AS, United Kingdom
525 B Street, Suite 1800, San Diego, CA 92101-4495, United States
50 Hampshire Street, 5th Floor, Cambridge, MA 02139, United States
The Boulevard, Langford Lane, Kidlington, Oxford OX5 1GB, United Kingdom

Notices
Knowledge and best practice in this field are constantly changing. As new research and experience broaden our understanding, changes in research methods, professional practices, or medical treatment may become necessary.

Practitioners and researchers must always rely on their own experience and knowledge in evaluating and using any information, methods, compounds, or experiments described herein. In using such information or methods they should be mindful of their own safety and the safety of others, including parties for whom they have a professional responsibility.

To the fullest extent of the law, neither the Publisher nor the authors, contributors, or editors, assume any liability for any injury and/or damage to persons or property as a matter of products liability, negligence or otherwise, or from any use or operation of any methods, products, instructions, or ideas contained in the material herein.

Library of Congress Cataloging-in-Publication Data
A catalog record for this book is available from the Library of Congress

British Library Cataloguing-in-Publication Data
A catalogue record for this book is available from the British Library

ISBN: 978-0-12-804536-7

For information on all Academic Press publications
visit our website at https://www.elsevier.com/

Working together
to grow libraries in
developing countries

www.elsevier.com • www.bookaid.org

Publisher: Joe Hayton
Acquisition Editor: Tim Pitts
Editorial Project Manager: Charlotte Kent
Production Project Manager: Caroline Johnson
Designer: Victoria Pearson

Typeset by Thomson Digital

Contents

List of Contributors

H. Adeli
Department of Civil, Environmental and Geodetic Engineering, Ohio State University, Columbus, OH, United States

C. Agarwal
Department of Computer Science, University of Delhi, Delhi, India

B. Aliahmad
Biosignals Group, School of Electrical and Computer Engineering, RMIT University, Melbourne, VIC, Australia

A. Amine
BOSS Team, National School of Applied Sciences (ENSA), Ibn Tofail University, Kenitra, Morocco

A. Arsic
University of Belgrade, Belgrade, Serbia

A.S. Ashour
Department of Electronics and Electrical Communications Engineering, Faculty of Engineering, Tanta University, Tanta, Egypt; College of CIT, Taif University, Saudi Arabia

V.E. Balas
Faculty of Engineering, Aurel Vlaicu University of Arad, Arad, Romania

J.C. Becceneri
National Institute for Space Research—INPE, São José dos Campos, São Paulo, Brazil

C.W. Bong
School of Science and Technology, Wawasan Open University, Penang; Northern Health Cardiothoracic Services Sdn. Bhd., Malaysia

M.G. Carvalho
School of Technology, University of Campinas (UNICAMP), Limeira, São Paulo, Brazil

S. Chakraborty
Department of CSE, Bengal College of Engineering and Technology, Durgapur, West Bengal, India

N. Dey
Department of Information Technology, Techno India College of Technology, Kolkata, West Bengal, India

S.E.N. Fernandes
Department of Computing, Federal University of São Carlos, São Carlos, São Paulo, Brazil

S. Fong
Department of Computer and Information Science, University of Macau, Macau SAR, China

C.C. Freitas
National Institute for Space Research—INPE, São José dos Campos, São Paulo, Brazil

M. Jordanski
University of Belgrade, Belgrade, Serbia

D.K. Kumar
Biosignals Group, School of Electrical and Computer Engineering, RMIT University, Melbourne, VIC, Australia

M.C. Kuroda
University of Campinas (UNICAMP), Institute of Geosciences, Campinas, São Paulo, Brazil

H.Y. Lam
Department of Cardiothoracic Surgery, Hospital Penang; Lam Wah Ee Hospital, Penang, Malaysia

J. Li
Department of Computer and Information Science, University of Macau, Macau SAR, China

C.C. Liew
Koo Foundation of Sun Yat Sen Cancer Hospital, Taipei, Taiwan

T. Ljouad
Faculty of Sciences of Rabat (FSR), Mohammed V University, Morocco

P.S. Martins
School of Technology, University of Campinas (UNICAMP), Limeira, São Paulo, Brazil

F.R. Massaro
School of Technology, University of Campinas (UNICAMP), Limeira, São Paulo, Brazil

A. Mishra
Department of Electronics, Deendayal Upadhyay College, University of Delhi, Delhi, India

S. Nandy
Budge Budge Institute of Technology, Kolkata, West Bengal, India

J.P. Papa
Department of Computing, São Paulo State University, Bauru, São Paulo, Brazil

J. Real
Universitat Politècnica de València, Valencia, Spain

D. Rodrigues
Department of Computing, Federal University of São Carlos, São Carlos, São Paulo, Brazil

M. Rziza
Faculty of Sciences of Rabat (FSR), Mohammed V University, Morocco

S. Samanta
Department of Computer Science & Engineering, University Institute of Technology, Burdwan, West Bengal, India

S. Sandri
National Institute for Space Research—INPE, São José dos Campos, São Paulo, Brazil

S.J.S. Sant'Anna
National Institute for Space Research—INPE, São José dos Campos, São Paulo, Brazil

P.P. Sarkar
Kalyani University, Kalyani, West Bengal, India

J. Senthilnath
Geospatial Sciences Center of Excellence, South Dakota State University, Brookings, SD, United States

K.K.F. Setoue
Department of Computing, São Paulo State University, Bauru, São Paulo, Brazil

L. Torres
National Institute for Space Research—INPE, São José dos Campos, São Paulo, Brazil

M. Tuba
John Naisbitt University, Belgrade, Serbia

E.L. Ursini
School of Technology, University of Campinas (UNICAMP), Limeira, São Paulo, Brazil

A.C. Vidal
University of Campinas (UNICAMP), Institute of Geosciences, Campinas, São Paulo, Brazil

X.-S. Yang
School of Science and Technology, Middlesex University, London, United Kingdom

About the editors

XIN-SHE YANG

Xin-She Yang obtained his DPhil in Applied Mathematics from the University of Oxford. He then worked at Cambridge University and the National Physical Laboratory (United Kingdom) as a Senior Research Scientist. Now he is Reader in Modelling and Optimisation at Middlesex University London, Adjunct Professor at Reykjavik University (Iceland), and Guest Professor at the Xi'an Polytechnic University and Harbin Engineering University (China). He is also a Bye-Fellow at Downing College, Cambridge University. He is the IEEE Computational Intelligence Society (CIS) Task Force Chair on Business Intelligence and Knowledge Management, the Editor-in-Chief of *International Journal of Mathematical Modelling and Numerical Optimisation*, and the Director of the International Consortium for Optimization and Modelling in Science and Industry (iCOMSI.org).

JOÃO PAULO PAPA

João Paulo Papa received his BSc in Information Systems from the São Paulo State University, SP, Brazil. In 2005, he received his MSc in Computer Science from the Federal University of São Carlos, SP, Brazil. In 2008, he received his PhD in Computer Science from the University of Campinas, SP, Brazil. During 2008–09, he worked as a postdoctorate researcher at the same institute. He has been Professor at the Computer Science Department, São Paulo State University, since 2009. During 2014–15, he worked as a visiting professor at the Center for Brain Science, Harvard University, USA, under the supervision of Prof. David Cox. His main research interests include machine learning, pattern recognition, and image processing.

Preface

Throughout history, human beings have been fascinated by pictures and images, and images have played an important role in our understanding and recording of the world. It is hard to imagine what modern life would look like without images. Modern life is filled with images and multimedia, which affect greatly the ways we live, work, and think. Image processing involves a diverse range of hardware, software, and technologies, which in turn use a vast range of algorithms and methodologies. Some of the primary aims of image processing are to extract useful information, to recognize patterns and objects, to enhance and reconstruct the images, and ultimately to make sense of the images so as to improve the quality of life. In order to do so, useful tools and techniques have been developed for processing images efficiently. Within such tool sets, algorithms are the key part. However, due to the complicated nature of images with potentially huge datasets, image processing is usually a time-consuming task, and there are many challenging issues related to it.

Even for seemingly simple images, extracting useful information may not be easy. First, what "usefulness" means may be quite subjective, largely depending on the knowledge set of the decision maker or the user. Even if a useful feature can be clearly defined, extracting it may not be an easy task. For example, to find a straight line or an object in an image is an easy task for human eyes, but to extract it using digital image processing requires edge detection techniques. Depending on the shape of the object and the image quality, the techniques may vary from simple gradient-based detection methods to very sophisticated machine learning techniques. Many image processing tasks may require starting with image segmentation, which itself is not a trivial task. In fact, image segmentation is closely related to optimization. For example, for image thresholding, choosing the right threshold can be very tricky. To carry out such tasks, efficient algorithms are needed, though efficient algorithms may not always exist. Even when good algorithms are available, almost all have algorithm-dependent adjustable parameters, and the performance of an algorithm can be affected a great deal by the settings of these adjustable parameters. In fact, tuning these parameters properly for a given algorithm and for a given set of problems is a nontrivial task, which is essentially a challenging optimization problem.

To complicate things even further, stringent time and resource constraints may be imposed on image processing tasks. For example, a key factor is time; many applications require processing the images in real time with limited computational resources. In addition, it is also necessary to minimize energy consumption and computational costs while at the same time it is necessary to maximize processing speed and accuracy. Such requirements pose a series of challenging optimization problems in image processing and optimization.

Many image processing tasks can be formulated as optimization problems so that they can in principle be tackled by sophisticated optimization techniques; however, usually traditional approaches do not work well. In addition, ever-increasing complexity in constraints and the need to handle big data have complicated these challenging issues even further, and the issues

become even more challenging for dynamic, noisy images and for machine intelligence. Such challenges necessitate new approaches and new methods, such as bio-inspired computation. One of the current trends is to combine traditional image processing techniques with bio-inspired algorithms and swarm intelligence.

In recent years, there have been significant developments in bio-inspired computation and image processing with a rapidly expanding literature. Such bio-inspired algorithms are flexible, versatile, and efficient. Consequently, these algorithms can be used to deal with a wide range of challenging problems that arise from diverse applications. There is a strong need to review and summarize the latest developments in both bio-inspired computation and image processing. Obviously, it is not possible to summarize even a good fraction of the state-of-the-art developments in a single volume because the literature is vast and expanding. Therefore, we have selected only a subset of the developments so as to provide a timely snapshot that may be representative enough to inspire more research in this area.

This edited book strives to provide a timely summary and review of a selection of topics, including feature selection, deep belief networks, grayscale image enhancement, image segmentation, remote-sensing image registration, radar imagery analysis, retinal image analysis, image contrast enhancement, mobile object tracking, glass opacity detection, image watermarking, oil reservoir quality assessment, handwritten digits recognition, and others. Algorithms used in these case studies and applications include particle swarm optimization, bat algorithm, cuckoo search, firefly algorithm, harmony search, neural networks, genetic algorithms, probabilistic neural networks, self-organized map, restricted Boltzmann machines, and support vector machines as well as many others. It is hoped that this book can serve as an ideal reference and a rich source of literature for graduates, lecturers, engineers, and researchers in image processing, computer science, machine learning, artificial intelligence, optimization, and computational intelligence.

We would like to thank our editors, especially Charlotte Kent, and the staff at Elsevier for their help and professionalism. Last but not least, we thank our families for their support and encouragement.

<div style="text-align: right">

X.-S. Yang

J.P. Papa

Mar. 2016

</div>

Chapter

1

Bio-inspired computation and its applications in image processing: an overview

X.-S. Yang*, J.P. Papa**

**School of Science and Technology, Middlesex University, London, United Kingdom;*
***Department of Computing, São Paulo State University, Bauru, São Paulo, Brazil*

Bio-Inspired Computation and Applications in Image Processing. http://dx.doi.org/10.1016/B978-0-12-804536-7.00001-6

1 INTRODUCTION

Among the many tasks in image processing, one of the main aims is to make sense of the image contents using image recognition, feature extraction, and measurements of patterns in addition to useful processing, such as visualization, image sharpening, and restoration. Obviously, image data can have noise and images can be analog or digital, although our focus in this book is mainly on digital image processing. Whether it is feature extraction, image enhancement, classification, or ultimately image interpretation, in most cases we may have to deal with supervised or unsupervised learning in combination with standard image processing techniques. Nowadays, image processing often has to deal with complex, time-dependent, noisy, dynamic images and make sense of the image data at the lowest computational costs with high accuracy, often with the lowest energy consumption possible and in a practically acceptable time scale. All these form a series of very challenging problems related to machine learning and optimization.

It is no exaggeration to say that optimization is almost everywhere. In almost every application, especially engineering designs, we are trying to optimize something, whether to minimize the cost and energy consumption, or to maximize the profit, output, performance, and efficiency. In reality, resources, time, and money are always limited; consequently, optimization is far more important in practice (Yang, 2010b; Koziel and Yang, 2011). Thus, the proper use of available resources of any sort requires a paradigm shift in scientific thinking and design innovation. In the area of image processing and optimization, new methods tend to be evolutionary or bio-inspired. Good examples include evolutionary algorithms, artificial neural networks (ANNs), swarm intelligence (SI), cellular signaling pathways, and others. In fact, an emerging area, namely the bio-inspired computation, is becoming increasingly popular. Good examples of SI-based, bio-inspired algorithms are ant colony optimization, particle swarm optimization (PSO), bat algorithm (BA), firefly algorithm (FA), cuckoo search (CS), and others. For example, genetic algorithms (GA) and the BA have been used in many applications including image feature extraction and classification. In fact, all major bio-inspired algorithms have been used in image processing and optimization, and we discuss a diverse range of examples and case studies in this book.

The main purpose of this chapter is to provide a brief overview. Therefore, this chapter is organized as follows. Section 2 provides a brief discussion of the formulation concerning the optimization problems in image processing. Section 3 discusses the key issues in optimization, followed by the detailed introduction of commonly used bio-inspired algorithms in Section 4. Section 5 discusses neural networks and support vector machines. Section 6

discusses some recent trends and applications in image processing. Finally, Section 7 concludes with some discussions.

2 IMAGE PROCESSING AND OPTIMIZATION

Many image processing tasks can be reformulated as optimization problems. For example, image thresholding and segmentation can obviously formulated as optimization problems in terms of the design parameter of the threshold, while the objective can be properly defined. As there are dozens of image processing techniques (Glasbey and Horgan, 1995; Gonzalez and Woods, 2007; Sonka et al., 2014; Russ and Neal, 2015), it is not possible to discuss them in general. Instead, we use image segmentation as an example to show how such tasks are linked to optimization.

2.1 Image segmentation via optimization

The aim task of image segmentation is to divide an image into different regions (or categories) so that different regions belong to different objects or different part of objects. Ideally, the pixels in the same region or category have similar grayscale, forming a connected region, while neighboring pixels have dissimilar grayscale if they belong to a different category (Glasbey and Horgan, 1995; Russ and Neal, 2015). Segmentation is a major step in image processing for other tasks, such as object recognition, image compression, image editing, and image understanding. Again, there are many different segmentation techniques; but loosely speaking, there are three different types of approaches for image segmentation: thresholding-based segmentation, edge-based segmentation, and region-based segmentation.

For the simplest binary thresholding, an image with a grayscale value I_{ij} at position or lattice (i, j) is segmented into a binary image (two different categories or classes). If the pixel value is less than a threshold T (ie, $I_{ij} \leq T$), then it is allocated to one category (category 1); otherwise, it belongs to another category. The choice of the threshold value T will affect the segmented results. If there exists an optimal/best T, how do find this value? This is an optimization problem. Obviously, there are many methods that can help to find a good value of T. For example, histogram-based thresholding uses the histogram of the pixel values. The aim is to try to split or reposition exactly half between the means of the two category pixel values, to minimize the errors, or to maximize the interclass variance (Glasbey and Horgan, 1995; Russ and Neal, 2015). In addition, these methods can be combined with machine learning techniques, such as supervised and unsupervised learning. Whatever the technique is, the main purpose is to find the best thresholding T so that the segmented image produces the best results and makes sense in

real-world applications. Without an effective way to find the optimal T, it is not possible to carry out segmentation automatically.

Furthermore, for edge-detection–based segmentation techniques, the correct edge-detection method has to be used. Otherwise, the inappropriate detection of edges will affect subsequent segmentation results. In general, edge detection can be also considered as filters. For example, gradient-based edge detection can be very sensitive to noise, while the Canny edge detection algorithm can largely be influenced by the variance of the Gaussian filter and the size of the filter kernel (Gonzalez and Woods, 2007). The choices of the best values for such key parameters again form an optimization problem. In fact, almost all edge detectors have algorithm-dependent parameters, and tuning of these parameters becomes a nonlinear optimization problem.

On the other hand, the techniques for region-based segmentation can be considered as a kind of spatial clustering (Glasbey and Horgan, 1995; Russ and Neal, 2015). Many clustering algorithms, such as the K-means and fuzzy clustering, can be formulated as optimization problems. For example, the centroids in the K-mean clustering method can affect the clustering results greatly, and the effective determination of the centroid locations for the clusters is in fact a challenging optimization problem. In addition, other segmentation methods, including graph-based segmentation, the partial differential equation-based approach, the variational method, and the Markov random field method, all have adjustable parameters, and the choice of parameter values can also be solved using optimization techniques. As we will see in later chapters, deep belief networks and restricted Boltzmann machines can also be formulated as types of optimization problem (Papa et al., 2015).

We will formulate optimization problems in a more generic form in the next subsection so that it forms a basis for introducing nature-inspired optimization algorithms later in this chapter.

2.2 Optimization

In general, all optimization problems can be written in more general form. The most widely used formulation is to write a nonlinear optimization problem as

$$\text{Minimize} \quad f(x), \tag{1.1}$$

subject to the constraints

$$h_j(x) = 0, \quad (j = 1, 2, ..., J), \tag{1.2}$$
$$g_k(x) \leq 0, \quad (k = 1, 2, ..., K),$$

where all the functions are in general nonlinear. Here the design vector $x = (x_1, x_2, \ldots, x_d)$ can be continuous, discrete, or mixed in a d-dimensional space (Yang, 2010b).

It is worth pointing out that the definition of the objective related to image processing can often be linked to the computation of certain image-related metrics. The aim is to optimize (either minimize or maximize) the defined metric. Similarly, the constraints may also be implicitly or indirectly related to other measures in image processing. Here we write the problem as a minimization problem, but it can also be written as a maximization problem by simply replacing $f(x)$ by $-f(x)$. When all functions are nonlinear, we are dealing with nonlinear constrained problems. In some special cases when all functions are linear, the problem becomes linear and we can use widely known linear programming techniques, such as the simplex method. When some design variables can take only discrete values (often integers) while other variables are real continuous, the problem is of mixed type, which is often difficult to solve, especially for large-scale optimization problems. On the other hand, a very special class of optimization is convex optimization, which has guaranteed global optimality. Any optimal solution is also the global optimum and most important, there are efficient algorithms of polynomial time to solve such problems (Conn et al., 2009). Efficient algorithms such the interior-point methods (Karmarkar, 1984) are widely used and have been implemented in many software packages.

In contrast to other optimization problems, image-related optimization problems tend to be highly nonlinear and computationally expensive. First, the objectives and constraints may be related to image metrics that need to be calculated based on the images, and each evaluation of such an objective requires the combination of applying traditional image processing techniques (such as edge detection, convolution, and gradient-based manipulations) with optimization-related techniques. Second, as the sizes and numbers of images increase, the computational costs will increase (often nonlinearly). Third, the application of nontraditional methods, such as metaheuristic algorithms, will also require substantial computational efforts due to the multiple evaluations and stochastic nature so as to provide meaningful statistics. Finally, some image processing techniques themselves, such as those related to neural networks, deep learning, and computational intelligence, are intrinsically iterative, which will inevitably require high computational costs. All these factors usually lead to high computational costs. Thus, any efforts or techniques that can reduce computational costs will be desirable.

3 SOME KEY ISSUES IN OPTIMIZATION

Optimization problems can be very challenging to solve, especially for non-linear optimization problems with complex constraints and for large-scale problems. Many key issues need to be addressed, and we highlight only three key issues here: efficiency of an algorithm, choice of algorithms, and time constraints.

3.1 Efficiency of an algorithm

One of the key issues in optimization is the efficiency of an algorithm that can depend on many factors, such as the intrinsic structure of the algorithm, the way it generates new solutions, and the setting of its algorithm-dependent parameters. The essence of an optimizer is a search or optimization algorithm implemented correctly so as to carry out the desired search (though not necessarily efficiently). Typically, an algorithm starts with an educated guess or a random guess as the initial solution vector. The aim is to try to find a better solution (ideally the best solution) as quickly as possible, either in terms of the minimum computational costs or in terms of the minimum number of steps. In reality, this is usually not achievable. In many cases, even a single feasible solution may not be easy to find.

The efficiency of an algorithm is often measured by the number of steps, iterations, or trials that it needs to find a converged solution, and this converged solution is usually no longer changing as the iterations continue. However, such a converged solution does not necessarily guarantee that it is an optimal solution. In fact, there is no guarantee that it is a sufficiently good solution at all. This kind of solution is often called a premature solution and such behavior of the algorithm is thus referred to as premature convergence. Alternatively, the efficiency of an algorithm can also be measured by the rate of convergence, and an efficient algorithm should converge quickly.

In addition, an optimization algorithm can be integrated and linked with other modeling components. There are many optimization algorithms in the literature and no single algorithm is suitable for all problems, as dictated by the No Free Lunch Theorems (Wolpert and Macready, 1997). In order to solve an optimization problem efficiently, an efficient optimization algorithm is needed.

In order to understand optimization algorithms in greater depth, it is often helpful to see how optimization algorithms are classified. Obviously, there are many ways to classify algorithms, depending on the focus or the characteristics we are trying to compare. For example, from the mobility point of

view, algorithms can be classified as local or global. Local search algorithms typically converge toward a local optimum, not necessarily (often not) the global optimum, and such algorithms are often deterministic and are not able to escape local optima. Simple hill-climbing is an example.

On the other hand, we always try to find the global optimum for a given problem. If this global optimality is robust, it is often the best, though it is not always possible to find such global optimality. For global optimization, local search algorithms are not suitable. We have to use a global search algorithm. In most cases modern bio-inspired metaheuristic algorithms are intended for global optimization, though they are not always successful or efficient. A simple strategy, such as hill-climbing with random restart may change a local search algorithm into a global search. In essence, randomization is an efficient component for global search algorithms.

In this chapter, we provide a brief review of most metaheuristic optimization algorithms. From a practical point of view, an important question is how to choose the right algorithm(s) so that the optimal solutions can be found quickly.

3.2 How to choose algorithms?

The choice of the right optimizer or algorithm for a given problem can be crucially important to determine both the solution quality and how quickly the solutions can be obtained. However, the choice of an algorithm for an optimization task will largely depend on the type of the problem, the nature of the algorithm, the desired quality of solutions, the available computing resource, time limits, the availability of the algorithm implementation, and the expertise of the decision makers (Blum and Roli, 2003; Yang, 2010b, 2014).

From the algorithm point of view, the intrinsic nature of an algorithm may essentially determine if it is suitable for a particular type of problem. For example, gradient-based algorithms such as hill-climbing are not suitable for an optimization problem whose objective is discontinuous because of the difficulty in determining the derivatives needed by such gradient-based algorithms. On the other hand, the type of problem to be solved can also determine the algorithms needed to obtain good-quality solutions. For example, if the objective function of an optimization problem at hand is highly nonlinear and multimodal, classic algorithms, such as hill-climbing are usually not suitable because the results obtained by these local search methods tend to be dependent on the initial starting points. For nonlinear global optimization problems, algorithms based on SI, such as the FA and PSO, can be very effective (Yang, 2010a, 2014).

The desired solution quality and available computing resources may also affect the choice of algorithms. As in most applications, computing resources are limited, and good solutions (not necessary the best) have to be obtained in a reasonable and practical time, which means that there is a certain compromise between the available resource and the needed solution quality. For example, if the main aim is to find a feasible solution (not necessarily the best solution) in the least amount of time, greedy methods or gradient-based methods should be the first choice. In addition, the availability of software packages and expertise of the designers are also key factors that can affect the algorithm choice. For example, Newton's method, hill-climbing, Nelder–Mead downhill simplex, trust-region methods (Conn et al., 2009), and interior-point methods are implemented in many software packages, which partly increase their popularity in applications.

In practice, even with the best possible algorithms and well-crafted implementation, we may still not get the desired solutions. This is the nature of nonlinear global optimization, as most of these problems are NP-hard, and no efficient (in the polynomial sense) exist for a given problem. Therefore, one of the main challenges in many applications is to find the right algorithm(s) most suitable for a given problem so as to obtain good solutions (hopefully also the global best solutions), in a reasonable time scale with a limited amount of resources. However, there is no simple answer to this problem. As a result, the choice of the algorithms still largely depends on the expertise of the researchers involved and the available resources in a more or less heuristic way.

3.3 Time and resource constraints

Apart from the challenges already mentioned, one of the most pressing requirements in image processing is the speed of finding the solutions. In some applications, images need to be processed in a dynamic, real-time manner in practice. Therefore, the time should be sufficiently short so that the solution methods can be useful in practice and this time factor poses a key constraint to most algorithms. Saving time means reducing the computational efforts and thus saving money. The fact that computing resources are often limited poses even greater challenges to obtain good solutions in the least amount of time and using the least amount of computing resources. In a way, the choice of the algorithm depends on such requirements.

If the requirement is to solve the optimization problem in real time or in situ, then the number of steps to find the solution should be minimized. In this case, in addition to the critical designs and choice of algorithms, the details of implementations and feasibility of realization in terms of both software and hardware can be very important.

In the vast majority of optimization applications, the evaluations of the objective functions often form the most computationally expensive part of the process. In simulations using the finite element methods and finite volume methods in engineering applications, the numerical solver typically takes a few hours up to a few weeks, depending on the problem size of interest. In this case, the use of the numerical evaluator or solver becomes crucial (Yang, 2008; Koziel and Yang, 2011). On the other hand, in combinatorial problems, the evaluation of a single design may not take long, but the number of possible combinations can be astronomical. In this case, the way to move from one solution to another solution becomes more critical, and thus optimizers can be more important than numerical solvers. Similarly, many image processing applications are also computationally expensive, and thus any approach to save computational time either by reducing the number of evaluations or by increasing the simulator's efficiency will save time and money.

4 NATURE-INSPIRED OPTIMIZATION ALGORITHMS

There are many optimization algorithms in the literature. An incomplete survey suggests there are over 200 optimization algorithms, among which more than half are nature inspired. In fact, nature-inspired optimization algorithms, especially those based on SI, are among the most widely used algorithms for optimization. Nature-inspired algorithms have many advantages over conventional algorithms, as we can see from many case studies presented in later chapters in this book. A few recent books are solely dedicated to nature-inspired metaheuristic algorithms (Dorigo and Stütle, 2004; Yang, 2008, 2010a,b, 2014; Talbi, 2009; Yang et al., 2015).

Nature-inspired algorithms are very diverse. They include GA, simulated annealing, differential evolution (DE), ant and bee algorithms, PSO, harmony search (HS), BA, FA, CS, flower pollination algorithms (FPAs), gravitational search, and others (Yang, 2014). In general, they can be put into two categories: those that are SI based and those that are non-SI based. In the rest of this section, we briefly introduce some of these algorithms.

4.1 Bio-inspired algorithms based on swarm intelligence

The nature-inspired optimization algorithms that are based on SI typically use multiple agents and their characteristics have often been drawn from the inspiration of social insects, birds, fish, and other swarming behavior in biological systems. As multiagent systems with local interactions rules, they can behave or act in a self-organized manner without central control, and certain characteristics of the systems may emerge such that these

characteristics can be referred to as the so-called collective intelligence (Yang et al., 2013; Yang, 2014).

4.1.1 *Ant and bee algorithms*

Among the class of algorithms based on the social behavior of ants, ant colony optimization (Dorigo and Stütle, 2004) is a main example, mimicking the foraging behavior of social ants via pheromone deposition, evaporation, and route marking. The chemical concentrations of pheromones along the paths in a transport problem can also be considered as the indicator of quality solutions. In addition, the movement of an ant is controlled by pheromones that will evaporate over time. For example, exponential decay for pheromone exploration is often used, and the deposition is incremental for transverse routes such that

$$p^{t+1} = \delta + (1 - \rho)p^t, \tag{1.3}$$

where ρ is the evaporation rate and δ is the incremental deposition. Obviously, if the route is not visited during an iteration, then $\delta = 0$ should be used for nonvisited routes. In addition to the pheromone variation, the probability of choosing a route needs to be defined properly. Different variants and improvements of ant algorithms may differ largely in terms of ways of handling pheromone deposition, evaporation, and route-dependent probabilities.

In contrast, bee algorithms are based on the foraging behavior of honeybees. Interesting characteristics, such as the waggle dance and nectar maximization, are often used to simulate the allocation of the foraging bees along flower patches and thus different search regions in the search space (Nakrani and Tovey, 2004; Karaboga, 2005). For a more comprehensive review, please refer to Yang (2010a) and Parpinelli and Lope (2011).

4.1.2 *Bat algorithm*

The BA was developed by Xin-She Yang in 2010 (Yang, 2011), based on the echolocation behavior of microbats. Such echolocation is essentially frequency tuning. These bats emit a very loud sound pulse and listen for the echo that bounces back from surrounding objects.

In the BA, a bat flies randomly with a velocity v_i at position x_i with a fixed frequency range $[f_{min}, f_{max}]$, varying its emission rate $r \in (0,1]$ and loudness A_0 to search for prey, depending on the proximity of the target. The main updating equations are

$$f_i = f_{min} + (f_{max} - f_{min})\varepsilon, \tag{1.4}$$

$$v_i^{t+1} = v_i^t + \left(x_i^t - x*\right)f_i, \qquad (1.5)$$

$$x_i^{t+1} = x_i^t + v_i^t, \qquad (1.6)$$

where ε is a random number drawn from a uniform distribution and $x*$ is the current best solution found so far during iterations. The loudness and pulse rate can vary with iteration t in this way:

$$A_i^{t+1} = \alpha A_i^t, \qquad r_i^t = r_i^0[1 - \exp(-\beta t)]. \qquad (1.7)$$

Here α and β are constants. In fact, α is similar to the cooling factor of a cooling schedule in the simulated annealing to be discussed later. In the simplest case, we can use $\alpha = \beta = 0.9$ in most simulations. The BA has been extended to a multiobjective BA (MOBA) by Yang (2011), and preliminary results suggest that it is very efficient (Yang and Gandomi, 2012). Yang and He (2013) provide a relatively comprehensive review of the BA and its variants.

4.1.3 *Particle swarm optimization*

PSO was developed by Kennedy and Eberhart (1995), based on the swarm behavior of fish and bird schooling in nature.

In PSO, each particle has a velocity v_i and position x_i, and their updates can be determined by this formula:

$$v_i^{t+1} = v_i^t + \alpha \varepsilon_1[g* - x_i^t] + \beta \varepsilon_2[x_i^* - x_i^t]. \qquad (1.8)$$

Here $g*$ is the current best solution and x_i^* is the individual best solution for particle i; ε_1 and ε_2 are two random variables drawn from the uniform distribution in [0,1]. In addition, α and β are the so-called learning parameters. The position is updated as

$$x_i^{t+1} = x_i^t + v_i^{t+1}. \qquad (1.9)$$

Many variants extend the standard PSO algorithm, and the most noticeable improvement is probably to use an inertia function. A relatively vast literature exists about PSO (Kennedy et al., 2001; Yang, 2014).

4.1.4 *Firefly algorithm*

The FA was first developed by Xin-She Yang in 2007 (Yang, 2008, 2009). It was based on the flashing patterns and behavior of fireflies. In the FA, the

movement of a firefly i that is attracted to another more attractive (brighter) firefly j is determined by this nonlinear updating equation:

$$x_i^{t+1} = x_i^t + \beta_0 e^{-\gamma r_{ij}^2}(x_j^t - x_i^t) + \alpha \varepsilon_i^t, \tag{1.10}$$

where β_0 is the attractiveness at distance $r = 0$. The attractiveness of a firefly varies with distance from other fireflies. The variation of attractiveness β with the distance r can be defined by

$$\beta = \beta_0 e^{-\gamma r^2}. \tag{1.11}$$

A demonstration version of FA implementation, without Lévy flights, can be found at the Mathworks file exchange website.[a] The FA has attracted much attention, and some comprehensive reviews exist (Fister et al., 2013; Gandomi et al., 2011; Yang, 2014).

4.1.5 Cuckoo search

CS was developed by Yang and Deb (2009). CS is based on the brood parasitism of some cuckoo species. In addition, this algorithm is enhanced by the so-called Lévy flights (Pavlyukevich, 2007) rather than by simple isotropic random walks. Recent studies show that CS is potentially far more efficient than PSO and GA (Yang and Deb, 2010).

In essence, the CS algorithm uses a balanced combination of local random walk and the global explorative random walk, controlled by a switching parameter p_a. The local random walk can be written as

$$x_i^{t+1} = x_i^t + \alpha s H(p_a - \varepsilon)(x_j^t - x_k^t), \tag{1.12}$$

where x_j^t and x_k^t are two different solutions selected randomly by random permutation.

Here, $H(u)$ is the Heaviside function, and ε is a random number drawn from a uniform distribution, while the step sizes are drawn from a Lévy distribution. On the other hand, the global random walk is carried out by using Lévy flights:

$$x_i^{t+1} = x_i^t + \alpha L(s, \lambda), \tag{1.13}$$

where

$$L(s, \lambda) = \frac{\lambda \Gamma(\lambda) \sin(\pi \lambda / 2)}{\pi} \frac{1}{s^{1+\lambda}}, \quad (s \gg s_0 > 0). \tag{1.14}$$

[a]http://www.mathworks.com/matlabcentral/fileexchange/29693-firefly-algorithm

Here, $\alpha > 0$ is a scaling factor controlling the scale of the step sizes, and s_0 is small fixed step size.

For an algorithm to be efficient, a substantial fraction of the new solutions should be generated by far-field randomization, and their locations should be far enough from the current best solution; this will ensure that the system will not be trapped in a local optimum (Yang and Deb, 2010). A Matlab implementation is given by author Yang and can be downloaded.[b] CS is very efficient in solving engineering optimization problems (Yang, 2014).

4.1.6 *Flower pollination algorithm*

The FPA was developed by Xin-She Yang (2012), based on the pollination characteristics of flowering plants. The main algorithmic equations were based on the biotic cross-pollination, abiotic self-pollination, and flower constancy. These equations can be written as

$$x_i^{t+1} = x_i^t + \gamma L(s, \lambda)(g_* - x_i^t), \tag{1.15}$$

where x_i^t is the pollen i or solution vector x_i at iteration t, and g_* is the current best solution found among all solutions at the current generation or iteration. Here, γ is a scaling factor to control the step size. The randomization $L(s, \lambda)$ is drawn from the same distribution as given in Eq. (1.14). This step is a global search step, which is complemented by an intensive local search:

$$x_i^{t+1} = x_i^t + \epsilon \left(x_j^t - x_k^t \right), \tag{1.16}$$

where x_i^t, x_j^t, x_k^t are three different solutions vectors at iteration t, representing different flowers from the same flowering plant species; ε is a uniformly distributed random number. Between the two search branches [Eqs. (1.15) and (1.16)], there is a proximity probability p to control which branch or search will be used. Typically, $p = 0.5$ can be used, though $p = 0.8$ seems to be more realistic and relevant to reality.

Preliminary studies show that the FPA is very promising and can be efficient in solving multiobjective optimization problems (Yang et al., 2014).

4.2 **Nature-inspired algorithms not based on swarm intelligence**

Not all nature-inspired algorithms are based on SI. In fact, their sources of inspiration can be very diverse, from physical processes to biological processes. In this case, it is better to extend the bio-inspired computation to nature-inspired computation.

[b]www.mathworks.com/matlabcentral/fileexchange/29809-cuckoo-search-cs-algorithm

4.2.1 *Simulated annealing*

Simulated annealing (SA) is a good example of nature-inspired algorithms that are not based on SI (Kirkpatrick et al., 1983). In fact, SA is a trajectory-based algorithm, not a population-based algorithm. In certain sense, SA can be considered as an extension of traditional Metropolis–Hastings algorithm but applied in a different context. In deterministic algorithms, such as hill-climbing, the new moves are generated by using gradients and thus are always accepted. In contrast, SA uses a stochastic approach for generating new moves and deciding the acceptance.

Loosely speaking, the probability of accepting a new move is determined by the Boltzmann-type probability:

$$p = \exp\left[-\frac{\Delta E}{k_{\mathrm{B}} T} \right], \tag{1.17}$$

where k_{B} is the Boltzmann's constant and T is the temperature for controlling the annealing process. The energy change ΔE should be related to the objective function $f(x)$. In this case, the preceding probability becomes

$$p(\Delta f, T) = e^{-\Delta f / T}. \tag{1.18}$$

Whether or not a change is accepted, a random number (r) is often used as a threshold. Thus, if $p > r$, the move is accepted. It is worth pointing out that the special case when $T \to 0$ corresponds to the classical hill-climbing because only better solutions are accepted, and the system is essentially climbing up or descending along a hill.

4.2.2 *Genetic algorithms*

GA are a class of algorithms based on the abstraction of Darwin's evolution of biological systems, pioneered by J. Holland and his collaborators in the 1960s and 1970s (Holland, 1975). GAs use the so-called genetic operators: crossover, mutation, and selection. Each solution is encoded as a string (often binary or decimal), called a chromosome. The crossover of two parent strings produce offspring (new solutions) by swapping part or genes of the chromosomes. Crossover has a higher probability, typically 0.8–0.95. Crossover provides a good mixing capability for the algorithm to produce new solutions so that the main good characteristics in the solutions will largely pass on to new solutions, while at the time new characteristics will also be produced through the mixing of the parent solutions. This will enable sufficiently good convergence under the right conditions.

On the other hand, mutation is carried out by flipping some digits of a string, which generates new solutions. This mutation probability is typically low,

from 0.001 to 0.05. New solutions generated in each generation will be evaluated by their fitness that is linked to the objective function of the optimization problem. Mutation provides a mechanism to generate new solutions that may not be within the subspace of the solutions and thus some advantages over crossover in escaping the local optima.

Selection provides a driving force for the system to select good solutions. New solutions are selected according to their fitness: selection of the fittest. Sometimes, in order to make sure that the best solutions remain in the population, the best solutions are passed onto the next generation without much change. This is called elitism. GAs have been applied to almost all areas of optimization, design, and applications. There are hundreds of good books and thousands of research articles on the topic. There are many variants and hybridization with other algorithms, and interested readers can refer to more advanced literature, such as Goldberg (1989).

4.2.3 *Differential evolution*

DE consists of three main steps: mutation, crossover, and selection (Storn, 1996; Storn and Price, 1997). Mutation is carried out by the mutation scheme. The mutation scheme can be updated as

$$v_i^{t+1} = x_p^t + F(x_q^t - x_r^t), \tag{1.19}$$

where x_p^t, x_q^t, and x_r^t are three distinct solution vectors and $F \in (0,2]$ is a parameter, often referred to as the differential weight. This requires that the minimum number of population size is $n \geq 4$.

The crossover is controlled by a crossover probability C_r, and actual crossover can be carried out in two ways: binomial and exponential. Selection is essentially the same as that used in GAs. It is to select the most fit and, for the minimization problem, the minimum objective value. Therefore, we have

$$x_i^{t+1} = \begin{cases} u_i^{t+1} & \text{if } f(u_i^{t+1}) \leq f(x_i^t), \\ x_i^t & \text{otherwise.} \end{cases} \tag{1.20}$$

There are many variants of DE, and some review studies can be found in the literature (Price et al., 2005). DE has a good autoscaling property in the sense that the solution ranges can be taken care of as the solutions are generated. Similar autoscaling properties also exist in PSO and the FPA.

4.2.4 *Harmony search*

Strictly speaking, HS is not a bio-inspired algorithm and should not be included in this chapter. However, as it has some interesting properties, we will discuss it briefly. HS is a music-inspired algorithm, first developed by

Z.W. Geem et al. (2001). The usage of harmony memory is important as it is similar to choosing the best-fit individuals in the GA. The pitch adjustment can essentially be considered as a random walk:

$$x_{\text{new}} = x_{\text{old}} + b(2\varepsilon - 1), \tag{1.21}$$

where ε is a random number drawn from a uniform distribution [0,1]. Here b is the bandwidth, which controls the local range of pitch adjustment. There are also relatively extensive studies concerning the HS algorithm (Geem et al., 2001).

4.3 Other algorithms

There are many other metaheuristic algorithms which may be equally popular and powerful, and these include Tabu search (Glover and Laguna, 1997), the artificial immune system (Farmer et al., 1986), and others (Yang, 2010a,b; Koziel and Yang, 2011). The literature on nature-inspired computation is still expanding rapidly, and it is estimated that there are more than 100 different variants of nature-inspired algorithms. Interested readers can refer to more specialized literature (Yang et al., 2013, 2015).

The efficiency of nature-inspired algorithms can be attributed to the fact that they imitate the best features in nature, especially the selection of the fittest in biological systems that have evolved by natural selection over millions of years. There is no doubt that bio-inspired computation will continue to become even more popular in the coming years.

5 ARTIFICIAL NEURAL NETWORKS AND SUPPORT VECTOR MACHINES

Image processing techniques are often linked or combined with techniques in machine learning and computational intelligence. Apart from the algorithms based on SI, image processing also uses other popular methods, such as ANNs networks. As we will see, ANNs are in essence optimization algorithms, working in different contexts and applications (Gurney, 1997; Yang, 2010a).

5.1 Artificial neural networks

The basic mathematical model of an artificial neuron was first proposed by W. McCulloch and W. Pitts in 1943, and this fundamental model is referred to as the McCulloch–Pitts model (Gurney, 1997). An artificial neuron with n inputs or impulses and an output y_k will be activated if the signal strength reaches a certain threshold θ. Each input has a corresponding weight w_i. The output of this neuron is given by

$$y_k = \Phi\left(\sum_{i=1}^{n} w_i u_i\right), \qquad \xi = \sum_{i=1}^{n} w_i u_i, \tag{1.22}$$

where the weighted sum ξ is the total signal strength and Φ is the so-called activation function, which can be taken as a step function. That is, we have

$$\Phi(\xi) = \begin{cases} 1 & \text{if } \xi \geq \theta, \\ 0 & \text{if } \xi < \theta. \end{cases} \tag{1.23}$$

We can see that the output is activated only to a nonzero value if the overall signal strength is greater than the threshold θ. This function has discontinuity, so it is easier to use a smooth sigmoid function

$$S(\xi) = \frac{1}{1 + e^{-\xi}}, \tag{1.24}$$

which approaches 1 as $U \to \infty$ and becomes 0 as $U \to -\infty$. Interestingly, this form will lead to a useful property in terms of the first derivative:

$$S'(\xi) = S(\xi)[1 - S(\xi)]. \tag{1.25}$$

The power of the ANN becomes evident with connections and combinations of multiple neurons. The structure of the network can be complicated, and one of the most widely used is arranged in a layered structure, with an input layer, an output layer, and one or more hidden layers. The connection strength between two neurons is represented by its corresponding weight. Some ANNs can perform complex tasks and can simulate complex mathematical models, even if there is no explicit functional form mathematically. Neural networks have developed over last few decades and have been applied in almost all areas of science and engineering.

The construction of a neural network involves the estimation of the suitable weights of a network system with some training/known data sets. The task of the training is to find the suitable weights w_{ij} so that the neural networks not only can best-fit the known data but also can predict outputs for new inputs. A good ANN should be able to minimize both errors simultaneously: the fitting/learning errors and the prediction errors. The errors can be defined as the difference between the calculated (or predicated) output o_k and real output y_k for all output neurons in the least-square sense:

$$E = \frac{1}{2} \sum_{k=1}^{n_o} (o_k - y_k)^2. \tag{1.26}$$

Here the output o_k is a function of inputs/activations and weights. In order to minimize this error, we can use the standard minimization techniques to find the solutions of the weights.

There are many ways of calculating weights by supervised learning. One of the simplest and most widely used methods is to use the backpropagation algorithm for training neural networks, often called backpropagation neural networks (BPNNs). The basic idea is to start from the output layer and propagate backward so as to estimate and update the weights (Gurney, 1997). There are many good software packages for ANNs, and there are dozens of good books fully dedicated to the implementation (Gurney, 1997).

5.2 Support vector machines

Support vector machines are an important class of methods that can be very powerful in classifications, regression, machine learning, and other applications (Vapnik, 1995).

The basic idea of classification is to try to separate different samples into different classes. For binary classifications, we can try to construct a hyperplane

$$w x + b = 0, \tag{1.27}$$

so that the samples can be divided into two distinct classes. Here the normal vectors w and b have the same size as x, and they can be determined using the data, though the method of determining them is not straightforward. It requires the existence of a hyperplane.

In essence, if we can construct such a hyperplane, we should construct two hyperplanes so that the two hyperplanes are as far away as possible, and no samples should be between these two planes. Mathematically, this is equivalent to two equations:

$$w x + b = +1, \tag{1.28}$$

and

$$w x + b = -1. \tag{1.29}$$

From these two equations, it is straightforward to verify that the normal (perpendicular) distance between these two hyperplanes is related to the norm $\|w\|$ via

$$d = \frac{2}{\| w \|}. \tag{1.30}$$

A main objective of constructing these two hyperplanes is to maximize the distance or the margin between the two planes. The maximization of d is equivalent to the minimization of $\|w\|$ or, more conveniently, $\|w\|^2$. In

reality, most problems are nonlinear, and the linear SVM cannot be used. Ideally, we should find some nonlinear transformation ϕ so that the data can be mapped onto a high-dimensional space where the classification becomes linear. The transformation should be chosen in a certain way so that their dot product leads to a kernel-style function: $K(x, x_i) = \phi(x)\dot{\phi}(x_i)$. This is the so-called kernel function trick. Now the main task is to chose a suitable kernel function for a given problem.

Though there are polynomial classifiers and others, the most widely used kernel is the Gaussian radial basis function (RBF)

$$K(x,x_i) = \exp[-\parallel x - x_i \parallel^2/(2\sigma^2)] = \exp[-\gamma \parallel x - x_i \parallel^2], \qquad (1.31)$$

for nonlinear classifiers. This kernel can easily be extended to any high dimensions. Here, σ^2 is the variance and $\gamma = 1/(2\sigma^2)$ is a constant. Often the formulations become optimization problems, and thus they can be solved efficiently by many techniques, such as quadratic programming techniques. Many software packages (either commercial or open source) are readily available, so we will not discuss the implementation. In addition, some methods and their variants are still an area of active research. Interested readers can refer to more advanced literature.

6 **RECENT TRENDS AND APPLICATIONS**

In the recent years, a considerable number of works somehow model image processing-driven applications by means of optimization problems (Ashour et al., 2015; Pires et al., 2015; Malik et al., 2016; Osaku et al., 2015; Babu and Sunitha, 2015). In fact, computer vision-based techniques are often parameterized by a number of variables. Since they are usually designed to cope with different domains, they are not designed to work on a single problem only. In order to allow a more flexible usage, image processing techniques often make use of parameters that can be adjusted to certain requirements. The applications range from image thresholding and segmentation, image restoration, denoising and filtering, just to name a few. In addition, image-based applications related to feature selection can benefit from optimization models. Usually one needs to find out the minimal subset of features that maximize the classification accuracy on some image/face/object recognition task.

It is worth noting that deep learning techniques are used as well, mostly over images to learn features. However, often hundreds of parameters need to be fine-tuned. In this case, bio-inspired optimization techniques seem to be a page-turner, since computing derivatives in high-dimensional spaces,

as required by most standard optimization techniques, may not be a good idea. The problem gets worse in large-scale data sets. In fact, it is difficult to think about images without recognizing that one needs to deal with machine learning techniques. As mentioned, techniques often make use of parameters to allow a certain degree of flexibility, and the same occurs with machine learning techniques. Loosely speaking, when working with machine learning techniques, the most painful step is the fine-tuning. Otherwise, the accuracy may be neglected by the lack of information and experience of the user. Interestingly, most applications in the literature deal with images, since they are one of the most natural sources of information. On the other hand, one can also consider using a network of sensors. However, buying hundreds of them may be unviable, or there may be places where they just do not work well.

A number of works have recently considered applying bio-inspired optimization techniques to image content. Satellite images usually suffer from noise and blurring effects; thus it is desirable to restore their details without enhancing the noise, since both components are composed of high frequencies. An interesting way to handle the problem is by means of iterative image restoration techniques, which have parameters as well. Pires et al. (2015), for instance, employed nature-inspired techniques to fine-tune an image restoration algorithm based on projections onto convex sets. The authors obtained very competitive results, but with lower computational burden. Osaku et al. (2015) optimized the amount of contextual information added during the learning process of a hybrid classifier composed of optimum-path forests and Markov random fields. The proposed approach was validated in the context of land-cover image classification.

In addition, image segmentation was carried out by using a CS-based approach so as to optimize the cluster centers and subsequently segment images properly (Nandy et al., 2015). Automatic registration of multitemporal remote sensing images can be a challenging task. Senthilnath et al. (2014) used bio-inspired techniques, such as PSO and FA to carry out effective image registration.

Image filtering, in which sequences of different filters can be applied differently for each image, has attracted a considerable attention as well (Malik et al., 2016; Babu and Sunitha, 2015). Also, the size and parameters of each filter can be optimized according to the target application. Edge-detection and computed tomography image enhancement are other examples of successful applications of bio-inspired optimization algorithms (Ashour et al., 2015). Curiously, a considerable number of studies employed CS in the context of image processing applications. There are two possible explanations: first, CS is one the most recent bio-inspired techniques in the

literature, and it turns out to be the most frequently used technique as well; and second, CS seems to be more adaptive to image processing–like optimization problems, which deserves deeper studies as well.

One may also argue that there are some possible shortcomings in using bio-inspired techniques. In fact, they can be time-consuming when the fitness function to be evaluated requires a considerable computational burden. In this context, we can shed light on parallel and GPU-based programming, since most techniques update each possible solution independently within a single iteration. Therefore, the execution of the fitness function can be performed in parallel. Furthermore, it is worth mentioning that readers should also consider other search spaces, such as ones based on quaternions and arithmetic interval. One of the aims is to allow the modifications of the fitness landscape so that smoother fitness landscapes can become easier to search.

As it is obvious that no single method can be universally useful for all applications, the best option is to investigate various methods to see how they perform for different problems and thus learn how to choose a good set of algorithms for a given set of common problems. In the end, a good combination of various techniques (traditional and new) can be useful when dealing with challenging optimization problems related to image processing and many other applications.

7 CONCLUSIONS

The extensive literature of bio-inspiration computation and its application in image processing is expanding. We have carried out a brief review of some bio-inspired optimization algorithms in this chapter. But we have not focused sufficiently on the implementations, especially in the context of image processing. It may also argued that we ignored all the traditional image processing techniques; we believe there are many good books and a vast literature so that interested readers can learn more about traditional methods easily (Gonzalez and Woods, 2007; Russ and Neal, 2015). However, this chapter may pave ways for introducing in-depth methods and case studies in the rest of the book. The next chapters start to emphasize various bio-inspired methods and their diverse range of applications in image processing and machine intelligence.

REFERENCES

Ashour, A.S., Samanta, S., Dey, N., Kausar, N., Abdessalemkaraa, W.B., Hassanien, A.E., 2015. Computed tomography image enhancement using cuckoo search: a log transform based approach. J. Signal Inform. Process. 6 (5), 244–257.

Babu, R.T., Sunitha, K.V.N., 2015. Enhancing digital images through cuckoo search algorithm in combination with morphological operation. J. Comput. Sci. 11 (1), 7–17.

Blum, C., Roli, A., 2003. Metaheuristics in combinatorial optimization: overview and conceptual comparison. ACM Comput. Surv. 35, 268–308.

Conn, A.R., Schneinberg, K., Vicente, L.N., 2009. Introduction to Derivative-Free Optimization. SIAM, Philadelphia, PA.

Dorigo, M., Stütle, T., 2004. Ant Colony Optimization. MIT Press, Cambridge, MA.

Farmer, J.D., Packard, N., Perelson, A., 1986. The immune system, adaptation and machine learning. Phys. D 2, 187–204.

Fister, I., Fister, Jr., I., Yang, X.S., Brest, J., 2013. A comprehensive review of firefly algorithms. Swarm Evol. Comput. 13 (1), 34–46.

Gandomi, A.H., Yang, X.S., Alavi, A.H., 2011. Mixed variable structural optimization using firefly algorithm. Comput. Struct. 89 (23/24), 2325–2336.

Geem, Z.W., Kim, J.H., Loganathan, G.V., 2001. A new heuristic optimization: harmony search. Simulation 76 (1), 60–68.

Glasbey, C.A., Horgan, G.W., 1995. Image Analysis for the Biological Sciences. Wiley, New York, NY.

Glover, F., Laguna, M., 1997. Tabu Search. Kluwer Academic Publishers, Boston, MA.

Goldberg, D.E., 1989. Genetic Algorithms in Search, Optimization and Machine Learning. Addison Wesley, Reading, MA.

Gonzalez, R.C., Woods, R.E., 2007. Digital Image Processing, third ed. Prentice Hall, Upper Saddle River, NJ.

Gurney, K., 1997. An Introduction to Neural Networks. Routledge, London.

Holland, J., 1975. Adaptation in Natural and Artificial Systems. University of Michigan Press, Ann Anbor, MI.

Karaboga, D., 2005. An Idea Based on Honey Bee Swarm for Numerical Optimization, Technical Report TR06, Erciyes University, Kayseri, Turkey.

Karmarkar, N., 1984. A new polynomial-time algorithm for linear programming. Combinatorica 4 (4), 373–395.

Kennedy, J., Eberhart, R.C., 1995. Particle swarm optimization. In: Proceedings of IEEE International Conference on Neural Networks, Piscataway, NJ, pp. 1942–1948.

Kennedy, J., Eberhart, R.C., Shi, Y., 2001. Swarm Intelligence. Morgan Kaufmann Publishers, San Francisco, CA.

Kirkpatrick, S., Gelatt, C.D., Vecchi, M.P., 1983. Optimization by simulated annealing. Science 220 (4598), 671–680.

Koziel, S., Yang, X.S., 2011. Computational Optimization, Methods and Algorithms. Springer, Berlin, Heidelberg, Germany.

Malik, M., Ahsan, F., Mohsin, S., 2016. Adaptive image denoising using cuckoo algorithm. Soft Comput. 20 (3), 925–938.

Nakrani, S., Tovey, C., 2004. On honey bees and dynamic server allocation in Internet hosting centers. Adapt. Behav. 12 (3–4), 223–240.

Nandy, S., Yang, X.S., Sarkar, P.P., Das, A., 2015. Color image segmentation by cuckoo search. Intell. Autom. Soft Comput. 21 (4), 673–685.

Osaku, D., Nakamura, R., Pereira, L.A.M., Pisani, R.J., Levada, A.L.M., Cappabianco, F.A.M., Falcão, A.X., Papa, J.P., 2015. Improving land cover classification through contextual-based optimum-path forest. Inform. Sci. 324 (1), 60–87.

Papa, J.P., Rosa, G.H., Marana, A.N., Scheirer, W., Cox, D.D., 2015. Model selection for discriminative restricted Boltzmann machines through meta-heuristic techniques. J. Comput. Sci. 9 (1), 14–18.

Parpinelli, R.S., Lopes, H.S., 2011. New inspirations in swarm intelligence: a survey. Int. J. Bio-Inspired Comput. 3, 1–16.

Pavlyukevich, I., 2007. Lévy flights, non-local search and simulated annealing. J. Comput. Phys. 226, 1830–1844.

Pires, R.G., Pereira, D.R., Pereira, L.A.M., Mansano, A.F., Papa, J.P., 2015. Projections onto convex sets parameter estimation through harmony search and its application for image restoration. Nat. Comput. Available from: http://link.springer.com/article/10.1007/s11047-015-9507-4

Price, K., Storn, R., Lampinen, J., 2005. Differential Evolution: A Practical Approach to Global Optimization. Springer.

Russ, J.C., Neal, F.B., 2015. The Image Processing Handbook, seventh ed. CRC Press, Boca Raton, FL.

Senthilnath, J., Yang, X.S., Benediktsson, J.A., 2014. Automatic registration of multi-temporal remote sensing images based on nature-inspired techniques. Int. J. Image Data Fusion 5 (4), 263–284.

Sonka, M., Hlavac, V., Boyle, R., 2014. Image Processing, Analysis and Machine Vision, fourth ed. Cengage Learning Engineering, UK.

Storn, R., 1996. On the usage of differential evolution for function optimization. In: Biennial Conference of the North American Fuzzy Information Processing Society (NAFIPS), pp. 519–523.

Storn, R., Price, K., 1997. Differential evolution—a simple and efficient heuristic for global optimization over continuous spaces. J. Global Optim. 11 (2), 341–359.

Talbi, E.G., 2009. Metaheuristics: From Design to Implementation. John Wiley & Sons, Hoboken, NJ.

Vapnik, V., 1995. The Nature of Statistical Learning Theory. Springer-Verlag, New York, NY.

Wolpert, D.H., Macready, W.G., 1997. No free lunch theorems for optimization. IEEE Trans. Evol. Comput. 1 (1), 67–82.

Yang, X.S., 2008. Nature-Inspired Metaheuristic Algorithms, first ed. Luniver Press, Bristol, UK.

Yang, X.S., 2009. Firefly algorithms for multimodal optimization. In: Watanabe, O., Zeugmann, T. (Eds.), 5th Symposium on Stochastic Algorithms, Foundations and Applications (SAGA 2009), LNCS, 5792, pp. 169–178.

Yang, X.S., 2010a. Nature-Inspired Metaheuristic Algorithms, second ed. Luniver Press, Bristol, UK.

Yang, X.S., 2010b. Engineering Optimization: An Introduction with Metaheuristic Applications. John Wiley & Sons, Hoboken, NJ.

Yang, X.S., 2011. Bat algorithm for multi-objective optimisation. Int. J. Bio-Inspired Comput. 3 (5), 267–274.

Yang, X.S., 2012. Flower pollination algorithm for global optimization. Unconventional Computation and Natural Computation. Lecture Notes in Computer Science, vol. 7445. Springer, Heidelberg, pp. 240–249.

Yang, X.S., 2014. Nature-Inspired Optimization Algorithms. Elsevier, London, UK.

Yang, X.S., Deb, S., 2009. Cuckoo search via Lévy flights. In: Proceedings of World Congress on Nature & Biologically Inspired Computing (NaBic 2009), IEEE Publications, USA, pp. 210–214.

Yang, X.S., Deb, S., 2010. Engineering optimization by cuckoo search. Int. J. Math. Model. Num. Optimisation 1 (4), 330–343.

Yang, X.S., Gandomi, A.H., 2012. Bat algorithm: a novel approach for global engineering optimization. Eng. Comput. 29 (5), 1–18.

Yang, X.S., He, S., 2013. Bat algorithm: literature review and applications. Int. J. Bio-Inspired Comput. 5 (3), 141–149.

Yang, X.S., Cui, Z.H., Xiao, R.B., Gandomi, A.H., Karamanoglu, M., 2013. Swarm Intelligence and Bio-Inspired Computation: Theory and Applications. Elsevier, Waltham, MA.

Yang, X.S., Karamanoglu, M., He, X.S., 2014. Flower pollination algorithm: a novel approach for multiobjective optimization. Eng. Optimiz. 46 (9), 1222–1237.

Yang, X.S., Chien, S.F., Ting, T.O., 2015. Bio-Inspired Computation in Telecommunications. Morgan Kaufmann, San Francisco, California.

Fine-tuning enhanced probabilistic neural networks using metaheuristic-driven optimization

S.E.N. Fernandes*, K.K.F. Setoue**, H. Adeli†, J.P. Papa**

*Department of Computing, Federal University of São Carlos, São Carlos, São Paulo, Brazil; **Department of Computing, São Paulo State University, Bauru, São Paulo, Brazil; †Department of Civil, Environmental and Geodetic Engineering, Ohio State University, Columbus, OH, United States

1 INTRODUCTION

Pattern recognition techniques aim at learning decision functions that separate a dataset into clusters of samples that share similar properties. Such a process of learning decision functions can be addressed through three main approaches: (1) supervised, in which one has a priori information about the whole training set; (2) semisupervised, where partial information about the training set is known; and (3) unsupervised, in which one has no information about the training samples. Supervised techniques are known to be the

Bio-Inspired Computation and Applications in Image Processing. http://dx.doi.org/10.1016/B978-0-12-804536-7.00002-8

most accurate, since the amount of information available about the training samples allows them to learn class-specific properties; in addition, one can design more complex learning algorithms to improve the quality of the training data. The reader can refer to some state-of-the-art supervised techniques, such as support vector machines (SVMs), proposed by Cortes and Vapnik (1995), neural networks (NNs), discussed by Haykin (2007), Bayesian classifiers, and the well-known k-nearest neighbors (k-NN), among others. Duda et al. (2000) provides a wide discussion about such methods.

Applications of NNs to pattern classification have been extensively studied in the past years; applications include radial basis function neural networks (Adeli and Karim, 2000; Ghosh-Dastidar et al., 2008; Karim and Adeli, 2003; Savitha et al., 2009), recurrent neural networks (Panakkat and Adeli, 2009; Puscasu et al., 2009), wavelet neural networks (Ghosh-Dastidar and Adeli, 2003; Zou et al., 2008), neural dynamics models (Rigatos and Tzafestas, 2007; Senouci and Adeli, 2001), complex-valued neural networks (Buchholz and le Bihan, 2008; Kawata and Hirose, 2008), neurogenetic/evolutionary models (Elragal, 2009; Roy et al., 2009), and probabilistic neural networks (PNNs) (Specht, 1990, 1992), just to name a few. PNNs have become an efficient (Hoya, 2003) and effective (Devaraju and Ramakrishnan, 2011) tool for solving many classification problems (Kramer et al., 1995; Sun et al., 1996; Romero et al., 1997; Wen-tsao and Wei-yuan, 2008; Ning, 2013), since they have a simple and elegant formulation that allows a fast training procedure.

Although we have very sophisticated and complex techniques, it is always important to keep an open mind for different approaches that may lead us to better results. Simple ideas can improve the effectiveness of some well-known techniques. Ahmadlou and Adeli (2010), for instance, proposed enhanced probabilistic neural networks (EPNNs) to avoid the influence of noisy samples when computing the covariance matrix of each class. Usually, standard PNNs consider the very same weight for each training sample when computing the covariance matrix for each class. However, the aforementioned authors proposed to consider only the samples that fall in a neighborhood of given a training sample for computing the covariance matrix. Therefore, each training sample has its own variance, which will be used to compute the covariance matrix of its class. Outliers will have little or no contribution to that process. This simple idea has shown to be very effective in some situations.

The approach proposed by Ahmadlou and Adeli (2010) provides a confidence for samples based on local decision circles (ie, using local information and inhomogeneity existing in the training population for the

refinement of a smoothing parameter on unseen data). For such purpose, EPNNs use two Bayesian rules: (1) a global rule based on PNN that estimates the conditional probability of each class given an input vector of data considering all training data and using the spread parameter; and (2) a local rule which estimates the conditional probability of each class given an input vector of data existing within a decision circle delimited by the radius parameter. When the parameter radius is zero, there is no local decision, which means PNNs are a special case of EPNNs without local decision circles.

However, some computational drawbacks associated with PNNs are related to network size, which may affect the efficiency and the value of the smoothing parameter, thus interfering with its effectiveness. As a consequence, the classifier tends to be oversensitive to the training data and is likely to exhibit poor generalization capacities concerning the unseen data (Bishop, 1995). The first problem mentioned earlier has been studied by some researchers, and some algorithms for the reduction of training samples have been proposed (Burrascano, 1991; Traven, 1991; Zaknich, 1997; Kou et al., 2010; Lotfi and Benyettou, 2015). The second problem can be easily solved by using well-known metaheuristic-based techniques: particle swarm optimization (PSO) (Kennedy and Eberhart, 2001; Kaveh and Shojaee, 2007; Ahmadlou and Adeli, 2010), harmony search (HS) (Geem et al., 2001; Geem, 2009), firefly algorithm (FFA) (Yang, 2008), and cuckoo search (CS) (Yang and Deb, 2009), for instance.

In this study we extend the research of Ahmadlou and Adeli (2010) by addressing in more detail the working mechanism of EPNNs. We also propose to model the problem of finding the value of smoothing and radius parameters as an optimization task using metaheuristics. Since the standard approach uses an exhaustive search for finding the best value of smoothing parameters (ie, the one that maximizes the accuracy over the training set), the proposed approach can speed up the original work, and we can reduce overtraining, since the proposed optimization process is conducted over a validating set. Therefore, this study offers two main contributions: (1) It presents a deeper formulation with respect to EPNNs, and (2) it proposes a metaheuristic-based approach to automatically estimate the smoothing and radius parameters. In addition, we compared EPNNs against traditional PNNs.

The remainder of the chapter is organized as follows. Section 2 presents the PNN background theory and the EPNN with metaheuristic-based approach. Experiments are discussed in Section 3, and Section 4 states conclusions and future works.

2 PROBABILISTIC NEURAL NETWORK

2.1 Theoretical foundation

PNNs are closely related to the Parzen window-based probability density function (pdf) estimator. A PNN classifier, which was first proposed by Specht (1990), can be broken up into a large number of simple processes implemented in a multilayer neural network, each of which is a Parzen window pdf estimator for each class (Hajmeer and Basheer, 2002). Given that the PNN is initially based on the Bayes–Parzen classification, it is important to discuss briefly both the Bayes' theorem for conditional probabilities and Parzen's method for estimating the probability density function.

The Bayes' theorem describes the probability of an event based on conditions that might be related to that event. Consider the labeled sample (\mathbf{z}, y), where $\mathbf{z} \in \Re^d$ and $y \in \{1, 2, ..., k\}$ is the label of sample \mathbf{z} (notice we have k classes). Assuming the prior probability that sample \mathbf{z} belongs to the kth class is h_k, the cost associated with misclassifying that sample is c_k, as well as the pdf of all populations $f_1(\mathbf{z}), f_2(\mathbf{z}), ..., f_k(\mathbf{z})$ are known, the Bayes' theorem classifies an unknown sample into the ith class if:

$$h_i c_i f_i\left(z^1\right) > h_j c_j f_j\left(z^1\right), \forall j \neq i, \tag{2.1}$$

where $f_1(\mathbf{z})$, is the probability density function of ith class considering z.

The estimation of the pdf using the samples of the training set is given by:

$$P(z^1) = \frac{1}{N\sigma} \sum_{j=1}^{N} W\left(\frac{z^1 - x_j}{\sigma}\right), \tag{2.2}$$

where $\mathbf{z}^1 \in \Re$ is an input data, x_j is the jth sample, N is the total number of training examples, W is the weighting function, and σ is smoothing parameter. Parzen's (1962) method is usually used to derive such a distribution estimator from a set of training examples. The univariate case of the probability distribution function was proposed by Parzen (1962), and then was extended to the multivariate case by Cacoullos (1966). The multivariate pdf estimator, $P(\mathbf{z})$, may be expressed as follows:

$$P\left(z^1, z^2, \cdots, z^d\right) = \frac{1}{N\sigma_1\sigma_2,\cdots,\sigma_d} \sum_{j=1}^{N} W\left(\frac{z^1 - x_j^1}{\sigma_1}, \frac{z^2 - x_j^2}{\sigma_2}, \cdots, \frac{z^d - x_j^d}{\sigma_d}\right), \tag{2.3}$$

where $\sigma_1, \sigma_2, \cdots, \sigma_d$, are the smoothing parameters representing the standard deviation (Hajmeer and Basheer, 2002).

The PNN, as shown in Fig. 2.1, is organized in interconnected processing units or neurons, which are organized in four layers: (1) an input layer unit

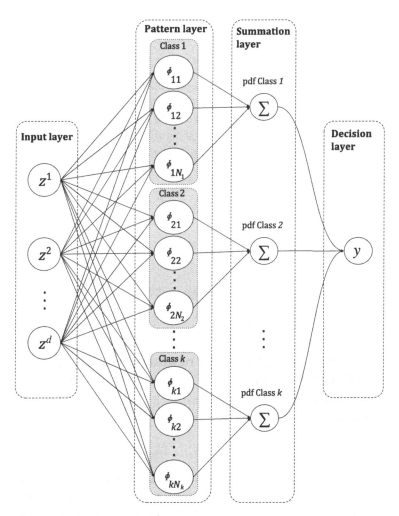

■ FIGURE 2.1 Architecture of a PNN.

with d neurons (d is the dimension of the input data) that simply distributes the pattern vector $z = \left[z^1, \cdots z^d \right]$ to the next neurons; (2) the pattern layer with N neurons (note N_i is the number of training data belonging to the ith class) that receives a pattern **z** from the input layer to be classified into one of the k classes. Assuming all smoothing parameters in Eq. (2.3) are equal, that is, $\sigma_1 = \sigma_2 = \cdots = \sigma_d$, and a bell-shaped Gaussian function is used for W, a reduced form of Eq. (2.3) in the pattern layer results in the standard pdf equation:

$$\phi_j^i(z) = \frac{1}{(2\pi)^{d/2}\sigma^d} \times \exp\left[-\frac{\left(z - x_j^i\right)^T \left(z - x_j^i\right)}{2\sigma^2}\right],\qquad(2.4)$$

where ϕ_j^i is a function of $z - x_j^i$ that represents the likelihood of z being equal to x_j^i, and x_j^i is the jth data training vector belonging to the ith class. The σ, as described, is the spread of the Gaussian function, which can take a value between 0 and 1. The summation layer (3) of k neurones computes the maximum likelihood of pattern z belonging to the ith class, given as follows:

$$P_i(z) = \frac{1}{N_i}\sum_{j=1}^{N_i}\phi_j^i(z).\qquad(2.5)$$

In the last phase (4), a decision layer assigns to z a class with maximum likelihood, as follows:

$$C(z) = \arg\max_i\left\{P_i(z)\right\}, i = 1, 2, \cdots, k,\qquad(2.6)$$

where $C(z)$ is the class that z belongs to.

2.2 Enhanced probabilistic neural network with local decision circles

The approach proposed by Ahmadlou and Adeli (2010) supposes the use of a hypersphere S_{r,x_j} with radius r and center x_j that can be written as follows:

$$\alpha_{x_j} = P\left[x \in C(x_j)\,|\,x \in S_{r,x_j}\right],\qquad(2.7)$$

where α_{x_j} is the ratio of the number of data in the hypersphere S_{r,x_j} that come from the same class of x_j to the number of all data in the same hypersphere. The α parameter can be implemented simply by changing the smoothing parameter in Eq. (2.4) by:

$$\sigma_{x_j} = \alpha_{x_j} \times \sigma.\qquad(2.8)$$

Rewriting Eqs. (2.4) and (2.5), the conditional probability of z belonging to the ith class in the pattern layer of EPNN is computed as follows:

$$P_i(z) = \frac{1}{N_i}\sum_{j=1}^{N_i}\left(\frac{1}{(2\pi)^{d/2}\sigma_{x_j}^d} \times \exp\left[-\frac{\left(z - x_j^i\right)^T \left(z - x_j^i\right)}{2\sigma_{x_j}^2}\right]\right).\qquad(2.9)$$

Therefore, the α_{x_j} for a best case (ie, all samples in S_{r,x_j} belonging to the class of x_j are from the same ith class) is expected to be higher than its

probability of belonging to other classes with fewer data. On the other hand, α_{x_j} close to zero means that few data in the hypersphere S_{r,x_j} come from the same class of x_j, thus resulting in a lower probability of \mathbf{z} belonging to the ith class. Consequently, supposing $\alpha_{x_j} = 1$, it remains unchanged, and σ_{x_j} will be the same as σ. Given $r = 0$ in S_{r,x_j}, the only data is its central hypersphere, thus $\sigma_{x_j} = \sigma$. In this case, Eq. (2.9) is reduced to Eq. (2.4), which means PNN is a special case of EPNN without local decision circles.

3 METHODOLOGY AND EXPERIMENTAL RESULTS

In this section we present the methodology and experiments employed to validate the effectiveness and efficiency of naïve EPNN, EPNN meta-heuristic-based fine-tuning, and standard PNN. As already mentioned, the standard approach uses an exhaustive search for finding the best value of the smoothing parameter (ie, the one that maximizes the accuracy over the training set). Note that the proposed approach can speed up the original work; in addition, we can reduce overtraining, since the optimization process is conducted over a validating set.

3.1 Datasets

We perform experiments over nine classification datasets (real and synthetic datasets)[a,b,c,d] whose main characteristics are presented in Table 2.1.[e]

3.2 Experimental setup

We divided the experiments in two rounds: (1) we evaluated the effectiveness and efficiency of EPNNs against traditional PNNs; (2) we compared the proposed approach to fine-tune EPNN by means of metaheuristics against the standard EPNN.

In regard to the optimization task, we opted to employ the techniques described next due to their simplicity and elegant solutions. In regard to their configuration, we employed this setup:

- *Harmony search* (HS) (Geem et al., 2001): 10 harmonies with 30 iterations, *HMCR* = 0.5, *PAR* = 0.5 and β = 10. Variables *HMCR* and

[a]http://mldata.org
[b]http://archive.ics.uci.edu/ml
[c]http://pages.bangor.ac.uk/~mas00a/activities/artificial_data.htm
[d]https://www.csie.ntu.edu.tw/~cjlin/libsvmtools/datasets/
[e]The experiments were conducted on a computer with a Pentium Intel Core i5 3.2 Ghz processor, with 4 GB of memory RAM and Linux Ubuntu Desktop LTS 14.04 as the operating system.

Table 2.1 Description of the Datasets

Dataset	No. of Samples	No. of Features	No. of Classes
Boat	100	2	3
Fourclass	862	2	2
Saturn	200	2	2
Statlog-Heart	270	13	2
Synthetic3	200	2	2
UCI-Breast-Cancer	683	10	2
UCI-Iris	150	4	3
UCI-Pima-Indians-Diabetes	768	8	2
UCI-Wine	178	13	3

PAR, which stand for "harmony memory considering rate" and "pitch adjusting rate," are used to guide HS onto the search space and to avoid traps from local optima. Variable β denotes the "bandwidth" (step size) used within *PAR*.

- *Improved harmony search* (IHS) (Mahdavi et al., 2007): an improved variant of HS to generate new solution vectors that enhance accuracy and the convergence rate of the HS algorithm. IHS often provides better accuracies through the change of parameter *PAR* and β instead of the constant value in the HS algorithm. The same HS input configuration was used in IHS.

- *Global-best harmony search* (GHS) (Omran and Mahdavi, 2008): another variant of HS that uses concepts from swarm intelligence to enhance the performance of HS. The same configuration from HS was used in GHS.

- *Particle swarm optimization* (PSO) (Kennedy and Eberhart, 2001): 10 particles with 30 iterations, $c_1 = 1.4$, $c_2 = 0.6$, and $w = 0.7$. Variables c_1 and c_2 are used to weight the importance of a possible solution being far or close to the local and global optimum, respectively. Variable w stands for the well-known "inertia weight," which is used as a step size toward better solutions.

- *Cuckoo search* (CS) (Yang and Deb, 2009): 10 particles with 30 iterations and $p_a = 0.25$. Variable p_a is used to control the elitism and the balance of the randomization and local search. In this case, few parameters in CS make an algorithm less complex and thus potentially more generic.

- *Firefly algorithm* (FFA) (Yang, 2008): population size of 10 with 30 iterations, $\gamma = 0.3$ and $\mu = 1.0$. The variables γ and μ are used to control the randomness and the attractiveness, respectively. The FFA has shown to be very effective in dealing with multimodal and global optimization problems (Yang and He, 2013).

For each dataset, we conducted an experiment with 200 runs in order to generate a stable average of the outputs of each approach, being each of them partitioned in two stages: (1) In the first stage, each dataset was partitioned into 40% of the samples for training and the remaining 60% for the validating (ie, parameter fine-tuning) and testing sets, ranging from 10% to 50%, 20% to 40%, …, 50% to 10%. (2) In the second stage, after finding the best parameters in the validating phase according to the metaheuristic approaches, we ended up merging the training and validating sets into a new training set once more, thus generating these settings: 50–50%, 60–40%, …, 90–10%. These percentages have been empirically chosen, being more intuitive, to provide a larger validating set for fine-tuning parameters. The final results were evaluated trough the Wilcoxon signed-rank test with significance of 0.05 (Wilcoxon, 1945). In addition, the mean accuracy and computational load (in seconds) have been computed for each compared technique—PNN, EPNN, and EPNN—using a metaheuristic-based approach. For this comparison, we used the open-source libraries LibDEEP[f] and LibOPT.[g]

3.2.1 *PNNs versus EPNNs*

In this section we evaluated both the efficiency and effectiveness of EPNN against traditional PNN. Fig. 2.2 shows the mean recognition rates of the compared techniques, that is, PNNs against naïve EPNNs with respect to the testing phase. Table 2.2 shows the mean recognition rates over the testing set, in which the values in bold stand for the most accurate techniques according of the Wilcoxon signed-rank test. We can observe EPNN obtained the best results in all datasets, but some recognition rates were very similar to the ones obtained by PNNs for some situations.

Fig. 2.3 depicts the mean computational load considering the training time (log [s]). Clearly, PNNs are faster than naïve EPNNs, since EPNNs need to estimate the radius in the hypersphere, and PNNs need only the σ parameter to be optimized. On average, considering all nine datasets, PNNs are about 64.73 times faster than EPNNs for training + validating phases (ie, considering grid search for finding the best value of smoothing parameters). Note that we also employed a grid search to select the best σ value considering PNNs.

In addition, Fig. 2.4 displays the mean execution time considering now the testing time (log [s]). In this case, since the main difference between both

[f]https://github.com/jppbsi/LibDEEP.git
[g]https://github.com/jppbsi/LibOPT.git

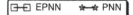

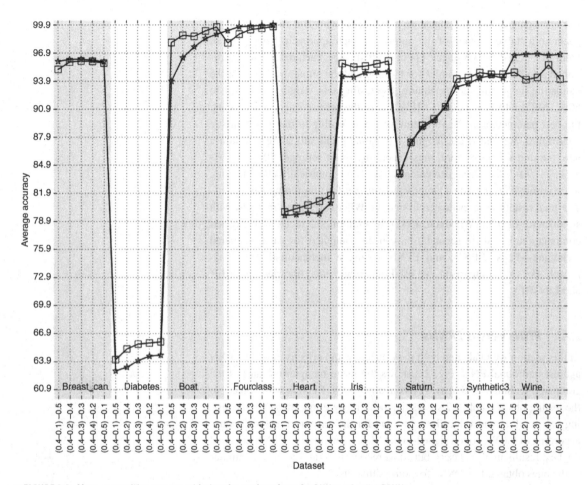

■ FIGURE 2.2 Mean recognition rates considering the testing phase for PNNs and naïve EPNNs.

Table 2.2 Mean Accuracy Results

Dataset	EPNN	PNN
Boat	**98.89** ± 1.93	97.05 ± 3.38
Fourclass	99.11 ± 1.08	**99.70** ± 0.47
Saturn	**88.34** ± 5.93	88.23 ± 6.43
Statlog-Heart	**80.72** ± 4.69	79.92 ± 4.17
Synthetic3	**94.53** ± 2.84	94.02 ± 3.06
UCI-Breast-Cancer	95.81 ± 1.80	**96.13** ± 1.53
UCI-Iris	**95.72** ± 2.69	94.70 ± 3.42
UCI-Pima-Indians-Diabetes	**65.41** ± 3.27	63.86 ± 3.42
UCI-Wine	94.64 ± 8.53	**96.78** ± 1.82

The bold values stand for the most accurate techniques.

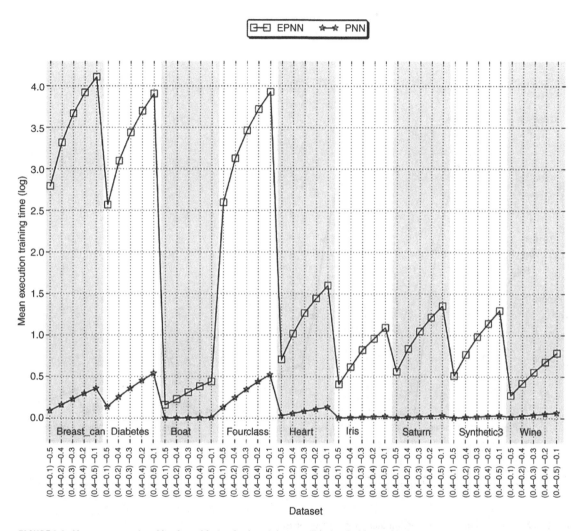

■ **FIGURE 2.3** Mean computational load considering both training + validation (grid-search) phases.

techniques is to find the best radius for EPNNs concerning the training phase, it is expected that the testing time will be very close in both approaches.

In order to provide a robust statistical analysis, we performed the nonparametric Friedman test, which is used to rank the algorithms for each dataset separately. If the Friedman test provides meaningful results to reject the null hypothesis (h_0: all techniques are equivalent), we can perform a further posthoc test. For this purpose, we conducted the Nemenyi test, proposed by Nemenyi (1963) and described by Demšar (2006), which allows us to verify

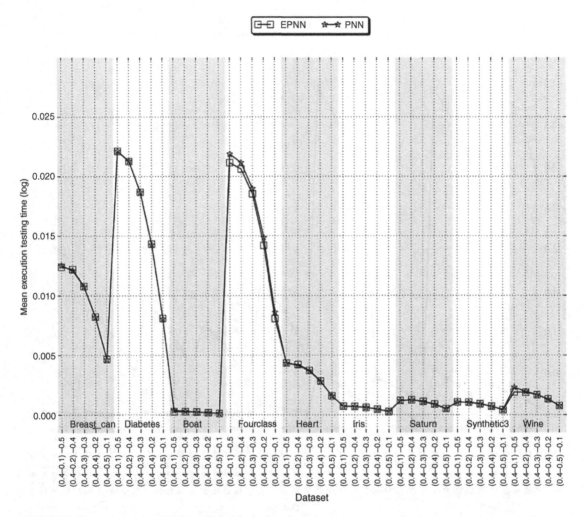

■ FIGURE 2.4 Mean computational load considering the testing phase.

whether there is a critical difference (CD) among techniques or not. The results of the Nemenyi test can be represented in a simple diagram, in which the average ranks of the methods are plotted on the horizontal axis; the lower the average rank is, the better the technique is. Moreover, the groups with no significant difference are then connected with a horizontal line.

Fig. 2.5 depicts the statistical analysis considering the accuracy results. As we can observe, the naïve EPNNs can be considered the most accurate technique by Nemenyi test. This reflects the fact that the EPNNs achieved the best accuracy rates in the majority of datasets.

CD = 0.0207

■ FIGURE 2.5 Comparison of EPNN against PNN according to the accuracies with the Nemenyi test. Groups of approach that are not significantly different (at $p = 0.05$) are connected.

In order to obtain some insight about the structure in high-dimensional data, we employed the Andrews curve method (Andrews, 1972), which represents high-dimensional feature spaces by means of finite Fourier series. The transformation has to maintain some inherent properties of the data, thus making possible to identify some behaviors (Koziol and Hacke, 1991). Each line in this plot stands for a sample, and the variation in grayscale corresponds to a given class. Fig. 2.6 shows the structure of the data for the "UCI-Breast-Cancer," "UCI-Wine," "Statlog-Heart," and "UCI-Pima-Indians-Diabetes" datasets.

As we can observe in Fig. 2.6a and b, patterns from different classes are somehow separated. Note that "UCI-Breast-Cancer" and "UCI-Wine" are two of the three datasets with best results for the PNNs approach. In addition, Fig. 2.6c and d show a more complex data pattern, which was better classified by EPNNs. Considering Fig. 2.6, we can establish that more complex datasets may be better generalized by EPNNs due to the confidence provided by the estimation of individual smoothing parameters for each training sample.

3.2.2 *Evaluating the EPNN and metaheuristic-based EPNNs*

In this section we evaluated the effectiveness of metaheuristic-based EPNNs, and we also showed they can be as accurate as naïve EPNNs. Since naïve EPNNs make use of an exhaustive search to find out σ and radius, we proposed to model such problem as an optimization task in order to speed up the EPNNs fine-tuning.

It is worth mentioning that PSO, FFA, and CS update all possible solutions at each iteration, which means it needs to evaluate the fitness function (EPNN training and classification) whenever a particle changes its position. As such, we shall have $10 \times 30 = 300$ evaluations of the fitness function, plus 10 more evaluations to initialize the swarm. Therefore, EPNN using the PSO approach will require 310 calls to the EPNN training and classification functions. In regard to EPNN using HS, it requires $10 + 30 = 40$ evaluations of the fitness function only, plus 10 more to initialize the harmony memory

■ **FIGURE 2.6** **Andrews plot.** (a) "UCI-Breast-Cancer," (b) "UCI-Wine," (c) "Statlog-Heart," and (d) "UCI-Pima-Indians-Diabetes" datasets in the range of $\pi < t < -\pi$.

(search space or swarm). Therefore, HS requires 50 calls to the fitness function, since it creates only one possible solution at each iteration.

In any case, EPNN using metaheuristics would be faster than naïve EPNN, since they would require fewer computations of the fitness function. However, we would like to evaluate whether the 6 variants of metaheuristics (HS, IHS, GHS, PSO, CS, and FFA) approaches have similar recognition rates with respect to EPNN, since they do not consider all possible ranges of σ and radius values. As mentioned, the experimental

setup was conducted in this way: We partitioned the datasets into three subsets, say, training (40%), initial validating (10%), and testing sets (50%). We used the former two sets to guide the optimization techniques onto the search space, which means the metaheuristics approaches are looking for the σ and radius values that maximize the accuracy over the validating set. Soon after finding out the best parameters, EPNN using metaheuristics is trained once more over the training + validating set. In order to provide a statistical validation, we employed a crossvalidation procedure with 200 runs.

Table 2.3 presents the mean accuracy over the test set, mean training time (we consider the step for learning parameter σ and radius in this computation), as well as the mean σ and mean radius values. The values in bold stand for the most accurate techniques according of the Wilcoxon signed-rank test with significance of 0.05. It is clear that the proposed metaheuristic-based optimization is much faster than naïve EPNNs, particularly for the bases with a greater number of samples as well as the "Fourclass," "UCI-Breast-Cancer," and "UCI-Pima-Indians-Diabetes" datasets.

Fig. 2.7 depicts the statistical analysis. The average accuracy results are shown in Fig. 2.7a and the training (training + validating) time results are shown in Fig. 2.7b. As can be observed, the naïve EPNNs can be considered the most accurate by the Nemenyi test. However, the statistical test did not point out a CD between naïve EPNNs and EPNN metaheuristics using GHS, IHS, and PSO, which means they performed similarly in some problems. In the second group, we have the EPNN using HS and CS. Last, we have the FFA approach. In regard to the training phase, Fig. 2.7b emphasizes the EPNN with GHS as the fastest approach. It is worth noting that the statistical test pointed to the same approach that is considered the closest to the naïve EPNNs regarding accuracy results in Fig. 2.7a. Furthermore, we can highlight three groups in Fig. 2.7b: one composed of the EPNNs metaheuristic-based using GHS (the fastest ones), IHS, and HS approaches, where there is no CD between them; the second group composed of FFA and PSO approaches; and the last group composed of the CS optimization approach and naïve EPNN (the slowest ones).

In short, we can drawn two conclusions:

1. The comparison of the naïve EPNNs against the PNNs standard approach showed that EPNNs obtained the best results in six out of nine datasets.
2. The proposed approach based on metaheuristics for fine-tuning EPNNs has been demonstrated suitable since EPNNs with GHS was 71.35 times faster than an exhaustive search.

Table 2.3 Experimental Results Considering the Proposed Approach for Learning the Parameters Using Metaheuristics

Dataset	Approach	Training Time (s)	Mean σ	Mean Radius	Accuracy
Boat	EPNN	0.3632	0.902299	16.740145	98.89 ± 1.93
	EPNN$_{CS}$	0.0663	0.493065	265.806012	97.76 ± 8.49
	EPNN$_{FFA}$	0.0531	0.520151	246.550750	80.99 ± 23.78
	EPNN$_{GHS}$	0.0075	0.525971	262.013168	99.43 ± 1.41
	EPNN$_{HS}$	0.0120	0.517308	262.942406	99.18 ± 3.83
	EPNN$_{IHS}$	0.0078	0.513935	264.663305	99.36 ± 1.66
	EPNN$_{PSO}$	0.0516	0.489114	265.152184	**99.52** ± 1.13
Fourclass	EPNN	31.0514	0.242549	5.555555	99.11 ± 1.08
	EPNN$_{CS}$	4.8807	0.190801	233.233107	98.88 ± 4.51
	EPNN$_{FFA}$	3.8177	0.217331	251.241594	86.59 ± 20.40
	EPNN$_{GHS}$	0.5051	0.178731	242.194249	**99.31** ± 1.92
	EPNN$_{HS}$	0.5221	0.170435	245.575741	96.31 ± 11.78
	EPNN$_{IHS}$	0.5056	0.181609	242.109301	**99.36** ± 1.24
	EPNN$_{PSO}$	4.0879	0.187606	243.665983	98.96 ± 3.75
Saturn	EPNN	1.8314	0.191100	6.537043	88.34 ± 5.93
	EPNN$_{CS}$	0.2534	0.189239	254.673435	88.47 ± 6.85
	EPNN$_{FFA}$	0.1986	0.289318	253.681262	70.16 ± 17.27
	EPNN$_{GHS}$	0.0271	0.155029	247.003839	**89.32** ± 5.76
	EPNN$_{HS}$	0.0318	0.147871	246.111695	87.50 ± 10.07
	EPNN$_{IHS}$	0.0274	0.153028	247.259233	**89.32** ± 5.86
	EPNN$_{PSO}$	0.2281	0.226130	260.660753	88.00 ± 6.52
Statlog-Heart	EPNN	2.5083	0.864950	14.845467	**80.72** ± 4.69
	EPNN$_{CS}$	1.0193	0.537261	104.998928	74.96 ± 7.63
	EPNN$_{FFA}$	0.7964	0.539966	171.892137	67.50 ± 12.39
	EPNN$_{GHS}$	0.1037	0.587619	59.271041	77.78 ± 7.09
	EPNN$_{HS}$	0.1088	0.595988	61.445244	76.83 ± 8.92
	EPNN$_{IHS}$	0.1037	0.571253	52.396725	77.82 ± 7.49
	EPNN$_{PSO}$	0.7727	0.552817	180.845509	72.93 ± 6.79
Synthetic3	EPNN	1.6559	0.646900	22.364819	94.53 ± 2.84
	EPNN$_{CS}$	0.2527	0.494180	242.677071	93.85 ± 5.86
	EPNN$_{FFA}$	0.1945	0.536348	244.299008	84.07 ± 18.96
	EPNN$_{GHS}$	0.0256	0.499887	242.354885	94.38 ± 3.22
	EPNN$_{HS}$	0.0309	0.479402	249.211453	92.18 ± 10.12
	EPNN$_{IHS}$	0.0260	0.510512	249.479778	94.46 ± 3.17
	EPNN$_{PSO}$	0.1888	0.495530	255.075947	**94.74** ± 2.89
UCI-Breast-Cancer	EPNN	37.8702	0.788000	4.459035	**95.81** ± 1.80
	EPNN$_{CS}$	3.0426	0.620338	111.555685	80.73 ± 10.17
	EPNN$_{FFA}$	2.3292	0.688842	196.014866	74.39 ± 12.17
	EPNN$_{GHS}$	0.3048	0.666642	75.333917	85.92 ± 9.83

Table 2.3 Experimental Results Considering the Proposed Approach for Learning the Parameters Using Metaheuristics (*cont.*)

Dataset	Approach	Training Time (s)	Mean σ	Mean Radius	Accuracy
	EPNN$_{HS}$	0.2991	0.664220	86.310874	84.66 ± 12.03
	EPNN$_{IHS}$	0.3039	0.680609	79.148945	85.80 ± 9.94
	EPNN$_{PSO}$	2.1673	0.675971	179.237911	79.62 ± 11.27
UCI-Iris	EPNN	1.2463	0.846399	14.820302	**95.72** ± 2.69
	EPNN$_{CS}$	0.1797	0.574233	214.296879	94.17 ± 8.19
	EPNN$_{FFA}$	0.1414	0.516897	248.756448	79.36 ± 21.50
	EPNN$_{GHS}$	0.0187	0.613060	214.177775	**95.44** ± 4.37
	EPNN$_{HS}$	0.0233	0.625604	214.012238	94.17 ± 8.42
	EPNN$_{IHS}$	0.0191	0.602112	216.234822	**95.49** ± 3.83
	EPNN$_{PSO}$	0.1371	0.522516	250.041947	**95.72** ± 2.75
UCI-Pima-Indians-Diabetes	EPNN	30.2933	0.924550	3121.349099	**65.41** ± 3.27
	EPNN$_{CS}$	4.5979	0.479119	289.393978	58.23 ± 6.40
	EPNN$_{FFA}$	3.5682	0.639498	280.592486	60.88 ± 6.45
	EPNN$_{GHS}$	0.4667	0.621475	320.455072	61.25 ± 5.63
	EPNN$_{HS}$	0.4463	0.618305	314.432576	60.88 ± 6.14
	EPNN$_{IHS}$	0.4661	0.627712	321.290680	61.32 ± 5.77
	EPNN$_{PSO}$	3.5488	0.669926	313.770173	62.64 ± 4.23
UCI-Wine	EPNN	0.7488	0.799700	35.714110	**94.64** ± 8.53
	EPNN$_{CS}$	0.4533	0.549325	121.291272	92.74 ± 10.71
	EPNN$_{FFA}$	0.3551	0.524857	186.595187	77.80 ± 21.86
	EPNN$_{GHS}$	0.0483	0.535441	88.181578	93.45 ± 9.98
	EPNN$_{HS}$	0.0525	0.565454	88.822526	92.99 ± 11.22
	EPNN$_{IHS}$	0.0485	0.519782	89.808248	93.28 ± 10.41
	EPNN$_{PSO}$	0.3442	0.536938	198.791548	93.04 ± 7.62

The bold values stand for the most accurate techniques.

4 CONCLUSIONS

In this work we demonstrated both the efficiency and the effectiveness of EPNNs against traditional PNNs. The performance of EPNNs was evaluated using nine different benchmark datasets. It was shown that EPNNs obtained the best results in six out of nine datasets classification problems. In addition, we proposed to speed up the EPNN fine-tuning step by means of metaheuristics, which proved to be 71.35 times faster than naïve EPNN.

In regard to future works, we intend to evaluate other metaheuristic techniques to fine-tune EPNNs.

■ **FIGURE 2.7 Comparison of naïve EPNNs against metaheuristic-based EPNNs approach.** (a) Accuracies and (b) training time (training + validating) with the Nemenyi test. Groups of approach that are not significantly different (at $p = 0.05$) are connected.

ACKNOWLEDGMENTS

The authors are grateful to FAPESP grant #2014/16250-9 and #2015/50319-9, CNPq grants #470571/2013-6 and #306166/2014-3, as well as CAPES grant for financial support.

REFERENCES

Adeli, H., Karim, A., 2000. Fuzzy-wavelet RBFNN model for freeway incident detection. J. Transp. Eng. 126 (6), 464–471.

Ahmadlou, M., Adeli, H., 2010. Enhanced probabilistic neural network with local decision circles: a robust classifier. Integr. Comput. Aided Eng. 17 (3), 197–210.

Andrews, D.F., 1972. Plots of high-dimensional data. Biometrics 28 (1), 125–136.

Bishop, C.M., 1995. Neural Networks for Pattern Recognition. Oxford University Press, Inc., New York, NY.

Buchholz, S., le Bihan, N., 2008. Polarized signal classification by complex and quaternionic multilayer perceptrons. Int. J. Neural Syst. 18 (02), 75–85.

Burrascano, P., 1991. Learning vector quantization for the probabilistic neural network. IEEE Trans. Neural Netw. 2 (4), 458–461.

Cacoullos, T., 1966. Estimation of a multivariate density. Ann. Inst. Stat. Math. 18 (1), 179–189.

Cortes, C., Vapnik, V., 1995. Support-vector networks. Mach. Learn. 20 (3), 273–297.

Demšar, J., 2006. Statistical comparisons of classifiers over multiple data sets. J. Mach. Learn. Res. 7, 1–30.

Devaraju, S., Ramakrishnan, S., 2011. Performance analysis of intrusion detection system using various neural network classifiers. In: International Conference on Recent Trends in Information Technology (ICRTIT), Chennai, Tamil Nadu, 3–5 June 2011, pp. 1033–1038.

Duda, R.O., Hart, P.E., Stork, D.G., 2000. Pattern Classification, second ed. Wiley-Interscience, New York, NY.

Elragal, H.M., 2009. Improving neural networks prediction accuracy using particle swarm optimization combiner. Int. J. Neural Syst. 19 (05), 387–393.

Geem, Z.W., 2009. Music-Inspired Harmony Search Algorithm: Theory and Applications. Springer, Berlin, Heidelberg.

Geem, Z., Kim, J., Loganathan, G., 2001. A new heuristic optimization algorithm: harmony search. Simulation 76 (2), 60–68.

Ghosh-Dastidar, S., Adeli, H., 2003. Wavelet-clustering-neural network model for freeway incident detection. Comput. Aided Civil Infrastruct. Eng. 18 (5), 325–338.

Ghosh-Dastidar, S., Adeli, H., Dadmehr, N., 2008. Principal component analysis-enhanced cosine radial basis function neural network for robust epilepsy and seizure detection. IEEE Trans. Biomed. Eng. 55 (2), 512–518.

Hajmeer, M., Basheer, I., 2002. A probabilistic neural network approach for modeling and classification of bacterial growth/no-growth data. J. Microbiol. Methods 51 (2), 217–226.

Haykin, S., 2007. Neural Networks: A Comprehensive Foundation, third ed. Prentice-Hall, Inc., Upper Saddle River, NJ.

Hoya, T., 2003. On the capability of accommodating new classes within probabilistic neural networks. IEEE Trans. Neural Netw. 14 (2), 450–453.

Karim, A., Adeli, H., 2003. Radial basis function neural network for work zone capacity and queue estimation. J. Transp. Eng. 129 (5), 494–503.

Kaveh, A., Shojaee, S., 2007. Optimal design of scissor-link foldable structures using ant colony optimization algorithm. Comput. Aided Civil Infrastruct. Eng. 22 (1), 56–64.

Kawata, S., Hirose, A., 2008. Frequency-multiplexing ability of complex-valued hebbian learning in logic gates. Int. J. Neural Syst. 18 (02), 173–184.

Kennedy, J., Eberhart, R.C., 2001. Swarm Intelligence. Morgan Kaufmann Publishers Inc., San Francisco, CA.

Kou, J., Xiong, S., Wan, S., Liu, H., 2010. The incremental probabilistic neural network. In: Sixth International Conference Natural Computation (ICNC), Yantai, Shandong, August 10–12, vol. 3, pp. 1330–1333.

Koziol, J., Hacke, W., 1991. A bivariate version of Andrews plots. IEEE Trans. Biomed. Eng. 38 (12), 1271–1274.

Kramer, C., McKay, B., Belina, J., 1995. Probabilistic neural network array architecture for ECG classification. In: IEEE 17th Annual Conference of the Engineering in Medicine and Biology Society, vol. 1, pp. 807–808.

Lotfi, A., Benyettou, A., 2015. Over-fitting avoidance in probabilistic neural networks. In: Information Technology and Computer Applications Congress (WCITCA), pp. 1–6.

Mahdavi, M., Fesanghary, M., Damangir, E., 2007. An improved harmony search algorithm for solving optimization problems. Appl. Math. Comput. 188 (2), 1567–1579.

Nemenyi, P., 1963. Distribution-Free Multiple Comparisons. Princeton University, Princeton, NJ.

Ning, L., 2013. Network intrusion classification based on probabilistic neural network. In: 2013 International Conference on Computational and Information Sciences (ICCIS), pp. 57–59.

Omran, M.G., Mahdavi, M., 2008. Global-best harmony search. Appl. Math. Comput. 198 (2), 643–656.

Panakkat, A., Adeli, H., 2009. Recurrent neural network for approximate earthquake time and location prediction using multiple seismicity indicators. Comput. Aided Civil Infrastruct. Eng. 24 (4), 280–292.

Parzen, E., 1962. On estimation of a probability density function and mode. Ann. Math. Stat. 33 (3), 1065–1076.

Puscasu, G., Codres, B., Stancu, A., Murariu, G., 2009. Nonlinear system identification based on internal recurrent neural networks. Int. J. Neural Syst. 19 (02), 115–125.

Rigatos, G.G., Tzafestas, S.G., 2007. Neurodynamics and attractors in quantum associative memories. Integr. Comput. Aided Eng 14 (3), 225–242.

Romero, R.D., Touretzky, D.S., Thibadeau, R.H., 1997. Optical chinese character recognition using probabilistic neural networks. Pattern Recogn. 30 (8), 1279–1292.

Roy, G., Panigrahi, B., Chakraborty, P., Mallick, M., 2009. On optimal feature selection using modified harmony search for power quality disturbance classification. In: Nature Biologically Inspired Computing, 2009 (NaBIC 2009), Coimbatore, Tamil Nadu, December 9–11, pp. 1355–1360.

Savitha, R., Suresh, S., Sundararajan, N., 2009. A fully complex-valued radial basis function network and its learning algorithm. Int. J. Neural Syst. 19 (04), 253–267.

Senouci, A.B., Adeli, H., 2001. Resource scheduling using neural dynamics model of adeli and park. J. Constr. Eng. Manag. 127 (1), 28–34.

Specht, D.F., 1990. Probabilistic neural networks. Neural Netw. 3 (1), 109–118.

Specht, D.F., 1992. Enhancements to probabilistic neural networks. In: IJCNN, vol. 1, pp. 761–768.

Sun, Y., Horng, M.-H., Lin, X., Wang, J.-Y., 1996. Ultrasonic image analysis for liver diagnosis. IEEE Eng. Med. Biol. Mag. 15 (6), 93–101.

Traven, H.G., 1991. A neural network approach to statistical pattern classification by "semiparametric" estimation of probability density functions. Trans. Neural Netw. 2 (3), 366–377.

Wen-tsao, P., Wei-yuan, L., 2008. Use probabilistic neural network to construct early warning model for business financial distress. In: 15th ICMSE 2008, Long Beach, CA, September 10–12, pp. 134–139.

Wilcoxon, F., 1945. Individual comparisons by ranking methods. Biometrics Bull. 1 (6), 80–83.

Yang, X.-S., 2008. Nature-Inspired Metaheuristic Algorithms. Luniver Press, Bristol, UK.

Yang, X.-S., Deb, S., 2009. Cuckoo search via Lévy flights. In: Nature Biologically Inspired Computing, 2009 (NaBIC 2009), Coimbatore, Tamil Nadu, pp. 210–214.

Yang, X.-S., X., He., 2013. Firefly algorithm: recent advances and applications. CoRR abs/1308.3898.

Zaknich, A., 1997. A vector quantisation reduction method for the probabilistic neural network. In: International Conference on Neural Networks, Houston, TX, vol. 2, pp. 1117–1120.

Zou, W., chi, Z., lo, K.C., 2008. Improvement of image classification using wavelet coefficients with structured-based neural network. Int. J. Neural Syst. 18 (03), 195–205.

Fine-tuning deep belief networks using cuckoo search

D. Rodrigues*, X.-S. Yang**, J.P. Papa†

*Department of Computing, Federal University of São Carlos, São Carlos, São Paulo, Brazil;
**School of Science and Technology, Middlesex University, London, United Kingdom; †Department of Computing,
São Paulo State University, Bauru, São Paulo, Brazil

1 INTRODUCTION

Image analysis consists of a workflow in charge of extracting relevant features from a collection of images for further classification. A number of works can cope with such problems, usually by first addressing an overview of the problem, followed by learning the proper features that better describe the data. Soon after, a pattern recognition technique is employed to separate samples (feature vectors extracted from images) from different classes.

47

Bio-Inspired Computation and Applications in Image Processing. http://dx.doi.org/10.1016/B978-0-12-804536-7.00003-X

However, learning features is not so straightforward, since there is a gap in "what a person (expert) uses to describe the problem" and "what is really important to describe it." Therefore, handcrafted features can lead to a painful and time-consuming step in designing good features. In this context and for this purpose, deep learning techniques seem to be very useful, since they aim at learning features by means of unsupervised approaches. Convolutional neural networks (CNNs) (LeCun et al., 1998) and restricted Boltzmann machines (RBMs) (Hinton, 2012; Ackley et al., 1988) are among the most used techniques to perform unsupervised learning tasks. Although their rationale is the same, CNNs and RBMs differ from each other in their internal working mechanism. However, they share the same shortcomings, that are related to the fine-tuning parameters, which can easily reach thousands of them.

Recently, some works have attempted to model the task of choosing suitable parameters for such deep learning techniques as a metaheuristic optimization problem. Papa et al. (2015a) introduced the harmony search (HS) in the context of RBM optimization, and Papa et al. (2015b) dealt with the problem of fine-tuning discriminative restricted Boltzmann machines, which are a variant of naïve RBMs that can address both feature learning and pattern classification. Rosa et al. (2015) also employed harmony search to fine-tune CNNs, and Papa et al. (In Press) addressed harmony search and a number of its variants to optimize deep belief networks (DBNs), which essentially are composed of stacked RBMs. Last but not least, Fedorovici et al. (2012) optimized CNNs in the context of optical character recognition using gravitational search algorithms.

However, as the reader can observe, the area of metaheuristic-based deep learning optimization is still in its embryonic stage. In this work, we evaluated a swarm-based metaheuristic optimization technique called cuckoo search (CS) (Yang and Deb, 2009), which is based on the brooding parasitism mechanism of cuckoos, which make use of nests from other species to raise their own brood. The CS is employed to optimize DBNs and RBMs in the context of binary image reconstruction. We present a discussion about the viability of using such approach compared to harmony search and particle swarm optimization. The experimental section comprised two public datasets, as well as a statistical evaluation by means of Wilcoxon signed-rank test. We hope this work can guide readers and enthusiasts toward a better comprehension of using metaheuristics for deep learning techniques and their fine-tuning. The remainder of this chapter is organized as follows. Section 2 introduces the background of RBMs, DBNs, and CS. Sections 3 and 4 present the methodology and the experimental results, respectively. Finally, Section 5 states conclusions and future works.

2 THEORETICAL BACKGROUND

In this section, we briefly review some of the main important concepts regarding RBMs and DBNs as well as the CS technique.

2.1 Deep belief networks

2.1.1 Restricted Boltzmann machines

RBMs are energy-based stochastic neural networks composed of two layers of neurons (visible and hidden), in which the learning phase is conducted in an unsupervised fashion. Fig. 3.1 depicts the architecture of a RBM, which comprises a visible layer v with m units and a hidden layer h with n units. The real-valued $m \times n$ matrix W models the weights between visible and hidden neurons, where w_{ij} stands for the weight between the visible unit v_i and the hidden unit h_j.

Let us assume v and h as the binary visible and hidden units, respectively. In other words, $v \in \{0,1\}^m$ and $h \in \{0,1\}^n$. The energy function of a Bernoulli RBM is given by:

$$E(v,h) = -\sum_{i=1}^{m} a_i v_i - \sum_{j=1}^{n} b_j h_j - \sum_{i=1}^{m}\sum_{j=1}^{n} v_i h_j w_{ij}, \qquad (3.1)$$

where a and b stand for the biases of visible and hidden units, respectively. The probability of a configuration (v, h) is computed as follows:

$$P(v,h) = \frac{e^{-E(v,h)}}{\sum_{v,h} e^{-E(v,h)}}, \qquad (3.2)$$

where the denominator of Eq. (3.2) is a normalization factor that stands for all possible configurations involving the visible and hidden units. In short, the Bernoulli RBM learning algorithm aims at estimating W, a, and b. The next subsection describes this procedure in more detail.

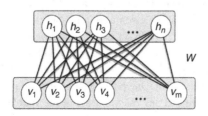

■ FIGURE 3.1 The RBM architecture.

2.1.2 *Learning algorithm*

The parameters of a Bernoulli RBM can be optimized by performing stochastic gradient ascent on the log-likelihood of training patterns. Given a training sample (a visible unit), its probability is computed over all possible hidden vectors, as follows:

$$P(v) = \frac{\sum_h e^{-E(v,h)}}{\sum_{v,h} e^{-E(v,h)}}. \tag{3.3}$$

In order to update the weights and biases, it is necessary to compute the following derivatives:

$$\frac{\partial \log P(v)}{\partial w_{ij}} = E[h_j v_i]^{\text{data}} - E[h_j v_i]^{\text{model}}, \tag{3.4}$$

$$\frac{\partial \log P(v)}{\partial a_i} = v_i - E[v_i]^{\text{model}}, \tag{3.5}$$

$$\frac{\partial \log P(v)}{\partial b_i} = E[h_i]^{\text{data}} - E[h_i]^{\text{model}}, \tag{3.6}$$

where $E[\cdot]$ stands for the expectation operation and $E[\cdot]^{\text{data}}$ and $E[\cdot]^{\text{model}}$ correspond to the data-driven and the reconstructed-data-driven probabilities, respectively.

In practical terms, we can compute $E[h_j v_i]^{\text{data}}$ considering h and v as follows:

$$E[hv]^{\text{data}} = P(h \mid v) v^T, \tag{3.7}$$

where $P(h \mid v)$ stands for the probability of obtaining h given the visible vector (training data) v:

$$P(h_j = 1 \mid v) = \sigma\left(\sum_{i=1}^m w_{ij} v_i + b_j\right), \tag{3.8}$$

where $\sigma(\cdot)$ stands for the logistic sigmoid function. Therefore, it is straightforward to compute $E[hv]^{\text{data}}$: given a training data $x \in \mathfrak{X}$, where \mathfrak{X} stands for a training set, we just need to set $v \leftarrow x$ and then employ Eq. (3.8) to obtain $P(h \mid v)$. Furthermore, we use Eq. (3.7) to finally obtain $E[hv]^{\text{data}}$. However, we need to deal with the problem of estimating $E[hv]^{\text{model}}$, which is the model learned by the system. One possible strategy is to perform alternating Gibbs sampling starting at any random state of the visible units until a certain convergence criterion, such as k steps, for instance. The Gibbs sampling

consists of updating hidden units using Eq. (3.8) followed by updating the visible units using $P(v \mid h)$, given by:

$$P(v_j = 1 \mid h) = \sigma\left(\sum_{j=1}^{n} w_{ij} h_i + a_j\right), \qquad (3.9)$$

and then updating the hidden units once again using Eq. (3.8). In short, it is possible to obtain an estimative of $E[hv]^{\mathrm{model}}$ by initializing the visible unit with random values and then performing Gibbs sampling. Notice that a single iteration is defined by computing $P(h \mid v)$, followed by computing $P(v \mid h)$, and then computing $P(h \mid v)$ once again.

For the sake of explanation, let us assume $P(v \mid \tilde{h})$ is used to denote the visible unit v and is going to be reconstructed using \tilde{h}, which was obtained through $P(h \mid v)$. The same takes place with $P(\tilde{h} \mid \tilde{v})$, that reconstructs \tilde{h} using \tilde{v}, which was obtained through $P(v \mid \tilde{h})$. However, to perform Gibbs sampling until convergence is time consuming, and it is also quite hard to establish suitable initial values for k^{a}. Fortunately, Hinton (2002) introduced a faster methodology to compute $E[hv]^{\mathrm{model}}$ based on contrastive divergence. Basically, the idea is to initialize the visible units with a training sample, to compute the states of the hidden units using Eq. (3.8), and then to compute the states of the visible unit (reconstruction step) using Eq. (3.9). Roughly speaking, this is equivalent to performing the Gibbs sampling using $k = 1$.

Based on the above assumption, we can now compute $E[hv]^{\mathrm{model}}$ as follows:

$$E[hv]^{\mathrm{model}} = P(\tilde{h} \mid \tilde{v})\tilde{v}^T. \qquad (3.10)$$

Therefore, Eq. (3.11) leads to a simple learning rule for updating the weight matrix W:

$$\begin{aligned} W^{t+1} &= w^t + \eta(E[hv]^{\mathrm{data}} - E[hv]^{\mathrm{model}}) \\ &= w^t + \eta(P[h \mid v]v^T - P[\tilde{h} \mid \tilde{v}]\tilde{v}^T), \end{aligned} \qquad (3.11)$$

where W^t stands for the weight matrix at time step t and η corresponds to the learning rate. Additionally, we have the following formulas to update the biases of the visible and hidden units:

$$\begin{aligned} a^{t+1} &= a^t + \eta(v - E[v]^{\mathrm{model}}) \\ &= a^t + \eta(v - \tilde{v}), \end{aligned} \qquad (3.12)$$

[a]Actually, it is expected a good reconstruction of the input sample when $k \to +\infty$.

and

$$b^{t+1} = b^t + \eta(E[h]^{\text{data}} - E[h]^{\text{model}})$$
$$= b^t + \eta(P(h \mid v) - P(\tilde{h} \mid \tilde{v})), \tag{3.13}$$

where a^t and b^t stand for the visible and hidden units biases at time step t, respectively. In short, Eqs. (3.11)–(3.13) are the vanilla formulation for updating the RBM parameters.

Later on, Hinton (2012) introduced a weight decay parameter λ, which penalizes weights with large magnitudes[b], as well as a momentum parameter α to control possible oscillations during the learning process. Therefore, we can rewrite Eqs. (3.11)–(3.13) as follows[c]:

$$W^{t+1} = W^t + \underbrace{\eta(p[h \mid v]v^T - P[\tilde{h} \mid \tilde{v}]\tilde{v}^T - \lambda W^t + \alpha\Delta W^{t-1})}_{= \Delta W^t}, \tag{3.14}$$

$$a^{t+1} = a^t + \underbrace{\eta(v - \tilde{v} + \alpha\Delta a^{t-1})}_{= \Delta a^t}, \tag{3.15}$$

and

$$b^{t+1} = b^t + \underbrace{\eta(P(h \mid v) - P(\tilde{h} \mid \tilde{v}) + \alpha\Delta b^{t-1})}_{= \Delta b^t}. \tag{3.16}$$

2.2 Deep belief nets

Loosely speaking, DBNs are composed of a set of stacked RBMs, with each being trained using the learning algorithm presented in Section 2.1 in a greedy fashion, which means an RBM at a certain layer does not consider others during its learning procedure. Fig. 3.2 depicts such architecture where each RBM at a certain layer is represented as illustrated in Fig. 3.1. In this case, we have a DBN composed of L layers, being W^i the weight matrix of RBM at layer i. Additionally, we can observe the hidden units at layer i become the input units to the layer $i + 1$. Although we did not illustrate the bias units for the visible (input) and hidden layers in Fig. 3.2, we also have such units for each layer.

The approach proposed by Hinton et al. (2006) for the training step of DBNs also considers a fine-tuning as a final step after the training of each RBM. Such procedure can be performed by means of a backpropagation or gradient descent algorithm, for instance, in order to adjust the matrices W^i, $i = 1$, $2, ..., L$. The optimization algorithm aims at minimizing some error measure considering the output of an additional layer placed at the top of the DBN

[b]The weights may increase during the convergence process.
[c]Notice when $\lambda = 0$ and $\alpha = 0$, we have the naïve gradient ascent.

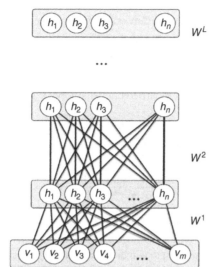

■FIGURE 3.2 The DBN architecture.

after its former greedy training. Such a layer is often composed of softmax or logistic units, or even some supervised pattern recognition technique.

2.3 Cuckoo search

The parasitic behavior of some cuckoo species is extremely intriguing. These birds can lay their eggs in host nests and mimic external characteristics of host eggs, such as color and spots. Sometimes this strategy is unsuccessful, and the host throws the cuckoo's egg away or simply abandons its nest and makes a new one elsewhere. Based on this context, Yang and Deb (2010) presented a novel evolutionary optimization algorithm named as CS, and they have summarized CS using three rules, as follows:

1. Each cuckoo chooses a nest randomly to lay its eggs.
2. The number of available host nests is fixed, and nests with high-quality eggs will carry over to the next generations.
3. If a host bird discovers the cuckoo's egg, it can throw the egg away or abandon the nest and build a completely new nest. There is a fixed number of host nests, and the probability that an egg laid by a cuckoo is discovered by the host bird is $p_a \in [0,1]$.

CS performs a balanced combination of a local random walk and the global explorative random walk, controlled by a switching parameter, $p_a \in [0,1]$. The local random walk can be written as:

$$x_i^j(t) = x_i^j(t-1) + \alpha.s \oplus H(p_a - \varepsilon) \oplus \left(x_{k'}^j(t-1) - x_{k''}^j(t-1) \right), \qquad (3.17)$$

where $x_{k'}^{j}$ and $x_{k''}^{j}$ are two different solutions selected by random permutation, and x_i^j stands for the jth egg at nest i, $i = 1, 2, ..., M$, and $j = 1, 2, ..., d$. $H(\cdot)$ is a Heaviside function, ε is a random number drawn from a uniform distribution, and s is the step size.

The global random walk is carried out using Lévy flights as follows:

$$x_i^j(t) = x_i^j(t-1) + \alpha.L(s, \lambda), \qquad (3.18)$$

where

$$L(s, \lambda) = \frac{\lambda.\Gamma(\lambda).\sin(\lambda)}{\pi} . \frac{1}{s^{1+\lambda}}, \quad s \gg s_0 > 0. \qquad (3.19)$$

The Lévy flights employ a random step length which is drawn from a Lévy distribution. Therefore, the CS algorithm is more efficient in exploring the search space as its step length is much longer in the long run. The parameter $\alpha > 0$ is the step-size scaling factor, which should be related to the scales of the problem of interest. Yang and Deb (2010) claimed that $\alpha = O(S/10)$ can be used in most cases, where S denotes the scale of the problem of interest, while $\alpha = O(S/100)$ can be more effective and avoid flying too far. For a comprehensive review of the CS and its applications, interested readers can refer to Yang and Deb (2014).

3 METHODOLOGY

In this section, we present the methodology used to evaluate the performance of CS regarding the task of DBN model selection and its application for binary image reconstruction. Details about the dataset, experimental setup, and the compared techniques are provided.

3.1 Datasets

- MNIST dataset: It is composed of images of handwritten digits. The original version contains a training set with 60,000 images from digits "0" to "9," as well as a test set with 10,000 images. Due to the high computational burden for RBM model selection, we decided to employ the original test set together with a reduced version of the training set. In addition, we resized all images to a resolution of 14×14.
- Semeion Handwritten Digit dataset: This dataset contains 1593 binary images of manuscript digits with resolution of 16×16 from about 80 persons. We employed the whole dataset in the experimental section.

3.2 **Harmony search and particle swarm optimization**

In this work, we have also considered other evolutionary optimization techniques for comparison purposes. Brief details about each is given next.

Harmony search is a metaheuristic algorithm inspired by the improvisation process of musicians (Geem, 2009). Musicians often improvise the pitches of their instruments searching for a perfect state of harmony. The main idea is to use the same process adopted by musicians to create new songs to obtain a near-optimal solution, according to some fitness function. Each possible solution is modeled as a harmony, and each musical note corresponds to one decision variable.

Improved harmony search (IHS) (Mahdavi et al., 2007) differs from traditional HS by updating the *PAR* and ρ values dynamically, thus enhancing accuracy and convergence rate.

Particle swarm optimization (PSO) is inspired by the social behavior of birds flocking or fish schooling (Kennedy and Eberhart, 2001). The fundamental idea is that each particle represents a potential solution that is updated according to its own experience and from its neighbors' knowledge. The motion of an individual particle for the optimal solution is governed by its position and velocity interactions and also by its own previous best performance and the best performance of its neighbors.

4 **EXPERIMENTS AND RESULTS**

4.1 **Experimental setup**

In this work, we compared the proposed CS-based DBN model selection against with HS, IHS, and PSO. The robustness of parameter fine-tuning was evaluated in three DBN models: one layer (1L)[d], two layers (2L), and three layers (3L). Additionally, 5 agents over 50 iterations were evaluated for convergence considering all techniques with 20 runs with a crossvalidation procedure in order to provide a statistical analysis by means of Wilcoxon signed-rank test (Wilcoxon, 1945).

Table 3.1 presents the parameter configuration for each metaheuristic optimization technique. Finally, we have set each DBN parameter according to the following ranges: $n \in [5,100]$, $\eta \in [0.1,0.9]$, $\lambda \in [0.1,0.9]$, and $\alpha \in [0.0,0.001]$. We employed $T = 10$ as the number of epochs for the DBN learning weights procedure with mini-batches of size 20 and contrastive

[d]Notice the 1L approach stands for the standard RBM.

Table 3.1 Parameters Used for Each Technique

Technique	Parameters
HS	HMCR = 0.7, PAR = 0.7, $\eta = 1.0$
IHS	HMCR = 0.7, $PAR_{min} = 0.1$, $PAR_{max} = 0.7$, $\eta_{min} = 1.0$, $\eta_{max} = 0.10$
PSO	$c_1 = 1.7$, $c_2 = 1.7$, $w = 0.7$
CS	$\alpha = 0.1$, $p_a = 0.25$

divergence (Hinton, 2002) as the training method. Notice the fitness function used in this work is the reconstruction error [ie, mean squared error (MSE)] over the training set.

4.2 **Experimental results**

In this section, we present the experimental evaluation considering CS, HS, IHS, and PSO over the MNIST and SEMEION datasets. Table 3.2 presents the MSE for each optimization technique over the test set considering DBNs with one, two, and three layers for the MNIST dataset. Notice we used only 2% of the original training set for training purposes. The most accurate techniques are in bold.

Although the lowest MSE was obtained by IHS using three layers (IHS-3L), a statistical evaluation by means of the Wilcoxon signed-rank test (Wilcoxon, 1945) with $\alpha = 0.05$ showed no difference between IHS-2L and IHS-3L. However, all remaining techniques, including CS, obtained close results as well. Fig. 3.3a displays the logarithm of the pseudolikelihood, considering the 10 iterations of the CS-1L learning step over the MNIST dataset. Although we employed 10 iterations for learning only, we can see that the pseudolikelihood values are increasing, which means the reconstruction error is decreasing at each iteration. Usually thousands of iterations are employed in the literature, but for the sake of computational purposes, we did not go so far. The main idea of this work is to show we can obtain reasonable reconstructed images using CS. We are not interested into outperforming the best results available, since they use specific configurations

Table 3.2 Average MSE Over the Test Set Considering MNIST Dataset

Technique	1L	2L	3L
HS	0.1059 ± 0.0002	0.1059 ± 0.0002	0.1059 ± 0.0002
IHS	0.0903 ± 0.0048	**0.0885 ± 0.0039**	**0.0877 ± 0.0003**
PSO	0.1057 ± 0.0002	0.1060 ± 0.0005	0.1058 ± 0.0003
CS	0.1066 ± 0.0028	0.1076 ± 0.0007	0.1064 ± 0.0037

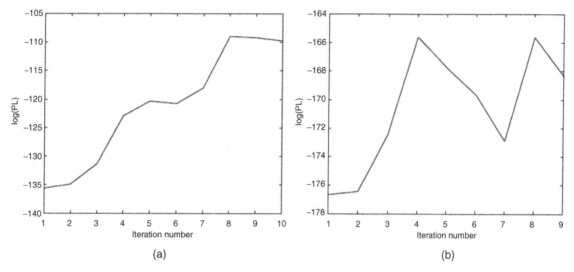

■ **FIGURE 3.3** **Logarithm of the pseudolikelihood values.** (a) MNIST and (b) SEMEION dataset using CS.

that concern the minibatch size and number of epochs. Furthermore, empirical studies suggested CS may have slower convergence rate at the initial stage but convergence continues as iterations continue; this may mean that a higher number of iterations will lead to better results. However, this is not the main focus of this chapter; the emphasis here is to provide a feasibility study and to guide readers to carry out further research in this area.

In regard to the Semeion dataset, 30% was used for training, and the remaining 70% was employed for testing purposes. Table 3.3 presents the same procedure applied to the MNIST dataset, where the most accurate technique is in bold. Once again, IHS obtained the lowest MSE using three layers. Fig. 3.3b shows the logarithm of the pseudolikelihood considering the 10 iterations of the CS-1L learning step over the Semeion dataset. In this case, if one takes a look at the convergence curve, a more oscillating behavior can be observed, since this dataset poses a bigger challenge than MNIST, which

Table 3.3 Average MSE Over the Test Set Considering Semeion Dataset

Technique	1L	2L	3L
HS	0.2128 ± 0.0002	0.2128 ± 0.0002	0.2129 ± 0.0002
IHS	0.2127 ± 0.0003	0.2116 ± 0.0010	**0.2103 ± 0.0009**
PSO	0.2128 ± 0.0002	0.2128 ± 0.0003	0.2128 ± 0.0002
CS	0.2135 ± 0.0005	0.2134 ± 0.0002	0.2132 ± 0.0008

can be reflected in the MSE as well. Actually, although IHS obtained the best result, all techniques achieved very close results, thus proving that all are suitable to the task addressed in this work.

5 CONCLUSIONS

In this work, we evaluated the CS for the optimization of DBNs concerning the task of binary image reconstruction. We considered two public datasets and a DBN with one, two, and three layers. In order to evaluate the robustness of CS, we compared it with HS, IHS, and PSO. The experimental results using the Wilcoxon signed-rank test highlighted IHS with three layers as the most accurate technique for the current dataset, although all techniques obtained very close results.

Actually, it is expected that better results can be obtained using three layers, since one can obtain more discriminative information to be used in the reconstruction process. Based on our experience, IHS is the most accurate technique when compared to a number of metaheuristic techniques out there. In regard to future work, we aim to use modified versions of the CS, and we will try to perform a deeper study about the influence of its parameters for the optimization of DBNs. We will also test a more extensive benchmark set of images and seek out ways to extend our work to nonbinary images.

ACKNOWLEDGMENTS

The authors are grateful to FAPESP grant #2014/16250-9, Capes, Capes PROCAD #2966/2014, and CNPq grants #306166/2014-3 and #470571/2013-6.

REFERENCES

Ackley, D., Hinton, G., Sejnowski, T.J., 1988. A learning algorithm for Boltzmann machines. In: Waltz, D., Feldman, J. (Eds.), Connectionist Models and Their Implications: Readings from Cognitive Science. Ablex Publishing Corp., Norwood, NJ, pp. 285–307.

Fedorovici, L., Precup, R., Dragan, F., David, R., Purcaru, C., 2012. Embedding gravitational search algorithms in convolutional neural networks for OCR applications. In: 7th IEEE International Symposium on Applied Computational Intelligence and Informatics, pp. 125–130.

Geem, Z.W., 2009. Music-Inspired Harmony Search Algorithm: Theory and Applications, first ed. Springer, Berlin, Heidelberg.

Hinton, G.E., 2002. Training products of experts by minimizing contrastive divergence. Neural Comput. 14 (8), 1771–1800.

Hinton, G.E., 2012. A practical guide to training restricted Boltzmann machines. Montavon, G., Orr, G., Müller, K.R. (Eds.), Neural Networks: Tricks of the Trade, Lecture Notes in Computer Science, vol. 7700, Springer, Berlin, Heidelberg, pp. 599–619.

Hinton, G.E., Osindero, S., Teh, Y.W., 2006. A fast learning algorithm for deep belief nets. Neural Comput. 18 (7), 1527–1554.

Kennedy, J., Eberhart, R.C., 2001. Swarm Intelligence. Morgan Kaufmann, San Francisco, CA.

LeCun, Y., Bottou, L., Bengio, Y., Haffner, P., 1998. Gradient-based learning applied to document recognition. Proc. IEEE 86 (11), 2278–2324.

Mahdavi, M., Fesanghary, M., Damangir, E., 2007. An improved harmony search algorithm for solving optimization problems. Appl. Math. Comput. 188 (2), 1567–1579.

Papa, J.P., Rosa, G.H., Costa, K.A.P., Marana, A.N., Scheirer, W., Cox, D.D., 2015a. On the model selection of bernoulli restricted boltzmann machines through harmony search. In: Proceedings of the Genetic and Evolutionary Computation Conference. ACM, New York, NY, pp. 1449–1450.

Papa, J.P., Rosa, G.H., Marana, A.N., Scheirer, W., Cox, D.D., 2015b. Model selection for discriminative restricted Boltzmann machines through meta-heuristic techniques. J. Comput. Sci. 9 (1), 14–18.

Papa, J.P., Scheirer, W., Cox, D.D., In Press. Fine-tuning deep belief networks using harmony search. Appl. Soft Comput.

Rosa, G.H., Papa, J.P., Marana, A.N., Scheirer, W., Cox, D.D., 2015. Fine-tuning convolutional neural networks using harmony search. Pardo, A., Kittler, J. (Eds.), Progress in Pattern Recognition, Image Analysis, Computer Vision, and Applications, Lecture Notes in Computer Science, vol. 9423, Springer International Publishing, Cham, Switzerland, pp. 683–690.

Wilcoxon, F., 1945. Individual comparisons by ranking methods. Biometrics Bull. 1 (6), 80–83.

Yang, X.S., Deb, S., 2009. Cuckoo search via levy flights. In: World Congress on Nature & Biologically Inspired Computing. IEEE Publications, USA, pp. 210–214.

Yang, X.S., Deb, S., 2010. Engineering optimisation by cuckoo search. Int. J. Math. Model. Numer. Optimisation 1 (4), 330–343.

Yang, X.S., Deb, S., 2014. Cuckoo search: recent advances and applications. Neural Comput. Appl. 24 (1), 169–174.

Chapter 4

Improved weighted thresholded histogram equalization algorithm for digital image contrast enhancement using the bat algorithm

M. Tuba*, M. Jordanski**, A. Arsic**

*John Naisbitt University, Belgrade, Serbia; **University of Belgrade, Belgrade, Serbia*

1 INTRODUCTION

Image processing has numerous applications in most human activities, from medicine (Papour et al., 2015) or security (Zhou et al., 2015) to astronomy (Wang et al., 2014) or transportation (Zeng et al., 2015) and quality control (Jeong and Lee, 2015). Hence it is also a very active area of research in

Bio-Inspired Computation and Applications in Image Processing. http://dx.doi.org/10.1016/B978-0-12-804536-7.00004-1

computer science. It includes all operations applied to digital images that aim at changing the photometric or structural characteristics of the image. Image enhancement is an important phase, and it is usually a preprocessing stage in many image processing systems. Contrast enhancement is one of the key steps in image enhancement. The aim of image contrast enhancement is to improve the perception of information in images for human viewers or to provide better input for other automated image processing techniques. Images can be damaged due to poor quality of the acquisition device, climate conditions at the time of acquisition, and other disturbances. Producing digital images with good brightness, contrast, and detail is a strong requirement in several areas, such as texture synthesis (Pei et al., 2004), satellite image processing (Bhandari et al., 2015), biomedical image analysis (Wu et al., 2015), real-life photographic image correction (Hashemi et al., 2010), and others.

Histogram equalization (HE) is one of the most commonly used methods for image contrast enhancement because of its high efficiency and simplicity (Gonzalez and Woods, 2008). The HE techniques use linear cumulative histogram of the input image and distribute its pixel values over its dynamic intensity range. HE-based enhancement finds applications in medical image processing (Sundaram et al., 2011), speech recognition (De la Torre et al., 2005), satellite image processing (Ganesan and Rajini, 2014), and others. Various HE methods have been proposed in the literature.

The weighted thresholded HE (WTHE) method is an improved method for contrast enhancement (Wang and Ward, 2007). It modifies the probability distribution function of an image by weighting and thresholding before the HE is performed. Optimization of the weighting constrains is a hard optimization problem.

Metaheuristics are high-level algorithms designed to find a sufficiently good solution for hard optimization problems, especially with limited computational capacity. They do not guarantee that the globally optimal solution will be found for some class of problems. Several metaheuristic algorithms derived from the behavior of biological and physical systems in nature have been proposed. Since a magic method which works for all problems does not exist, various approaches have been developed. The most popular nature-inspired algorithms for optimization, with improvements, adjustments, and hybridizations, include particle swarm optimization (PSO) (Kennedy and Eberhart, 1995), the firefly algorithm (Yang, 2009; Fister et al., 2013; Tuba and Bacanin, 2014), cuckoo search (Yang and Deb, 2009, 2010; Gandomi et al., 2013), ant colony optimization (ACO) (Dorigo and Gambardella, 1997; Jovanovic and Tuba, 2013;

Verma et al., 2012), differential evolution (Storn and Price, 1997), and the artificial bee colony algorithm (Karaboga, 2005; Bacanin and Tuba, 2012).

The bat algorithm (BA) is a novel swarm intelligence metaheuristic algorithm introduced by Yang (2010), based on bat echolocation.

In this chapter, a modified HE-based method for image contrast enhancement which improves the performance of the WTHE (Wang and Ward, 2007) is developed. The proposed method employs the BA in order to optimize weighting constraints.

The remainder of the chapter is organized as follows. A literature review is presented in Section 2. Section 3 presents the swarm intelligence–based BA. In Section 4, we present our proposed modified HE method which employs the BA. Discussion and analysis of obtained experimental results are provided in Section 5. Finally, our conclusions are discussed in Section 6.

2 LITERATURE REVIEW

Histogram equalization is a well-known and commonly used method for image contrast enhancement. HE algorithms may be divided into two types: global HE (GHE) and local (or adaptive) HE (LHE).

GHE methods improve the quality of images by normalizing the distribution of intensities over the dynamic range, using the histogram of the entire image (Gonzalez and Woods, 2008). The main objective of this method is to achieve a uniformly distributed histogram by using the cumulative density function of the input image. In theory, it can be shown that the mean brightness of the histogram-equalized image is always the middle gray level, regardless of the mean of the input image. Though this global approach is suitable for overall enhancement, it fails to preserve the local brightness features of the input image. In some applications where brightness preservation is necessary, this property is unacceptable.

LHE tries to eliminate such problems. It uses the histogram intensity statistics of neighboring pixels of an image for equalization. These methods use a small square that slides through every pixel of the image sequentially, and only pixels that fall in this square are taken into account. Gray-level mapping for contrast enhancement is then done only for the center pixel of that square (Gonzalez and Woods, 2008). Thus, it utilizes local information as much as possible. However, LHE requires high computational load and sometimes causes overenhancement in some portions of the image.

Moreover, this technique has the problem of enhancing the noise in the input image along with the image features. Nonoverlapping blocks can be used in order to decrease the high computational cost of LHE (Gonzalez and Woods, 2008). Nonetheless, these methods produce an undesirable checker-board effects on enhanced images.

Histogram specification (HS) is another enhancement method in which the expected output of the image histogram can be controlled by specifying the desired output histogram (Gonzalez and Woods, 2008). However, specify-ing the desired output histogram varies with the input image and is a very difficult task which cannot be not automated.

To overcome the brightness preservation problem, different methods based on HE have been proposed. Brightness-preserving bihistogram equalization (BBHE) (Kim, 1997), dualistic subimage HE (DSIHE) (Wang et al., 1999), and minimum mean brightness error bihistogram equalization (MMBEBHE) (Chen and Ramli, 2003b) are the variants of HE-based contrast enhance-ment which try to preserve image brightness and enhance image contrast at the same time. BBHE first separates the input image's histogram into two histograms based on its mean: one having a range from the minimum gray level to the mean and the other having ranges from the mean to the maximum gray level. Next, it equalizes the two histograms independently. DSIHE differs from BBHE only in the segmentation process. The histo-gram of the input image is segmented into two subhistograms based on the median instead of the mean. MMBEBHE is an extension of BBHE method that provides maximal brightness preservation. It is based on the minimum absolute mean brightness error between the input mean value and the output mean value. Although these methods can perform good contrast enhance-ment, they also cause annoying side effects depending on the variation of gray level distribution in the histogram and may fail to produce images with natural looks.

In order to overcome aforementioned problems, multi-HE methods have been proposed. Multi-HE methods divide histograms into more than two subhistograms, and each histogram is equalized independently. Recur-sive mean-separate HE (RMSHE) (Chen and Ramli, 2003a) and recursive subimage HE (RSIHE) (Sim et al., 2007) are multi-HE methods and rep-resent extensions of BBHE and DSIHE, respectively. These methods use either the mean or the median intensity of an image as a threshold value to divide its histogram into two parts. Then this process is repeated recursively, resulting in 2^r segments.

Minimum-within-class variance is another way of choosing threshold value for dividing histograms (Menotti et al., 2007). Parameter r has a big influence

on brightness preservation and the contrast enhancement property of the output image in all multi-HE methods. But as the recursion level increases, the computational complexity also increases, and finding an optimal recursion level is a difficult task for all such methods.

The weighted thresholded HE (WTHE) method is an effective method for contrast enhancement of videos and images (Wang and Ward, 2007). In this method, the probability distribution function of an image is modified by weighting and thresholding before the HE is performed. A mean adjustment factor is then added with the expectation to normalize the luminance changes. This algorithm provides a good trade-off between the two features, adaptivity to different images and ease of control, which is difficult to achieve through GHE-based enhancement methods.

Two more weighting techniques, weight-clustering HE (Sengee and Choi, 2008) and recursively separated and weighted HE (Kim and Chung, 2008), have been developed. These techniques use different weighting principles and have their own merits. Subregions HE is another HE-based method which partitions the input images based on Gaussian-filtered, smoothed intensity values and produces the sharpened output image (Ibrahim and Kong, 2009). The range-limited bihistogram equalization method for image contrast enhancement is another technique which divides the input histogram into two independent subhistograms (Zuo et al., 2013). Division is done using a threshold which minimizes the intraclass variance. Then the range of the equalized image is calculated to minimize absolute the mean brightness error between the original image and the equalized one.

Different techniques have been proposed in order to optimize weighting constraints of the WTHE method. The modified HE method improves WTHE by employing the PSO algorithm to obtain optimized weighting constraints, which are defined for the whole histogram (Shanmugavadivu et al., 2011). Particle swarm optimized multiobjective HE (PSOMO) (Shanmugavadivu and Balasubramanian, 2014a) and thresholded and optimized HE (Shanmugavadivu and Balasubramanian, 2014b) are methods which improve the WTHE with some modifications. First, they use Otsu's method to perform histogram separation. Then a set of weighting constraints are defined and applied to the subhistograms, and each subhistogram is equalized independently. PSO is employed to optimize weighting constraints for each subhistogram. The particle swarm optimized bihistogram equalization method is similar to the PSOMO method except that it divides histogram into two subhistograms based on its mean (Shanmugavadivu et al., 2014). Then a set of weighting constraints are

defined and optimized using PSO for each subhistogram, before they are equalized independently.

Other applications of swarm intelligence for image enhancement include gray-level image enhancement by PSO (Gorai and Ghosh, 2009; Kwok et al., 2012) and image fuzzy enhancement based on the self-adaptive bee colony algorithm (Lei and Fan, 2014). Evolutionary soft computing techniques were used for enhancing the contrast of images in the optimal fuzzy system for color image enhancement (Hanmandlu and Jha, 2006), image fuzzy enhancement based on self-adaptive bee colony algorithm (Vlachos and Sergiadis, 2006), contrast enhancement for image by WNN and a genetic algorithm (GA) combining PSNR with information entropy (Zhang and Wei, 2007), automatic image enhancement using genetic algorithms (Munteanu and Rosa, 2000), and an image contrast enhancement method based on genetic algorithm (Hashemi et al., 2010).

One of the simplest and most popular ways to perform contrast enhancement of an input image is by using global intensity transformation. The main objective in global intensity transformation is to obtain a transfer function or lookup table which yields an output image with contrast improvement. A GA for image contrast enhancement has been proposed (Hashemi et al., 2010). The GA is used to find the optimal mapping of the gray levels of the input image into another one such that the resulting image has more contrast. The main contribution of this method is using a simple chromosome structure and genetic operators. An artificial bee colony algorithm for image contrast enhancement is similar to the previous method, except it uses an artificial bee colony for finding optimal mapping (Draa and Bouaziz, 2014). A hybrid algorithm including GA, ACO, and simulated annealing (SA) metaheuristics for increasing the contrast of images has been proposed (Hoseini and Shayesteh, 2013). ACO generates the transfer functions considering directions of the ants' movement. GA sets the movement directions of ants automatically. Also, SA as a local search modifies and enhances the transfer functions and pheromone traces generated by ACO.

Local and global enhancement models apply transformation functions that are based on the gray-level distribution in the neighborhood of each pixel in the given image. The transformation function is designed in such a way that it takes both global as well as local information from the input image to produce the enhanced image. Metaheuristics were used for optimizing parameters of the transformation function. Gray-level image enhancement by the PSO method employs PSO in order to optimize parameters of the local transformation function (Gorai and Ghosh, 2009). A PSO algorithm

has been also developed for enhancing contrast of color images (Gorai and Ghosh, 2011). First, the input image is transformed from the *RGB* to the *HSI* color system, and the local transformation function with optimized parameters is performed on *I* component of *HSI* color space. Then the scaling factor is calculated from the enhanced intensity image, and an enhanced color image is formed by scaling. Automatic image enhancement using GAs (Munteanu and Rosa, 2000) is another method which optimizes parameters of the transformation function by employing the GA. Biogeography-based optimization and blended migration operation have also been proposed in order to optimize parameters of the transformation function (Jasper et al., 2014).

3 BAT ALGORITHM

The BA is a metaheuristic algorithm based on swarm intelligence presented by Yang (2010) and later used to solve many different problems (Alihodzic and Tuba, 2014; Mirjalili et al., 2014; Luo et al., 2014). It has been inspired by the echolocation of bats with varying pulse rates of emission and loudness. All bats use natural sonar in order to navigate and hunt. The primary purpose of bat echolocation is to act as a signal system to sense distance. Bats move by using the time delay between emission and reflection from prey or obstacles. The echolocation behavior of bats can be formulated in such a way that it can be associated with the objective function to be optimized, and this makes it possible to design an optimization algorithm.

If some of the echolocation characteristics of bats are idealized, various bat-inspired algorithms can be developed (Yang, 2010). In order to transform echolocation behaviors of bats, Yang proposed three idealized rules:

1. All bats use echolocation to sense distance, and they also "know" the difference between food/prey and background barriers in some unknown way.
2. Bats fly randomly with velocity v_i at position x_i with a fixed frequency f_{min}, varying wavelength λ and loudness A_0 to search for prey. They are able to automatically set the wavelength of their transmitted pulses and tune the rate of pulse emission r from [0,1], depending on the proximity of their target.
3. Since the loudness of bats can vary in several ways, it is supposed that the loudness changes from a positive large value A_0 to a minimum constant value A_{min}.

Based on these approximations and idealization, the basic steps of the BA can be described as shown next:

1) *Initialization*.
 a) Initialize the population of n bats randomly where each bat corresponds to a potential solution to the given problem;
 b) Define loudness A_i, frequency f_i, pulse rate r_i and the initial velocities $v_i (i = 1, 2, ..., N)$;
 c) Set iteration counter $t = 1$;
 d) Find the best initial solution x^*;

2) *Repeat*.
 a) Generate new solution: Eqs. (4.1)–(4.3);
 b) **if** (*r and* $> r_i$) **then**
 i) Select a solution among the best solutions;
 ii) Generate a local solution around the selected best solution Eq. (4.4);
 end if
 c) Make a new solution by flying randomly;
 d) **if** (*r and* $< A_i$ and $f(x_i) < f(x^*)$) **then**
 i) Accept the new solutions;
 ii) Increase r_i and reduce A_i Eqs. (4.5) and (4.6);
 end if
 e) Rank the bats and find the current best x^*;
 f) $t = 1 + 1$

3) *Check the termination criterion*. Until the termination criteria is not satisfied or $t <$ *MaxGeneration*.

4) *Finish*. Show the results of processing and make visualization.

In the BA, an artificial bat has its location x_i^t, velocity v_i^t, frequency $f_i \in [f_{min}, f_{max}]$, loudness A_i^t, and emission pulse rate r_i^t, which are updated during the search process. Initialization of the bat population is performed randomly. Starting with an initial population of bats spread over the solution space, the algorithm proceeds in iterations. The new solutions x_i^t are performed by moving virtual bats according to the following equations:

$$f_i = f_{min} + \left(f_{max} - f_{min} \right) \cdot \beta, \tag{4.1}$$

$$v_i^t = v_i^{t-1} + \left(x^* - x_i^{t-1} \right) \cdot f_i, \tag{4.2}$$

$$x_i^t = x_i^{t-1} + v_i^t, \tag{4.3}$$

where β is a random vector drawn from the closed interval [0,1] from a uniform distribution. Here x^* is the current global best solution. These equations could guarantee the exploitability of the BA. Initially, each bat is randomly assigned a frequency, which is drawn uniformly from the interval $[f_{min}, f_{max}]$. A local search phase, which modifies the current best solution, is performed using a random walk:

$$x_{new} = x^* + \varepsilon \cdot A^t, \tag{4.4}$$

where $A^t = \langle A_i^t \rangle$ is the average loudness of all the bats at the time step t and ε from the interval $[-1,1]$ is a random number. Pulse rate and loudness are responsible for controlling the local search. Therefore, the loudness A^i and the rate r^i of pulse emission have to be updated as the iterations proceed. As the loudness usually decreases once a bat has found its prey whereas the rate of pulse emission increases, the loudness can be chosen as any value of convenience. For simplicity, we can also use $A_0 = 1$ and $A_{min} = 0$, where $A_{min} = 0$ means that a bat has just found the prey. Mathematically, these characteristics are defined with the following equations:

$$A_i^{t+1} = \alpha \cdot A_i^t, \tag{4.5}$$

$$r_i^{t+1} = r_i^0 \cdot \left(1 - e^{-\gamma t}\right), \tag{4.6}$$

where α and γ are constants. In fact, α is similar to the cooling schedule in the simulated annealing algorithm (Kirkpatrick et al., 1983). For any $0 < \alpha < 1$ and $\gamma > 0$, we have

$$A_i^{t+1} \to 0, \quad r_i^t \to r_i^0, \quad \text{as} \quad t \to \infty, \tag{4.7}$$

The choice of parameters requires some experimentations. For example, the initial loudness A_i^0 can typically be taken as 1, whereas the initial emission rate r_i^0 can be around zero or any value $r_0^i \in (0,1]$.

4 OUR PROPOSED METHOD

4.1 Global histogram equalization

Let $I = \{I(i,j)\}$ represent a digital image, where $I(i,j)$ denotes the gray-level intensity of the pixel at location (i,j). The total number of pixels is n, the image has L intensity levels $\{r_0, r_1, ..., r_{L-1}\}$, and n_k is the total number of pixels with gray-level r_k in the image. The probability density function (PDF) for a given image I, $P(r_k)$ is defined as:

$$P(r_k) = \frac{n_k}{n}, \qquad k = 0, 1, ..., L-1 \tag{4.8}$$

Graphical representation of the PDF is known as the histogram of an image. Based on the PDF, an image's cumulative distribution function (CDF) is defined as

$$c(r_k) = \sum_{j=0}^{k} P(r_j) = \sum_{j=0}^{k} \frac{n_j}{n}, \qquad k = 0, 1, ..., L-1 \tag{4.9}$$

It is obvious that $c(r_{L-1}) = 1$. GHE maps the input image into the entire dynamic range $[r_0, r_{L-1}]$ by using the cumulative density function as a transform function. Let us define the transform function $f(x)$ based on the CDF as shown next:

$$f(x) = r_0 + (r_{L-1} - r_0)c(x) \tag{4.10}$$

Then the output image of HE $I' = \{I'(i,j)\}$ can be expressed as:

$$I' = f(X) = \{f(I(i,j)) \mid \forall I(i,j) \in I\} \tag{4.11}$$

4.2 Development of weighting constraints with respect to the threshold

Our proposed method represents an enhancement of the WTHE method in such a way that the BA is implemented to determine weighting constraints. It performs HE on a modified histogram which is obtained by using a transformation function. Weighted thresholded PDF P_{wt} is obtained by applying transformation function $T(\cdot)$ on the original PDF $P(r_k)$ with constraints, as shown next:

$$P_{wt}(r_k) = T(P(r_k)) = \begin{cases} P_u & \text{if} \quad P(r_k) \geq P_u \\ \left(\dfrac{P(r_k) - P_l}{P_u - P_l}\right)^r \cdot P_u & \text{if} \quad P_l < P(r_k) \leq P_u \\ 0 & \text{if} \quad P(r_k) \leq P_l \end{cases} \tag{4.12}$$

where values P_u and P_l represent upper and lower thresholds, respectively, and transformation function $T(\cdot)$ transforms all the original values between them using a normalized power low function with parameter $r > 0$.

In the mapping scheme shown in Eq. (4.12), the transformed histogram determines the increment for each intensity level. The index r of the power law function controls the level increment. The power law function gives higher weights to the low-probability values than the high-probability values in the PDF when $r < 1$. On the other hand, when $r > 1$, more weight is given to the high-probability values, which usually results in overenhancement. In order to avoid the dominance of the high-probability levels in the output histogram, the value P_u is given as:

$$P_u = v \cdot P_{max}, \tag{4.13}$$

where P_{max} is the highest probability value of the original PDF. The parameter v determines the upper threshold normalized to P_{max}. A lower value of

v results in more high-probability levels being clamped and thus less likelihood of their dominance in the output range.

On the other hand, the lower threshold P_l is used to eliminate levels with too low probability in order to better utilize the full dynamic range. As in Shanmugavadivu et al. (2011), P_l is not used as a parameter, and its value is set to fixed low value $P_l = 0.0001$. It is obvious from Eq. (4.12) that for $r = 1$, $P_l = 0$, and $P_u = 1$, the proposed method is equal to GHE.

The next step, after getting the weighted thresholded PDF $P_{wt}(r_k)$, is applying HE. First, the weighted thresholded cumulative distribution function is obtained by:

$$C_{wt}(r_k) = \sum_{i=0}^{k} P_{wk}(r_i), \quad \text{for} \quad k = 0, \dots, L-1 \tag{4.14}$$

The next step is performing HE method, as shown next:

$$I'(i,j) = (L-1) \cdot C_{wt}(I(i,j)) + M_{adj} \tag{4.15}$$

where M_{adj} is the mean adjustment quantity that reduces luminance change after enhancement. In order to determine the value M_{adj}, we first calculate the mean of the enhanced image, assuming $M_{adj} = 0$ in Eq. (4.15). After that, M_{adj} is set to the mean difference between the original and the enhanced image.

4.3 Optimizing the weighting constraints using the bat algorithm

In the WTHE method (Wang and Ward, 2007), two parameters, v and r, are identified. Parameters v and r play the most important role in the transformation function (4.12) and thereby in enhancing image contrast. In order to find values of v and r which enhance contrast as much as possible, the BA is employed. The values of the parameters v and r are fixed in the range $(0.1,1)$. Several measures can be used to estimate the degree of image contrast enhancement. One such measure is discrete entropy $E(I)$, which is defined as:

$$E(I) = -\sum_{k=0}^{255} p(r_k) \cdot \log_2(p(r_k)) \tag{4.16}$$

where r_k is an intensity level of image I. According to the entropy theory, the bigger the entropy of an image is, the richer the information and details of the image are. Increasing the measure of entropy means, equivalently,

transforming the histogram of the image to one that approximates a uniform distribution. The entropy of the whole image achieves its maximum when the histogram of the image has uniform distribution. When the entropy value of an enhanced image is closer to that of the original input image, the details of the input image are said to be preserved in the output image. Therefore, the objective function is defined as difference between the discrete entropy of an input image and the enhanced image. The BA tries to minimize this objective function in order to improve image contrast enhancement.

In this approach, the BA tries to find the optimal two-dimensional vector (v, r) which will minimize the difference between discrete entropy of the original image and the enhanced image. The values v and r are found using the next algorithm:

1) *Initialization.*
 a) Initialize the population of n bats where each bat contains its location $x_i = (v_i, r_i)$, loudness $A_i \in (0.1)$, frequency $f_i \in [f_{min}, f_{max}]$, pulse rate $r_i \in (0.1)$, and the initial velocities $v_i \in (v_{min}, v_{max})$ $(i = 1,2, ..., n)$;
 b) Set iteration counter $t = 1$;
 c) Find the best initial solution x^*;

2) *Repeat.*
 a) Generate new solution: Eqs. (4.1)–(4.3);
 b) *Bound* (v_i, r_i);
 c) **if** $(r$ and $< r_i)$ **then**
 i) Select a solution among the best solutions;
 ii) Generate a local solution around the selected best solution Eq. (4.4);
 end if
 d) Make a new solution by flying randomly;
 e) Find the Discrete Entropy value of MHEed image with parameters v_i and r_i;
 f) Evaluate the difference between Discrete Entropy values of original and MHEed image ($f(x_i)$);
 g) **if** $(r$ and $< A_i$ and $f(x_i) < f(x^*))$ **then**
 i) $x^* = x_i$;
 ii) Increase r_i and reduce A_i: Eqs. (4.5)–(4.6);
 end if
 h) Rank the bats and find the current best x^*;
 i) $t = 1 + 1$

3) *Check the termination criterion.* Until the termination criteria is not satisfied or $t < MaxGeneration$.

4) *Finish.* Show the results of processing and make visualization.

In each step, velocity v_i and solution x_i are bound using function *Bound*(), which regulates that velocity belongs to the interval (v_{min}, v_{max}) and solution belongs to the interval $(0.1,1)$.

5 EXPERIMENTAL RESULTS

The performance of the proposed method was tested on standard images: Einstein, village, house, peppers, truck, cameraman, and F16.[a] Parameters α, γ, f_{min}, f_{max}, v_{min}, v_{max}, the size of population n, and the number of iterations were determined empirically. The method was found to produce best results when $\alpha = 0.9$, $\gamma = 0.9$, $f_{min} = 0$, $f_{max} = 2$, $v_{min} = -0.2$, $v_{max} = 0.2$, $n = 50$, and number of iterations was set to 50. We implemented the proposed algorithm in Matlab with the Intel Core 2 Duo CPU 2.00 GHz with 4 GB RAM. To compare the performance of the proposed method, the same images are enhanced with the contemporary enhancement algorithms GHE, BBHE, DSIHE, and RMSHE. The results of the proposed method were evaluated via quantitative analysis and qualitative analysis.

First, a visual assessment is performed. By visually analyzing the result of enhancement on the image Einstein, it is evident that the presented method produced a natural-looking image with more contrast enhancement. Fig. 4.1b and c show that methods GHE and BBHE, respectively, overenhance the input image and do not preserve brightness, while Fig. 4.1d shows that the DSIHE method provides good contrast enhancement but does not preserve brightness. RRMSHE ($r = 2$) degrades the input image and does not provide brightness preservation (Fig. 4.1e). Fig. 4.1f depicts the result of our proposed method. It is clear that the proposed method enhances contrast while preserving brightness and natural appearance.

The histogram patterns of the original, enhanced images by GHE, BBHE, DSIHE, RMSHE ($r = 2$) and the proposed method of Einstein are shown in Fig. 4.2. In Fig. 4.2b–e, the unexpected changes in contrast as well as brightness are clear because of the uncontrolled distribution of the histogram. On the other hand, Fig. 4.2f shows the controlled distribution, which leads to the expected contrast enhancement and brightness preservation.

The enhanced images of the Village image by GHE, BBHE, DSIHE, RMSHE ($r = 2$) and the proposed method are shown in Fig. 4.3b–f. It is evident that even though BBHE does not preserve the brightness of the input image, it performs better than GHE due to its partition. The DSIHE method overenhances the input image and does not produce a natural-looking image. On the other hand, RMSHE ($r = 2$) and the proposed method succeeded to enhance image contrast and at the same time preserve brightens and natural appearance.

The histograms corresponding to input image Village and those of its enhanced equivalents are presented in Fig. 4.4. It is easy to see from the histograms of the enhanced images that the gray levels have become more stretched over the

[a]http://decsai.ugr.es/cvg/dbimagenes

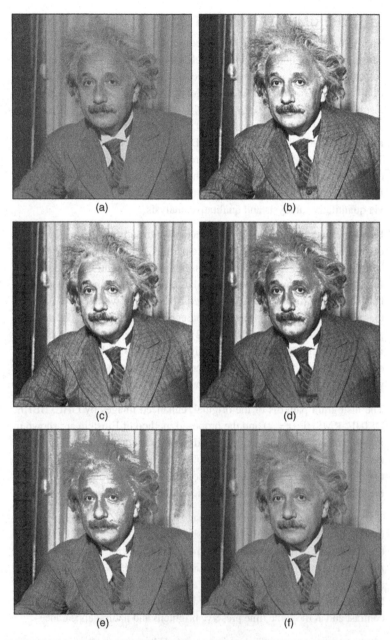

■ **FIGURE 4.1** (a) Original Einstein image, (b) GHE, (c) BBHE, (d) DSIHE, (e) RMSHE ($r = 2$), and (f) proposed method.

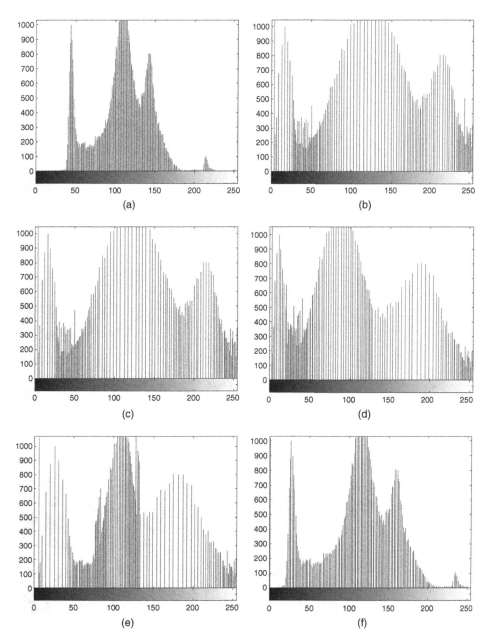

■ **FIGURE 4.2** (a) Original Einstein histogram, (b) GHE, (c) BBHE, (d) DSIHE, (e) RMSHE ($r = 2$), and (f) proposed method.

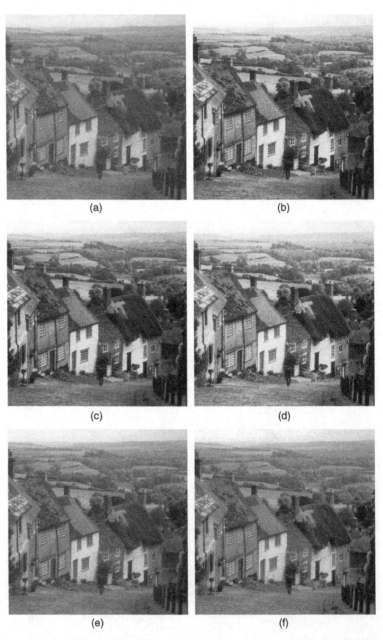

(a) (b)

(c) (d)

(e) (f)

■ **FIGURE 4.3** (a) Original Village image, (b) GHE, (c) BBHE, (d) DSIHE, (e) RMSHE ($r = 2$), and (f) proposed method.

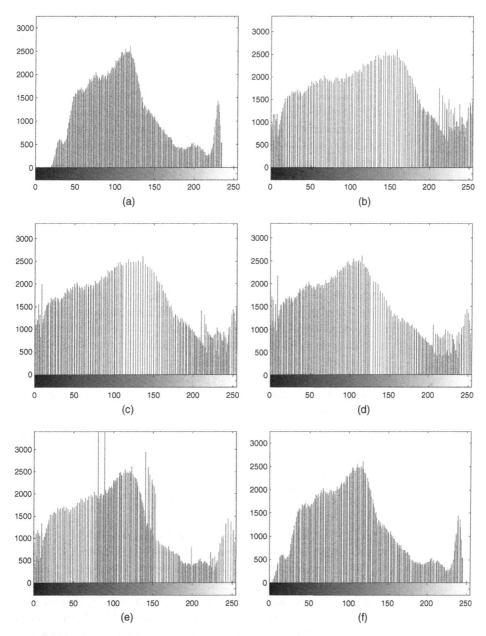

■ **FIGURE 4.4** (a) Original Village histogram, (b) GHE, (c) BBHE, (d) DSIHE, (e) RMSHE ($r = 2$), and (f) proposed method.

interval [0,255]. Also, it can be easily noticed from the Fig. 4.4f that the proposed method gives the distribution which is most similar to the original distribution and which is best controlled, which results in good contrast enhancement.

Fig. 4.5b–f depicts the results of applying GHE, BBHE, DSIHE, RMSHE ($r = 2$) and the proposed method, respectively, on the House image. Obviously, the proposed method shows better results in terms of visual perception when compared with other methods. In addition, Fig. 4.6a–f shows that the proposed method gives the controlled distribution of the enhanced image, which leads to brightness preservation and good contrast enhancement.

Also, Fig. 4.7b–f shows that on the Peppers image, the proposed method produces the best result in terms of contrast enhancement and brightness preservation. The histograms of the original Peppers image as well as the enhanced images are shown in Fig. 4.8a–f. It is evident that the histogram of the proposed method is well balanced, which results in good contrast enhancement as well as brightness preservation.

Further, the qualities of the enhanced test images are measured in terms of discrete entropy. For these tests three additional well-known benchmark images were included: truck, cameraman and F16. The bigger the entropy of an image is, the richer the information and details of the image are. As Table 4.1 shows, the proposed method reaches the highest entropy value for all images. It is evident that our proposed method outperforms all other methods in terms of contrast enhancement, brightness preservation, and production of natural-looking images.

Finally, the structural similarity index matrix (SSIM) is used as a measure for image contrast enhancement. SSIM is defined as:

$$\text{SSIM}(X,Y) = \frac{\left(2\mu_X\mu_Y + C_1\right)\left(2\sigma_{XY} + C_2\right)}{\left(\sigma_X^2 + \sigma_Y^2 + C_1\right)\left(\sigma_X^2 + \sigma_X^2 + C_2\right)} \tag{4.17}$$

where X and Y are the input and the output images respectively; μ_X and μ_Y represent respective mean of X and Y, σ_X and σ_Y are standard deviations of X and Y, respectively, σ_{XY} is the square root of covariance of X and Y, while C_1 and C_2 are constants. The resultant SSIM index is a real value between -1 and 1, and value 1 is reachable only when $X = Y$. The closer the SSIM value is to 1, the higher the degree of structural similarity between two images is. The SSIM values obtained for each test image are shown in Table 4.2. It is evident that our proposed method outperforms other methods in all cases. Computational time for our proposed MOHEBAT is acceptable; average CPU time for all used images is 0.006 s for GHE, 0.017 s for BBHE, 0.866 s for DSIHE, 0.016 for RMSHE, and 6.320 for MOHEBAT.

(a)

(b)

(c)

(d)

(e)

(f)

■ **FIGURE 4.5** (a) Original House image, (b) GHE, (c) BBHE, (d) DSIHE, (e) RMSHE ($r = 2$), and (f) proposed method.

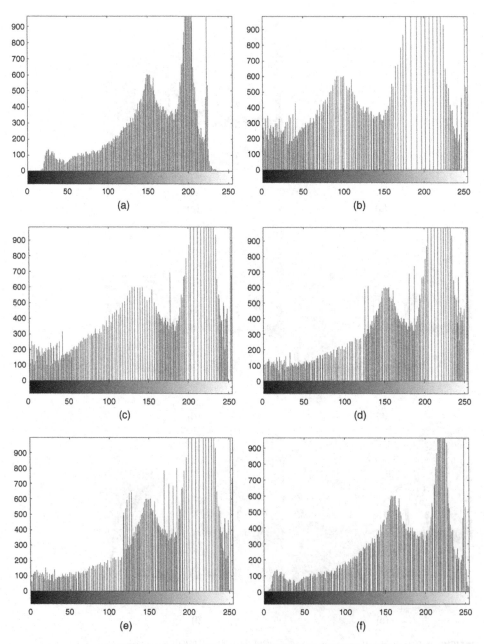

■ FIGURE 4.6 (a) Original House histogram, (b) GHE, (c) BBHE, (d) DSIHE, (e) RMSHE ($r = 2$), and (f) proposed method.

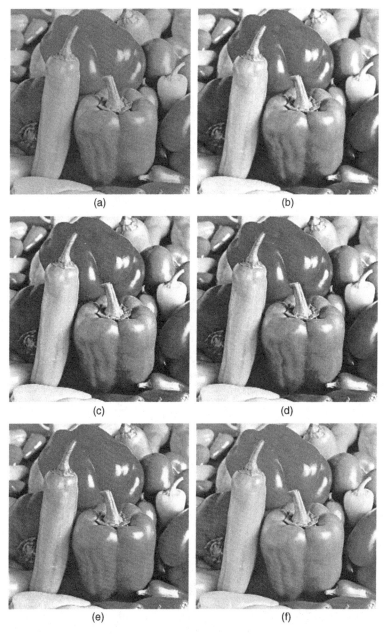

(a) (b)

(c) (d)

(e) (f)

■ **FIGURE 4.7** (a) Original Peppers image, (b) GHE, (c) BBHE, (d) DSIHE, (e) RMSHE ($r = 2$), and (f) proposed method.

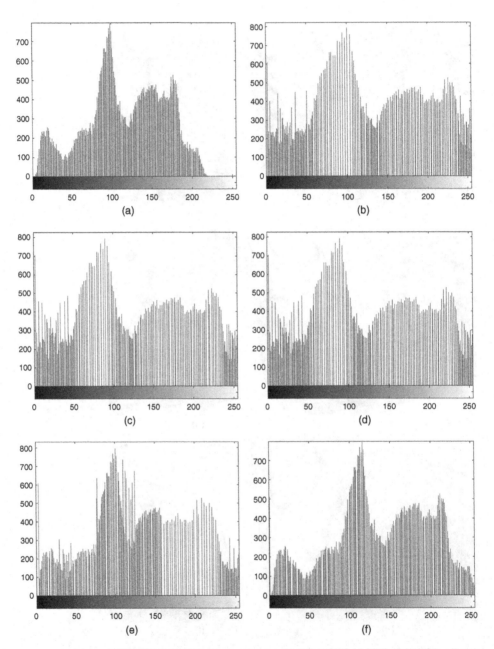

■ **FIGURE 4.8** (a) Original Peppers histogram, (b) GHE, (c) BBHE, (d) DSIHE, (e) RMSHE ($r = 2$), and (f) proposed method.

Table 4.1 Performance Measure of Discrete Entropy Values From Different Techniques

Method/ Image	Original Image	GHE	BBHE	DSIHE	RMSHE (r = 2)	MOHEBAT
Einstein	6.8841	6.7470	6.7442	6.7151	6.7125	6.8821
Village	7.4778	7.3012	7,3263	7.3550	7.3417	7.4774
House	7.2389	7.0389	7.0784	7.1191	7.0862	7.2344
Peppers	7.5251	7.3652	7.3423	7.3421	7.3799	7.5188
Truck	6.0281	5.9197	5.9334	5.9671	5.9502	6.0121
Cameraman	7.0097	6.7699	6.8088	6.7994	6.7721	7.0020
F16	6.6744	6.4263	6.5731	6.4423	6.5388	6.6734

Table 4.2 Performance Measure of SSIM Values From Different Techniques

Method/ Image	GHE	BBHE	DSIHE	RMSHE (r = 2)	MOHEBAT
Einstein	0.6879	0.6814	0.6745	0.8283	0.9608
Village	0.8083	0.8037	0.8331	0.9252	0.9820
House	0.7531	0.8331	0.9257	0.9293	0.9836
Peppers	0.8946	0.8844	0.8843	0.9498	0.9736
Truck	0.5717	0.5808	0.6408	0.6857	0.9685
Cameraman	0.8107	0.8230	0.8217	0.8544	0.9885
F16	0.5578	0.8784	0.7938	0.8852	0.9852

6 CONCLUSIONS

Adjustment and application of the BA to the image contrast enhancement problem is described in this chapter. The proposed method represents performance improvement of the WTHE, while the BA is employed for optimizing weighting constraints. Standard test images Einstein, Village, House, Peppers, and Truck were used to evaluate the performance of the proposed method. The results of the proposed method were evaluated via quantitative analysis and qualitative analysis. The results were compared with GHE, BBHE, DSIHE, and RMSHE methods. According to the experimental results for all images, it can be concluded that the proposed algorithm outperforms aforementioned methods. Future work may include a modification of the BA as well as hybridization with another metaheuristic in order to improve contrast enhancement of the input image.

ACKNOWLEDGMENT

This research was supported by Ministry of Education, Science and Technological Development of Republic of Serbia, Grant No. III-44006.

REFERENCES

Alihodzic, A., Tuba, M., 2014. Improved bat algorithm applied to multilevel image thresholding. Sci. World J., 16, Article ID 176718.

Bacanin, N., Tuba, M., 2012. Artificial bee colony (ABC) algorithm for constrained optimization improved with genetic operators. Stud. Inform. Control 21 (2), 137–146.

Bhandari, A.K., Kumar, A., Singh, G.K., 2015. Improved knee transfer function and gamma correction based method for contrast and brightness enhancement of satellite image. AEU—Int. J. Electron. Commun. 69 (2), 579–589.

Chen, S.-D., Ramli, A.R., 2003a. Contrast enhancement using recursive mean-separate histogram equalization for scalable brightness preservation. IEEE Trans. Consum. Electron. 49, 1301–1309.

Chen, S.-D., Ramli, A.R., 2003b. Minimum mean brightness error bi-histogram equalization in contrast enhancement. IEEE Trans. Consum. Electron. 49, 1310–1319.

De la Torre, A., Peinado, A.M., Segura, J.C., Perez-Cordoba, J.L., Benitez, M.C., Rubio, A.J., 2005. Histogram equalization of speech representation for robust speech recognition. IEEE Trans. Speech Audio Process. 13, 355–366.

Dorigo, M., Gambardella, L.M., 1997. Ant colonies for the travelling salesman problem. Biosystems 43, 73–81.

Draa, A., Bouaziz, A., 2014. An artificial bee colony algorithm for image contrast enhancement. Swarm Evol. Comput. 16, 69–84.

Fister, I., Fister, Jr., I., Yang, X.S., Brest, J., 2013. A comprehensive review of firefly algorithms. Swarm Evol. Comput. 13, 34–46.

Gandomi, A.H., Yang, X.-S., Alavi, A.H., 2013. Cuckoo search algorithm: a metaheuristic approach to solve structural optimization problems. Eng. Comput. 29, 17–35.

Ganesan, P., Rajini, V., 2014. YIQ color space based satellite image segmentation using modified FCM clustering and histogram equalization. In: ICAEE, Velore, Tamil Nadu, January 9–11, pp. 1–5.

Gonzalez, R.C., Woods, R.E., 2008. Digital Image Processing, third ed. Prentice Hall, Upper Saddle River, NJ.

Gorai, A., Ghosh, A., 2009. Gray-level image enhancement by particle swarm optimization. In: World Congress on NaBIC, Coimbatore, Tamil Nadu, December 9–11, pp. 72–77.

Gorai, A., Ghosh, A., 2011. Hue-preserving color image enhancement using particle swarm optimization. In: IEEE in Recent Advances in Intelligent Computational Systems (RAICS), Trivandrum, Kerala, September 22–24, pp. 563–568.

Hanmandlu, M., Jha, D., 2006. An optimal fuzzy system for color image enhancement. IEEE Trans. Image Process. 15, 2956–2966.

Hashemi, S., Kiani, S., Noroozi, N., Moghaddam, M.E., 2010. An image contrast enhancement method based on genetic algorithm. Pattern Recogn. Lett. 31, 1816–1824.

Hoseini, P., Shayesteh, M.G., 2013. Efficient contrast enhancement of images using hybrid ant colony optimisation, genetic algorithm, and simulated annealing. Digit. Signal Process. 23, 879–893.

Ibrahim, H., Kong, N.S.P., 2009. Image sharpening using sub-regions histogram equalization. IEEE Trans. Consum. Electron. 55, 891–895.

Jasper, J., Shaheema, S.B., Shiny, S.B., 2014. Natural image enhancement using a biogeography based optimization enhanced with blended migration operator. Math. Probl. Eng. 2014, 11.

Jeong, H., Lee, J.-R., 2015. Investigation of mobile ultrasonic propagation imager as a tool for composite wind blade quality control. Compos. Struct. 133 (1), 39–45.

Jovanovic, R., Tuba, M., 2013. Ant colony optimization algorithm with pheromone correction strategy for the minimum connected dominating set problem. Comp. Sci. Inform. Syst. (ComSIS) 10 (1), 133–149.

Karaboga, D., 2005. An Idea Based on Honey Bee Swarm for Numerical Optimization, Technical Report TR06, ErciyesUniversity, Kayseri, Turkey.

Kennedy, J., Eberhart, R.C., 1995. Particle swarm optimization. In: Proceedings of IEEE International Conference on Neural Networks, Piscataway, NJ, pp. 1942–1948.

Kim, Y.-T., 1997. Contrast enhancement using brightness preserving bi-histogram equalization. IEEE Trans. Consum. Electron. 43, 1–8.

Kim, M., Chung, M., 2008. Recursively separated and weighted histogram equalization for brightness preservation and contrast enhancement. IEEE Trans. Consum. Electron. 54, 1389–1397.

Kirkpatrick, S., Gelatt, Jr., C.D., Vecchi, M.P., 1983. Optimization by simulated annealing. Science 220, 671–680.

Kwok, N.M., Wang, D., Ha, Q.P., Fang, G., Chen, S.Y., 2012. Locally-equalized image contrast enhancement using PSO-tuned sectorized equalization. Computational Intelligence in Image Processing. Springer-Verlag, Berlin, pp. 21–36.

Lei, M., Fan, Y., 2014. Image fuzzy enhancement based on self-adaptive bee colony algorithm. TELKOMNIKA 12, 875–882.

Luo, Q., Zhou, Y., Xie, J., Ma, M., Li, L., 2014. Discrete bat algorithm for optimal problem of permutation flow shop scheduling. Sci. World J. 2014. Article ID 630280, 15 pages.

Menotti, D., Najman, L., Facon, J., De Araujo, A.A., 2007. Multi-histogram equalization methods for contrast enhancement and brightness preserving. IEEE Trans. Consum. Electron. 53, 1186–1194.

Mirjalili, S., Mirjalili, S.M., Yang, X.-S., 2014. Binary bat algorithm. Neural Comput. Appl. 25 (3), 663–681.

Munteanu, C., Rosa, A., 2000. Towards automatic image enhancement using genetic algorithms. In: Proceedings of the 2000 Congress on Evolutionary Computation, vol. 2, pp. 1535–1542.

Papour, A., Kwak, J.H., Taylor, Z., Wu, B., Stafsudd, O., Grundfest, W., 2015. Wide-field raman imaging for bone detection in tissue. Biomed. Opt. Express 6, 3892–3897.

Pei, S.-C., Zeng, Y.-C., Chang, C.-H., 2004. Virtual restoration of ancient chinese paintings using color contrast enhancement and lacuna texture synthesis. IEEE Trans. Image Process. 13, 416–429.

Sengee, N., Choi, H., 2008. Brightness preserving weight clustering histogram equalization. IEEE Trans. Consum. Electron. 54, 1329–1337.

Shanmugavadivu, P., Balasubramanian, K., 2014a. Particle swarm optimized multi-objective histogram equalization for image enhancement. Opt. Laser Technol. 57, 243–251.

Shanmugavadivu, P., Balasubramanian, K., 2014b. Thresholded and optimized histogram equalization for contrast enhancement of images. Comput. Electr. Eng. 40, 757–768.

Shanmugavadivu, P., Balasubramanian, K., Muruganandam, A., 2014. Particle swarm optimized bi-histogram equalization for contrast enhancement and brightness preservation of images. Vis. Comput. 30, 387–399.

Shanmugavadivu, P., Balasubramanian, K., Somasundaram, K., 2011. Modified histogram equalization for image contrast enhancement using partical swarm optimization. Int. J. Comput. Sci. Eng. Inform. Technol. 1, 13–27.

Sim, K.S., Tso, C.P., Tan, Y.Y., 2007. Recursive sub-image histogram equalization applied to gray scale images. Pattern Recogn. Lett. 28, 1209–1221.

Storn, R., Price, K., 1997. Differential evolutiona simple and efficient heuristic for global optimization over continuous spaces. J. Global Optimiz. 11, 341–359.

Sundaram, M., Ramar, K., Arumugam, N., Prabin, G., 2011. Histogram modified local contrast enhancement for mammogram images. Appl. Soft Comput. 11 (8), 5809–5816.

Tuba, M., Bacanin, N., 2014. Improved seeker optimization algorithm hybridized with firefly algorithm for constrained optimization problems. Neurocomputing 143, 197–207.

Verma, O.P., Kumar, P., Hanmandlu, M., Chhabra, S., 2012. High dynamic range optimal fuzzy color image enhancement using artificial ant colony system. Appl. Soft Comput. 12, 394–404.

Vlachos, I.K., Sergiadis, G.D., 2006. Parametric indices of fuzziness for automated image enhancement. Fuzzy Set. Syst. 157, 1126–1138.

Wang, Y., Chen, Q., Zhang, B., 1999. Image enhancement based on equal area dualistic sub-image histogram equalization method. IEEE Trans. Consum. Electron. 45, 68–75.

Wang, B., Tian, L., Wang, Z., Yin, Z., Liu, W., Qiao, Q., Wang, H., Han, Y., 2014. Image and data processing of digital zenith telescope (DZT-1) of china. Chin. Sci. Bull. 49, 1984–1991.

Wang, Q., Ward, R.K., 2007. Fast image/video contrast enhancement based on weighted thresholded histogram equalization. IEEE Trans. Consum. Electron. 53, 757–764.

Wu, H.-T., Huang, J., Shi, Y.-Q., 2015. A reversible data hiding method with contrast enhancement for medical images. J. Vis. Commun. Image Represent. 31, 146–153.

Yang, X.-S., 2009. Firefly algorithms for multimodal optimization. In: Proceedings in Stochastic Algorithms: Foundations and Applications: 5th International Symposium, SAGA 2009, Sapporo, Japan, October 26–28, 2009. Springer, Berlin, Heidelberg, pp. 169–178.

Yang, X.-S., 2010. A new metaheurisitic bat-inspired algorithm. Stud. Comput. Intell. 284, 65–74.

Yang, X.-S., Deb, S., 2009. Cuckoo search via Lévy flights. In: Proceedings of the World Congress on NaBIC, Coimbatore, Tamil Nadu, 9–11 December, pp. 210–214.

Yang, X.-S., Deb, S., 2010. Engineering optimisation by cuckoo search. Int. J. Math. Model. Numer. Optimisation 1, 330–343.

Zeng, Y., Lan, J., Ran, B., Wang, Q., Gao, J., 2015. Restoration of motion-blurred image based on border deformation detection: a traffic sign restoration model. PLoS One 10, e0120885.

Zhang, C.-J., Wei, H., 2007. Contrast enhancement for image by WNN and GA combining PSNR with information entropy. In: Fuzzy Information and Engineering: Proceedings of the Second International Conference of Fuzzy Information and Engineering (ICFIE). Springer, Berlin, Heidelberg, pp. 3–15.

Zhou, G., Zhang, D., Liu, Y., Yuan, Y., Liu, Q., 2015. A novel image encryption algorithm based on chaos and line map. Neurocomputing 169, 150–157.

Zuo, C., Chen, Q., Sui, X., 2013. Range limited bi-histogram equalization for image contrast enhancement. Optik 124, 425–431.

Chapter 5

Ground-glass opacity nodules detection and segmentation using the snake model

C.W. Bong*,§, C.C. Liew**, H.Y. Lam†,‡

*School of Science and Technology, Wawasan Open University, Penang, Malaysia; **Koo Foundation of Sun Yat Sen Cancer Hospital, Taipei, Taiwan; †Department of Cardiothoracic Surgery, Hospital Penang, Penang, Malaysia; ‡Lam Wah Ee Hospital, Penang, Malaysia; §Northern Health Cardiothoracic Services Sdn. Bhd., Malaysia

1 INTRODUCTION

Early detection of lung nodules is extremely important for the diagnosis and clinical management of lung cancer (Messaya et al., 2010). Inaccurate nodule segmentation could generate considerable errors in the diagnosis, making it tremendously risky to depend on the results as clinical reference. Lung nodule detection is a challenging task in medical imaging as early lung nodules may be difficult to detect using computed tomography (CT). Nevertheless, nodule characterizations have shown promise in helping with differential diagnosis and assessment of treatment response (Tsou et al., 2015).

Bio-Inspired Computation and Applications in Image Processing. http://dx.doi.org/10.1016/B978-0-12-804536-7.00005-3

In this chapter, early detection of lung nodules in a form of ground-glass opacity (GGO) is analyzed for the diagnosis of lung cancer at a potentially more curable stage, following our earlier study (Bong et al., 2016). With the tremendous increase of the amount of CT data for prognosis purposes, automatic or semiautomatic ways of identifying those problematic nodules is crucial in helping clinicians reduce the repetitive process of visual analysis that may potentially cause misdiagnosis. Accurate and consistent methods of nodule delineation also significantly help to avoid overdiagnosis (Bong et al., 2012).

A GGO is defined using high-resolution computed tomography (HRCT) imaging as a pulmonary shadow consists of hazy increased attenuation with preservation of the bronchial and vascular margins (Austin et al., 1996). The appearance of GGN on CT images, such as its shape, pattern, and boundary, is very different from solid nodules. Thus, algorithms developed exclusively for solid nodule segmentation are likely to produce inaccurate results when directly applied to GGN (Zhou et al., 2006). In spite of this, quantitative analysis of CT imaging metrics can help distinguish GGN with little solid components on CT scans (Son et al., 2014). Given the clinical importance of chest CT, the computer analysis of chest CT scans is a very active research field (Sluimer et al., 2006).

Delineating the GGO is the process of detecting the boundary of the GGO nodule followed by its segmentation process using the CT images. This type of image is a low-contrast grayscale image that provides limited information in nodule delineation. Variable nodule sizes, especially small sizes, pose an extra challenge in the automatic or semiautomatic delineation process (Dehmeshki et al., 2008). The location of the nodule within an area of complicated anatomy in the CT image may cause inaccurate nodule detection. Nevertheless, nodule information, such as the shape complexity, volume size, and the percentage of GGO volume, are possible areas for optimization criteria in GGO delineation. It is a combinatorial optimization problem that needs further research. The outcome of the optimization carries significant impact in benign lung cancer diagnosis and prognosis.

This chapter presents a framework by utilizing a snake model (active contour) model for delineation of GGO. Snake models have been some of the most successful nature-inspired methods for image segmentation (Chan and Vese, 2001; Li et al., 2013). Kass et al. (1988) introduced the model which deforms contours to lock onto features of interest within an image. This model is known as the snake model, based on the fact that the contour resembles snakes crawling. Several functions were defined, such as the internal energy due to bending, image forces (further categorized as line

functional, edge functional, and termination functional) along with external constrict forces. Collectively, they determine the behavior of the snake; in another words, the method is a "snake-inspired" one. The snake model is an energy-minimization algorithm induced not only by low-level image features, such as image gradient or image intensity, but also with higher-level information, such as object shape, continuity of the contour, and user interaction. Given an approximation of the object boundary, the snake model will be able to find the precise boundary of that object, making it suitable for GGO delineation. Please note that the terms snake model and active contour model are used interchangeably in this chapter.

Four variants of the snake model have been incorporated to identify the most suitable characteristics of the model in an overall framework that aims to accurately delineate GGO nodules. The delineation using B-spline active contour model produced the best result as it covered the most human-delineated results by clinicians and was less sensitive to noise. Design and development of the proposed overall framework in this work incorporated procedures of multiple contour analysis and segmentation process for the optimization of the GGO delineation. The preliminary experimental results have validated that the proposed framework achieves a desirable rate of successful detections and segmentations. The following sections of this chapter discuss the related work on delineation of GGO lesions. After that, we present the background of the snake method and its basic formulation and continue with the proposed framework for GGO detection using a random moving window followed by snake model segmentation. Then we discuss our experiment and its result and analysis. The final section concludes the chapter and discusses future works.

2 RELATED WORKS ON DELINEATION OF GGO LESIONS

GGOs can be divided into nonsolid, part solid, and solid types (Asamura et al., 2003). In other words, a GGO lesion may or may not be accompanied by a solid part, mainly in the center of the nodule. A GGO without a solid part is defined as a "nonsolid" GGO; a GGO with a solid part that occupies less than 50% of the whole area is a "part-solid" GGO. Only the solid component of a GGO is evident using the chest window or mediastinal window in a CT scan. As shown in Table 5.1, image density values in CT scans correspond to a range of numbers in the Hounsfield scale [referred to as Hounsfield unit (HU)]. The CT window width determines range of CT numbers displayed on an image, and the window level determines the location which the window width will be centered. Referring to Fig. 5.1, two GGO nodules

Table 5.1 Type of Tissue Corresponding With the Density Values in the Hounsfield Scale

Type of Tissue	Bone	Congealed Blood	Gray Matter	White Matter	Blood	Water	Fat	Air
Hounsfield scale (HU) (±1000)	+1000	40 to −500	30–50	20–30	10–20	0–10	−100	−1000

are identified in the lung window; they are not visible in the chest window. The lung window is window level at −550 to 2000 HU; meanwhile, the chest window is window level at 50–450 HU.

Currently, GGO nodules are detected mainly by one or multiple expert radiologists or clinicians inspecting CT images of the lung. Recent research, however, shows that there may exist interreader variability in the detection of nodules by expert radiologists (Armato et al., 2004). Even though the use of computer-aided segmentation algorithms for the segmentation of solid nodules is popular, limited research has been done on part-solid nodules, which actually show a higher malignancy rate than solid nodules (Tsou et al., 2015). Table 5.2 summarizes some of the related research conducted.

The method introduced in Heitmann et al. (1997) may be used only for large GGOs and may not be able to obtain accurate segmentation for small GGO

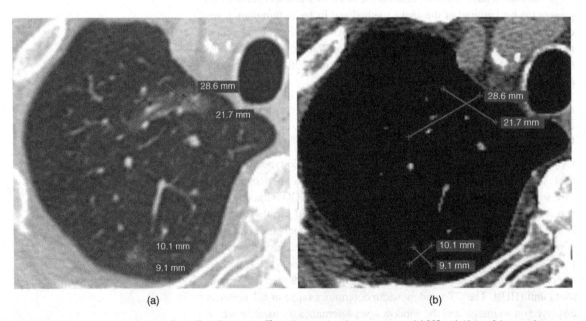

(a) (b)

■ **FIGURE 5.1** **Pulmonary nodule on chest CT.** (a) Thin-section CT with lung window showing two nonsolid GGO with 10.1 × 9.1 mm and 28.6 × 21.7 mm in size. (b) At the same window, the GGO was not visible in mediastinum/chest window.

Table 5.2 Existing Literature Studies Related to the Detection/Segmentation/Characterization of GGO Nodules

Literature	Method Used
Heitmann et al. (1997)	Hybrid neural network of three single nets and an expert rule are applied
Tanino et al. (2003)	Automatic clustering techniques
Zhang et al. (2004)	Markov random field and vessel removal method based on shape analysis
Zheng et al. (2008)	A voxelwise ground-glass opacity index feature that can be used for other applications
Zhou et al. (2006)	Nonparametric 3D texture likelihood map analysis
Yoo et al. (2006)	Four-phase level set segmentation
Kubota et al. (2008)	Six-stage region growing
Tao et al. (2009)	LDA-based machine learning approach
Son et al. (2010)	Modeling of ROI histogram with a Gaussian mixture
Jung et al. (2012)	Histogram modeling by Gaussian mixture modeling and local contrast
Zhu et al. (2012)	Markov random field-based algorithms
Li et al. (2013)	Fuzzy integrated active contour model–based segmentation method, a segmentation refinement method based on the parametric mixture model of juxtavascular nodules, and a knowledge-based cost-sensitive support vector machine classifier
Chae et al. (2014)	Computerized texture analysis with three-layered artificial neural networks with a back-propagation algorithm
Tsou et al. (2015)	Semantic segmentation algorithm that provides the spatial distribution patterns of pulmonary ground-glass nodules with solid portions; algorithm used called anatomy packing with hierarchical segments
Liu et al. (2015)	Combining fast self-adaptive FCM and classification

nodules. The work of Tanino et al. (2003) focused only on GGO detection; GGO segmentation was not discussed. Zhang et al. (2004) applied the GGO segmentation method, but not on GGO detection. Most other works (Zheng et al., 2008; Zhou et al., 2006; Kubota et al., 2008; Tao et al., 2009) focus on maximizing segmentation accuracy rather than robustness/reproducibility. The main challenge posed by Son et al. (2010), Li et al. (2013) and Zhu et al. (2012) in recognizing the small nodules is mainly toward the handling of noise. Special effort has been made to identify vessels due to the partial volume effect. For example, some parts of vessels in some images are still classified as GGOs. The other group of studies may be subject to potential bias. The examination protocol was not standardized among patients, and

the CT examinations were performed by using different technical parameters. Their texture feature in Chae et al. (2014) was derived from manual segmentation by radiologists.

Despite increasing interest, GGN–computer-aided diagnosis (CAD) remains an open optimization problem with much room for improvement, especially in robustness. Most of these contemporary methods need human intervention, and most perform well only for isolated solid pulmonary nodules (Liu et al., 2015). Most of the current nodules segmentation methods do not work well for segmenting tiny nodules. Segmentations of GGO nonsolid or part-solid nodules and tightly adhered nodules are unstable.

3 SNAKE MODEL

3.1 Background

Active contours, or snakes, are computer-generated curves that move within images to find object boundaries. The active contour model is a method to minimize the energy function from an external and internal force. It was first introduced by Kass et al. (1988). An external force is measured from image data, and an internal force is defined as curves or surfaces. The external force is a force that enables initial contours (refer to those curves or surfaces) to change their shapes automatically into the shapes of objects in the images.

Snake or active contours are extensively used in medical image processing, and particularly to locate object boundaries. However, there are still limitations related to initialization and poor convergences. Choi and Kim (2010) presented an automatic initialization value of the snake algorithm for the segmentation of the chest wall. Their method of external force for active contours, which is called gradient vector flow (GVF), was introduced to address the problems. However, the use of active contour model in this research is limited in the chest wall by the chest CT. Boscolo et al. (2002) presented a framework for integrating the active contour model with available a priori knowledge in an attempt to how to combine a higher-level image understanding system with a lower-level contouring method. In some cases, their proposed technique may outperform standard segmentation methods due to its capacity to fully enforce the available a priori knowledge concerning the anatomic structure of interest. Further study is required to determine whether the proposed algorithm is indeed capable of providing consistently superior segmentation. Way et al. (2006) developed a CAD system to classify malignant and benign lung nodules found on CT scans. Image segmentation was performed with a three-dimensional (3D) active

contour method. Their preliminary results indicate that use of the 3D model is a promising approach to the segmentation and classification of lung nodules with CAD; however, more intelligent methods for differentiating nodules from other normal lung structures in the volume of interest (VOI) segmented by clustering still have to be investigated.

A number of new nodules segmentation methods do not work well for segmenting tiny nodules (diameter < 1 cm) and segmentations of GGO nonsolid or part-solid nodules and tightly adhered nodules are unstable (Liu et al., 2015). Active contours have become an invaluable base tool for segmentation and object tracking for delineating GGO nodules. A very specific energy minimization criteria based on image intensity has been used for reaching local minima corresponding to the overall model of an edge or subjective contour in an image. The method discussed in this chapter of modeling contours using energy-minimizing splines comprises a unique approach to the problem. The energy minimization developed here differs from traditional contour modeling approaches, which typically involve edge detection followed by subjective interpretation and edge connection.

3.2 **Basic formulation**

The snake model is described as a controlled continuity model under the influence of image forces. The basic formulation of the model used in this work is based on Kass et al. (1988). Internal forces control the bending characteristics of the line, while image forces, such as the gradient, serve to push the snake toward image features. When the snake coordinate vector is defined parametrically as $\mathbf{v}(s) = (x(s), y(s))$, the total energy of the snake is defined as:

$$E_{snake}^{*} = \int_{0}^{1} E_{snake}(\mathbf{v}(s))\,ds = \int_{0}^{1} E_{int}(\mathbf{v}(s))\,ds + \int_{0}^{1} E_{image}(\mathbf{v}(s))ds \qquad (5.1)$$

where E_{int} and E_{image} are the internal and image energy terms, respectively.

The spline's internal bending energy has been defined as shown next:

$$E_{int} = \alpha(s)\left|\mathbf{v}_{s}(s)\right|^{2} + \beta(s)\left|\mathbf{v}_{ss}(s)\right|^{2} \qquad (5.2)$$

for which \mathbf{v}_s is the first spatial derivative and \mathbf{v}_{ss} is the second spatial derivative of the snake parameters (coordinates). The first term represents elasticity, while the second term represents rigidity, or thin-plate behavior. The coefficients α and β can be used to control the continuity characteristics of the snake by changing its elasticity and rigidity.

When E_{snake}^{*} is minimized, the snake has reached a local minimum associated with a contour of the image, and the modeling ceases to evolve until the image is changed. Assuming the external force is constant during a time step, the solution to a single iteration is determined by matrix inversion. This procedure is applied iteratively for given internal energy parameters and the specified image information. Under the smoothness constraints of the internal energy coefficients, the local minimum is determined through the application of the image information. Four variants of the snake model are incorporated into this work for evaluation of suitable modifications of the original snake model for GGO lesion delineation.

3.3 Variants of snake models

Four snake model variants with adjustments in the basic formulation have been used for delineation of a GGO lesion which has weak edges and intensity in homogeneity that caused difficulties in defining its boundaries. The four variants include the basic active contour, active GVF, the B-spline active contour, and the B-spline GVF. The variants are crucial to measure the performance of the segmentation accuracy, sensitivity to noise, and computation speed.

- *Active contour.* The basic snake model that gives an elegant method to simulate an elastic material which can dynamically conform to local image features. It has two main features: (1) a large number of control points that define the curve and (2) an explicit formulation of the smoothness constraint. However, several problems have been recognized. It has slow convergence speed, it has difficulty in determining the weights associated with the smoothness constraints, and it is very sensitive to noise.
- *Active GVF.* This variant of the snake model is adapted from Xu and Prince (1998). A gradient magnitude filters to determine the structure's boundary. The GVF snake begins with the calculation of a GVF field of forces by applying generalized diffusion equations to both components of the gradient of an image edge map. Here, GVF fields are dense vector fields derived from images by minimizing a certain energy functional in a variational framework. The minimization is achieved by solving a pair of decoupled linear partial differential equations that diffuse the gradient vectors of a gray-level or binary edge map computed from the image.
- *B-spline active contour.* An alternative approach to snakes, which circumvents some of the problem in the basic snake model, first introduced by Menet et al. (1990). The variant of the B-spline snake formulation we used is adapted from Brigger et al. (2000) based on the

use of node points, a variable known spacing, and a multiresolution optimization strategy. The method can be applied to a wide range of images with different signal-to-noise ratios and resolutions.

- *B-spline GVF.* This is the combination of the GVF force with the B-spline snake. B-spline snakes have several characteristics which make them suitable for describing VOI boundaries as well as snake evolution. The B-spline implicitly incorporates contour smoothness and avoids the ad hoc tension and rigidity parameters of the traditional GVF snake. Also, fewer sample points are required to implement contour evolution for the B-spline.

The most suitable model would then be incorporated into the overall framework, discussed in the next section.

4 PROPOSED FRAMEWORK

The proposed framework aims to conduct the GGO nodule detection and segmentation process. Only the CT image with a nodule detected would undergo the segmentation process. The nodules would be detected based on the comparison of the density value in HU in randomly designed moving window. It is especially useful if the GGO is nonsolid or part solid and where the density value is within the range visible in the lung window but not in the chest window. The GGO nodules detection method is adapted from Tan et al. (2012).

4.1 Overall framework

Fig. 5.2 shows an overview for the suggested model. Given a set of target CT images, each image is cropped for a number of image blocks, *N*, from

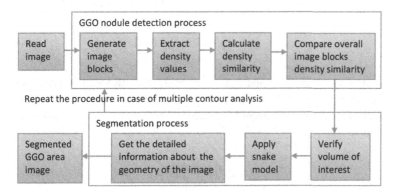

■ FIGURE 5.2 Proposed framework and algorithms for the study.

various random location within the image. Each image block will then go through a density extraction process for obtaining the density value, denoted as D_c^i, where $i = 1, ..., N$. The D_c^i belong to the density value obtained from CT image block number ith. We perform a similarity calculation by comparing the density value extracted from the target image with the density similarity obtained from a training set image. The training image dataset is a set of images that contain predominantly density content belonging to GGO nodules at different windows and levels. Thus, each image block will draw a similarity value after the comparison process. If the similarity value exceeds a preset threshold value, we marked the respective image block with a positive count. If the total count exceeded a satisfy threshold of value C, where $C \in [0, 1]$, we consider the VOI detected.

Density similarity calculation, $\text{sim}(V, F)$, is utilized to measure the distance between the training set, denoted as set $V = \{V^j \mid j \in [1, M]\}$, and the density extracted from the target image, denoted as set $F = \{F^i \mid i \in [1, N]\}$. A higher similarity indicates that there is more similarity between the training images and a target image. Thus, it helps to determine whether the object in training images is available in the target image.

Cosine similarity is used to measure the similarity. Cosine similarity is a measure of similarity of two density vectors by measuring the cosine of the angle between them (Tan et al., 2012). The similarity distance value is given as:

$$S^{i,j} = \text{sim}\left(F_c^i, V_c^j\right) = \frac{\left(F_c^i \cdot V_c^j\right)}{\left\|F_c^i\right\| \times \left\|V_c^j\right\|} \tag{5.3}$$

where the density is extracted from the ith image block from a specific target image and the trained value is extracted from the jth image in the training set. Then a matching signal for the ith image block is triggered when

$$\left(\sum_{j=1}^{M} d(j)\right) / M \geq T_i, \; T_i \in [0, 1] \tag{5.4}$$

where $d(j) = 1$, $S^{i,j} \geq T_v$ and $d(j) = 0$, $S^{i,j} < T_v$. Note that $T_i, T_v \in [0, 1]$ are preset threshold values. Let $B(i) = 1$ when the mentioned matching signal is triggered for the ith image block, and a detection decision is considered positive when

$$\left(\sum_{i=1}^{N} B(i)\right) / N \geq C \tag{5.5}$$

4.2 **Experimental data**

This chapter uses experimental data from whole lung image series provided by the Lung Image Database Consortium (LIDC), obtained at http://www.cancerimagingarchive.net/. The LIDC study (Armato et al., 2011) explicitly presents the variation among radiologists in the identification of lung nodules. In the LIDC study, we identified 25 nodules in 55 chest CT scans. The dataset used from this source are from anonymized CT scans. Axial images with a 512×512 matrix are reconstructed with 2.0–3.0-mm thickness and 0.7-mm increment. All the datasets used in the CT images are in the Digital Imaging and Communication in Medicine (DICOM) standard format. We then implemented our semisupervised method utilizing the snake model in Matlab.

5 **RESULT AND DISCUSSION**

In this work, we conducted detection and segmentation of GGO lesions using our proposed framework with experiments using the selected dataset. Here we demonstrate single- and multiple-lesion detection and segmentation. Besides that, we also describe the comparison result for the four variants of the snake model.

Fig. 5.3 presents three examples of GGO nodules detection and segmentation results. The top row with three images is a sample of three GGOs detected with the respective bounding windows. The first GGO detected on the left is a nonsolid GGO; usually this indicates a patient with very early stage of potentially curable lung cancer. The second and third lesions are part-solid GGOs, where the whiter areas are solid areas and are surrounded by nonsolid areas. The middle lesion actually had a discontinuous area where the surrounding area could potentially lead to the formation of GGOs. Compared to the last lesion on the right, the GGO nodules are the smallest in size. With the proposed framework, the GGO nodules are delineated successfully with the detection strategy followed by its segmentation.

On the other hand, Fig. 5.4 presents an example of segmentation with two GGO nodules in a same lung chest image. As visualized in the Fig. 5.4, one GGO is detected in the left bottom lingular lobe, and another GGO is found in the right top lingular lobe. With two detected bounding windows, both of the nodules are delineated with their corresponding shapes and sizes using our framework. From the visualization, it is observed that the framework is able to segment the nonsolid area of the nodule detected.

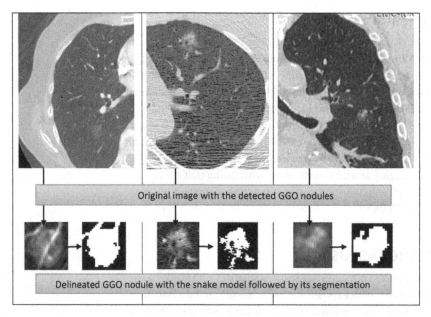

■ FIGURE 5.3 Three examples of segmentation results with different GGO nodule sizes.

As we have implemented four variants of the snake model, selected delineation results from each variant is presented in Fig. 5.5. The same GGO nodule is used to compare the result for the four variants of snake model. At first, the original view of the GGO nodules is shown at the left lingular lobe in the CT axial lung window. At each of the delineation result (with contour), the same bounding box or the region of interest (in red contour) is used. The intensity graphs for each delineation result are also presented for ease of comparison. The four intensity graphs show that the ranges of intensity are almost identical for the four variants of the snake model. The delineation using the basic active contour model is presented with the intensity count up to 310, followed by the Gaussian version of the model with

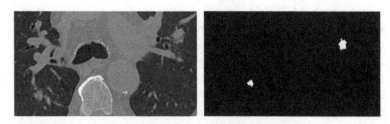

■ FIGURE 5.4 Segmentation result with two GGO nodules in the same image.

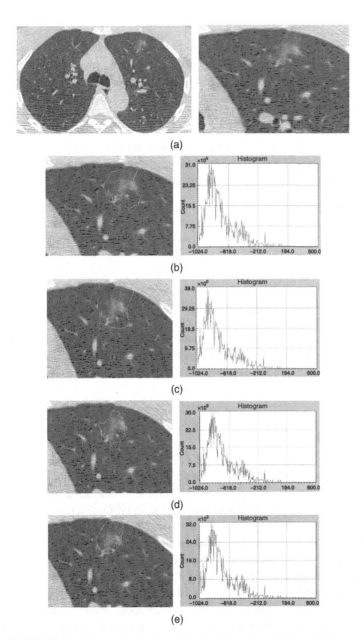

■**FIGURE 5.5 Experiment using the four variants of the snake model toward the same GGO lesion.** (a) Original view of GGO at the left lingular lobe in CT axial lung window. (b) Delineation using active contour model. (c) Delineation using active Gaussian contour model. (d) Delineation using B-spline active contour model. (e) Result using B-spline active Gaussian contour model.

count up to 390. Delineation using the B-spline active contour model has the lowest count of intensity up to 300. On the other hand, results using the B-spline active Gaussian contour model have the intensity count up to 310. From the visualized result, the delineation using the B-spline active contour model has the best result as it covers most of the human-delineated result by the clinician, as this is the method which less sensitive to noise. Based on the performance of the four variants of the snake model in Fig. 5.5, the active Gaussian contour model is the least accurate, as it has delineated an additional area of the GGO nodule. On top of this, the computation duration using this model is longest compared to the other three variants.

To further analyze the performance of the snake models, the delineation process is repeated for nonsolid and part-solid GGO nodules. As shown in Fig. 5.6, five detected GGO nodules are delineated with the three variants of the snake model. The first image is at the leftmost side as the original GGO nodule with the bounding box, followed by the delineation with the active contour model, the B-spline active contour model, and finally the B-spline active Gaussian contour model. From the result, it is also observed that the B-spline active Gaussian contour model (Fig. 5.6d) is more stable and able to identify the nonsolid and part-solid GGO lesions. The basic active contour model determines the structure's boundary more quickly than the B-spline active contour algorithm, but it is also more sensitive to noise present in the image.

6 CONCLUSIONS

The delineation of a GGO lesion is a challenging problem which is crucial to identifying benign lung cancer for early follow-up and possible treatment. Although a number of research studies have been conducted on detection and/or segmentation, the nonsolid or part-solid GGO nodule is extremely difficult to identify. Algorithms developed exclusively for solid-nodule segmentation are likely to produce inaccurate results when applied directly to this type of GGN lesions. This research is to detect the possible area of GGN lesions with a randomly moving window and density similarity measurement method. Manual verification of the detected region of interest is still needed before the segmentation process is conducted with the snake model. On the other hand, the snake or active contour model plays a vital role in determining the exact shape and size of any abnormalities found in any of the biomedical imaging modalities. A lot of research on the biomedical applications using this method still needs to be done. The preliminary result of this chapter demonstrates that adaptation of the snake model will contribute to accuracy in GGO nodule delineation. We implemented four variants of the

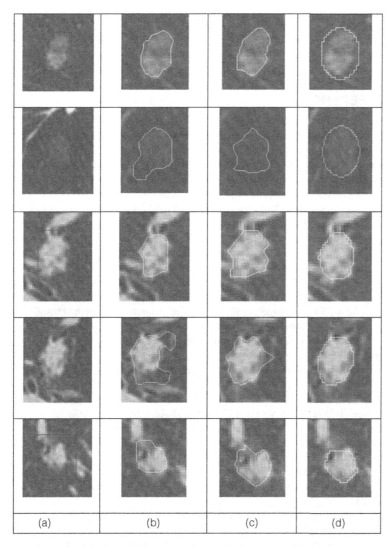

■ FIGURE 5.6 Comparison of the three variants of snake models with five nonsolid and part-solid GGO nodules. (a) Original GGO nodules with the bounding box, (b) delineation with active contour model, (c) delineation using B-spline active contour model, and (d) B-spline active Gaussian contour model.

snake model (basic active contour, active Gaussian contour model, B-spline active contour, and B-spline active Gaussian contour). From our preliminary experiment results in GGO nodule delineation, we are able to conclude that the B-spline active contour model is accurate and less sensitive to noise while the B-spline active Gaussian contour model is more stable and robust.

However, there is a lot more to do in order to strengthen our method. Further validation will be conducted with more datasets. Another future project is to extend the segmentation into three dimensions.

REFERENCES

Armato, S.G., McLennan, G., Bidaut, L., et al., 2011. The lung image database consortium (LIDC) and image database resource initiative (IDRI): a completed reference database of lung nodules on CT scans. Med. Phys. 38 (2), 915–931.

Armato, S.G., McLennan, G., McNitt-Gray, M.F., Meyer, C.R., Yankelevitz, D., Aberle, D.R., 2004. Lung image database consortium developing a resource for the medical imaging research community. Radiology 232, 739–748.

Asamura, H., Suzuki, K., Watanabe, S., Matsuno, Y., 2003. A clinicopathological study of resected subcentimeter lung cancers: a favorable prognosis for ground glass opacity lesions. Ann. Thorac. Surg. 76, 1016–1022.

Austin, J.H., Mueller, N.L., Friedman, P.J., 1996. Glossary of terms for CT of the lungs: recommendations of the nomenclature. Radiology 200, 327–331.

Bong, C.W., Lam, H.Y., Hamzah, C.K., 2016. Delineation Of Ground Glass Opacity Nodules in CT Images (POSTER). 24th Annual Meeting of Asian Society for Cardiovascular and Thoracic Surgery (ASCVTS 2016) in conjunction with 9th AATS/ASCVTS Postgraduate Course as well as 4th Asian Single Port VATS Symposium and 5th Strait Vascular Forum Organizing Committee, Taipei, Taiwan, April 6–10, 2016.

Bong, C.W., Lam, H.Y., Khader, A.T., Hamzah, C.K., 2012. Adaptive multi-objective archive-based hybrid scatter search for segmentation in lung computed tomography imaging. Eng. Optimiz. 44 (3), 327–350.

Boscolo, R., Brown, M.S., McNitt-Gray, M.F., 2002. Medical image segmentation with knowledge-guided robust active contours. RadioGraphics 22, 437–448.

Brigger, P., Hoeg, J., Unser, M., 2000. B-spline snakes: a flexible tool for parametric contour detection. IEEE Trans. Image Process. 9 (9), 1484–1496.

Chae, H.D., Park, C.M., Park, S.J., Lee, S.M., Kim, K.G., Goo, J.M., 2014. Computerized texture analysis of persistent part-solid ground-glass nodules: differentiation of preinvasive lesions from invasive pulmonary adenocarcinomas. Radiology 273 (1), 285–293.

Chan, T.F., Vese, L.A., 2001. Active contours without edges. IEEE Trans. Image Process. 10 (2), 266–277.

Choi, S., Kim, C., 2010. Automatic initialization active contour model for the segmentation of the chest wall on chest CT. Healthc. Inform. Res. 16 (1), 36–45.

Dehmeshki, J., Amin, H., Valdivieso, M., Ye, X., 2008. Segmentation of pulmonary nodules in thoracic CT scans: a region growing approach. IEEE Trans. Image Process. 27 (4), 467–480.

Heitmann, K., Kauczor, H.U., Mildenberger, P., Uthmann, T., Perl, J., Thelen, M., 1997. Automatic detection of ground glass opacities on lung HRCT using multiple neural networks. Eur. Radiol. 7, 1463–1472.

Jung, J., Hong, H., Goo, J.M., 2012. Automatic segmentation of ground-glass opacity nodule on chest CT images by histogram modeling and local contrast. Proc. SPIE 8315, 83152T.

Kass, M., Witkin, A., Terzopoulos, D., 1988. Snakes: active contour models. Int. J. Comput. Vision 1 (4), 321–331.

Kubota, T., Jerebko, A., Salganicoff, M., Dewan, M., Krishnan, A., 2008. Robust segmentation of pulmonary nodules of various densities: from ground-glass opacities to solid nodules. In: First International Workshop on Pulmonary Image Processing, August 15, New York, NY, September 6, 2008, pp. 253–262.

Li, B., Chen, K., Tian, L., Yao, Y., Ou, S., 2013. Detection of pulmonary nodules in CT images based on fuzzy integrated active contour model and hybrid parametric mixture model. Comput. Math. Methods Med. 2013. Article ID 515386, 15 pages.

Liu, H., Zhang, C.-M., Su, Z.-Y., Wang, K., Deng, K., 2015. Research on a pulmonary nodule segmentation method—combining fast self-adaptive FCM and classification. Comput. Math. Method. Med. 2015. Article ID 185726, 14 pages.

Menet, S., Saint-Marc, P., Medioni, G., 1990. B-snakes: implementation and application to stereo. In: Image Understanding Workshop, pp. 720–726.

Messaya, T., Hardiea, R.C., Rogersb, S.K., 2010. A new computationally efficient CAD system for pulmonary nodule detection in CT imagery. Med. Image Anal. 14 (3), 390–406.

Sluimer, I., Schilham, A., Prokop, M., Ginneken, B., 2006. Computer analysis of computed tomography scans of the lung: a survey. IEEE Trans. Med. Imaging 25 (4), 385–430.

Son, J.Y., Lee, H.Y., Lee, K.S., Kim, J.-H., Han, J., et al., 2014. Quantitative CT analysis of pulmonary ground-glass opacity nodules for the distinction of invasive adenocarcinoma from pre-invasive or minimally invasive adenocarcinoma. PLoS One 9 (8), e104066.

Son, W., Park, S.J., Chang, M.P., Goo, J.M., Kim, J.-H., 2010. Automated volumetric segmentation method for computerized-diagnosis of pure nodular ground-glass opacity in high-resolution CT. Proc. SPIE 7624, 76241P.

Tan, S.Y., Bong, C.W., Lukose, D., 2012. Building detection with loosely-coupled hybrid feature descriptors. 12th Pacific Rim International Conference on Trends in Artificial Intelligence. In: Anthony, P., Ishizuka, M., Lukose, Dickson (Eds.), Communications in Computer and Information Science, Springer-Verlag, Berlin, Germany, pp. 552–563.

Tanino, M., Takizawa, H., Yamamoto, S., Matsumoto, T., Tateno, Y., Inuma, T., 2003. A detection method of ground glass opacities in chest X-ray CT images using automatic clustering techniques. Proc. SPIE 5032, 1728–1737.

Tao, Y., Lu, L., Dewan, M., Chen, A., Corso, J., Xuan, J., Salganicoff, M., Krishnan, A., 2009. Multi-level ground glass nodule detection and segmentation in CT lung images. Med. Image Comput. Comput. Assist. Interv. 12, 715–723.

Tsou, C.H., Lor, K.L., Chang, Y.C., Chen, C.M., 2015. Anatomy packing with hierarchical segments: an algorithm for segmentation of pulmonary nodules in CT images. Biomed. Eng. Online 14, 42.

Way, T., Hadjiiski, L., Sahiner, B., Chan, H., Cascade, P., Kazerooni, E., Bogot, N., Zhou, C., 2006. Computer-aided diagnosis of pulmonary nodules on CT scans: segmentation and classification using 3D active contours. Med. Phys. 33 (7), 2323–2337.

Xu, C., Prince, J.L., 1998. Snakes, shapes, and gradient vector flow. IEEE Trans. Image Process. 7 (3), 359–369.

Yoo, Y., Shim, H., Yun, I., Lee, K., Lee, S., 2006. Segmentation of ground glass opacities by asymmetric multi-phase deformable model. Proc. SPIE 6144, 614440.

Zhang, L., Fang, M., Naidich, D., Novak, C., 2004. Consistent interactive segmentation of pulmonary ground glass nodules identified in CT studies. Proc. SPIE 5370, 1709–1719.

Zheng, Y., Kambhamettu, C., Bauer, T., Steiner, K., 2008. Estimation of ground-glass opacity measurement in CT lung images. Med. Image. Comput. Comput. Assist. Interv. 11 (Pt 2), 238–245.

Zhou, J., Chang, S., Metaxas, D.N., Zhao, B., Schwartz, L.H., Ginsberg, M.S., 2006. Automatic detection and segmentation of ground glass opacity nodules. In: Larsen, R., Nielsen, M., Sporring, J. (Eds.), Med. Image. Comput. Comput. Assist. Interv. Lecture Notes in Computer Science, vol. 4190, pp. 784–791.

Zhu, Y., Tan, Y., Hua, Y., Zhang, G., Zhang, J., 2012. Automatic segmentation of ground-glass opacities in lung CT images by using Markov random field–based algorithms. J. Digit. Imaging 25 (3), 409–422.

Mobile object tracking using the modified cuckoo search

T. Ljouad*, A. Amine**, M. Rziza*

*Faculty of Sciences of Rabat (FSR), Mohammed V University, Morocco; **BOSS Team, National School of Applied Sciences (ENSA), Ibn Tofail University, Kenitra, Morocco*

Bio-Inspired Computation and Applications in Image Processing. http://dx.doi.org/10.1016/B978-0-12-804536-7.00006-5

1 INTRODUCTION

Image processing is a constantly growing research area that is used in many applications in different fields, such as security, medicine, quality control, and astronomy, among others. It involves different techniques belonging to low-level signal processing; medium-level morphological processing and segmentation for feature selection and detection; and high-level artificial intelligence algorithms for object recognition, information extraction, and image understanding.

Considering that object tracking is one of the major tasks in the computer vision area, numerous techniques were proposed to detect and/or track patterns and retrieve information in images and/or video sequences by using low-level features of the image or the results of mathematical morphology directly applied on it. Nowadays, usual examples of object tracking in video sequences can be found in areas, such as industry, security, engineering, and others. Using traditional search algorithms to retrieve the geographical information of a target is computationally expensive, which prevents the real-time use that is becoming crucial in real-life scenarios. A possible and potentially suitable way to face such an issue is to use population-based metaheuristics. These algorithms were previously applied to analog issues and provided very interesting and satisfying results. Encouraging examples can be cited, such the ant colony optimization algorithm (ACO) that was applied for image thresholding (Zhao et al., 2008) and particle swarm optimization (PSO) for object classification problems (Evans and Zhang, 2008). In Cuevas et al. (2012), the authors also explore the use of the artificial bee colony algorithm for automatic threshold selection for image segmentation.

2 METAHEURISTICS IN IMAGE PROCESSING: OVERVIEW

The reason for using bioinspired algorithms, and specifically the population-based algorithms, rather than traditional algorithms is their outstanding ability to perform extensive searches in the entire search space. The algorithms can be adjusted to make them appropriate for the purpose of image processing, especially for object tracking. Over the past decades, several research efforts have focused on this particular area. In the literature, bioinspired approaches are used for solving an impressive array of problems. More recently, a number of studies have reported on the success of such techniques for solving difficult problems in all key areas of computer science, such as traveling salesman and graph coloring problems, scheduling and resource-constrained problems, and optimizing routing in

networks. These algorithms are mostly proposed and used for optimizing search operation, prediction, classification, and clustering in image processing and neural networks and for routing, clustering, and scheduling of resources in the field of networking (Zhang et al., 2013; Teodorovic and Dell'Orco, 2005).

The real attractiveness of nature-inspired algorithms lies in their faculty to describe and resolve complex relationships from basically very simple initial conditions and rules with little or no knowledge of the search space. Nature is the perfect example for optimization. Also, optimization is a commonly encountered mathematical problem in all engineering disciplines. It means finding the best possible solution. Optimization problems are wide ranging and numerous, hence methods for solving these problems are active research topics.

Some of the most popular swarm algorithms are inspired from nature, such as the ACO (Dorigo and Stutzle, 2004), the PSO (Kennedy and Eberhart, 2001), bee colony optimization, and other algorithms that are inspired from fish schools (Cai, 2009), gravity, and mass interactions (Rashedi et al., 2009) as well as different aspects of the behavior of bees (Abbass, 2001a,b), particle filters (Del Moral, 1996), fireflies (Yang, 2008, 2009), cockroaches (Havens et al., 2008), bats (Yang, 2010), and cuckoo birds (Yang, 2009). Some of these algorithms have been proposed in the last decade for object tracking or multiobject tracking algorithm and are described in following sections.

2.1 Genetic algorithm

The genetic algorithm (GA) is introduced and applied to find the tracked object in a search area. Wang et al. (2008) proposed a novel tracking approach for a single object, which combines GA and the Kalman filter. Then a multiblocks voting is exploited for obtaining more perfect object localization. The Kalman filter is exploited to both estimate the position of object center and cope with temporary occlusion.

2.2 Particle swarm optimization

PSO is old and is the most used swarm intelligence algorithm. The general idea of PSO is inspired by a flying swarm of birds searching for food. In Kwolek (2013), the task of object tracking is considered as a numerical optimization problem, where a PSO is used to track the local mode of the similarity measure and to seek a good local minimum, and then the conjugate gradient is utilized to find the local minimum accurately. But the ordinary PSO is not well suited for multiple object tracking. As presented in Keyrouz (2012), the proposed algorithm introduces two new components

to PSO: a self-adapting component, which is robust against drastic brightness changes of the image sequence, and a self-splitting component, which decides to track the scene as one connected object, or as more stand-alone objects.

2.3 Artificial bee colony algorithm

The artificial bee colony is one of the recent and very successful swarm intelligence metaheuristics. This algorithm is a population-based search algorithm that mimics the food foraging behavior of swarms of honeybees. Honeybee colonies have a decentralized system to collect food and can adjust the searching pattern precisely in order to enhance the collection of nectar. The modified algorithm for image classification involves these assumptions: bees are the pixels of the input image; food sources are taken as land cover features; neighborhood solutions are taken as the adjacent pixels of the previously classified dataset given by experts. Bees are regulated by pixels of the classified dataset, which contains the actual values of the optimization solution. This optimization algorithm is based on the behavior of a colony of honeybees. The colony can extend itself over long distances and in multiple directions simultaneously to exploit a large number of food sources. In addition, the colony of honeybees presents as characteristic the capacity of memorization, learning, and transmission of information, thus forming the so-called swarm intelligence (Von Frisch, 1976).

The basic steps in the bee colony algorithm (Pham et al., 2006) are:

1. Initialize the population with random solutions.
2. Evaluate the fitness of the population.
3. While (stopping criterion not met)
 a. Select the sites for neighborhood search.
 b. Recruit bees for selected sites and evaluate their fitness.
 c. Select the fittest bee from each site.
 d. Assign remaining bees to search randomly and evaluate their fitness.
4. End while.

2.4 Ant colony optimization

An ant colony (Holldobler and Wilson, 1990) is also named a formicary. The objective of the work presented by Lai et al. (2009) is to develop an object tracking system for active contour tracking of moving objects using edge flows and ACO in video sequences. The proposed approach is designed to segment and track the foreground object in video sequences without constructing and updating a background model. In particular, this system is

effective when tracking nonrigid objects (eg, human) in a scene where the complete background cannot be acquired from the whole video sequence.

2.5 **Particle filter**

Particle filters (Isard and Blake, 2006) are some of the most efficient techniques for object tracking. As is recognized, visual object tracking is an important component of any multiobject tracking algorithm. They were successfully applied in many visual tracking applications (Yang et al., 2011), including multiobject tracking (Breitenstein et al., 2009; Okuma et al., 2004).

2.6 **Firefly algorithm**

The firefly algorithm (FA) is one of the latest swarm intelligence algorithms created by Yang. In the work presented by Gao et al. (2015), an improved particle filter based on FA is proposed to solve a main handicap of the particle filter. The particles in the particle filter are optimized using FA before resampling. As is known, particle filter algorithm has been proven to be a powerful tool in solving visual tracking problems. However, the problem of sample impoverishment that is brought by the procedure of resampling is a main obstacle of the particle filter. Thus, the proposed method in this work is to increase the number of meaningful particles, and the particles can approximate the true state of the target more accurately.

2.7 **Cuckoo search**

Cuckoo search (CS) is also one of the latest swarm intelligence algorithms. CS was developed by Yang and Deb (2009) and is inspired by the brood parasitism of the cuckoo species. In fact, instead of hatching their own eggs, the cuckoo female explores the space searching for other host bird's nests where the probability of hatching of its own eggs is optimized. This brood parasitism is combined with a flying pattern adopted during the space exploration, which is commonly used with other flying species and animals, called the Lévy flight. The Lévy flight is characterized by a series of straight flights, punctuated by sudden random changes in the movement's direction and local exploration. This flying pattern has been proven to be a more efficient search pattern compared to the random walk (Viswanathan, 2010), since it allows a zoom effect during the space exploration (Walton et al., 2011), using the small steps for a search intensification around a specific location but keeping an eye on remotely located regions.

This inspiration has been then formulated in a mathematical way, leading to the pseudocode Algorithm 6.1.

ALGORITHM 6.1: PSEUDOCODE OF THE CUCKOO SEARCH

Cuckoo search via Lévy flights

Objective function $f(x)$, $x = (x_1, ..., x_d)^T$;

Generate an initial population of $n - 2$ host nests x_i with $(i = 1, 2, ..., n - 2)$;

__while__ (($t < MaxGeneration$) or (Stop Criteria))__do__

> *Get a cuckoo, (say i), randomly by a Lévy flights;*
> *Evaluate its quality/fitness F_i;*
> *Choose a nest among n, (say j) randomly;*
> *__If__ ($F_i > F_j$) __then__*
>> *Replace j by the new solution;*
> *__end if__*
> *Abandon a fraction (P_a) of worst nests and build new ones at new locations;*
> *Rank the solutions and find the current best;*

__end while__

__Update the Kalman measurement and Kalman gain;__

Post process results and visualization;

3 CUCKOO SEARCH FOR OBJECT TRACKING

From all possible application domains of a metaheuristic, and specifically the one we previously detailed, our interest was focused on the problem of mobile object tracking. In fact, this research area has triggered so much attention in the literature that it kept growing since 1988 (Pylyshyn and Storm, 1988). Despite the huge interest shown by many researchers and the constantly increasing number of contributions in this area, mobile object tracking still represents a very challenging process to be fully automated. The interest is fully justified by the increasing number of application domains that are interacting with a human's daily life, such as video surveillance systems, military applications, such as missile tracking, and even human–computer interaction.

Mobile object tracking can be approached in different ways, depending on the main challenge we aim to address. We believe one of the main challenges to be addressed is the required execution time, especially when aiming at a mobile object tracker to be implemented in a video surveillance application. We believe that there is reason to track an individual and extract the information about his trajectory long after he has left the stage. Any planed reaction, analysis, or classification should be performed while the information flow is gathered from the camera sensor, in order to give space for a meaningful human intervention. Therefore, we have aimed at reducing, or rather optimizing, the computation cost of a tracking algorithm, to produce a real-time performance in a very common and basic hardware environment.

In fact, depending on how the problem is approached, mobile object tracking can be considered an optimization problem. To give an insight on this perspective, we have proposed two different tracking methods where the issue is analyzed as being an optimization issue. In this section, we present the two different tracking methods, both tackling the computation cost issue by considering the problem as an optimization one and making use of the CS metaheuristic to provide reasonable and acceptable performances in a highly reduced execution time. The first contribution (Ljouad et al., 2014b) provides the trajectory information of a single mobile object in a video sequence along its appearance by considering at each time, implicitly each frame of the sequence, the image itself as a search space with multiple candidates, and representing each candidate image region by its color density estimation. The second contribution (Ljouad et al., 2014a) deals with the multiple objects tracking issue by dividing it into a detection phase followed by a profile matching operation. To handle this issue, we construct a new database based on the pedestrian's parametric representations and then consider this database as a search space where we apply the CS algorithm in order to identify each new passenger in the scene.

3.1 Single mobile object tracking using the modified cuckoo search algorithm

3.1.1 *Problem formulation*

In a video sequence issued from a surveillance camera system, one of the most important tasks to be performed is to retrieve the location information of an object of interest (OI), whether it is a human, an animal, or even a moving object (cars, ball, etc). The motivation behind such a process is that many recent application and scene understanding algorithms make use of the object tracking technique in order to extract location and velocity features of the dynamics (Zhan et al., 2008). As trivial as this task might appear from a human's perspective, it does require an advanced analysis of the captured data to correctly discriminate the OI along its appearance.

After creating the reference patch in the first image of the video which defines the OI and will serve as the target profile, the aim is to locate the image region in the next frame that best represents the target; that is, to find the most similar region of the test image ($i + 1$) to the previously defined target in the reference image i. An exhaustive search in the test image will most likely return the best solution, provided that a perfectly discriminating parametric representation has been adopted. Nevertheless, such a heuristic is a time-consuming approach, especially when dealing with high-definition images. Existing work has tried to handle this issue by replacing the

exhaustive search with different heuristics. In our study, we were interested in how a metaheuristic can be used to optimize the search for the sought-after solution within an image processing framework.

In our context, each solution (implicitly a candidate image region) is represented by its parametric representation, which is the color histogram. In fact, each image—initially defined in the RGB form—is indexed. Then the indexed histogram is computed. In order to eliminate the borders effect, the obtained distribution is smoothed using a convolution with a unit Gaussian filter. The unity factor is used to keep the image center intact while reducing the appearance of the borders pixels in the color distribution.

3.2 Proposed approach: hybrid Kalman cuckoo search tracker

Considering that the requested solution is a region in the test image that maximizes the similarity with the target patch, and that evaluated/candidate regions are image regions picked up from the test image, we set up this analogical theory: the test image can be seen as a search space, and every different image region is a candidate solution that might represent the sought solution. Therefore, the adopted search method should optimize the search for the best candidate solution in the newly established search space. Considering that the image is a discrete search space and that we are investigating the use of a metaheuristic in the computation optimization, we used the CS algorithm to simplify the computation process. The next statements were the key elements that drove our choice to the CS algorithm instead of any other one:

- The CS has been proven to be efficient in discrete search space (such as a two-dimensional image).
- The CS has been successfully integrated in multiple application domains.
- The comparison study provided by the CS's authors obviously highlights the superiority of this algorithm in discrete search spaces.

Our projection of the CS algorithm considers this analogy:

- *Egg*. The cuckoo bird is only only lay one egg per nest at a time as per the previously cited idealizing rules. Therefore, the egg can represent:
 - An adopted solution in the space of belief when the egg is assumed in a nest.
 - A region of the image representing a candidate solution otherwise.

Thus, the egg represents a general solution of the algorithm. As the search space is none other than the image, a solution is understood as a region of the image. For simplification purposes, we will use the same term to refer to a solution region of the image, as well as its parametric representation used

to allow comparison and assessment of the quality of a region of the image compared to other "solutions."

- *Nest.* The nest is a theoretical concept in the CS algorithm. It is characterized by:
 - The number of nests n is set before execution. It remains unchanged during the same performance.
 - The number of nests is also the size of the population (possibly original).
 - An egg in a nest represents a temporary solution (and possibly final) adopted.

Therefore, we concluded that a nest represents a position occupied by a solution in the population. As we work in an area of research that is the image, a nest is a position or location in the population of solutions, representing a region of the image whose quality is high enough to represent a possible final solution (ie, represent the corresponding desired object in the current image).

- *Objective function.* The objective function is a widely used concept in metaheuristics which associates a scalar to each solution, defining its quality within the set of all possible solutions. An egg of good quality represents a region of the image that is similar enough to the predefined profile (ie, histogram) of the tracked object. In other words, the objective function should provide the ability to assess and compare the similarity between a candidate region of the test image and the OI. In this study, we adopt the Bhattacharyya distance to evaluate and compare solutions. Readers should refer to Ljouad et al. (2014a,b) for further details on this distance.
- *Lévy flights.* The Lévy flights substitution step starts from the best solution in the current population and uses a Lévy distributed step size to move onto a candidate nest called the Lévy candidate. This search pattern intensifies the search space's exploration in the close neighborhood to the best solution in the current iteration, while maintaining a visibility on remote locations in the test image. We highlight the difference between Lévy distributed displacements and normally distributed ones in Fig. 6.1. In this context, a huge number of improvements had been introduced in the literature to refine the Lévy flights behavior as the convergence approaches. A well-known variation introduced by Walton et al. (2011) aims at readjusting the Lévy step size while converging to the optimal solution. This helps gradually transform the search from an exploration pattern in the early stages of the convergence into a refinement mechanism and adjustment of the accuracy. Controlling the Lévy step size is done by operating changes on the multiplicative scalar used in the Lévy step formula.

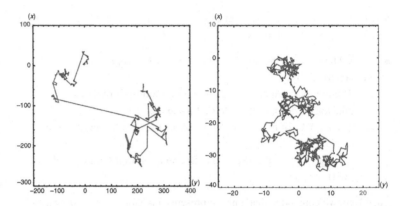

■ **FIGURE 6.1 Example of a particle's trajectory after performing a series of 1000 steps starting from the origin of the reference (0,0).** The Lévy distributed steps are displayed on the left side, while the normally distributed ones are shown on right.

We remind readers that in the basic version of the CS, the Lévy candidate's position $X(lévy)$ is generated using the following formula:

$$X(lévy) = X(best) \oplus \alpha Lévy(\lambda)$$

The original authors concluded that a practical value of α is 1. In the modified CS version (MCS), this parameter is decreased from its initial value set to 1 using the formula $\alpha = 1/G$, where G is the number of generation so far performed. The final resulting equation is then as follows:

$$X(lévy) = X(best) \oplus \frac{1}{G} Lévy(\lambda)$$

■ *Discovery probability.* This process has not been altered from the version initially introduced by Xin-She et al. and is implemented exactly as in the demo source code released by the original authors. In this phase, a subset P_a of the initial population is replaced by randomly generated solutions from the space of believe.

When projecting these concepts into the initially provided CS's pseudo-code, we obtain following statements as in Algorithm 6.2.

ALGORITHM 6.2: PSEUDOCODE OF THE CUCKOO SEARCH–BASED MOBILE OBJECT TRACKER

Cuckoo search–based tracker
Objective function $f(x)$, $x = (x_1, ..., x_d)^T$;
Generate an initial population of n host nests x_i with $(i = 1, 2, ..., n)$;

while ((t < *MaxGeneration*) *or* (*Stop Criteria*))*do*
 Update the step size of the Lévy flights process;
 Get a cuckoo, (say i), randomly by a Lévy flights performed around the
 current best solution;
 Evaluate its quality/fitness F_i;
 Choose a nest among n, (say j), randomly;
 If *($F_i > F_j$)* **then**
 Replace j by the new solution;
 end if
 Abandon a fraction (P_a) of worst nests and build new ones at new loca-
 tions via Lévy flights;
 Rank the solutions and find the current best;
end while
Post process results and visualization;

A better initial population in terms of similarity with the target profile would lead to a reduction in the exploration phase and a better refinement, and therefore a faster convergence. For that purpose, we have strengthened the quality of the first generated population by including a prediction mechanism. In fact, predicting the next position of the mobile object based on its movement history would generally land in a region close to the actual position of the object in the current frame. The algorithm would theoretically need only a reduced number of iterations in order to refine the predicted position.

On the other hand, based on the proximity assumption as explained in Yilmaz et al. (2006), we assume that the object would not drastically change its location from one frame to the very next one: the OI's position in the previous frame would more likely still contain a portion of it. Therefore, including this position in the initial population would guarantee a minimal similarity to the desired object. We called this process a rollback process.

Including these assumptions in the previously described pseudocode, the final form of the modified CS-based tracker is what we called the hybrid Kalman CS (HKCS) tracker and is detailed in Algorithm 6.3.

ALGORITHM 6.3: PSEUDOCODE OF THE PROPOSED APPROACH FOR SINGLE OBJECT TRACKING HKCS

Hybrid Kalman cuckoo search tracker
Objective function f(x), x = (x_1, ..., x_d)T;
Generate an initial population of n − 2 host nests x_i with (i = 1, 2, ..., n − 2);
Include the predicted solution by the Kalman Filter;
Include the previous best solution;

while ((t < MaxGeneration) or (Stop Criteria)) *do*
 Update the step size of the Lévy flights process;
 Get a cuckoo, (say i), randomly by a Lévy flights performed around the current best solution;
 Evaluate its quality/fitness F_i;
 Choose a nest among n, (say j), randomly;
 If ($F_i > F_j$) then
 Replace j by the new solution;
 end if
 Abandon a fraction (P_a) of worst nests and build new ones at new locations via Lévy flights;
 Rank the solutions and find the current best;
end while
Update the Kalman measurement and Kalman gain;
Post process results and visualization;

Translating Algorithm 6.2 into image processing terminology, the functioning scenario, illustrated in Fig. 6.2, is: at each image, the HKCS starts by initializing a set of $n - 2$ candidate regions by iteratively selecting a random region in the test image. The algorithm then adds the previous position of the object to the set of candidates and predicts the position of the object using its previous position as well as the velocity and movement direction

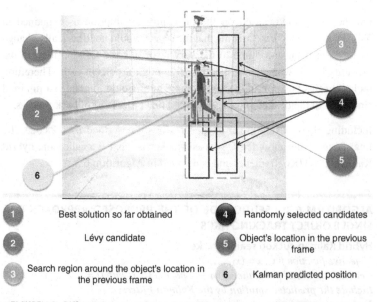

1 Best solution so far obtained		**4** Randomly selected candidates	
2 Lévy candidate		**5** Object's location in the previous frame	
3 Search region around the object's location in the previous frame		**6** Kalman predicted position	

■ **FIGURE 6.2 Different image regions selected in one iteration of the HKCS.**

history. The predicted position is considered as well as a new candidate region in the population. The image regions in the population are ranked based on their similarity to the target patch, and the coordinates (x_b, y_b) of the best region are handed out to the Lévy-based substitution process.

In the Lévy-based substitution process, two random numbers are generated following the Lévy distribution. These numbers represent the step size separating the best element in the population and new Lévy candidate's position in X and Y directions. In this version, they are multiplied by the previously defined $A = 1/G$. Once generated, the Lévy candidate is compared to a randomly chosen region from the population in terms of similarity with the target. If the Lévy candidate region is more similar to the target, it replaces the randomly chosen region in the population set. Otherwise, the Lévy candidate is abandoned and the previous population carries on to the discovery probability substitution phase.

In this phase, the population is sorted again based on its similarity to the target patch. A portion p_a of the population is replaced by randomly selected regions in the test image. The replaced portion is composed of the least similar regions to the target patch.

The population is sorted again, and the best element is evaluated against the stop criteria. These criteria are defined as:

- A maximum number of generations are reached.
- An important number of iterations is performed without a considerable improvement in the similarity measure.
- The similarity measure of the best so far obtained region is exceeding a certain threshold considered as a satisfying similarity measure.

Once the position refined and a stop criterion is met, the HKCS output coordinates are then handed out to the Kalman measurement step in order to incorporate the newly detected changes in the object direction, velocity, and pattern. The complete functioning diagram of the proposed algorithm is shown in Fig. 6.3.

3.3 Experimental results

In this section, we list some experimental results that highlight the efficiency and superiority of the HKCS in the mobile object tracking field. For a detailed and exhaustive experimentation study, the reader should refer to the original paper Ljouad et al. (2014a,b).

The algorithm was evaluated in different environments using videos taken from different publicly available databases: CAVIAR, SPEVI, the handsome

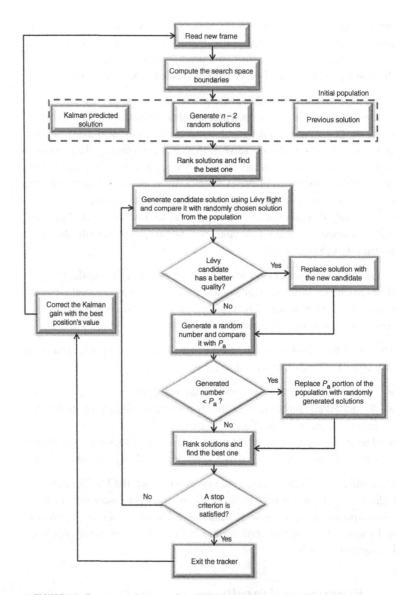

■ **FIGURE 6.3 Functional diagram of the HKCS approach.**

fellow as well as a personal database. Fig. 6.4 presents a sample of the obtained visual results.

Since a set of sample images is not enough to prove an algorithm's accuracy at tracking moving patches along their movement, we have used the Euclidean distance in order to compare the object location provided by the HKCS

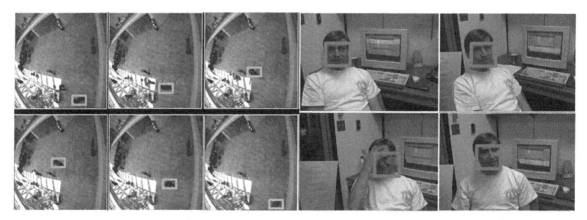

■ FIGURE 6.4 Visual results of the HKCS on the Walk3 and Dudek video sequences.

and the ground-truth data. We have run the algorithm on different videos, selected one target per video, and tracked it along its appearance. Table 6.1 lists the obtained results, which represents the mean value of 10 executions per video.

It is very hard to achieve a fair comparison between different tracking algorithms, since it is not possible to tune two algorithms the exact same way and thus give the same chances to both algorithms in different contexts. Therefore, we thought that comparing the HKCS to another metaheuristic-based tracker would be fair enough validation study. We selected one of the most successful metaheuristic-based trackers according to the literature, introduced by Zheng and Meng (2008). When run over the motinas_toni. avi test video where the target's pattern drastically and suddenly changes its movement, and using a population of 20 particles in all trackers (PSO-based tracker, CS-based tracker and the HKCS tracker), average position errors (APE) were obtained as shown in Fig. 6.5. The APE represents the Euclidean distance between the computed coordinates by the HKCS and the actual coordinates of the object along its appearance and frame by frame.

Table 6.1 Summary of the HKCS Performances Over Different Benchmarking Videos

Video	Dataset	Total Number of Frames	Frame Size	Threshold	Missing Rate (%)	Running Time (s)
Walk Regular	Personal dataset	191 (11 used)	352 × 288	10	0.8849	3.8721
Walk And Run	Personal dataset	214 (128 used)	352 × 288	10	1	4.6153
Walk1	CAVIAR	609 (160 used)	288 × 384	15	5	5.8833
Walk By Shop 1 front	CAVIAR	2359 (280 used)	288 × 384	40	10	11.9645
Dudek	Ross et al.	1145	720 × 480	40	31.6157	104.2755

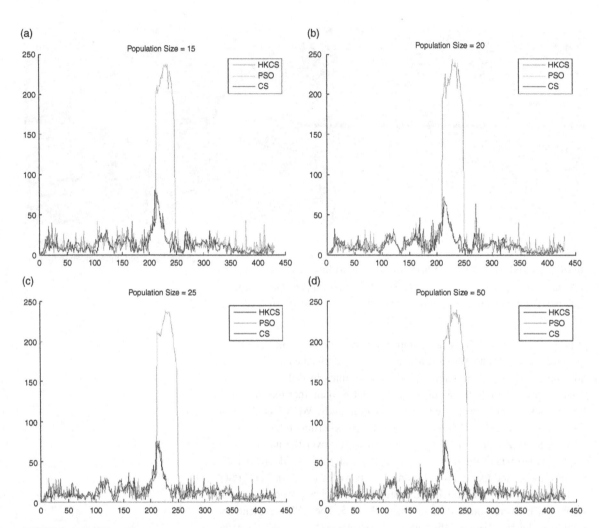

■ FIGURE 6.5 Euclidean distance between the Ground Truth data and the computed coordinates using PSO, CS, and HKCS Population size used is: (a) 15, (b) 20, (c) 25, and (d) 50.

As can be seen, the HKCS as well as the CS-based trackers both outperform the PSO-based tracker in the video sequence where the AO drastically changes both its displacement direction as well as its appearance (the AO turns over and his face is no longer visible for almost 50 frames). It is also worth mentioning that, as shown in Table 6.2, the HKCS and the CS provide more accurate results than the PSO in a significantly reduced time; in fact, the HKCS can be only one-third of the PSO computation time. It is important to note that even though the HKCS and the CS provide similar results in terms of the accuracy and precision of the computed trajectory, the HKCS is slightly faster than the CS, due to the use of the Kalman filter in the initial population. In many frames of the test video, the mobile person moves in

Table 6.2 Evaluation of the Population Size's Impact on Algorithm Performance

Population Size	Criteria	HKCS	CS	PSO
15	APE	14.2910	15.2780	36.1490
	SR	96.7442%	96.5116%	86.7442%
	MRT	76.8545	s 80.0124	s 198.3425 s
20	APE	14.5252	14.4359	36.3007
	SR	95.5814%	95.8140 %	89.0698%
	MRT	78.6484 s	103.3091 s	244.2376 s
25	APE	14.1598	14.3882	34.0783
	SR	97.8140%	95.4419%	89.0698%
	MRT	70.7028 s	110.4012 s	315.0317 s
50	APE	13.4153	13.2903	32.3574
	SR	96.5116%	96.7442%	89.7674%
	MRT	134.7517 s	145.9145 s	609.1694 s

a uniform direction; therefore, the provided output from the Kalman filter already contains a good solution. Additional iterations are then performed in order to refine the already acceptable solution. The CS, on the other hand, completely relies on the random mechanism and therefore needs more iterations to achieve the same performances as the HKCS, which explains the difference in the execution time. On the other hand, for the PSO-based tracker to achieve the same precision performances as the HKCS and CS, the algorithm needs to be running with a minimum of 100 particles while the others only use 20, which significantly impacts the computation time.

4 CUCKOO SEARCH–BASED REIDENTIFICATION

Reidentification is a new emerging research topic in computer vision research field, which focuses on focuses on the task of person's identity recognition. This task is becoming critical for many daily applications, such as video surveillance systems over camera networks with nonoverlapping fields of view, individual behavior analysis within a crowded environment, and so on. The main idea is that, given an unknown observed profile in a camera, the algorithm should be able to rank all existing individuals in the gallery in terms of their similarity to the query to be reidentified.

The literature on person reidentification has been approached from two different angles: human appearance modeling to create a discriminative invariant and metric learning for accurate descriptor matching (Lisanti et al., 2015). Human appearance modeling techniques aim at providing the most discriminative descriptor by extracting invariant low-level and

semantic features, building connections between the features in order to compensate for the loss of information due to image acquisition, such as the illumination variation, pose changes, and camera perspective. Metric learning methods, on the other hand, are classifier-based methods that require labeled training data and are most suitable for large datasets.

Another classification can be considered in the reidentification research field, which is based on the adopted reidentification scenario or modality. Three major classes can be highlighted in this context:

1. *Single versus Single (SvsS).* For each profile to be identified, there is only one corresponding image in the training set.
2. *Multi versus Single (MvsS).* A group of profiles are available for each person to be recognized.
3. *Multi versus Multi (MvsM).* Both the gallery and the query are composed of group of profiles for each person.

In this section, we introduce a reidentification approach that handles both aspects of the reidentification challenges and evolves from SvsS scenario to the MvsS as we introduced a self-training mechanism. We first detail the adopted parametric representation for each query to be identified and then present the CS-based reidentification strategy. The obtained experimental results highlight the algorithm's efficiency in a multiple object tracking framework.

4.1 Proposed parametric representation

Inspired by the work presented by Zhang et al. (2013), we aimed at a parametric representation that would cover more than one low-level feature, in order to create a discriminative descriptor in different complex environments. Using a single characteristic, such as the color representation, would provide a very fast descriptor but would present a major drawback when applied to the grayscale environment and contexts with major illumination changes. Using an exhaustive combination of features would result in very large vectors, requiring long computation times. As in Prosser et al. (2010), we combined the color and texture representation of the query object and replaced the time-consuming feature by lightweight ones that serve the same purpose. For example, instead of using the Gabor filter to represent the texture, we used the LBP signature that provides the same information in a much-reduced computation time. In conclusion, the adopted parametric representation was as presented in Fig. 6.6.

For each profile, we compute the the color histogram in the RGB color space. We follow by computing the histogram of both H and S components in the HSV color space. The texture component is then represented

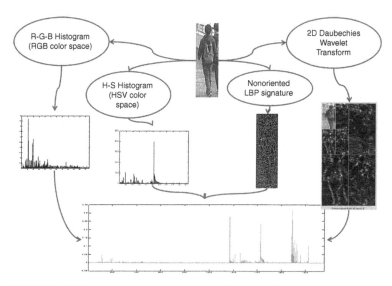

■ **FIGURE 6.6** Adopted parametric representation for reidentification purposes.

by the LBP signature as well as the two-dimensional Daubechies wavelet transom. All components are then concatenated after normalization to form the descriptive vector of the query image.

4.2 **MCS-driven reidentification strategy**

The typical reidentification diagram, when applied to mobile object tracking in a video sequence, starts by detecting moving pedestrians in a frame, then follows up with an identity matching process. Nevertheless, all reidentification approaches skip the detection phase and start from the reidentification task, assuming a perfect prior detection (Li et al., 2014; Gong et al., 2014). In our case, and since we are aiming for a reidentification within a video sequence, the first image serves as an initialization phase. The initialization process is described in Fig. 6.7.

This step is the equivalent of the training phase when the reidentification is performed by means of a classifier. Based on the data in the ground truth file, moving objects location is extracted and bounding boxes are drawn around the objects. Data are then collected from within the drawn bounding boxes to create the objects descriptors. These descriptors are then stored in a matrix called the descriptors database. Each descriptor is then assigned a new identifier (ID) that would be returned after reidentification using the MCS algorithm. By the end of the first frame, data in the descriptors database are sorted based on the assigned ID, and each ID is associated to a randomly generated RGB color that should serve for visualization purposes.

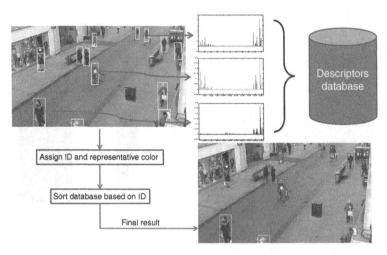

Assign ID and representative color

Sort database based on ID

Final result

■ **FIGURE 6.7 Initialization of different profiles to be reidentified.**

Starting from the second frame, we collect object locations from the ground truth data and compute the query descriptor. Each object is then fed to the reidentification algorithm. At each query, following operations are performed:

An initial population is formed by n descriptors taken from the descriptors database. As per the proximity concept, we assumed that it is more likely to find the same profiles in frame i as in frame $i - 1$. Therefore, we used the number of moving objects in the previous frame as a size for the initial population and initialized it using the identified profiles in the previous frame. The idea behind this method is that there is a high probability of matching the query profile with one of the profiles in the previous frame; otherwise it is either a new appearance or a reappearance of a previous profile. Most of the queries are identified in the first iteration, and the next iterations are used to refine the resemblance to the query.

The similarity is then computed, and the population is ranked based on that similarity. In our case, we used the Euclidean distance to compare descriptors. The best descriptor obtained so far is located in the descriptors database, and from its position, a Lévy flight is performed in order to select a new Lévy candidate. The similarity of this Lévy candidate with the query is compared with the similarity of a randomly chosen descriptor in the initial population with the query as well. If the Lévy flight is more similar to the query than the randomly selected one, the latter is replaced in the population by the newly generated Lévy candidate.

The initial population is then ranked again based on the similarity with the query, and a portion P_a of the worst descriptors are replaced by randomly

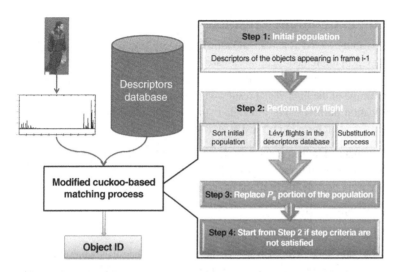

■ FIGURE 6.8 Sequential diagram of the MCS-driven reidentification approach.

selected descriptors from the descriptors database. The population is ranked again, and the best element is handed out to the next generation.

The process is repeated iteratively until one of the stop criteria is met. In that our case, stop criteria are a maximum of generations is performed, a satisfying similarity to the query has been met, or the best element has not been updated after an important number of generations. This process is summarized in Fig. 6.8.

With convergence assumed, the ID of the last best obtained descriptor is returned. If the similarity value is higher than a maximal threshold, the similarity is obvious. If it is less than a minimal threshold, the matching returned by the MCS reidentification is erroneous. Between the two thresholds, we consider that the similarity is doubtful. In order to validate the returned matching in ambiguous cases, we run a normalized cross-correlation–based matching to validate or reject the matching. Successfully matched profiles as well as validated ones are assigned the same ID as the one returned by the MCS-driven reidentification. Rejected and mismatched are assumed to be new appearances and are therefore assigned new IDs. By the end of the reidentification, the query descriptor is then added the descriptors database along with its assigned ID. The descriptors database is then sorted based on the IDs. This sorting regroups different profiles related to one same ID. Therefore, when using the Lévy flights, the intensification characteristic of the CS allows a better refinement of a previously established correspondence between the query and a descriptor from the population.

4.3 **Experimental results**

This study served as a first validation of a theory aiming at the integration of the CS in the reidentification research field. The results in this section represent a condensed conclusion of the obtained results. Figure 6.9 presents a sample of the final visual results when using the CS algorithm for reidentification purposes. For a detailed study of the algorithm's performances, readers are referred to Ljouad et al. (2014a).

As explained in the previous section, the major assertion of the CS is the reduced number of parameters to be tuned. These are the population size and the discovery probability. In all the next experiments, these values were adopted:

- Population size: 25
- Discovery probability: 0.25

Those values were proven to provide the best results while at the same time avoiding many extra useless comparisons. For an extensive evaluation of the parameter's impact on the algorithm's performance, kindly refer to Ljouad et al. (2014a).

In fact, a major drawback of the presented algorithm remains its memory consumption. In fact, storing a mean of 16-long descriptors per frame is a very memory-consuming approach. This prevents this method from being used in long video sequences, especially in crowded scenarios. And since many descriptors are stored in the descriptors matrix, browsing to select a new random element or locating the best descriptors obtained so far becomes a hard task to achieve as the algorithm advances in the processing. This is in fact reflected on the execution time, which grows constantly along the algorithm's execution, as can be seen in Fig.10.

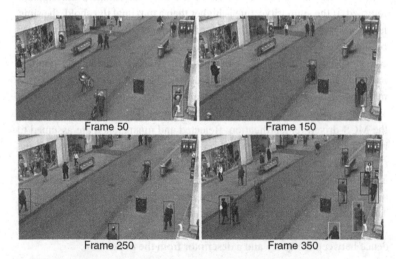

■ FIGURE 6.9 Visual results of the MCS-driven reidentification approach.

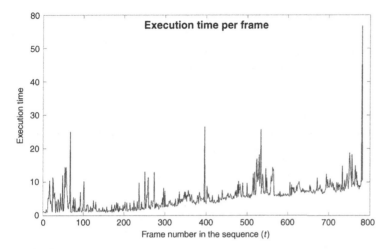

■ **FIGURE 6.10** Time consumption evolution during the algorithm's execution due to high memory usage.

5 CONCLUSIONS

This chapter presents some samples on how it is possible to build a bridge between the world of metaheuristics and the image and video processing. It especially deals with the issue of mobile object tracking from the computation cost perspective and presents a way on how to explore the advantage of the advanced optimization algorithms to reduce that factor, thus allowing the use of heavy algorithm within a real-time constrained environment.

Two different example approaches were detailed to show how to project a population-based metaheuristic, namely the CS algorithm, into the tracking problem by considering the adopted parametric representation as a candidate solution to eventually represent the sought object. The correspondence between different query and reference profile is driven by the modified CS to move from one solution to another, making use of the intensification and diversification powers provided by this metaheuristic. The experimental results have proven the robustness of both algorithms. When run against currently challenging databases, the tracking method was able to provide near-real-time performances. Nevertheless, one cannot firmly assert the real-time performance in all circumstances, due to the constant improvements in camera sensors, the constantly growing FPS, as well as the additional computational burden rising from pre- and postprocessing mechanisms.

Even though the obtained results seem to be convincing enough, there is still room for improvement: we are currently considering the use of other variants of the modified CS algorithm in order to improve the quality of the refinement mechanism. Also, many papers questioned the possibility of

strengthening the Lévy flight exploration by a simple exploration method, such as the simulated annealing or the genetic algorithms. Once this question is locked, we can investigate how to integrate this algorithm into a multiple-shot reidentification system in camera networks.

REFERENCES

Abbass. H., 2001. A monogenous MBO approach to satisfiability. In: International Conference on Computational Intelligence for Modelling, Control and Automation, Australia and IEEE ACT Section.

Abbass, H., 2001b. MBO: marriage in honey bees optimization a haplometrosis polygynous swarming approach. IEEE Congr. Evol. Comput. 1, 207–214.

Breitenstein, M.D., Reichlin, F., Leibe, B., Koller-Meier, E., Van Gool, L.J., 2009. Robust tracking by detection using a detector confidence particle filter. In: ICCV'09, pp. 1515–1522.

Cai, Y., 2009. Artificial fish school algorithm applied in a combinatorial optimization problem. Int. J. Intell. Syst. Appl. 1, 37–43.

Cuevas, E., Sención, F., Zaldivar, D., Pérez-Cisneros, M., Sossa, H.A., 2012. Multithreshold segmentation approach based on artificial bee colony optimization. Appl. Intell. 37 (3), 321–336.

Del Moral, P., 1996. Non linear filtering: interacting particle solution. Markov Process. Relat. 2 (4), 555–580.

Dorigo, M., Stutzle, T., 2004. Ant Colony Optimization. MIT Press, Cambridge, MA.

Evans, H., Zhang, M., 2008. Particle swarm optimization for object classification. In: Proceedings of 23rd International Conference on Image and Vision Computing, pp. 1–6.

Gao, M.L., Li, L.L., Sun, X.M., Luo, D.S., 2015. Firefly algorithm (FA) based particle filter method for visual tracking. Optik 126, 1705–1711.

Gong, S., Cristani, M., Yan, S., Loy, C.C., 2014. Person Re-Identificationvol. 1Springer, London.

Havens, T.C., Spain, C.J., Salmon, N.G., Keller, J.M., 2008. Roach infestation optimization. In: IEEE Swarm Intelligence Symposium, pp. 1–7.

Holldobler, B., Wilson, E.O., 1990. The Ants. Harvard University Press, Cambridge, MA.

Isard, M., Blake, A., 2006. Condensation—conditional density propagation for visual tracking. Int. J. Comput. Vision 29, 5–28.

Kennedy, J., Eberhart, R., 2001. Swarm Intelligence. Morgan Kaufmann, San Francisco, CA.

Keyrouz, F., 2012. A fast-multiplying PSO algorithm for real-time multiple object tracking. Int. J. Comput. Appl. 60 (3), 0975–8887.

Kwolek, B., 2013. Multi-object tracking using particle swarm optimization on target interactions. Advances in Heuristic Signal Processing and Applications. Springer, Berlin, Heidelberg, 63–78.

Lai, D.-X., Chang, Y.-H., Zhong, Z.-H., 2009. Active contour tracking of moving objects using edge flows and ant colony optimization in video sequences. In: Advances in Image and Video Technology, Third Pacific Rim Symposium, PSIVT 2009.

Lisanti, G., Masi, I., Bagdanov, A., Del Bimbo, A., 2015. Person re-identification by it-erative re-weighted sparse ranking. IEEE Trans. Pattern. Anal. Mach. Intell. 37 (8), 1629–1642.

Li, W., Zhao, R., Xiao, T., Wang, X., 2014. Deepreid: deep filter pairing neural network for person re-identification. In: 2014 IEEE Conference on Computer Vision and Pattern Recognition (CVPR), pp. 152–159.

Ljouad, T., Al-Hamadi, A., Amine, A., Rziza, M., 2014a. Projection of the modified cuckoo search metaheuristic into the multiple pedestrian tracking problem. In: International Conference on Metaheuristics and Nature Inspired Computing.

Ljouad, T., Amine, A., Rziza, M., 2014b. A hybrid mobile object tracker based on the modified cuckoo search algorithm and the Kalman filter. Pattern Recogn. 47 (11), 3597–3613.

Okuma, K., Taleghani, A., De Freitas, N., Little, J.J., Lowe, D.G., 2004. A boosted particle filter: Multitarget detection and tracking. In: ECCV, pp. 28–39.

Pham, D.T., Kog, E., Ghanbarzadeh, A., Otri, S., Rahim, S., Zaidi, M., 2006. The bees algorithm–a novel tool for complex optimization problems. In: Proceedings of the Second International Virtual Conference on Intelligent Production Machines and Systems, Elsevier, Oxford.

Prosser, B., Zheng, W.S., Gong, S., Xiang, T., Mary, Q., 2010. Person re-identification by support vector ranking. BMVC. 2 (5), 6.

Pylyshyn, Z.W., Storm, R.W., 1988. Tracking multiple independent targets: evidence for a parallel tracking mechanism. Spat. Vis. 3 (3), 179–197.

Rashedi, E., Nezamabadi-Pour, H., Saryazdi, S., 2009. GSA: a gravitational search algorithm. Inform. Sci. 179 (13), 2232–2248.

Teodorovic, D., Dell'Orco, M., 2005. Bee colony optimization—a cooperative learning approach to complex transportation problems. In: Proceedings of the 10th EWGT Meeting and 16th Mini-EURO Conference.

Viswanathan, G.M., 2010. Ecology: fish in Lévy-flight foraging. Nature 465 (7301), 1018–1019.

Von Frisch, K., 1976. Bees: Their Vision, Chemical Senses and Language, revised ed. Cornell University Press, Ithaca, NY.

Walton, S., Hassan, O., Morgan, K., Brown, M.R., 2011. Modified cuckoo search: a new gradient-free optimisation algorithm. Chaos Soliton. Fract. 44 (9), 710–718.

Wang, H., Ren, M., Yang, J., 2008. Object tracking based on genetic algorithm and Kalman filter. In: 9th International Conference on Computational Intelligence and Security, pp. 80–85.

Yang, X.S., 2008. Firefly algorithm. Nature-Inspired Metaheuristic Algorithms. Luniver Press, Bristol, UK.

Yang, X.S., 2009. Firefly algorithm, Lévy flights and global optimization. Research and Development in Intelligent Systems XXVI. Springer, London, UK, 209–218.

Yang, X.S., 2010. A new metaheuristic bat-inspired algorithm. Nature Inspired Cooperative Strategies for Optimization. Studies in Computational Intelligence. Springer, Berlin, Germany, vol. 284, pp. 65–74.

Yang, X.-S., Deb, S., 2009. Cuckoo search via Lévy flights. In: World Congress on Nature & Biologically Inspired Computing (NaBIC 2009). IEEE Publications, USA, pp. 210–214.

Yang, H., Shao, L., Zheng, F., Wang, L., Song, Z., 2011. Recent advances and trends in visual tracking: a review. Neurocomputing 74 (18), 3823–3831.

Yilmaz, A., Javed, O., Shah, M., 2006. Object tracking: a survey. ACM Comput. Surv. 38 (4), 13.

Zhan, B., Monekosso, D.N., Remagnino, P., Velastin, S.A., Xu, L.Q., 2008. Crowd analysis: a survey. Mach. Vis. Appl. 19 (5–6), 345–357.

Zhang, Y., Agarwal, P., Bhatnagar, V., Balochian, S., Yan, J., 2013. Swarm intelligence and its applications. Sci. World J. 2013, 528069.

Zhao, X., Lee, M.E., Kim, S.H., 2008. Improved image thresholding using ant colony optimization algorithm. In: Proceedings of International Conference on Advanced Language Processing and Web Information Technology, pp. 201–215.

Zheng, Y., Meng, Y., 2008. Object detection and tracking using Bayes-constrained particle swarm optimization. Computer Vision Research Progress. Nova Science Publishers, New York, pp. 245–260.

Toward optimal watermarking of grayscale images using the multiple scaling factor–based cuckoo search technique

A. Mishra*, C. Agarwal**

*Department of Electronics, Deendayal Upadhyay College, University of Delhi, Delhi, India; **Department of Computer Science, University of Delhi, Delhi, India

CHAPTER OUTLINE

Bio-Inspired Computation and Applications in Image Processing. http://dx.doi.org/10.1016/B978-0-12-804536-7.00007-7

1 INTRODUCTION

Owing to the fast development of the Internet, the duplication, modification, and transformation of digital media have become effortless. Consequently, this has given rise to mandatory requirement of a system which provides content authentication, copyright protection of data, and broadcast monitoring, especially in cases of image and video content. Watermarking of digital content has shown great potential to fulfill this requirement. In this technique, a suitable watermark is inserted at a suitable location within the digital content, both perceptibly and imperceptibly. Perceptible and imperceptible embedding is, however, based on the type of application. The embedding of a watermark may also be categorized as fragile, semifragile, and robust. Usually perceptible watermark embedding leads to fragile watermarking applications (Alexander et al., 2005; Barni et al., 2001; Cox et al., 1997; Meerwald and Uhl, 2001). The semifragile and robust applications are designed using imperceptible watermark embedding (Cox et al., 1997). The embedded watermarks are first detected and then extracted at a later stage in accordance with application requirements. Several similarity indices are applicable to compare the extracted watermarks with the embedded ones. The extraction process is further subdivided into two primary categories, blind and nonblind. It is equally important to understand that both blind and nonblind detection/extraction of the watermark may be based on the use of either soft-decision or threshold-based hard-decision detectors (Briassouli and Strintzis, 2004; Cox et al., 1997; Hernandez et al., 2000).

1.1 Earlier research work

Many watermarking techniques have been successfully developed in the transform domain. These include the use of discrete cosine transforms (DCT), singular value decomposition (SVD), and discrete wavelet transforms (DWT) (Briassouli and Strintzis, 2004; Hernandez et al., 2000; Jain et al., 2008; Liu and Liu, 2008; Liu and Chen, 2001; Liu and Tan, 2002). Frequency domain analysis is used to identify possible suitable locations to embed watermarks within the host signal. This is done with an aim to ensure strong integration of watermarks with image coefficients to enhance robustness of the embedding algorithm. As human eyes are more sensitive to low- and midfrequency band coefficients, the transform domain techniques work optimally if the watermarks are embedded within the low-frequency image coefficients (Cox et al., 1997; Nikolaidis and Pitas, 1998). Among the transform domain methods, DWT is found to be more suitable for achieving robust watermarking and also leads to good visual quality of the signed

images. However, both these transforms, DCT and DWT, only classify/ segregate visual image coefficients in the transform domain and hardly analyze the structural properties of the image in question.

On the other hand, in the case of SVD, singular vectors clearly provide structural information regarding the image. Modifications in the singular vectors lead to those in singular values which represent the image luminance. Several researchers have reported watermark embedding using the SVD transform (Chandra, 2002; Ghazy et al., 2007; Liu and Tan, 2002). Liu and Liu (2008) introduced the SVD-based watermarking algorithm. In this algorithm, they compute singular values of the host image and then modify them by adding the watermark. They again apply the SVD transform on the resultant matrix to find the modified singular values. These singular values are combined with the watermark to get the watermarked image. For watermark extraction, an inverse process is used. Chandra (2002) describes a method by embedding singular values of the watermark to the singular values of the entire image. First, singular values of the host image and watermark are computed, and then the singular values of the watermark are magnified and added to those of the host image. In addition to this, the use of hybrid variants of DCT, DWT, and SVD has also been widely reported in the literature (Bhatnagar and Raman, 2009; Ganic and Eskicioglu, 2004; Huang and Guan, 2004; Li et al., 2007). This is mainly intended to eliminate the possible shortcomings present in any singular transform method. Li et al. (2007) proposed a hybrid DWT–SVD domain watermarking scheme considering human visual system properties. They decompose the host image into four subbands, apply SVD to each subband, and embed singular values of the watermark into these subbands. In this experimental work, we use the hybrid DWT–SVD transform to carry out binary watermark embedding into grayscale host images.

The SVD transform has also been used for image watermarking by using a single value of the embedding strength, or single scaling factor (SSF), which assumes its constant or fixed numerical value for all parts of the host image. In this case, the local intensity and contrast distribution of the host image is not taken into account. It has been observed that this can lead to some undesirable visible artifacts in the watermarked image (Cox et al., 1997; Li et al., 2007; Liu and Chen, 2001). The deformities are noticed mainly in the smoother regions of the image because these are more sensitive to noise. It is proposed that to reduce these artifacts, the scaling factor be decreased in the plain regions of the image, which in turn may hamper the robustness of the embedding process. In other regions, if the scaling factor is increased beyond a certain limit, this may lead to visible distortions within the signed image. In view of this, the selection of the scaling factor has become a very

important issue while ensuring the second requirement of minimizing the trade-off between imperceptibility and robustness. Cox et al. (1997) have also argued that an SSF may not be applicable for perturbing all the coefficients of cover images as different spectral components may exhibit more or less tolerance to modification. Instead, they suggest use of multiple scaling factors (MSFs) or multiple values of scaling factors to be applied over the entire image. However, the main problem is to identify optimal values of the MSFs to obtain the best results. Thus, it is clear that, image watermarking at present has acquired multidimensional status in the multimedia research paradigm.

Over the last two decades, several watermarking schemes working in the transform domain have been developed. To optimize the two critical requirements of visual quality and robustness, various soft computing techniques, such as artificial neural networks (ANNs) of different architectures, fuzzy inference systems (FIS), support vector machines (SVMs), and also nearly all metaheuristic techniques such as genetic algorithms (GAs), particle swarm optimization (PSO), ant colony optimization (ACO), firefly algorithm (FA), and so on, have been successfully implemented (Fındık et al., 2010; Horng and Jiang, 2010; Huang et al., 2010; Ishtiaq et al., 2010; Kumsawat et al., 2005; Lai, 2011; Loukhaoukha, 2013; Loukhaoukha et al., 2011; Ali et al., 2014; Makbol and Khoo, 2012; Mishra and Goel, 2014; Motwani and Harris, 2009; Run et al., 2012; Senthilnath et al., 2011; Shieh et al., 2004; Shih and Wu, 2005; Tsai et al., 2012; Wang et al., 2011; Zhang and Wu, 2012). All these techniques intend to work on two primary aspects: first, to identify suitable locations to carry out the embedding process and to ascertain robust watermark embedding which makes it impossible for the copyright violator to remove the watermark from the signed content and thus claim a copyright over it. The second aspect is to minimize the trade-off between the twin mandatory objectives of watermarking as a precursor to optimal watermarking: imperceptibility of the embedded watermark, thus leading to good visual quality of the signed and attacked images, and robustness of the embedding scheme. Precisely due to this reason, image watermarking has acquired the status of an optimization problem. It is important to note that the second objective is to be achieved without compromising on the first. As watermarking techniques are also applicable to both compressed and uncompressed video sequences, any efficient technique is also expected to complete its task in real time. Recently, Mishra and Goel (2014) have reported the integration of fuzzy-ELM architecture for image watermarking. They make use of Mamdani-type FIS to develop a novel HVS-based watermarking technique capable of creating

signed frames (images) in real time. The training time of their SLFN is in milliseconds, and embedding and extraction is completed in seconds for an individual image. They further suggest that their technique is also suitable for video watermarking. However, they use SSF in their watermarking scheme.

As mentioned earlier, metaheuristic techniques such as PSO, the GA, bacterial foraging, and the FA have been extensively used for image watermarking. Among these, most are traditionally used to identify suitable image coefficients in the transform domain to embed the watermarks. Lately it has been observed that the problem of finding the optimal values of MSFs can also be solved by combining these techniques with the transform-based techniques. Lai (2011) has used the tiny genetic algorithm (tiny-GA) with SVD to find values of MSFs. However, Loukhaoukha (2013) point out that the algorithm proposed by Lai causes false positive detection, even if the embedded watermark is different or nonexistent. Ishtiaq et al. (2010) have applied PSO technique to find the MSFs in the DCT domain. They use PSNR as the objective function to evaluate each particle. The major drawback of this algorithm is that it focuses only on the visual quality of the watermarked image without taking into account robustness. Loukhaoukha et al. (2011) have utilized multiobjective ant colony optimization (MOACO) in the LWT–SVD domain to find the values of MSFs. Their objective function is an exponential weighted formulation given by Eq. (7.1).

$$F_{obj}(X) = \sum_{i=1}^{T+2} (e^{p.w} - 1)e^{p(F(X)-F_0)} \tag{7.1}$$

where p, w, and F_0 are the positive constants, $F(X)$ is the vector of objective values, and T is the number of selected image processing operations. Loukhaoukha et al. claim that the proposed MOACO-based MSF watermarking scheme outperforms different SSF watermarking schemes in terms of imperceptibility and robustness. Dey et al. (2013) have implemented the ECG pattern watermarking by optimizing MSFs using the cuckoo search (CS) technique. They have proposed a new approach to design a robust biomedical content authentication system by embedding a hospital logo within the ECG pattern by using wavelet transform and CS. The adaptive CS is used to find optimal scaling factors for logo embedding. Their algorithm shows good embedding results. They have used a fitness function of the form given by Eq. (7.2).

$$FT = PSNR + \rho \tag{7.2}$$

where ρ is a constant given by $100 * C$. C is the correlation parameter between the embedded and the extracted watermarks. According to the authors, since the numerical value of C is within the range 0–1, it is magnified by 100 times. Thus, this fitness function formulation is found to work well.

Mishra et al. (2014) have developed a robust watermarking scheme by optimizing MSFs using the FA. They take into account both the visual quality (PSNR) and robustness [normalized correlation (NC)] to develop their objective function. This objective function is given by Eq. (7.3).

$$\text{Objective} = \text{PSNR} + \phi * [NC(W,W') + \sum_{i=1}^{T} NC(W,W'_i)] \qquad (7.3)$$

They argue that both PSNR and NC get affected due to the variation in the scaling factor δ, and, therefore, any objective function must take both these parameters into account. According to the authors, the FA using Eq. (7.3) is capable of optimizing the scaling factors in a better manner. They compare their results with other metaheuristic techniques and conclude that their results are better except in the case of sharpening and cropping attacks due to having optimized MSFs using the firefly technique.

In this chapter, we propose a DWT–SVD hybrid transform–based novel image watermarking scheme which optimizes MSF using the CS technique to produce the best results. We compare our results with those published by Ishtiaq et al. (2010), Loukhaoukha et al. (2011), Mishra et al. (2014), and Xianghong et al. (2004).

1.2 Motivation and research contribution

The survey of research work just presented makes two aspects of the watermarking problem very clear: (1) the use of the DWT–SVD hybrid transform results in better identification of locations to embed the watermark coefficients, and (2) currently, the use of metaheuristic techniques is mainly focused on optimizing MSFs to obtain better results as compared to those obtained using SSF. In other words, the use of the SSF for image watermarking is fast becoming the thing of the past.

Recently, a newly developed optimization method based on the metaheuristic technique known as CS was developed by Yang and Deb (2009). This technique is arguably better than its counterparts, such as GA, PSO, and a few other metaheuristic techniques. Many researchers have employed CS for different applications and found that it outperforms other metaheuristic techniques, especially PSO and GA. In their paper,

Yang and Deb (2009) present an extensive comparison study using some standard test functions and newly designed stochastic test functions. They further apply the CS algorithm to solve engineering design optimization problems, including the design of springs and welded beam structures. They conclude that the optimal solutions obtained by CS are far better than the best solutions obtained by an efficient particle swarm optimizer. Dhivya et al. (2011) applied this technique to aggregate the data in a wireless sensor network. In their paper, they used a modified CS technique to get enhanced network performance by including balanced energy dissipation, which results in the formation of an optimum number of clusters and consumes minimum energy. The feasibility of the CS-based algorithm is evaluated and compared with conventional cluster-based routing methods. Valian et al. (2011) employed an improved CS algorithm to efficiently train feed-forward neural networks. They apply this hybrid technique to solve two benchmark classification problems: a breast cancer dataset and an iris dataset. They argue that their improved CS algorithm outperforms the original CS algorithm when applied to the same datasets. Ashour et al. (2015) have applied the CS algorithm to the problem of computed tomography–assisted image enhancement. They applied a log transform–based approach to ensure superior disease diagnosis and detection of tumors and vascular lesions. They used the CS algorithm for parameter setting for the log transform. Their results clearly show that the CS-based approach has superior convergence and fitness values compared to PSO. They attribute this outcome to the fact that the CS converges faster, which proves the efficacy of this technique. They also conducted image quality analysis to justify robustness of their proposed enhancement technique.

As far as watermarking of original content is concerned, very few researchers have applied the CS technique. For example, Dey et al. (2013) applied the DWT-based CS algorithm to a very important problem of validating medical content in the form of electrocardiogram signals by embedding the binary logo of the hospital within the signals. They use the CS algorithm to optimize the scaling factor settings within the signals for logo embedding. Their results show that the proposed method can serve as a secure and accurate authentication system. In addition, Ali et al. (2014) implemented the image watermarking by optimizing the scaling factors using the CS technique. They argue that they have applied this technique without compromising image quality. They treat image watermarking as an optimization problem and use a grayscale cameraman image of size 256×256 as watermark. They decompose the grayscale images using DWT in low- and high-frequency bands whose coefficients are modified by embedding the watermarks multiplied by the scaling factors optimized by using the CS

technique. They also investigate the issue of robustness of their scheme by applying several image processing attacks to create distortion within the signed content. They use the fitness function of the form given in Eq. (7.4).

$$\text{Minimize } f = \frac{N}{\sum_{i=1}^{N} NC(W, W_i^*)} - NC(I, I_w) \tag{7.4}$$

where I and I_w denote the cover and watermarked images, respectively; NC represents the two-dimensional normalized correlation value; W and W^* are original and extracted watermark images, respectively; and N is the number of attacking methods. This formulation does not take into account the visual quality/imperceptibility of the signed images. The authors compare their results with those obtained using SSF and RDWT transform without applying any metaheuristic technique published by Makbol and Khoo (2012).

The current research work focuses on optimizing the trade-off between the twin parameters of image watermarking: imperceptibility/visual quality of the signed or attacked images and the issue of robustness. We propose a new image watermarking scheme based on the hybrid transform: DWT–SVD and identifying MSFs by using a novel evolutionary technique named CS. For this purpose, the objective function used by this algorithm is a linear combination of PSNR and normalized crosscorrelation (NC). The NC is a metric to determine the robustness. Therefore, we select eight different image processing attacks to distort the signed images. These attacks are: JPEG compression (QF = 95); salt and pepper noise (5%); Gaussian filtering (filter aperture = 3 × 3); sharpening (aperture = 0.2); histogram equalization (with 64 discrete gray levels); scaling (512→1024→512); grayscale quantization (1-bit); and cropping by dividing the image into 9 equal blocks and replacing the central block with zeros. After comparing the results obtained by using SSF and MSFs, we observe that the MSF-based watermarking scheme outperforms SSF-based watermarking in terms of imperceptibility and robustness. Note that our SSF-based watermarking technique does not use any metaheuristic technique for optimization of the scaling factor. It modifies the image coefficients in the transform domain by the use of selected scaling factor obtained through an experiment along with its analysis. A detailed analysis of this formulation is presented in Section 4.

The MSF-based results obtained by researchers using metaheuristic techniques other than CS are compared with our results in this chapter. Techniques include those used by Ishtiaq et al. (2010); Loukhaoukha et al. (2011); Mishra et al. (2014); and Xianghong et al. (2004). This comparative

analysis shows that the MSF-based proposed watermark embedding and extraction scheme using CS outperforms all other schemes for all image processing operations except sharpening and cropping. This is attributed to the better optimization of MSFs using the selected objective function (fitness function) using the CS algorithm in this chapter. The PSNR values indicate that the visual quality of the signed and attacked images is good. The embedding algorithm is robust against common image processing operations. In most of the cases, the *NC* value is 1.000, which is the maximum in the range and indicates perfect matching between original and extracted watermarks. Thus, the proposed scheme provides a scope to compute the optimal watermark strength by using CS in a scientific manner.

2 CUCKOO SEARCH ALGORITHM

The CS algorithm was first developed by Xin-She Yang and Suash Deb in 2009. This is a new metaheuristic-based optimization technique. It is based on brood parasitism of certain species of cuckoos and Lévy flights. Cuckoos make beautiful sounds and have an aggressive reproduction strategy in which they lay their eggs in communal nests, though they may remove others' eggs to increase the probability of their own eggs hatching. Quite a number of species engage the obligate brood parasitism by laying their eggs in the nests of other host birds (often other species).

In the CS algorithm, there are three idealized rules:

1. Each cuckoo lays one egg at a time and dumps it in a randomly chosen nest.
2. The best nests with high-quality eggs will be carried over to the next generations.
3. The number of available host nests is fixed, and the egg laid by a cuckoo is discovered by the host bird with a probability $p_a \in [0. 1]$. In this case, the host bird can either get rid of the egg or simply abandon the nest and build a completely new nest.

In this algorithm, each egg in a nest represents a solution, and a cuckoo egg represents a new solution. The aim of this algorithm is to use the new and potentially better solutions (cuckoos) to replace a not-so-good solution in the nests. For a maximization problem, the quality of a solution is proportional to the value of the objective function.

Yang and Deb (2009) used Lévy flight for generating new solutions $x^{(t+1)}$ for a cuckoo *i*. The formula for Lévy flight is given by Eq. (7.5):

$$x_i^{(t+1)} = x_i^t + \alpha \oplus L\acute{e}vy(\lambda) \tag{7.5}$$

where α ($\alpha > 0$) represents a step size. This step size is based on the scales of problem. Generally, α can be taken as 1. The previously mentioned expression is a stochastic equation for a random walk. It is a Markov chain, whose next location (status) depends on two parameters: current location [first term in Eq. (7.5)] and probability of transition (the second term in the same expression). The product \oplus represents entry-wise multiplications. Listing 7.1 gives the pseudocode for the CS.

Listing 7.1 Pseudocode for the CS

Input: Define objective function $f(x)$, $x = [x_1, x_{2, \ldots \ldots \ldots}, x_d]^T$

Generate initial population of n host nests $x_p(p = 1, 2, \ldots, n)$

Begin

while *(t < Maximum Generation) or (Stop criteria)*

Get a cuckoo randomly by Lévy flight

Evaluate its quality/objective F_i

Choose a nest among n (say, j) randomly

If $(F_i > F_j)$,

replace j by the new solution;

End

A fraction (p_a) of worse nests are abandoned and new ones are built;

Keep the best solutions (or nests with quality solutions);

Rank the solutions and find the current best

End while

Post process results and visualization

End

3 WATERMARKING SCHEME USING THE SINGLE SCALING FACTOR

To study the effect of the scaling factor on PSNR and the normalized cross-correlation $NC(W, W')$ parameter, the DWT–SVD-based watermarking algorithm is used. The signed images are examined for visual quality by PSNR given by Eq. (7.6). A watermark is extracted and the $NC(W, W')$

parameter where W and W' are original and recovered watermarks, respectively, is computed by Eq. (7.7).

$$PSNR = 10\log_{10}\left(\frac{I_{max}^2}{MSE}\right)$$ (7.6)

where I_{max} is the maximum possible pixel value of the image I and MSE is the mean square error.

$$NC(W,W') = \frac{\sum_{i=1}^{m}\sum_{j=1}^{n}[W(i,j).W'(i,j)]}{\sum_{i=1}^{m}\sum_{j=1}^{n}[W(i,j)]^2}$$ (7.7)

3.1 DWT–SVD-based watermark embedding algorithm

We consider the host image I of size $N \times N$ and the watermark W of size $m \times m$. The embedding algorithm is given in Listing 7.2.

Listing 7. 2 Embedding algorithm

Step 1. Apply four-level DWT using HAAR filter on the host image I to obtain LL4 subband of size $m \times m$.

Step 2. Apply SVD on LL4 subband coefficients of the host image obtained in Step 1 by using Eq. (7.8) and hence obtain S.

$$[U,S,V] = \text{SVD(LL4)}$$ (7.8)

Step 3. Apply SVD on the watermark (W) using Eq. (7.9) and identify the singular values (S_w).

$$[U_w,S_w,V_w] = \text{SVD}(W)$$ (7.9)

Step 4. Embed S_w into S values using the formula given by Eq. (7.10).

$$S' = S + \delta * S_w$$ (7.10)

where δ is the SSF, which controls the trade-off between imperceptibility and robustness of the proposed watermarking scheme.

Step 5. Compute the modified LL4 subband coefficients using Eq. (7.11):

$$LL4' = U * S' * V^T$$ (7.11)

Step 6. Apply inverse four-level IDWT to obtain the signed image I'.

3.2 **Watermark extraction algorithm**

The embedded watermarks are recovered from signed images. The extraction is carried out by applying DWT–SVD combined transform again to the signed images. The extracted watermark is denoted by W'. The watermark extraction algorithm is given in Listing 7.3.

Listing 7.3 Extraction algorithm

Step 1. Apply four-level DWT using HAAR filter on the host image I and signed image I' to obtain LL3 and LL3′ subband coefficients of size $m \times m$, respectively for the two images.

Step 2. Apply SVD on the LL4 and LL4′ subband coefficients using Eqs. (7.12) and (7.13) to obtain the singular values S and S', respectively.

$$[U,S,V] = \text{SVD}(\text{LL4}) \tag{7.12}$$

$$[U',S',V'] = \text{SVD}(\text{LL4}') \tag{7.13}$$

Step 3. Compute the singular values of the watermark using the formula given by Eq. (7.14):

$$S'_w = (S' - S)/\delta \tag{7.14}$$

Step 4. Recover the extracted watermark image using the formula given by Eq. (7.15):

$$W' = U_w * S'_w * S'_w * V_w^T \tag{7.15}$$

4 MINIMIZING TRADE-OFF BETWEEN VISUAL QUALITY AND ROBUSTNESS USING SINGLE SCALING FACTOR

Many researchers including Cox et al. (1997) have stressed the fact that an SSF may not be applicable for perturbing all the coefficients of the cover image in the transform domain. This is due to the fact that different spectral components may exhibit different tolerance to the induced modification. They advise the use of MSFs instead of an SSF to embed the watermark energy into the host image. They further state that the determination of MSFs might depend on the type and intensity of the image processing attack used. They argue that the use of MSFs is necessary to obtain better results, particularly for images exhibiting a large spatial variation of luminance values in the entire signal. As the low- and midfrequency band coefficients are more sensitive to the human visual system, any efficient image watermarking scheme should take into account these spatial variations in order

to optimize the scaling factor. A brief discussion on the use of MSFs for image watermarking has been done in Section 4.2. Next we examine the trade-off between the imperceptibility (PSNR) and robustness [$NC(W, W')$], first using SSF δ. The variations of $NC(W, W')$ versus δ and PSNR versus δ for Lena image are analyzed respectively in Section 4.1 and Section 4.2.

4.1 Effect of single scaling factor over *NC(W, W')* values for signed and attacked lena images

We first study the variation of $NC(W, W')$ with respect to an SSF (δ). In this case, no optimization technique is used to fix it. The plot of $NC(W, W')$ with respect to δ is given in Fig. 7.1. It is clear from Fig. 7.1 that $NC(W, W')$ values vary only in the range of δ = 0.005–0.1. Beyond δ = 0.1, the $NC(W, W')$ values get stabilized. This is specifically true for all attacks barring sharpening, histogram equalization, and cropping. For sharpening and histogram equalization attacks, the $NC(W, W')$ values with respect to δ are constant throughout. For a cropping attack, δ does not vary much, as in the case of the other attacks. Thus, we concluded that for the attacks we used in this simulation, δ = 0.005–0.1 is an appropriate range to determine MSFs, depending on the type and intensity of the attack. Mishra et al. (2014) have used a similar analysis for image watermarking using the FA. They report a smaller range of the scaling factor (δ = 0.005–0.06). They carry out their embedding and extraction using SSF on six different grayscale images of

■ **FIGURE 7.1** Plot of *NC(W, W')* with respect to scaling factor δ.

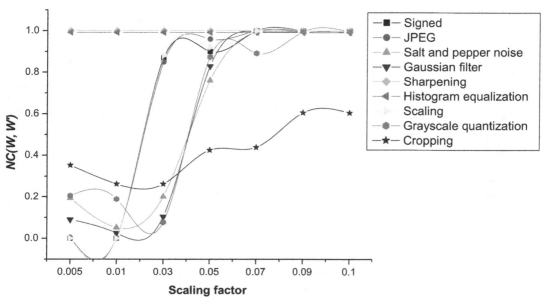

size 256×256, while using the same watermark as we use in this work. Usually the watermark embedding capacity is assumed constant because there is a large inequality between the sizes of the host and watermark signals. But, in the present case, as we use all grayscale host images of size 512×512, we obtain a bigger range of the scaling factor δ spread over a larger signal area having comparatively large luminance variations within it. We therefore use this range of δ for all our future practical computations. The analysis presented by Cox et al. (1997) corroborates our findings.

4.2 Effect of single scaling factor over PSNR for signed and attacked lena images

In this simulation, we plot PSNR with respect to δ to examine the effect of the scaling factor on the visual quality of the signed and attacked Lena image. This plot is depicted in Fig. 7.2. It is clear that PSNR and δ are inversely placed only for the signed image within the identified range of $\delta = 0.005$–0.1. Beyond $\delta = 0.1$, the PSNR is constant with respect to δ. For all attacked images without any exceptions, the PSNR is constant with respect to δ. This clearly implies that parameter PSNR contributes more toward the signed image only. On the other hand, the other parameter, which is indicative of the robustness of the embedding algorithm, $NC(W, W')$, is found to be a dominating factor both for watermark embedding and image processing attacks applied over the signed image. Thus, any objective function used to optimize watermark embedding must take both PSNR

■ FIGURE 7.2 Plot of PSNR with respect to scaling factor δ.

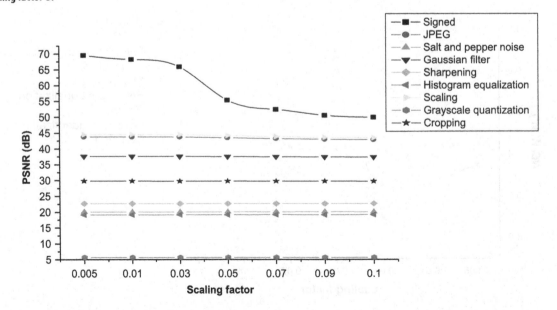

and $NC(W, W')$ into account. In this work, an objective function considering both PSNR and $NC(W, W')$ is used to optimize the value of MSFs (δ).

5 CUCKOO SEARCH–BASED WATERMARKING ALGORITHM TO OPTIMIZE SCALING FACTORS

In this chapter, we propose a novel DWT–SVD-based watermarking scheme which embeds a binary watermark in the image coefficients in the transform domain by making use of MSFs (δ), optimized by CS. The embedding and extraction algorithms of this scheme are presented in Listings 7.2 and 7.3, respectively. This watermarking scheme is given in Listing 7.4.

Listing 7.4 CS-based DWT–SVD watermarking scheme

Step 1. Initialize initial population of n host nests randomly, where each nest is a row vector of size $m \times m$ (equal to the size of the watermark).

Step 2. For each nest k:

1. Execute the watermark embedding algorithm given in Listing 7.2, by using Eq. (7.16) instead of Eq. (7.10).

$$S' = S + \delta * S_{\mathrm{w}} \qquad (7.16)$$

 where δ is the MSF optimized by using the CS algorithm.
2. Apply T different image processing attacks on the signed image I' one by one. This generates T different attacked watermarked images for the signed image I'.
3. Extract the watermarks from the attacked signed images using the algorithm given in Listing 7.3.
4. Compute the PSNR between the original image I and signed image I' and $NC(W, W')$ values for the attacked images.
5. Calculate the objective value of the nest using the objective function given by Eq. (7.17).

$$\text{Objective} = \text{PSNR} + \phi * [NC(W, W') + \sum_{i=1}^{t} NC(W, W_i')] \qquad (7.17)$$

where $NC(W, W')$ is the normalized crosscorrelation between the original watermark and extracted the watermark from signed image, $NC(W, W_i')$ is the normalized crosscorrelation between the original watermark and extracted watermarks from each attacked signed image, and ϕ is the weighting factor for NC values.

Step 3. Based on the objective value of each nest, get the current best nest. Evolve these nests according to the procedure given in Listing 7.1.

Step 4. Repeat Steps 2 and 3 until the maximum number of generations (ML) is reached.

In Eq. (7.17), the PSNR is much larger compared to the associated NC values; therefore, a weighting factor ϕ is used to balance out the influences caused by the two parameters (Dey et al., 2013).

6 EXPERIMENTAL RESULTS AND DISCUSSION

The performance of the proposed algorithm is evaluated on five different 512×512 grayscale host images: Baboon, Boat, Cameraman, Lena, and Pepper. A 32×32 binary image is used as a watermark. All our experiments are carried out by using $n = 15$ nests, $\alpha = 1$, and $p_a = 0.5$ (Horng and Jiang, 2010; Yang and Deb, 2009). The simulation is done for ML = 10 iterations. To compute the objective function, eight image processing operations are executed as attacks ($T = 8$). These attacks are described in Section 1. Fig. 7.3 depicts the host images and the binary watermark. Fig. 7.4 depicts the signed images obtained from the simulation of CS-based watermarking scheme, and Fig. 7.5 shows their corresponding extracted watermarks.

As mentioned in Section 5, our objective function takes into account both visual quality and robustness of the embedding scheme. According to Eq. (7.17), it is a linear combination of PSNR and $NC(W, W')$ obtained both from signed and attacked images. This is computed by implementing eight different image processing attacks. The CS algorithm uses this objective function to optimize the MSF used for watermark embedding. We expect enhancement in robustness of the embedding scheme as compared to that using an SSF due to better optimization of this parameter using CS. Mishra et al. (2014) reported a similar optimized behavior of the MSF using the FA. Table 7.1 compiles our results as well as those of several other researchers (Ishtiaq et al., 2010; Loukhaoukha et al., 2011; Mishra et al., 2014; Xianghong et al., 2004) based on SSF as well as MSF for signed images only. We analyze and compare these results on the basis of optimized MSF using CS.

Next we summarize the observations in Table 7.1.

1. In our SSF-based watermarking scheme, the average PSNR ranges between 50 and 53 (dB) for the selected five images, which indicates good visual quality of the signed images.
2. It is clear that our SSF-based PSNR results are better than those of other methods using SSF (Xianghong et al., 2004) for all host images and using MSF (Loukhaoukha et al., 2011) for all host images except Baboon and Boat. In addition, our SSF-based scheme outperforms the PSNR results of (Ishtiaq et al., 2010) for Baboon, Boat and Lena

■ **FIGURE 7.3 Original images.** (a) Baboon, (b) Boat, (c) Cameraman, (d) Lena, (e) Pepper, and (f) Watermark.

■ **FIGURE 7.4 Watermarked images.** (a) Baboon, (b) Boat, (c) Cameraman, (d) Lena, and (e) Pepper.

■ **FIGURE 7.5 Extracted watermarks.** (a) Baboon, Fig. 7.4a; (b) Boat, Fig. 7.4b; (c) Cameraman, Fig. 7.4c; (d) Lena, Fig. 7.4d; and (e) Pepper, Fig. 7.4e.

Table 7.1 PSNR and *NC* (*W*, *W'*) Values Between the Host and Signed Images of the Proposed and Other Researchers' Work

Image	Category/Algorithm	PSNR (dB)	NC(*W*, *W'*)
Baboon	SSF/Xianghong et al. (2004)	49.075	0.999
	SSF/our method	52.0533	1.000
	MSF/proposed method	*54.1514*	*1.000*
	MSF/Mishra et al. (2014)	50.76746	1.000
	MSF/Loukhaoukha et al. (2011)	52.379	1.000
	MSF/Ishtiaq et al. (2010)	44.9624	NA
Boat	SSF/Xianghong et al. (2004)	49.075	1.000
	SSF/our method	52.0743	0.991
	MSF/proposed method	*52.7807*	*1.000*
	MSF/Mishra et al. (2014)	51.49438	1.000
	MSF/Loukhaoukha et al. (2011)	54.810	1.000
	MSF/Ishtiaq et al. (2010)	50.1586	NA
Cameraman	SSF/Xianghong et al. (2004)	49.075	1.000
	SSF/our method	52.4147	0.995
	MSF/proposed method	*54.7313*	*1.000*
	MSF/Mishra et al. (2014)	53.65498	1.000
	MSF/Loukhaoukha et al. (2011)	48.902	1.000
	MSF/Ishtiaq et al. (2010)	NA	NA
Lena	SSF/Xianghong et al. (2004)	49.075	1.000
	SSF/our method	52.3904	0.995
	MSF/proposed method	*53.1956*	*1.000*
	MSF/Mishra et al. (2014)	55.7296	1.000
	MSF/Loukhaoukha et al. (2011)	47.718	1.000
	MSF/Ishtiaq et al. (2010)	48.105	NA
Peppers	SSF/Xianghong et al. (2004)	49.075	0.999
	SSF/our method	51.8689	1.000
	MSF/proposed method	*53.3627*	*1.000*
	MSF/Mishra et al. (2014)	52.15925	1.000
	MSF/Loukhaoukha et al. (2011)	48.097	1.000
	MSF/Ishtiaq et al. (2010)	NA	NA

NA, nonavailability of reported values by Ishtiaq et al. (2010).

images. Note that Ishtiaq et al. (2010) only use DCT as the transform technique to implement PSO-based watermarking. In contrast, both we and Loukhaoukha et al. (2011) use hybrid transforms to implement our respective watermarking schemes. In Table 7.1, "NA" indicates nonavailability of reported values by Ishtiaq et al. (2010). In addition, our results of $NC(W, W')$ are same as those reported for all five host images.

3. In this simulation, both PSNR and $NC(W, W')$, computed using MSF, are better than those computed using SSF for all five host images. This indicates that the proposed MSF-based scheme is robust against selected attacks for all five host images.

4. A close comparison of our MSF-based results with the MSF results presented by Loukhaoukha et al. (2011) clearly reveals that our results are better at least for four host images. We attribute this outcome to the use of DWT–SVD hybrid transform while Loukhaoukha et al. (2011) used LWT–SVD in their work.

5. We also compare the MSF-based results published by Mishra et al. (2014) with our MSF-based results obtained in this experiment. It is clear from Table 7.1 that except for the Lena host image, the proposed CS-based watermarking scheme outperforms the firefly-based watermarking scheme for all images. Examining the reasons for this outcome shall prove interesting, especially since both these schemes use the same formulation of the objective function.

We select eight different image processing operations as attacks to evaluate the robustness of the proposed scheme. These are: JPEG compression (QF = 95); salt and pepper noise (5%); Gaussian filtering (filter aperture = 3 × 3); sharpening (aperture = 0.2); histogram equalization (with 64 discrete gray levels); scaling (512→1024→512); grayscale quantization (1-bit); and cropping by dividing the image into 9 equal blocks, replacing the central block with zeros.

The $NC(W, W')$ values for the eight image processing attacks are compiled in Table 7.2. It is clear from Table 7.2 that the proposed watermarking scheme using CS outperforms all other schemes for all image processing operations except sharpening and cropping. We attribute these results for robustness against selected image processing attacks to better optimization of the MSF (δ) using CS. The CS makes use of the objective function, which is similar to one used by Mishra et al. (2014). The $NC(W, W')$ values we reported are better placed for several attacks compared to those of Mishra et al. (2014) A similar behavior also is obtained for PSNR in Table 7.1. However, there are few attacks for which the FA outperforms CS (Table 7.2). Thus, it is quite clear from these results that the MSF-based watermarking scheme using

Table 7.2 Comparison of NC (*W*, *W'*) Values of the Proposed Algorithm With Other Similar Works for Different Image Processing Attacks

Image	Algorithm	JPEG 5%	Noise	Gaussian Filter 3 × 3	Sharpening	Histogram Equalization	Scaling	Grayscale Quantization 1-bit	Cropping 1/8
Baboon	Proposed method (SSF)	1.000	1.000	1.000	1.000	0.841	1.000	0.966	0.751
	Proposed method (MSF)	1.000	1.000	0.884	0.995	1.000	1.000	1.000	0.961
	Mishra et al. (2014)	1.000	0.991	0.993	0.991	0.999	1.000	0.996	0.699
	Loukhaoukha et al. (2011)	0.986	0.975	0.985	0.985	0.995	1.000	0.995	0.987
	Xianghong et al. (2004)	0.633	0.694	0.858	0.713	0.440	0.986	0.570	0.983
Boat	Proposed method (SSF)	1.000	0.597	0.996	1.000	0.863	1.000	0.979	0.639
	Proposed method (MSF)	1.000	0.975	0.996	1.000	0.816	1.000	1.000	0.609
	Mishra et al. (2014)	1.000	0.998	0.984	0.991	0.997	1.000	0.990	0.756
	Loukhaoukha et al. (2011)	0.994	0.987	0.975	0.996	0.994	1.000	0.995	0.981
	Xianghong et al. (2004)	0.575	0.555	0.843	0.723	0.486	0.992	0.814	0.983
Camera-man	Proposed method (SSF)	1.000	0.609	0.996	1.000	1.000	1.000	0.983	0.133
	Proposed method (MSF)	1.000	0.738	0.983	1.000	0.850	1.000	0.949	0.464
	Mishra et al. (2014)	1.000	0.973	0.981	0.905	1.000	1.000	0.989	0.533
	Loukhaoukha et al. (2011)	0.963	0.968	0.970	0.982	0.981	1.000	0.978	0.941
	Xianghong et al. (2004)	0.621	0.495	0.847	0.580	0.621	0.993	0.750	0.983
Lena	Proposed method (SSF)	1.000	1.000	0.996	1.000	0.991	1.000	0.991	0.438
	Proposed method (MSF)	1.000	0.940	0.991	1.000	0.970	1.000	0.983	0.609
	Mishra et al. (2014)	1.000	0.979	0.991	0.996	0.994	1.000	0.984	0.490
	Loukhaoukha et al. (2011)	0.976	0.963	0.993	0.986	0.991	1.000	0.983	0.946
	Xianghong et al. (2004)	0.640	0.616	0.866	0.667	0.587	0.994	0.625	0.983
Pepper	Proposed method (SSF)	1.000	0.661	1.000	1.000	1.000	1.000	0.991	0.674
	Proposed method (MSF)	1.000	0.970	0.974	0.850	1.000	1.000	0.989	0.155
	Mishra et al. (2014)	1.000	0.988	0.995	0.954	1.000	1.000	0.991	0.758
	Loukhaoukha et al. (2011)	0.975	0.968	0.986	0.991	0.994	1.000	0.980	0.964
	Xianghong et al. (2004)	0.610	0.713	0.819	0.699	0.749	0.997	0.534	0.983

CS or FA clearly outperform all other watermarking schemes using other metaheuristic algorithms. This is explicitly correlated with the behavior of plots depicted in Figs. 7.1 and 7.2. For most of the selected attacks, the $NC(W, W')$ values vary between the range $\delta = 0.005$–0.1, thereby achieving high robustness within this range. Within the same range for δ, the proposed algorithm also maintains good perceptible quality of signed and attacked images and is correlated with Fig. 7.2. Therefore, we conclude that the requirement of minimizing the trade-off between visual quality and robustness is successfully achieved in the present scheme. We believe this is due to the fact that MSFs are efficiently optimized by the CS algorithm in the present scheme. The CS algorithm makes use of the objective function (fitness value) given by Eq. (7.17) to optimize MSFs in the present scheme, which produces better results than those obtained by Mishra et al. (2014) even though they use the same objective function.

7 CONCLUSIONS AND POSSIBLE EXTENSIONS OF THE PRESENT WORK

Traditionally, since the inception of image watermarking, its twin requirements—visual quality and robustness of the embedding scheme—have been considered the problems to optimize. Now we add another dimension: the goal of optimizing the MSFs to carry out efficient and robust embedding of the watermark within the host image. The most efficient optimization techniques—metaheuristic techniques working within the evolutionary soft computing paradigm—have been used extensively for this purpose. This is of critical importance because the host image usually offers large variations in luminance and contrast levels across its spatial spread. This becomes even more important if the size of the host image is too large in comparison to the size of the watermark. This problem is being addressed with the use of MSFs because the issue of optimizing the embedding strength based on MSF instead of a fixed value of SSF is also found to converge with this objective. This chapter proposes an optimized watermark embedding and extraction scheme based on combining DWT and SVD transforms. The singular values of LL3 subband coefficients of the host image are modified using singular values of a binary watermark image using MSFs. The MSFs are optimized using a newly developed metaheuristic technique known as the CS by employing an objective function which is a linear combination of imperceptibility and robustness. The major contribution of the proposed scheme is the application of CS for identifying optimal MSFs. Although CS has been applied for this purpose earlier, for the first time we present an extensive and detailed analysis of this problem. Our experimental results show that the proposed embedding scheme yields high PSNR values, which

indicate that the visual quality of the signed and attacked images is good and the embedding scheme, in general, shows high robustness against selected eight image processing attacks. The advantage of the proposed technique is that it adaptively selects the optimal MSFs, thereby producing better results compared to other similar works. The twin requirements of imperceptibility and robustness are successfully achieved in our scheme as a result of taking into account the MSFs optimized by the CS.

As discussed in Section 6, this newly developed evolutionary CS algorithm yields better results especially as compared to GAs and PSO for different applications. Although we compare our image watermarking scheme with those using ACO, PSO, and FA, we do not compared it to any work based on GA. Doing so would be a good problem to consider. Moreover, having compared our scheme with that using FA, the robustness studies indicate that FA-based image watermarking scheme is nearly equally robust, if not more so. A careful extensive analysis is needed which compares these two metaheuristic techniques for image watermarking. In addition, the present work can be extended to video watermarking of both types, compressed and uncompressed. However, to achieve this, real-time constraints have to be considered. To do so, the time complexity computation for embedding and extraction will have to be examined and carried out.

REFERENCES

Alexander, S., Scott, D., Ahmet, M.E., 2005. Robust DCT-SVD domain image watermarking for copyright protection: embedding data in all frequencies. In: Proceedings of the 13th European Signal Processing Conference (EUSIPCO 2005), Antalya, Turkey.

Ali, M., Ahn, C.W., Pant, M., 2014. Cuckoo search algorithm for the selection of optimal scaling factors in image watermarking. In: Proceedings of the Third International Conference on Soft Computing for Problem Solving, Advances in Intelligent Systems and Computing, vol. 258. Springer, New Delhi, India, pp. 413–425.

Ashour, A.S., Samanta, S., Dey, N., Kausar, N., Abdessalemkaraa, W.B., Hassanien, A.E., 2015. Computer tomography image enhancement using cuckoo search: a log transform based approach. J. Signal Inform. Process. 6, 244–257.

Barni, M., Bartolini, F., Piva, A., 2001. Improved wavelet based watermarking through pixel wise masking. IEEE Trans. Image Process. 10, 783–791.

Bhatnagar, G., Raman, B., 2009. A new robust reference watermarking scheme based on DWT–SVD. Comput. Stand. Inter. 31 (5), 1002–1013.

Briassouli, A., Strintzis, M.G., 2004. Locally optimum nonlinearities for DCT watermark detection. IEEE Trans. Image Process. 13 (12), 1604–1617.

Chandra, D., 2002. Digital image watermarking using singular value decomposition. In: Proceedings of the IEEE 45th Midwest Symposium on Circuits and Systems. Oklahoma State University, Norman, OK, vol. 3, pp. 264–267.

Cox, I., Kilian, J., Leighton, F.T., Shamoon, T., 1997. Secure spread spectrum watermarking for multimedia. IEEE Trans. Image Process. 6, 1673–1687.

Dey, N., Samanta, S., Yang, X.-S., Chaudhari, S.S., 2013. Optimisation of scaling factors in electrocardiogram signal watermarking using cuckoo search. Int. J. Bio-Inspired Comput. 5 (5), 314–326.

Dhivya, M., Sundarambal, M., Loganathan, N.A., 2011. Energy-efficient computation of data fusion in wireless sensor networks using cuckoo-based particle approach (CBPA). Int. J. Commun. Netw. Syst. Sci. V 4, 249–255.

Fındık, O., Babaŏglu, I., Ulker, E., 2010. A color image watermarking scheme based on hybrid classification method: particle swarm optimization and k-nearest neighbor algorithm. Opt. Commun. 283 (24), 4916–4922.

Ganic, E., Eskicioglu, A.M., 2004. Robust DWT–SVD domain image watermarking: embedding data in all frequencies. ACM Multimedia and Security Workshop, Magdeburg, Germany, pp. 166–174.

Ghazy, R., El-Fishawy, N., Hadhoud, M., Dessouky, M., El-Samie, F., 2007. An efficient block-by block SVD-based image watermarking scheme. In: Proceedings of the 24th National Radio Science Conference, Cairo, Egypt, pp. 1–9.

Hernandez, J., Amado, M., Perez-Gonzalez, F., 2000. DCT-domain watermarking techniques for still images: detector performance analysis and a new structure. IEEE Trans. Image Process. 9 (1), 55–67.

Horng, M.-H., Jiang, T.-W., 2010. Multilevel image thresholding selection based on the firefly algorithm top of form. In: Proceedings of 7th International Conference on Ubiquitous Intelligence and Computing and 7th International Conference on Autonomic and Trusted Computing (UIC/ATC), pp. 58–63.

Huang, H.-C., Chen, Y.-H., Abraham, A., 2010. Optimized watermarking using swarm-based bacterial foraging. J. Inform. Hiding Multimedia Signal Process. 1 (1), 51–58.

Huang, F., Guan, Z.-H., 2004. A hybrid SVD-DCT watermarking method based on LPSNR. Pattern Recogn. Lett. 25 (15), 1769–1775.

Ishtiaq, M., Sikandar, B., Jaffar, A., Khan, A., 2010. Adaptive watermark strength selection using particle swarm optimization. ICIC Express Lett. 4 (5), 1–6.

Jain, C., Arora, S., Panigrahi, P.K., 2008. A reliable SVD-based watermarking scheme. Available from: adsabs.harvard.edu/abs/2008arXiv0808.0309J

Kumsawat, P., Attakitmongcol, K., Srikaew, A., 2005. A new approach for optimization in image watermarking by using genetic algorithms. IEEE Trans. Signal Process. 53 (12), 4707–4719.

Lai, C.-C., 2011. A digital watermarking scheme based on singular value decomposition and tiny genetic algorithm. Digit. Signal Process 21, 522–527.

Li, Q., Yuan, C., Zong, Y.Z., 2007. Adaptive DWT–SVD domain image watermarking using human visual model. In: ICACT-2007, pp. 1947–1951.

Liu, J.-C., Chen, S.-Y., 2001. Fast two-layer image watermarking without referring to the original image and watermark. Image Vis. Comput. 19 (14), 1083–1097.

Liu, F., Liu, Y., 2008. A watermarking algorithm for digital image based on DCT and SVD. In: IEEE Congress on Image and Signal Processing, Sanya, Hainan, China, vol. 1, pp. 380–383.

Liu, R., Tan, T., 2002. A SVD-based watermarking scheme for protecting rightful ownership. IEEE Trans. Multimedia 4 (1), 121–128.

Loukhaoukha, K., 2013. Comments on "A digital watermarking scheme based on singular value decomposition and tiny genetic algorithm". Digit. Signal Process. 23, 1334.

Loukhaoukha, K., Chouinard, J.-Y., Taieb, M.H., 2011. Optimal image watermarking algorithm based on LWT–SVD via multi-objective ant colony optimization. J. Inform. Hiding Multimedia Signal Process. 2 (4), 303–319.

Makbol, N.M., Khoo, B.E., 2012. Robust blind image watermarking scheme based on redundant discrete wavelet transform and singular value decomposition. AEU Int. J. Electron. Commun. 65, 658–663.

Meerwald, P., Uhl, A., 2001. A survey on wavelet domain watermarking algorithms. Proc. SPIE 4314, 505–551.

Mishra, A., Agarwal, C., Mishra, A., Bedi, P., 2014. Optimized gray-scale image watermarking using DWT-SVD and firefly algorithm. Expert Syst. Appl. 41, 7858–7867.

Mishra, A., Goel, A., 2014. A novel HVS based gray scale image watermarking scheme using fast fuzzy-ELM hybrid architecture. In: Proceedings of ELM-2014, vol. 2, Proceedings in Adaptation, Learning and Optimization, vol. 4. Springer International Publishing, Switzerland, pp. 145–159.

Motwani, M.C., Harris Jr., F.C., 2009. Fuzzy perceptual watermarking for ownership verification. In: Proceedings of the International Conference on Image Processing, Computer Vision, and Pattern Recognition (IPCV'09), Las Vegas, NV.

Nikolaidis, N., Pitas, I., 1998. Robust image watermarking in the spatial domain. Signal Process. 66 (3), 385–403.

Run, R.-S., Horng, S.-J., Lai, J.-L., Kao, T.-W., Chen, R.-J., 2012. An improved SVD based watermarking technique for copyright protection. Expert Syst. Appl. 39, 673–689.

Senthilnath, J., Omkar, S.N., Mani, V., 2011. Clustering using firefly algorithm: performance study. Swarm Evol. Comput. 1, 164–171.

Shieh, C., Huang, H., Wang, F., Pan, J., 2004. Genetic watermarking based on transform domain techniques. Pattern Recogn. Lett. 37, 555–565.

Shih, F.Y., Wu, Y.-T., 2005. Enhancement of image watermark retrieval based on genetic algorithms. J. Vis. Commun. Image Represent. 16 (2), 115–133.

Tsai, H.-H., Jhuang, Y.-J., Lai, Y.-S., 2012. An SVD-based image watermarking in wavelet domain using SVR and PSO. Appl. Soft Comput. 12 (8), 2442–2453.

Valian, E., Mohanna, S., Tavakoli, S., 2011. Improved cuckoo search algorithm for feedforward neural network training. Int. J. Artif. Intell. Appl. 2 (3), 36–43.

Wang, Y.-R., Lin, W.-H., Yang, L., 2011. An intelligent watermarking method based on particle swarm optimization. Expert Syst. Appl. 38 (7), 8024–8029.

Xianghong, T., Lu, L., Lianjie, Y., Yamei, N., 2004. A digital watermarking scheme based on DWT and vector transform. In: Proceedings of the International Symposium on Intelligent Multimedia, Video and Speech Processing, pp. 635–638.

Yang, X.-S., Deb, S., 2009. Cuckoo search via Lévy flights. In: Proceedings of the World Congress on Nature & Biologically Inspired Computing (NaBIC 2009), India, pp. 210–214.

Zhang, Y., Wu, L., 2012. A novel method for rigid image registration based on firefly algorithm. Int. J. Res. Rev. Soft Intell. Comput. 2 (2), 141–146.

Bat algorithm–based automatic clustering method and its application in image processing

S. Nandy*, P.P. Sarkar**

**Budge Budge Institute of Technology, Kolkata, West Bengal, India; **Kalyani University, Kalyani, West Bengal, India*

CHAPTER OUTLINE

1 INTRODUCTION

Nature-inspired or evolutionary algorithms are population-based optimization algorithms and are developed from the inspiration of natural concepts. The numerical relationship is derived from natural concepts, and those numerical formulas are used to simulate various phases of natural life. The nature-inspired optimization algorithm is a solution to those combinatorial problems which are intended to find not only optimal or near-optimal solutions but to find good solutions. Metaheuristic methods are developed for finding a solution to the combinatorial optimization problem in a discrete

Bio-Inspired Computation and Applications in Image Processing. http://dx.doi.org/10.1016/B978-0-12-804536-7.00008-9

search space. The nature-inspired or evolutionary algorithms are categorized into the metaheuristic category because each iteration of the evolutionary algorithm provides a different solution from the previous iteration and, in each iteration, the algorithms are trying to provide a better solution for every candidate. One of the most common approaches used in population-based metaheuristic algorithms is the fitness-dependent modification of parameters, which provides possible solutions to given problems. Hence, the solution moves toward a better solution in the search space. Nowadays nature-inspired, metaheuristic population-based algorithms are applied for clustering to achieve better performance.

Clustering is the process of partitioning unlabeled datasets into meaningful groups of similar types of data. The successful group consists of the most similar items, which is evaluated by various processes of measuring the similarity between the two patterns. The successful grouping creates a meaningful cluster, and hence the purity of the corresponding cluster is maximum. The usage of nature-inspired optimization algorithms in clustering datasets has become very popular. Recently many researchers have turned their attention to algorithms inspired from natural life, in the quest to solve tough optimization problems ever more quickly. Ant colony optimization (ACO), firefly (FF) algorithms, particle swarm optimization (PSO), and others have been extensively used in the recent past. These kinds of metaheuristic algorithms not only solve particular types of problems but have the potential to be applied to a diverse array of problems, which has made them more popular. These algorithms have been tested on a popular optimization problem, namely the traveling salesman problem (He et al., 2006). This problem requires that a salesman is able to traverse a number of cities before returning to the starting point in the shortest possible time and also with the shortest distance traversed. One analogous problem to this is the vehicle routing problem (Maniezzo et al., 2004). This requires a set of vehicles able to serve customers situated at different places before returning to the depot by using the fewest number of vehicles and traversing the shortest possible distance. The ACO technique is used extensively in this problem, as this algorithm is reportedly one of the fastest available optimization techniques. As these kinds of problems involve clustering, the ACO can display categorization problems if the number of clusters is large. Document clustering is one such problem where categorization errors often occur. In those cases, the sole potential of the ACO is not enough; other algorithms, like the K-means algorithm, have to be incorporated in addition to the ACO to solve the categorization errors (He et al., 2006). The combination of ACO and the K-means algorithm has been shown to work on 20 Newsgroup data (He et al., 2006). Data clustering is an important problem that involves the

grouping of data, having a large amount of similarity in terms their attribute values, into several classes where one class of data is distinctly different from the members of another class (Niknam et al., 2010). Data clustering has found application in several fields including biology, statistics, and, more important, data mining (Niknam et al., 2010). The K-means clustering algorithm is the most suitable, and it is also capable of being run under unsupervised solution domains (van der Merwe, 2003). This is the most exciting thing about the nature-inspired algorithms: they can work efficiently in unsupervised environments. The artificial bee colony technique has also been used in data mining and reportedly is a considerable improvement over other available techniques (Shukran, 2011). The main algorithm proposed here, the bat algorithm (BA), has received considerable attention and is a potential improvement over the traditional techniques. The BA can also be used to solve optimization problems where the solution has many folds, or more precisely, multiobjective optimization problems, such as multiprocessor scheduling (Kim, 2010). As mentioned, this algorithm is also applicable to a large number of optimization problems. In this Internet era where online banking, smart shopping, and social networking are prevalent, users often fall victim of to phishing websites and end up sharing sensitive information with crooks. Some factors have been determined that are expected to represent phishing websites. The BA has been applied on such datasets to optimize the solution in detecting the fraudulent website. The BA has achieved a success rate of 70% in detecting phishing websites (Damodaram and Valarmathi, 2012).

The clustering technique has played a significant role in science and technology (Rao, 1971; Lillesand and Keifer, 1994; Evangelou et al., 2001; Everitt, 1993; Fukunaga, 1990; Sarkar et al., 1997). In order to meet the requirements of the different applications, various clustering algorithms (Jain and Dubes, 1988; Carpineto and Romano, 1996; Judd et al., 1998; Bhatia and Deogun 1998) have been proposed in the literature and the new clustering algorithm continues to appear. In most of the cases, the implementation of the nature-inspired algorithm in the clustering technique belongs to the hierarchical clustering categories, and the hierarchy of clustering consists of a partition of the dataset known as a cluster. Clustering algorithms are categorized into partitioning clustering and agglomerative hierarchical clustering (Frigui and Krishnapuram, 1999; Leung et al., 2000). Hierarchical clustering techniques organize data in nested sequences of groups. The hierarchical clustering algorithm is represented by a treelike format (Leung et al., 2000). Partition clustering algorithms are employed in a wide range of fields, such as expectation-maximization algorithms (Mitchell, 1997); graph theory (Zhan, 1971); artificial neural networks (Mao and Jain, 1995; Pal et al., 1995; Kohonen, 1995); evolutionary computation (Falkenaure, 1998;

Paterlini et al., 2003; Murthy and Chowdhury, 1996), swarm intelligence (Paterlinia and Krink, 2006); and others. The aim of the partition algorithmic problem is to find a k-cluster from a group of n patterns in a D-dimensional space. The k number of clusters consists of most similar patterns (Jain and Dubes, 1988). The algorithms of the partitioning clustering mechanism may be initiated with an unknown number or an exact number of clusters. In hierarchical clustering, the main idea is to build a binary tree of data that successively merges a similar group of data points. In this procedure, the most popular algorithm is the agglomerative hierarchical clustering algorithm (Hochbaum and Shmoys, 1985; Dasgupta, 2002). Several modified versions of the algorithm, such as the PSO algorithm (Kennedy and Eberhart, 1995), a kernel-based clustering algorithm, have been developed in recent years. The kernel-based clustering algorithm measures the similarity between two patterns based on the defined kernel. This type of algorithm does not use the conventional procedure of clustering, which depends on the Euclidean distance metric. The kernel maps any two data pattern into higher-dimensional feature space where data are linearly separable (Muller et al., 2001; Girolami, 2002). The most useful examples of this method is the support vector machine (SVM) (Scholkopf and Smola, 2002; Vapnik, 1998; Zhang and Chen, 2003; Zhang and Rudnicky, 2002), kernel base K-means (Forgy, 1965), and fuzzy C-means (Bezdek, 1981).

The proposed method is automatic in nature because the process of clustering is initiated without the knowledge of cluster center. The method consists of two phases. In one phase it performs the clustering, and the second phase, rule-based bat optimization guides the whole clustering process to achieve optimum results. The statistical hypothesis–based evaluation helps to merge similar clusters and also is used to remove the null cluster. The method is also applied to find the optimum segments in the image. The method is tested with the benchmark and the real-life dataset to establish its clustering and image segmentation superiority over other algorithms.

The performance comparison between the proposed method and the other four standard methods is performed in order to establish the efficacy of the present method over others. The effects on the clustering performance due to the data dimensionality are studied over the synthetic dataset. Section 2 of this chapter presents an overview of bat behavior and the concept of the bat optimization algorithm. In Section 3, the proposed clustering procedure is explained in detail, as is the rule-based statistical hypothesis approach in the merging of similar clusters. Section 4 evaluates the experimental results of automatic clustering over four synthetic and five real-life benchmark datasets. Section 5 discusses image segmentation, and Section 6 concludes the chapter.

2 BAT OPTIMIZATION ALGORITHM

The bat optimization algorithm (Yang, 2010, 2011) is based on the special characteristic of bats known as echolocation (Airas, 2003). To present the proposed method, we outline bat behavior and the bat optimization algorithm.

2.1 Bat algorithm

The concept of bat echolocation inspired the bat optimization algorithm. The bat's natural hunting characteristic is utilized to design the optimization concept. Three general rules are utilized in designing the optimization method:

1. The echolocation characteristic of bats is considered as the measurement procedure of distance between two objects. It is also held that the bat also knows the difference between the echoes of prey and of obstacles.
2. In the algorithm, it is considered that the bats are flying with the velocity p_i from a position s_i with a minimum frequencies f_{min} and varying wavelength λ and loudness L_0 to search for prey. The bats are capable of adjusting the frequencies f_i and also the rate of frequencies $r \in (0,1)$, and the adjustment depends on the successful or unsuccessful search for prey or on the type (small or large) of prey.
3. The emitted sound of the bat varies as it performs different activities in the social structure. The large loudness is represented by the L_0 and minimum loudness is represented by the L_{min}.

The rules are formed to design the optimization algorithm from the concept of the bat hunting procedure. The algorithm does not include the techniques for complex scenario where two or more bats target their sonar on the same object. In any type of implementation, any range of wavelength is considered, and it can be adjusted by adjusting the frequencies.

The conventional bat optimization algorithm did not specify the way to consider the time delay and three-dimensional topography. To maintain simplicity, the algorithm considers a range of frequencies that correspond to the range of wavelength. The frequencies also must belong within the range of minimum and maximum frequencies. This consideration leads to the bat optimization algorithm. The bat P_i moves from a position S_i with a velocity V_i and frequency F_i. The algorithm calculates the next bat position using these formulas:

$$F_i = f_{min} + (f_{max} - f_{min}) * \beta \tag{8.1}$$

$$V_{(i+1)} = V_{(i-1)} + (P_i - P) * F_i \tag{8.2}$$

$$P_{(i+1)} = P_{(i-1)} + v_{(i+1)} \tag{8.3}$$

where $\beta \in (0, 1)$, P_* is the best position of the bat, and the best solution of the current iteration is generated by comparing the current one with others. In the bat optimization algorithm, the minimum frequency (f_{min}) starts with zero and the maximum (f_{max}) is 100. The frequency range totally depends on the problem. Initially, each bat is assigned a randomly generated position, frequency, and velocity, but each assignment is uniform within its range. If the algorithm is able to find the local best solution among the all best solutions, a new solution for each bat is generated locally using the random walk.

$$P_{new} = P_{old} + \gamma L^t \tag{8.4}$$

where $\gamma \in (-1,1)$ and L^t is the average loudness of all bats at a specific time. The main convergence parameters L_i and r_i are modified on each iteration. The loudness actually decreases as the distance between bat and prey reduces and the rate of pulse increases. The loudness is adjusted using this formula:

$$L^{(i+1)} = \alpha.L_i \tag{8.5}$$

and the pulse rate is calculated as:

$$r_{(i+1)} = r^0[1 - e^{(-\lambda.t)}] \tag{8.6}$$

where λ and α are the constants, and it is always $0 < \lambda < 1$ and $0 < \alpha < 1$. The loudness and rate pulse is adjusted if the new solution is improved.

3 PROPOSED METHOD: BAT ALGORITHM–BASED CLUSTERING

The clustering of the proposed method incorporates the techniques of the bat optimization algorithm by considering the population as its cluster center. The clustering phase is a very simple one, and it depends on the cluster center. In the clustering phase, similar patterns are grouped together on the basis of the Euclidean distance between cluster center and pattern. Then the performance is measured by means of the sum of the squared Euclidean distance and clustering efficiency. Calculation of the sum of the squared Euclidean distance is important for image segmentation while the clustering accuracy is the only performance measuring tool for the data clustering. Once the clustering phase is completed, the overall accuracy is measured, and on the basis of that, the bat optimization phase is begun to modify the population. Then similar cluster centers are merged together, and null clusters are removed on the basis of some defined rules. This modification and the new formation of the clusters are accepted if better clustering accuracy

is observed, and the process of optimization continues for a certain number of predefined cycles. The details of this proposed method are explained through the next algorithm.

Begin:

Step 1. The population is randomly created, and the proposed method considers the initial values are within the range of (0,1). The data patterns are separated from their target value, and targets are kept separately for the measurement of clustering accuracy.

Step 2. The clustering is performed with the initial population, which is treated here as the cluster center, the pattern list, and its related target list. These lists are separated, but same index values are maintained. The clustering process is based on the cluster center. Fig. 8.1 is the flowchart that describes the process of the clustering.

The clustering process is initiated with the pattern list and cluster center or population list. A cluster list is created initially, and the output of this clustering phase is a cluster where the patterns are similar for a group but dissimilar in between the groups. In this method each cluster in the cluster

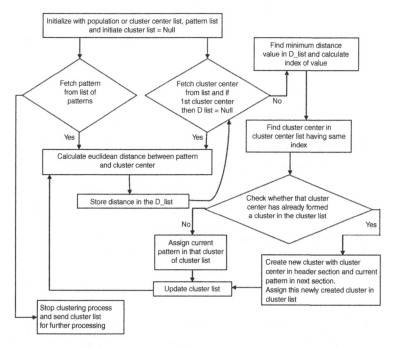

■ FIGURE 8.1 Flowchart of the clustering phase.

list divided into two parts. The first part consists of the cluster center, and the second part consists of similar types of patterns. Each time a single pattern is fetched, the Euclidean distance is calculated for every cluster center, and the distance values are kept in D_list. Then the process is searched for the minimum value in the list, and the index value of that is used to determine the cluster center from the cluster center list. Now, the process looks into the cluster list to find whether the present cluster center is already formed the cluster or not and if it is found that a cluster is formed with present cluster center then it assigned the pattern into it or else it will create a cluster with that cluster center and the pattern. In the next step, it fetches another pattern from the pattern list. If the pattern list is empty, then the clustering phase sends the cluster list for further processing.

Step 3. Clustering quality and performance are measured on the basis of the sum of squared error (SSE) calculation and the clustering accuracy measurement. In this step, the newly formed cluster list and the pattern and the target list are required. The kth cluster in the cluster list consists of $\{cl_1, cl_2, \ldots cl_n\}$ number of similar types of patterns. The Euclidean distance d_j is calculated as:

$$d_j = \sum_{j=1}^{k} \sqrt{\left(Ch_j - Cl_j\right)^2} \tag{8.7}$$

If the total number of patterns in a cluster is n_p, then the average is calculated as:

$$E(c) = \frac{\sum_{j=1}^{k} d_j}{n_p} \tag{8.8}$$

Eq. (8.8) creates a single-row matrix, and the final sum of the squared error of Euclidean distance is:

$$SSE_{eud} = \sum_{j=1}^{N} E(c)^T . E(c) \tag{8.9}$$

The clustering accuracy is calculated as:

$$A = \frac{\sum_{i=1}^{m} d_i}{n} \tag{8.10}$$

where A is the accuracy, d_i is the number of the common data pattern between the ith cluster and its corresponding true cluster, and n is the

number of the data pattern. This accuracy measure based on Eq. (8.10) is also known as Huang's accuracy measure (Huang and Ng, 1999). According to this measure, the value of A must lie within 0 and 1, $0 \leq A \leq 1$. The higher value of clustering accuracy is indicated by the nearest value of 1. Now the overall accuracy of the clustering method for a single iteration is calculated as:

$$\text{Clustering accuracy} = \frac{\sum_{i=1}^{n} A}{n} \times 100 \tag{8.11}$$

These two values, the SSE and clustering accuracy are kept on a list for comparative analysis and graphical presentation. If the threshold level is reached, then the clustering process displays the results; else it will jump into next phase, which is an optimization phase.

Step 4. The proposed method has incorporated the procedures of the bat optimization algorithm into clustering method to find a best cluster center for a group of data. In the method, the bat position is considered as the provisional cluster center and on each iteration those previously generated bat positions are modified according to the bat optimization method, hence the cluster centers are modified on each iteration. The automatic bat clustering algorithm is designed based on three assumptions:

1. The bat positions or provisional cluster centers are generated at the beginning of the algorithm and are modified on each iteration on the basis of clustering performance.
2. The loudness of the emitted sound from the bat increases or decreases based on the distance between prey and bat. So the closest one produces less SSE of Euclidean distance; hence less SSE implies a high pulse rate.
3. Frequency and velocity are automatically adjusted on the basis of the clustering performance. The algorithm also considers that the best solution of a current iteration is the cluster center with less SSE of Euclidean distance.

The bat position represents the cluster center or C_i and bats fly with frequencies Fc_i with velocities Vc_i. This can be calculated as:

$$Fc_i = fc_{\min} + \left(fc_{\max} - fc_{\min} \right) * \beta \tag{8.12}$$

$$Vc_{(i+1)} = V_{(i-1)} + \left(C_i - C \right) * Fc_i \tag{8.13}$$

$$C_{(i+1)} = C_{(i-1)} + Vc_{(i+1)} \tag{8.14}$$

The rate of the pulse is dependent on the distance between prey and bat. If the proposed method can find any local best solution among all best available solutions, then movement of each bat is modified as:

$$C_{new} = C_{old} + \gamma L^t \tag{8.15}$$

The loudness is modified according to Eq. (8.5) and λ, α are constant where the range of both constants is the same as it is in the bat optimization algorithm. The pulse rate (Rp_i) is adjusted in the proposed method by measuring the difference in Euclidean distance between the current solution (C_i) and the modified solution [$C_{(i+1)}$] with the best possible solution (C_*) for each bat. This is calculated as:

$$Rc_{i1} = \sqrt{\left(C_i - C^*\right)} \tag{8.16}$$

$$Rc_{i2} = \sqrt{\left(C_{(i+1)} - C^*\right)} \tag{8.17}$$

$$Rp_i = \left(Rc_{i1} - Rc_{i2}\right) \tag{8.18}$$

The experiment shows that the algorithm performs better if Eq. (8.14) is modified as shown next:

$$C_{(i+1)} = C_{(i-1)} + Vc_{(i+1)} - \alpha.\sqrt{\left(SSE_{eud}\right)} \tag{8.19}$$

A new cluster center list is generated, and it is sent to the next step for the formation of the cluster.

Step 5. The newly generated cluster center is sent to Step 2 for the clustering process, and the cluster list is sent to the next step.

Step 6. The rule-based methods are used to merge the two almost similar clusters and to eliminate the null cluster. The input of this phase is the cluster list, pattern list, and target list. The next four rules are used to merge and modify the clusters:

Rule 1: If ($\varphi_{ci} \vee \varphi_{cj}$) < τ and φ_{cn} < τ, then C_i and C_j are similar.
Rule 2: If ($\varphi_{ci} \vee \varphi_{cj}$) < τ and φ_{cn} > τ, then C_i and C_j are not similar.
Rule 3: If ($\varphi_{ci} \vee \varphi_{cj}$) > τ and φ_{cn} < τ, then C_i and C_j are not similar.
Rule 4: If ($\varphi_{ci} \vee \varphi_{cj}$) > τ and φ_{cn} > τ, then C_i and C_j are not similar.

The explanations of these rules are presented in the next section.

Step 7. The modified list of the cluster is now evaluated and sent to Step 3 for the evaluation process. If the improvement is observed, then the newly formed cluster center list is accepted for further processing and it is again sent to the Step 4.

The proposed method continues of up to a predefined number of cycles. It may also terminate if the threshold level of accuracy is reached.

3.1 Rule-based statistical hypothesis for clustering

The proposed method adopts a rule-based statistical hypothesis approach for merging the most similar clusters and produces a new cluster. This approach reduces the problem of the empty cluster. The proposed method considers any two partitions and measures the similarity between them. If the value is less than that of the threshold value, then a new cluster is generated, and if it is created, then it consists of the most similar pattern. The selection of the cluster center for the newly created cluster is based on measuring the minimum sum of the Euclidean distance between the each element of the new partition and the previously created cluster center. Now consider two independent partitions $C_i = \{1,2,\ldots k\}$ and $C_j = \{1,2,\ldots k\}$ that consist of k unlabeled patterns in the d-dimensional input space. The consideration of two patterns are based on these properties:

1. $C_i, C_j \neq \varphi$, where, $\forall (i,j) = \{1,2,\ldots,k\}$
2. $C_i \cap C_j = \varphi$

The standard deviation (*SD*) of the C_i, C_j, and C_N partition is calculated as:

$$\varphi = \sqrt{\left(\frac{\sum_{i=1}^{N}(X_i - \mu_{xi})^2}{N} \right)} \qquad (8.20)$$

and

$$\mu_x = \frac{\sum_{i=1}^{N} X_i}{N} \qquad (8.21)$$

The *SD* of C_i, C_j, and C_N is φ_{ci}, φ_{cj}, and φ_{cn}. Now the C_i, C_j, and C_N partitions are represented by φ_{ci}, φ_{cj}, and φ_{cn} values. In the proposed method, these four rules are applied for taking a decision on the similarity between C_i, C_j where τ is the threshold value.

> Rule 1: If $(\varphi_{ci} \lor \varphi_{cj}) < \tau$ and $\varphi_{cn} < \tau$, then C_i and C_j are similar.
> Rule 2: If $(\varphi_{ci} \lor \varphi_{cj}) < \tau$ and $\varphi_{cn} > \tau$, then C_i and C_j are not similar.
> Rule 3: If $(\varphi_{ci} \lor \varphi_{cj}) > \tau$ and $\varphi_{cn} < \tau$, then C_i and C_j are not similar.
> Rule 4: If $(\varphi_{ci} \lor \varphi_{cj}) > \tau$ and $\varphi_{cn} > \tau$, then C_i and C_j are not similar.

According to the proposed method, if the sum or product of the partition is less than that of the threshold value τ, then those partitions are similar ones; otherwise, the partitions are not similar. If the similarity of the C_i and C_j cluster is represented by S_{ij}, then it is possible to show logically that the rules are valid, and clusters can be merged based on the listed rules.

Rule 1: If $(\varphi_{ci} \vee \varphi_{cj}) < \tau$ and $\varphi_{cn} < \tau$, then C_i and C_j is similar. If the similarity is represented here as S_{ij}, then this condition is valid:

$$(\varphi_{ci} \vee \varphi_{cj}) \wedge \varphi_{cn} \rightarrow S_{ij}$$

Proof:

In order to prove that S_{ij} is valid for the considered rule, its negation $(\neg S_{ij})$ needs to be unsatisfied. In order to prove the rules are valid to prove the similarity between C_i and C_j, these items are considered as an element of set S:

$$S = \{\varphi_{ci}, \varphi_{cj}, \varphi_{cn}, (\varphi_{ci} \vee \varphi_{cj}) \wedge \varphi_{cn} \rightarrow S_{ij}\}$$

The rules are now converted to the conjugate normal form as:

$$S = \{\varphi_{ci}, \varphi_{cj}, \varphi_{cn}, \neg\varphi_{ci} \wedge \neg\varphi_{cj} \vee \neg\varphi_{cn} \vee S_{ij}\}$$

Now consider $S' = S \cup G'$, where $G' = \neg S_{ij}$ and hence S' is:

$$S' = \{\varphi_{ci}, \varphi_{cj}, \varphi_{cn}, \neg\varphi_{ci} \wedge \neg\varphi_{cj} \vee \neg\varphi_{cn} \vee S_{ij}, \neg S_{ij}\}$$

The five elements of set S' are: (1) φ_{ci}; (2) φ_{cj}; (3) φ_{cn}; (4) $\neg\varphi_{ci} \wedge \neg\varphi_{cj} \vee \neg\varphi_{cn} \vee S_{ij}$; (5) $\neg S_{ij}$

From (1) and (4): $\varphi_{ci} \wedge \neg\varphi_{ci} \wedge \neg\varphi_{cj} \vee \neg\varphi_{cn} \vee S_{ij} \equiv \neg\varphi_{cj} \vee \neg\varphi_{cn} \vee S_{ij}$ (6)

From (2) and (6): $\varphi_{cj} \wedge \neg\varphi_{cj} \vee \neg\varphi_{cn} \vee S_{ij} \neg\varphi_{cn} \vee S_{ij}$ (7)

From (3) and (7): $\varphi_{cn} \wedge \neg\varphi_{cn} \vee S_{ij} \equiv S_{ij}$ (8)

From (5) and (8): $\neg S_{ij} \wedge S_{ij} \equiv [\Phi]$

Hence, it is proved that the: $S \models G$

This implies that the use of Rule 1 can be valid to prove that the C_i and C_j clusters are similar.

Rule 2: If $(\varphi_{ci} \vee \varphi_{cj}) < \tau$ and $\varphi_{cn} > \tau$, then C_i and C_j are not similar, and if the similarity is represented here as S_{ij}, then the following condition is valid:

$$(\varphi_{ci} \vee \varphi_{ci}) \wedge \neg\varphi_{cn} \rightarrow S_{ij}$$

So, S_{ij}, which represents the dissimilarity between two clusters, is valid for Rule 1.

Proof:

To prove whether S_{ij} is valid for Rule 1, the negation of it ($\neg S_{ij}$) needs to be unsatisfied. In order to prove the rule is valid to prove the similarity between C_i and C_j, the following is considered an element of set S:

$$S = \{\varphi_{ci}, \varphi_{ci}, \varphi_{cn}, (\varphi_{ci} \vee \varphi_{ci}) \wedge \neg \varphi_{cn} \rightarrow S_{ij}\}$$

The rules are now converted to the conjugate normal form as:

$$S = \{\varphi_{ci}, \varphi_{cj}, \varphi_{cn}, \neg \varphi_{ci} \wedge \neg \varphi_{cj} \vee S_{ij}\}$$

Now consider:

$S' = S \cup G'$, where $G' = \neg S_{ij}$ and here the S' is:

$$S' = \{\varphi_{ci}, \varphi_{cj}, \varphi_{cn}, \neg \varphi_{ci} \wedge \neg \varphi_{cj} \vee \varphi_{cn} \vee S_{ij}, \neg S_{ij}\}$$

$S' = S \cup G'$, where $G' = \neg S_{ij}$ and hence the S' is:

$$S = \{\varphi_{ci}, \varphi_{cj}, \varphi_{cn}, \neg \varphi_{ci} \wedge \varphi_{cj} \vee \varphi_{cn} \vee S_{ij}\}$$

So, the five elements of set S' are: (1) φ_{ci}; (2) φ_{cj}; (3) φ_{cn}; (4) $\neg \varphi_{ci} \wedge \neg \varphi_{cj} \vee \varphi_{cn} \vee S_{ij}$; (5) $\neg S_{ij}$

From (1) and (4): $\varphi_{ci} \wedge \neg \varphi_{ci} \wedge \neg \varphi_{cj} \vee \neg \varphi_{cn} \vee S_{ij} \equiv \neg \varphi_{cj} \vee \neg \varphi_{cn} \vee S_{ij}$ (6)

From (2) and (6): $\varphi_{ci} \wedge \neg \varphi_{cj} \vee \neg \varphi_{cn} \vee S_{ij} \equiv \neg \varphi_{cn} \vee S_{ij}$ (7)

From (3) and (7): $\varphi_{cn} \wedge \varphi_{cn} \vee S_{ij} \equiv \varphi_{cn} \vee S_{ij}$ (8)

From (5) and (8): $\neg S_{ij} \wedge \varphi_{cn} \vee S_{ij} \equiv [\varphi_{cn}]$

Hence, it is proved that the: $S \nvDash G$

This implies that the use of Rule 1 can be valid if the C_i and C_j clusters are not similar.

The validity of other rules can be proved in a similar way, which is actually implemented to find nonsimilarity between two clusters. Hence, it is possible to merge the two clusters on the basis of the considered rules.

4 EVALUATION

The evaluation of the proposed method is twofold. First, the dataset and clustering accuracy calculation methods are described. Second, the performance of the proposed method is compared with four standard clustering algorithms. The data dimensionality effect is also studied by comparing the proposed method with other algorithms.

Table 8.1 Dataset Description

Dataset	No. of Instances	Data Dimensions	No. of Classes
Synthetic_1	633	2	2
Synthetic_2	566	2	2
Synthetic_3	1231	2	3
Synthetic_4	1218	3	5
Wine	178	13	3
Diabetes	768	8	2
Ionosphere	351	34	2
Glass	214	9	6
Sonar	208	60	2

The effectiveness of the proposed method is compared with four standard algorithms over nine artificial and benchmark datasets. The algorithms that are considered here for comparison are the expectation-maximization (EM) algorithm (Mitchell, 1997), DBSCAN algorithm (Ester et al., 1996), hierarchical clustering algorithm, and k-means clustering algorithm. The algorithms are provided with the correct number of clusters as they are not automatic clustering algorithms.

The datasets used here for clustering purposes are divided into two categories. Four synthetic datasets are used here, and they are generated with different seed values. Those synthetic datasets are created with the different dimensions and classes (Handl and Knowles, 2005).The real-time benchmark dataset is also used for comparison purposes. The details of the dataset are given in Table 8.1.

In this experiment, EM, DBSCAN, k-means, and hierarchical algorithms are run for 50 iterations. For the EM, k-means, and hierarchical algorithms, a true number of cluster centers is provided for each dataset. Other parameter details are given in Table 8.2. The details of the real-life dataset are presented here:

Table 8.2 Parameter Details

Algorithm	K-Means Clustering	EM Clustering	Hierarchical Clustering	DBSCAN Algorithm	Bat Clustering
Parameter details	No. of iterations = 50; seed value = 10	No. of iterations = 50; Minimum standard deviation = 1e-06; seed value = 100	No. of iterations = 50; seed value = 10	No. of iterations = 50; C1 = 0.9; C2 = 6	No. of iterations = 50; population size = 10; τ = 0.09; α = 0.009

Dataset 1: The wine dataset is also multivariate. This dataset consists of 178 instances, and 13 attributes are found. The chemical composition is measured for three types of wine and used here as attributes. The wine dataset consists of three classes of wine. (Datasets are from the UCI Machine Learning Repository, uci.edu; Wine dataset: http://archive.ics.uci.edu/ml/machine-learning-databases/wine/wine.data.

Dataset 2: The diabetes dataset consists of more than 768 instances, each of which consists of 8 attributes. Each of the data is classified by 1 or 2, where 1 stands for tested positive for diabetes and 2 stands for negative. (Dataset from UCI machine learning repository, uci.edu; Diabetes dataset: http://archive.ics.uci.edu/ml/datasets/Diabetes).

Dataset 3: This ionosphere dataset consists of 351 instances, and 34 attributes constitute one data. The datasets consists of "good" and "bad" classes represented using 1 and 0. The good represents the existence of some kind of structure; the bad class of data are passed through the ionosphere. (Data set from UCI machine learning repository, uci.edu; Ionosphere dataset: http://archive.ics.uci.edu/ml/datasets/Ionosphere).

Dataset 4: The glass dataset consists of 214 instances, each created with 10 attributes. The chemical composition of the various types of glass is considered. The dataset consists of 7 classes. (Data set from UCI machine learning repository, uci.edu; Glass dataset: http://archive.ics.uci.edu/ml/datasets/Glass+Identification).

Dataset 5: The sonar dataset consists of 208 patterns, and each is a result of transmitted sonar signals obtained at different aspect angles, spanning 90 degrees for the cylinder and 180 degrees for the rock. Each instance consists of 60 attributes, which represent the energy within a particular frequency band, integrated over a certain period of time. (Data set from UCI machine learning repository, uci.edu; Sonar dataset: http://archive.ics.uci.edu/ml/datasets/Connectionist+Bench+%28Sonar%2C+Mines+vs.+Rocks%29).

The clustering algorithms are developed in the Python programming language. The numerical analysis is performed in the algorithm with the "numpy" module, and the "matplotlib" module is used to plot the cluster. The experiment was carried out on an Intel Pentium 4 computer system configured with core2duo 1.66 GHz Intel processor, 2 GB of RAM and 500 GB of hard disk space.

In Table 8.3, the best performance of the proposed and another clustering method is shown in the form of an accuracy measurement, which is calculated over 50 iterations. Fig. 8.2 depicts the results of the proposed clustering algorithm in second or third form.

Table 8.3 Dataset Clustering Accuracy (%) Achieved by the Algorithms

Dataset	EM	DBSCAN	Hierarchical Clustering	K-Means Clustering	Bat Algorithm Clustering
Synthetic_1	71.22	71.9	76.67	79.11	99.62
Synthetic_2	96.75	78.27	76.83	90.25	99.36
Synthetic_3	51.45	78.25	48.83	54.17	100.00
Synthetic_4	86.90	24.14	66.63	86.89	98.57
Wine	97.00	39.89	74.35	95.2	100.00
Diabetes	68.96	65.11	51.10	38.24	99.71
Ionosphere	78.38	93.17	52.81	71.79	100.00
Glass	65.81	36.45	38.89	38.35	100
Synthetic_1	59.66	97.00	53.54	59.97	93

The proposed method consists of parameters which are tuned empirically to enhance the clustering performance for the different datasets. One threshold value is used in the rule-based statistical hypothesis for clustering, and it is described in Table 8.2 as τ. Another very important parameter is the population size of the bat in the proposed method. In order to investigate the effect of different population sizes over the clustering accuracy, the BA–based clustering method is executed separately with 10–70 populations; the rest of the parameters are same as defined in Table 8.2. In Figs. 8.3 and 8.4, the effect clustering accuracy over different population size is analyzed for the glass and sonar datasets. The experiment shows that the algorithm's performance is improved with populations of more than 40. In Eq. 8.19 one parameter α is used. This parameter is also treated as a convergence parameter, and the effect is analyzed over the glass and wine datasets, which are represented here in Figs. 8.5 and 8.6. The value of this parameter is chosen randomly, and fifth value is randomly selected between 0 and 1. The experiment shows that the algorithm's performance is improved if the value of α is set below 0.009. Another convergence coefficient involved in the rule-based statistical hypothesis for clustering is denoted in the proposed method as τ. This parameter actually effects the automatic cluster formation, which directly affects clustering accuracy. The consequences of the τ parameter for different values are experimented over the glass and sonar datasets. The values are randomly selected for an experiment on this convergence parameter. One value is selected randomly between 0 and 0.00001. The effects of the experiment with different values for these two datasets are depicted in Figs. 8.7 and 8.8. It is easily observed from the experiment that if this parameter value is less than 0.001, the algorithm performs better.

Wine dataset clustered with bat algorithm

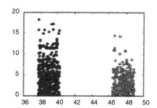

Diabetes dataset clustering with bat algorithm

Glass dataset clustered with bat algorithm

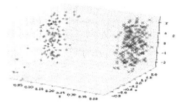

Ionosphere dataset clustered with bat algorithm

Sonar dataset clustering with bat algorithm

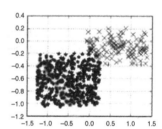

Synthetic_2 dataset clustering with bat algorithm

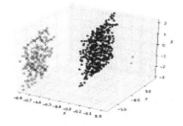

Synthetic_1 dataset clustering with bat algorithm

Synthetic_3 dataset clustering with bat algorithm

■ FIGURE 8.2 Synthetic and real-life benchmark dataset clustering using proposed method.

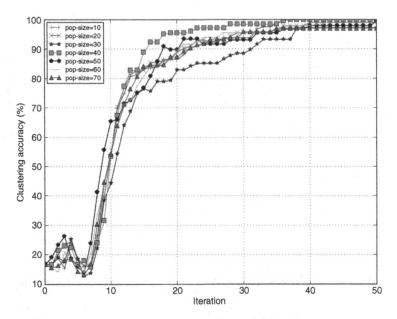

■ **FIGURE 8.3** The effect on clustering accuracy over glass dataset due to different population size.

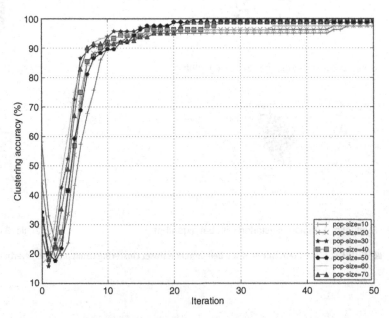

■ **FIGURE 8.4** The effect of clustering accuracy over sonar dataset due to different population size.

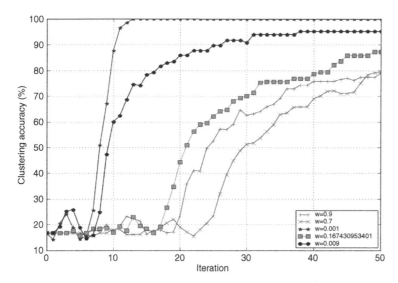

■FIGURE 8.5 The effect of the α parameter in clustering accuracy accuracy for the glass dataset.

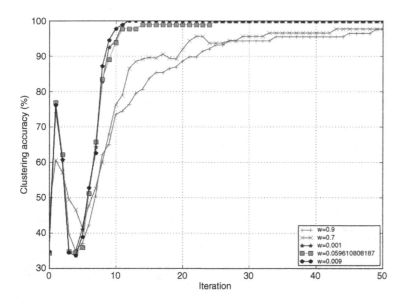

■FIGURE 8.6 The effect of the α parameter in clustering for the wine dataset.

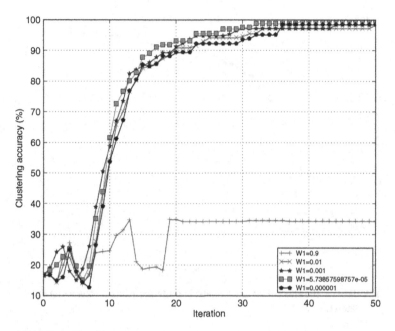

■ **FIGURE 8.7** The effect of τ(w1) over the glass dataset.

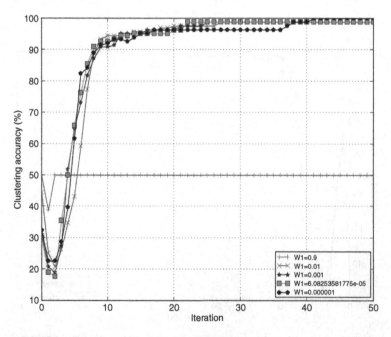

■ **FIGURE 8.8** The effect of τ(w1) over the sonar dataset.

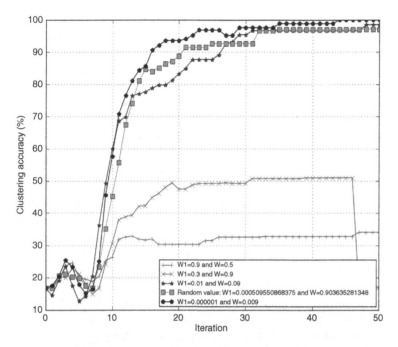

■ **FIGURE 8.9** The convergence behavior of bat algorithm-based clustering over a different combination of parameters for the glass dataset.

Next the experiment is performed with a fixed population size and varying values of τ and α. In order to perform this experiment, the value of both these parameters is fixed with different combinations and then the experiment is run for 50 iterations. So, for each set of values, the experiment is performed over 50 independent runs. The experiment showed that the combination of the high value of α and low value of τ enhanced the convergence rate. Fig. 8.9 shows that if the combination of values $\tau = 0.000001$ and $\alpha = 0.009$ are fixed, then the convergence of the proposed method is improved over any other combination. The deterioration of the convergence is observed with the wrong combination of convergence parameters. In order to achieve the best convergence result, the value of τ must be set to less than 0.01. With this value of τ, the value of α is set within the range of $0.009 \leq \alpha < 0.09$.

5 IMAGE SEGMENTATION

The process of partitioning the image into a group of continuous and similar types of regions is considered image segmentation. Image segmentation is the basis for many applications which are related to the process of image

analysis. Image segmentation is widely applied in the fields of gene analysis, biomedicine, computer vision, remote sensing, and others. Segmentation of an image is performed on the basis of the image pixels, which are treated as a pattern or vector in clustering. Hence image segmentation may be considered a clustering of the image (Jain et al., 1999). The clustering of a dataset is performed through various algorithms, some of which belong to the hybrid implementation strategies where two or more processes are embedded to perform the clustering task. Within this hybridization category, some are inspired by swarm intelligence and the rest belong to the general standard algorithm. Swarm intelligence or nature-inspired optimization algorithm–based clustering is performed automatically, with no information about cluster class or cluster center required. The proposed BA-based clustering is an automatic clustering algorithm. In the case of image segmentation, this algorithm is based on the SSE. Standard algorithms are used here to compare the performance of the proposed method and they are classical PSO-based clustering (Omran et al., 2005a,b), clustering based on the cuckoo search (CS) (Senthilnath et al., 2012), and the classical FF clustering algorithm (Hassanzadeh, 2012; Senthilnath et al., 2011; Abshouri and Bakhtiary, 2012; Horng and Jiang, 2010) based on color image segmentation. Each of those algorithms is performed on the color image segmentation based on the SSE measure.

5.1 Experimental details

The proposed automatic BA-based clustering is compared with three different sets of automatic clustering algorithms. The classical PSO, CS, and FF optimization method automatic clustering algorithms are compared with the proposed method to cover the broad range of comparison. The SSE-based clustering measure is adapted to design PSO, CS, and FF-based image clustering algorithms. The proposed bat and other three comparative automatic image segmentation algorithms are designed with two objectives:

1. Color image clustering is performed on each benchmark color image and each algorithm to try to find a maximum number of segments in the color image.
2. The SSE is applied to measure the segmentation performance. It is measured according to Eq. (8.9). Each algorithm is targeted to achieve a minimum SSE value within a finite number (10) of iterations; otherwise, the algorithms are terminated.

The classical PSO, CS, FF, and proposed bat-inspired automatic color segmentation algorithm is applied over four benchmark color images of 200 × 200 size (image data: http://www.eecs.berkeley.edu/Research/Projects/CS/vision/grouping/segbench/; Martin et al., 2001). The RGB

Table 8.4 Parameter Details

Bat Algorithm	Classical PSO	Classical Cuckoo Search	Classical Firefly Algorithm
Population size = 40	Population size = 40	Population size = 40	Population size = 40
Maximum iterations = 10	Maximum iterations = 10	Maximum iterations = 10	Maximum iterations = 10
SSE threshold = 5.0	SSE threshold = 5.0	SSE threshold = 5.0	SSE threshold = 5.0
$\tau = 0.09$	$c_1 = 0.2$	$c_1 = 12.5$	$c_1 = 0.09$
$\alpha = 0.009$	$c_2 = 0.5$	$c_2 = 3$	$c_2 = 0.009$
	Initial weight = 0.75		Initial weight = 0.5

value of each pixel serves as a feature for the segmentation process. The dimension of the data is 3, and the number of data items is 40,000, which is very high. In the case of color mapping, the clustered datasets are compared with a fixed number of previously defined color ranges. The mean of the R, G, and B values of each segment is compared with the 646 numbers of the previously defined color ranges on the basis of Euclidean distance measurement. So a color from the defined color list is selected for a segment on the basis of the minimum Euclidean distance between the mean RGB of a color from a color list and the mean of all RGB values of a cluster. The algorithms considered for comparison with the proposed method consist of many parameters, and the experiment is performed on various sets of parameter settings. The best observable parameter settings are reported in Table 8.4. The number of different clusters found by the algorithms is reported in Table 8.5. An improved segmentation result is achieved on five benchmark images for four algorithms using those parameter settings. The experiment on segmentation is based on the SSE measure, and 40 independent runs are performed on each benchmark images for a maximum of 10 iterations. The mean and *SD* (in brackets) of SSE are reported in Table 8.6. In Table 8.7, the unpaired *t*-test is performed between the best and the second-best result of the SSE reported in Table 8.6. The standard error and 95% confidence interval of two

Table 8.5 Number of Clusters Found Over Five Benchmark Color Image Using SSE-Based Fitness Function

Image	Bat Algorithm	Classical PSO	Classical Cuckoo Search	Classical Firefly Algorithm
Bird	24 (2.5159)	3 (0.6)	34 (2.2017)	32 (2.4789)
Church	53 (4.1945)	4 (0.8062)	36 (1.7269)	34 (2.0340)
Duck	42 (1.7732)	5 (0.4841)	37 (1.5169)	37 (1.7097)
Mushroom	49 (2.4534)	4 (0.43301)	36 (1.8991)	35 (2.2620)
Plane	31 (1.5650)	8 (1.3543)	37 (1.1913)	37 (1.3228)

Mean and standard deviation of the number of clusters found in 40 independent runs.

Table 8.6 Automatic Clustering Result Over Five Benchmark Color Image Using SSE-Based Fitness Function

Image	SSE-Based Measure			
	Bat Algorithm	Classical PSO	Classical Cuckoo Search	Classical Firefly Algorithm
Bird	3.74 (0.2491)	27.08 (9.3108)	20.6896 (0.7456)	21.8032 (0.5759)
Church	4.0703 (0.1393)	39.3078 (5.1825)	38.7041 (0.3259)	39.3135 (0.3501)
Duck	3.9425 (0.12117)	33.7213 (4.3278)	36.3765 (0.53291)	35.5444 (0.5057)
Mushroom	3.7851 (0.11067)	30.8237 (0.12813)	30.1978 (0.3697)	29.0045 (0.5221)
Plane	4.17122 (1.5650)	28.2579 (8.4460)	25.0365 (0.5746)	26.8557 (0.7451)

Mean and standard deviation of the number of clusters found in 40 independent runs.

Table 8.7 Results of the Unpaired *t*-Test Calculated in Between the Best and Second-Best Performing Algorithm for Segmentation of Each Image Based on the SSE Measure Shown in Table 8.6

Image	Standard Error	*t*-Test	95% Confidence Interval	Two-Tailed *P*	Significance
Bird	0.12	136.37	−17.197 to −16.702	<0.0001	Extremely significant
Church	0.06	618.03	−34.745 to −34.522	<0.0001	Extremely significant
Duck	0.69	43.5	−31.141 to −28.415	<0.0001	Extremely significant
Mushroom	0.08	298.86	−25.387 to −25.051	<0.0001	Extremely significant
Plane	0.26	79.16	−21.390 to −20.340	<0.0001	Extremely significant

values are also reported in Table 8.7. In Table 8.8, the original benchmark color images and the respective segmented color images are reported. The segmented image is the result of the best segmentation performed over all the iterations in 40 independent runs, and it is saved by each of the four algorithms automatically at the end of iterations.

5.2 Analysis image segmentation result

It can be easily observed from Table 8.6 that the color image segmentation result of the proposed method outperforms all the compared algorithms over the five images used here. The original image and the segmented one is reported in the Table 8.8. The proposed method captures all the possible segments that exist within the image and in comparison to others. The proposed one finally reached an SSE threshold value within a minimum number of iterations for five benchmark images used here for the experiment. The minimum number of iterations is the significance of fast segmentation, and the *SD* is also very stable for each image except the bird image. Other algorithms required more number of iterations to overcome the predefined SSE threshold value. The maximum iteration number is 10 and 40 number of the independent run are performed over each image. So, in Table 8.8, the

Table 8.8 Results of Color Image Segmentation Performed by Bat, PSO, Cuckoo Search, and Firefly Algorithms

Image	Original Image	Segmented Image and Mean and Standard Deviation of Required Number of Iterations in 40 Independent Runs			
		Bat	PSO	CS	FF
Bird		3.97 (0.1665)	9.0 (0.00001)	10 (0.00001)	10.0 (0.00001)
Church		5.0 (0.00001)	10 (0.00001)	10 (0.00001)	10.0 (0.00001)
Duck		5.0 (0.00001)	9.0 (0.00001)	10.0 (0.00001)	10.0 (0.00001)
Mushroom		5.0 (0.00001)	9.0 (0.000001)	10.0 (0.0001)	10.0 (0.00001)
Plane		4.0 (0.00001)	9.0 (0.00001)	10.0 (0.00001)	10.0 (0.00001)

mean and *SD* of the iteration is reported and as the maximum number of iterations is required for other algorithms (PSO, CS, and FF) hence the *SD* of the required iteration number is almost close to zero. According to the iteration numbers reported in Table 8.8, the proposed method requires fewer iterations for the segmentation of the five benchmark color images. Now, the church is visually understandable with the proposed method-based image segmentation. From close inspection, it is possible to see the segmentation effect on the sky color, but for the PSO, CS, and FF algorithms, the church segment is difficult to understand visually. In the case of the duck, bird,

and mushroom images, almost all algorithms have identified them properly (ie, the segments of the duck, bird, and mushroom images have been correctly identified by the algorithm). The plane image segmentation is also performed with the four algorithms, but close inspection reveals that the BA segmented the plane as well as the cloud of the respective image.

The experimental result shows that color image segmentation on the basis of the SSE measure with the automatic BA produces an improved output over the one to which it is compared. The results of BA, firefly, and PSO algorithm–based segmentation produce almost same output. It may be possible that PSO, FF, and CS algorithm–based segmentation needs a little more fine-tuning on their parameters and that more detailed experiments with CS and FF methods based color image segmentation is required. The experimental result shows that the CS, FF, and BA have the potential to meet the challenges of most standard algorithms. The algorithms are designed to find the segments of the church, duck, and mushroom in their respective images. From the results shown in Table 8.8, it can be seen that the segments are almost properly identified by the proposed method and that PSO-based image segmentation for the mushroom image segmentation produces a better result than the proposed one.

6 CONCLUSIONS

This work proposed a novel method of the automatic clustering method, known as the BA-based clustering technique. The method provides an almost accurate number of the clusters over every synthetic and real-life benchmarked linear and nonlinear dataset. The experimental results show that the proposed method produces an improved result which outperforms all the compared methods over the limited real-life and synthetic dataset used for the experiment. The proposed method incorporates a new rule-based statistical hypothesis method for clustering. This method is used here to judge the similarity between the two patterns, and this similarity measurement depends on a threshold value. The effect of this value is experimentally shown in Figs. 8.7 and 8.8. The effects of population size and other parameters are also analyzed, and an empirical way of choosing the best combination of parameter values for the BA-based clustering method is provided by means of a detailed experiment over different sets of parameter values. The values for different parameters are still selected based on the dataset on which it is applied, and it is done manually to achieve the best convergence. Future research should focus on the automatic and intelligent selection of the parameters of this algorithm so that it can be applied to any dynamic dataset clustering on real-time basis.

REFERENCES

Abshouri, A.A., Bakhtiary, A., 2012. A new clustering method based on firefly and KHM. Int. J. Commun. Comput. 9 (4), 387.

Airas, M., 2003. Echolocation in bats. In: Proceedings of Spatial Sound Perception and Reproduction, HUT Acoustics Laboratory.

Bezdek, J.C., 1981. Pattern Recognition With Fuzzy Objective Function Algorithms. Plenum Press, New York, NY.

Bhatia, S.K., Deogun, J.S., 1998. Conceptual clustering in information retrieval. IEEE Trans. Syst. Man Cybern. B 28 (3), 427–436.

Carpineto, C., Romano, G., 1996. A lattice conceptual clustering system and its application to browsing retrieval. Mach. Learn. 24 (3), 95–122.

Damodaram, R., Valarmathi, M.L., 2012. Phishing website detection and optimization using modified bat algorithm. Int. J. Eng. Res. Appl. 2 (1), 870–876.

Dasgupta, S., 2002. Performance guarantees for hierarchical clustering. In: 15th Annual Conference on Computational Learning Theory, pp. 351–363.

Ester, M., Kriegel, H.-P., Sander, J., Xu, X., 1996. A density-based algorithm for discovering clusters in large spatial databases with noise. In: Second International Conference on Knowledge Discovery and Data Mining, pp. 226–231.

Evangelou, I.E., Hadjimitsis, D.G., Lazakidou, A.A., Clayton, C., 2001. Data mining and knowledge discovery in complex image data using artificial neural network. Proceedings of Workshop Complex Reasoning on Geographic Data, Paphos.

Everitt, B.S., 1993. Cluster Analysis. Halsted Press, New York, NY.

Falkenaure, E., 1998. Genetic Algorithms and Grouping Problems. John Wiley and Sons, Chichester.

Forgy, E.W., 1965. Cluster analysis of multivariate data: efficiency versus interpretability of classification. Biometrics 21, 768–769.

Frigui, H., Krishnapuram, R., 1999. A robust competitive clustering algorithm with application in computer vision. IEEE Trans. Pattern Mach. Intell. 21 (5), 450–465.

Fukunaga, K., 1990. Introduction to Statistical Pattern Recognition. Academic Press, San Diego, CA.

Girolami, M., 2002. Mercer kernel-based clustering in feature space. IEEE Trans. Neural Netw. 13 (3), 780–784.

Handl, J., Knowles, J., 2005. Improving the scalability of multi-objective clustering. Proceedings of Congress in Evolutionary Computation (CEC 2005), vol. 3, pp. 2372–2379.

Hassanzadeh, T., 2012. A new hybrid approach for data clustering using firefly algorithm and k-means. In: 16th CSI International Symposium on Artificial Intelligence and Signal Processing (AISP).

He, Y., Hui, S.C., Sim, Y.X., 2006. A novel ant-based clustering approach for document clustering. In: Third Asia Information Retrieval Symposium (AIRS 2006), Singapore. Proceedings of Lecture Notes in Computer Science, Springer, Berlin, Heidelberg, pp. 537–544.

Hochbaum, D.S., Shmoys, D.B., 1985. A best possible heuristic for the k-center problem. Math. Oper. Res. 10 (2), 180–184.

Horng, M.H., Jiang, T.W., 2010. Multilevel image thresholding selection based on the firefly algorithm. In: 2010 Symposia and Workshops on Ubiquitous, Autonomic and Trusted Computing, pp. 58–63.

Huang, Z., Ng, M.K., 1999. A fuzzy k-modes algorithm for clustering categorical data. IEEE Trans. Fuzzy Syst. 7 (4), 446–452.

Jain, A.K., Dubes, R.C., 1988. Algorithm for Clustering Data. Prentice Hall, Englewood Cliffs, NJ.

Jain, A.K., Murty, M.N., Flynn, P.J., 1999. Data clustering: a review. ACM Comput. Surv. 31, 264–323, 3.

Judd, D., Mckinely, P., Jain, A.K., 1998. Large-scale parallel data clustering. IEEE Trans. Pattern Anal. Mach. Intell. 10 (8), 871.

Kennedy, J., Eberhart, R., 1995. Particle swarm optimization. In: Proceedings of IEEE International Conference on Neural Networks, pp. 1942–1948.

Kim, H.S., 2010. Bat intelligent hunting optimization with application to multiprocessor scheduling. PhD thesis, Case Western Reserve University.

Kohonen, T., 1995. Self-Organizing Maps. Springer Series in Information Science, vol. 30, Springer-Verlag, Berlin, Heidelberg.

Leung, Y., Zhang, J., Xu, Z., 2000. Clustering by space-space filtering. IEEE Trans. Pattern Anal. Mach. Intell. 22 (2), 1396–1410.

Lillesand, T., Keifer, R., 1994. Remote Sensing and Image Interpretation. John Wiley & Sons, New York, NY.

Maniezzo, V., Gambardella, L.M., Luigi, F.de., 2004. Ant colony optimization. Optimization Techniques in Engineering. Springer-Verlag, Berlin, Heidelberg, pp. 101–117.

Mao, J., Jain, A.K., 1995. Artificial neural networks for feature extraction and multivariate data projection. IEEE Trans. Neural Netw. 6, 296–317.

Martin, D., Fowlkes, C., Tal, D., Malik, J., 2001. A database of human segmented natural images and its application to evaluating segmentation algorithms and measuring ecological statistics. Proceedings of 8th International Conference in Computer Vision, pp. 416–423.

Mitchell, T, 1997. Machine Learning. McGraw-Hill, Inc., New York, NY.

Muller, K.R., Mika, S., Ratsch, G., Tsuda, K., Scholkopf, B., 2001. An introduction to kernel-based learning algorithms. IEEE Trans. Neural Netw. 12 (2), 181–202.

Murthy, C.A., Chowdhury, N., 1996. In search of optimal clusters using genetic algorithm. Pattern Recogn. Lett. 17, 825–832.

Niknam, T., Amiri, B., 2010. An efficient hybrid approach based on PSO, ACO and k-means for cluster analysis. Appl. Soft Comput. 10 (1), 183–197.

Omran, M., Engelbrecht, A., Salman, A, 2005a. Particle swarm optimization method for image clustering. Int. J. Pattern Recogn. Artif. Intell. 19 (3), 297–322.

Omran, M., Salman, A., Engelbrecht, A.P., 2005b. Dynamic clustering using particle swarm optimization with application in unsupervised image classification. In: Fifth World Enformatika Conference (ICCI 2005), Prague, Czech Republic.

Pal, N.R., Bezdek, J.C., Tsao, E.C.K, 1995. Generalized clustering networks and Kohonen's self-organizing scheme. IEEE Trans. Neural Netw. 4, 549–557.

Paterlinia, S., Krink, T., 2006. Differential evolution and particle swarm optimisation in partitional clustering. Comput. Stat. Data Anal. 50 (5), 1220–1247.

Paterlini, S., Minerva, T, 2003. Evolutionary approaches for cluster analysis. In: Bonarini, A., Masulli, F., Pasi, G. (Eds.), Soft Computing Applications. Springer-Verlag, Berlin, pp. 167–178.

Rao, M.R., 1971. Cluster analysis and mathematical programming. J. Am. Stat. Assoc. 22, 622–626.

Sarkar, M., Yegnanarayana, B., Khemani, D, 1997. A clustering algorithm using an evolutionary programming based approach. Pattern Recogn. Lett. 18, 975–986.

Scholkopf, B., Smola, A.J., 2002. Learning with Kernels. MIT Press, Cambridge, MA.

Senthilnath, J., Das, V., Omkar, S.N., Mani, V., 2012. Clustering using Lévy flight cuckoo search. In: Proceedings of the 7th International Conference on Bio-Inspired Computing: Theories and Applications (BIC-TA). Advances in Intelligent Systems and Computing, Springer India, pp. 65–75.

Senthilnath, J., Omkar, S.N., Mani, V., 2011. Clustering using firefly algorithm: performance study. Swarm Evol. Comput. 1 (3), 164–171.

Shukran, M.A.M., 2011. Artificial bee colony based data mining algorithms for classification tasks. Int. J. Modern Appl. Sci. 5 (4), 217–231.

van der Merwe, D.W., 2003. Data clustering using particle swarm optimization. Congress on Evalutionary Computation, CEC'03.

Vapnik, V.N., 1998. Statistical Learning Theory. Wiley, New York, NY.

Yang, X.-S., 2010. A new metaheuristic bat-inspired algorithm. In: Nature Inspired Cooperative Strategies for Optimization (NICSO 2010), Granada, Spain.

Yang, X.-S., 2011. Bat algorithm for multi-objective optimization. Int. J. Bio-Inspired Comput. 3 (5), 1–12.

Zhan, C.T., 1971. Graph-theoretical methods for detecting and describing gestalt clusters. IEEE Trans. Comput. 20, 68–80.

Zhang, D.Q., Chen, S.C., 2003. Clustering incomplete data using kernel based fuzzy c-means algorithm. Neural Process. Lett. 18, 155–162.

Zhang, R., Rudnicky, A.I., 2002. A large scale clustering scheme for kernel k-means. In: The Sixteenth International Conference on Pattern Recognition, pp. 289–292.

Multitemporal remote sensing image classification by nature-inspired techniques

J. Senthilnath*, X.-S. Yang**

*Geospatial Sciences Center of Excellence, South Dakota State University, Brookings, SD, United States;
**School of Science and Technology, Middlesex University, London, United Kingdom

Bio-Inspired Computation and Applications in Image Processing. http://dx.doi.org/10.1016/B978-0-12-804536-7.00009-0

1 INTRODUCTION

Floods are often regarded as the most detrimental natural disaster, accounting for nearly one-third of the worldwide disaster damage (Islam et al., 2009). Most countries, which suffer from the devastating effects of flood disasters have not adopted an efficient flood monitoring system. This has propelled many inquisitive researchers to develop different approaches for efficient flood monitoring. Nowadays, the most prominent tool for evaluating the damage caused due to floods is multitemporal satellite data because of its easy data acquisition and development of robust image processing techniques.

Extensive studies have been carried out during the past decades toward flood assessment using optical imagery. Analysis based on image segmentation has become the most preferred way of performing flood evaluation. For example, Shamaomaa et al. (2006) presented a segmentation-based analysis for flood assessment. In their study, rule-based and nearest-neighbor classifications are used to classify small objects in satellite images, like automobiles and buildings. High-resolution SPOT PAN satellite imagery has been employed for flood hazard management applications by Shaker and Yan (2010). Their study focused on different approaches for flood mapping, such as contextual and maximum likelihood classifiers to analyze PAN and SPOT imagery, respectively. Gianinetto et al. (2006) presented a work on flood damage evaluation using Landsat TM and ETM data. They applied the principal component analysis for image segmentation.

For an effective flood evaluation, the creation of a detailed land cover map is necessary. For this purpose, the usage of multitemporal satellite data is more appropriate because fewer channels can be used to represent the same spectral-spatial region (Stow, 2010). Multitemporal data acquired before, during, and after flood—three totally different datasets—were used in this study. Clustering and segmentation techniques were employed on the satellite data after analyzing spectral, spatial, and contextual information to extract flood-prone regions.

MODIS satellite data and images have been very handy in hydrological applications during the past decades. The easy availability of MODIS satellite images has propelled many researchers to work on flood detection, warning, damage assessment, and mitigation. MODIS is very efficient in discriminating lands from waters though it is a medium-resolution image sensor with a resolution of 250 m/pixel (Brakenridge and Anderson, 2006; Senthilnath et al., 2012). However, the linear feature extraction is complicated as some of the features, such as river courses and canals, can appear as simple lines in an image due to the medium resolution of MODIS. Currently, very few linear feature extraction algorithms are effective for

practical use. The challenges involved in extracting water-covered regions based on geometric features of rivers using multitemporal satellite data has attracted many researchers (Brakenridge and Anderson, 2006; Senthilnath et al., 2012). The main challenge in using these algorithms is to achieve highly reliable results, independent of the image used. Different types of linear feature extraction techniques, including pixel-based, region-based and knowledge-based methods, have been employed (Nevatia and Babu, 1980; Mingjun and Daniel, 2004).

Most of the conventional methods for flood assessment based on image segmentation follow a pixel-by-pixel analysis. Islam et al. (2009) presented a flood inundation mapping based on normalized difference water index (NDWI). Spectral information of MODIS band 4 and 5 are used for the calculation of NDWI. Zhan et al. (2002) proposed a vegetative cover conversion algorithm for land cover analysis of the Thailand–Laos flood region. Khan et al. (2011) employed ISODATA algorithm for the classification of flooded and nonflooded regions using MODIS data. Sakamoto et al. (2007) carried out an extensive research on detecting temporal changes using MODIS time-series data. They employed the enhanced vegetation index (EVI) and the land–water surface index to produce time-series inundation maps. However, the image segmentation techniques based on spectral information can lead to misclassification, if the image segments have very close spectral characteristics. Pixel-based methods that use spectral information do not account for extraction based on spatial features. Hence, the extraction of linear features based on a pixel-by-pixel approach to interpret the image does not provide accurate results (Boggess, 1993; Roberts et al., 2001).

In the past decades, spatial information–based region segmentation algorithms have been used for image classification by including neighborhood information (Roberts, 1970; Tilton, 1989). Most of these methods on their own do not lead to very accurate results (Mancas et al., 2005; Wilson and Spann, 1988). Therefore, McKeown et al. (1985) and Zhu and Yeh (1986) applied heuristic reasoning and knowledge-based techniques to evaluate linear features like the shape index, distance between image primitives, and contextual information. The study done by Senthilnath et al. (2009) involved connecting the image primitives or antiparallel linear edges to linear segments.

Other researchers have incorporated both spectral and spatial information for feature extraction using high-resolution images with promising results (Baatz and Schape, 2000; Sande et al., 2003). For example, Mingjun and Daniel (2004) successfully extracted road features by using a combined approach of pixel-based classification, region-based segmentation, and knowledge-based techniques for evaluating geometric features like shape

and density index. Jarabo et al. (2011) presented a mean shift segmentation considering both spectral and spatial domain for image classification. Spectral-spatial information is integrated in order to improve the accuracy of extraction of image end members in hyperspectral data (Rogge et al., 2007; Tarabalka et al., 2009). Another work on application of spectral-spatial fusion was done by Qiu (2009). In his study, blocky artifacts in the satellite image were reduced by integrating spectral and spatial information.

A different class of algorithms called nature-inspired techniques, including the genetic algorithm (GA), particle swarm optimization (PSO), and the firefly algorithm (FA) (Omkar et al., 2007; Senthilnath et al., 2011; Craig et al., 2012), can provide a set of potential solutions and identify the optimal solution through collaboration and contest among the individuals of the population. These techniques show better convergence to global optima in comparison with traditional optimization methods, which are prone to local optima. However, these algorithms can be more accurate compared to the aforementioned classification techniques. Therefore, today, nature-inspired algorithms have become more popular than some of the conventional optimization methods because of their simplicity, parallelism, and quick convergence of the population toward the best solution in a given search space.

A GA is one such family of adaptive search methods and has found its application in image segmentation. Since GA does not require the gradient information, it has wide applicability and therefore is suitable for many engineering applications. Bosco (2001) used a genetic approach for image segmentation, which was considered as a global optimization problem. GA was proposed for storm flood risk management by Jiafu et al. (2011). Another similar work on flood forecasting has been done by Wu and Chau (2006) using the GA.

PSO is another famous population-based technique. PSO has been quite efficient in optimizing multimodal problems. Nagesh and Janga (2007) presented multipurpose reservoir system operation using PSO. Also, Omran et al. (2006) made use of the PSO algorithm for image classification. In their work, remote sensing data and magnetic resonance imaging images were classified based on spectral features better than any existing image quantization technique. Huang and Zhang (2011) proposed multiswarm cooperative PSO for flood disaster assessment. GA and PSO have been applied successfully on image considering spectral information.

Recently, the FA has become one of the most popular population-based methods. It has been found to be more efficient in evaluating global maxima/minima for a diverse set of benchmark functions in comparison with the previously mentioned techniques (Yang, 2010). In addition, the FA is also a derivative-free method, which does not require gradient information, and

thus has wider applicability. Also, the FA is known to demonstrate robust capability in solving problems of data clustering (Senthilnath et al., 2011).

In this study, a combined approach of pixel-based optimization, region-based segmentation, and knowledge-based shape extraction is used for flood extent evaluation. This approach has been used for automatic extraction of river networks (before and after flood image) and evaluating floods (during flood image) using multitemporal MODIS data. This is the extension of the work by Senthilnath et al. (2013b). The nature-inspired techniques, GA, PSO, and FA, are used to cluster the satellite data based on spectral information or pixel intensity, to group the entire image into two clusters: water-covered regions and nonwater regions. A clustering algorithm takes only the spectral features into account, which might possibly lead to misclassification. The nonwater regions with the similar spectral reflectance will also be classified into the water group if the clustering algorithm alone is used. Hence, this inconsistency is resolved by region-based image segmentation to extract shape and area information of water-covered regions, which employs the spatial features of an image to differentiate between a true water region and a misclassified water region. The shape features are then evaluated to differentiate water segments from nonwater segments. The results of three unsupervised clustering techniques are compared to assess the best one. Further, the conventional method (K-means) is compared with GA, PSO, and FA for before-flood images. Finally, the performance of the proposed combined approach is evaluated using quality measures.

The remainder of this chapter is structured as follows: Section 2 describes the problem formulation with an illustrative example. Section 3 explains the methodology behind each of the image clustering algorithms. Section 4 discusses the performance measures used for comparing different clustering algorithms. The study area and experimental results are explained in Section 5, and the study concludes in Section 6.

2 PROBLEM FORMULATION

For a given optimization problem, it is necessary to find the most optimal solution, though it may not always possible to find the true optimality. Quite often, clustering algorithms involve global optimization (Senthilnath et al., 2011, 2013b) and local optimization (Senthilnath et al., 2013a) to partition the given dataset into a certain number of groups. The data points of the particles which share similar features are grouped together. In this work, the spectral feature of an image pixel is grouped based on a proper similarity measure. Pixel values refer to each pattern in a class which can be grouped using clustering techniques. The best solution for these clustering techniques is found using a fitness function (ie, a similarity measure).

A particle x is defined by its cluster centers as $x_i = \{m_{i1}, m_{i2}, \ldots, m_{ij}, \ldots, m_{iN}\}$ where N is the number of clusters and m_{ij} refers to jth cluster center of ith particle. For each particle x_i, the fitness function is described as follows (Omran et al., 2006):

$$f(x_i, Z_i) = w_1 d_{\max}(Z_i, x_i) + w_2 (Z_{\max} - d_{\min}(x_i)) \tag{9.1}$$

where Z_i is a matrix of pixel assignment to the clusters of ith particle, Z_{\max} is $2^s - 1$ for an s-bit image, and w_1 and w_2 are the inertia factors set by the user. In addition, d_{\max} can be also calculated by

$$d_{\max}(Z_i, x_i) = \max_{\forall z_p \in C_{i,j}} \sum d(Z_{p,m_{ij}}) / |C_{ij}| \tag{9.2}$$

which represents the maximum Euclidean distance of particles to their associated clusters. Here, C_{ij} is used to denote the ith cluster of the ith particle.

$$d_{\min}(x_i) = \min_{\forall j_1, j_2, j_1 \neq j_2} d(m_{ij_1}, m_{ij_2}) \tag{9.3}$$

where d_{\min} signifies the minimum average Euclidean distance between any pair of clusters.

For a given fitness function, w_1 and w_2 are the weights given for intercluster distance and intracluster distance, respectively. The best solution is the one which has the highest intercluster distance and the lowest intracluster distance. Hence, the inertia factors play an important role in image clustering. In this work, the spectral characteristics of different regions are used for clustering.

However, the reflectance properties of some of the nonwater regions are similar to those of water regions. This affects the clustering results of water regions. To overcome this problem, some researchers have adopted region-based segmentation to extract geometric features which can then be used to improve the clustering result. In this study, it is observed that rivers are lengthy and have relatively thin structures compared to nonriver regions. This clear distinction is used for reliable segmentation. To achieve this purpose, the image is divided into different regions using a simple region-growing technique. The region distinction can be binary (ie, the pixels corresponding to water is classified as white and nonwater pixels as black). Subsequently, the geometric parameters will be calculated and used to segment water and nonwater regions. In this work, the two geometric parameters considered are: shape index (SI) and density index (DI) (Mingjun and Daniel, 2004; Senthilnath et al., 2012).

The SI can be defined as

$$\text{SI} = \frac{P}{4\sqrt{A}} \tag{9.4}$$

where P is the perimeter of the image object and A is the area of the segmented region (or total number of pixels in the segmented image object).

The DI can be defined as

$$DI = \frac{\sqrt{A}}{1 + \sqrt{\mathrm{var}(X) + \mathrm{var}(Y)}} \qquad (9.5)$$

where N is the total number of pixels inside the region, $\mathrm{var}(X)$ and $\mathrm{var}(X)$ are the variance of X coordinates and Y coordinates of all the pixels in the region, respectively. Here, $\sqrt{\mathrm{var}(X) + \mathrm{var}(Y)}$ is an estimate of the approximate radius of the image object. Suitable thresholds of SI and DI are employed to classify the regions into water and nonwater regions.

2.1 Illustrative example

Before we present the proposed method in detail, let us use an illustrative example to show the need for spectral and spatial information for extracting water regions using multitemporal MODIS data (before, during, and after flood).

Though several clustering algorithms help in solving multimodal optimization problems, in the case of flood mapping, some nonwater regions may be also classified as water regions due to similar spectral features. Hence, adopting the SI and DI would effectively distinguish between water and nonwater regions.

Here we present an illustrative example taking a sample portion of the before-flood MODIS image shown in Fig. 9.1a, which is clustered in Fig. 9.1b as river and nonriver regions using a clustering algorithm. Fig. 9.1c shows the improvement over a spectrally clustered image using spatial information (SI and DI). The extracted river is shown in Fig. 9.1d.

Fig. 9.2 represents a 12×10 image portion with grayscale intensities. A clustering algorithm is applied on an image using the fitness function as discussed in Eq. (9.1). Regions clustered as river are represented by 1, and nonriver regions are represented by 2. Consequentially, the clustered matrix of the image matrix is shown in Fig. 9.3. From the Fig. 9.3, the portion between spatial coordinate, ie, (55, 346) and (353, 60) that contains 1 corresponds to misclassified river regions. To avoid discrepancies due to similar spectral features, SI and DI, as mentioned in Eq. (9.4) and Eq. (9.5), are applied on the clustered image. SI and DI being spatial parameters, resolve the issues associated with spectral inconsistency. The resulting segmented image matrix is shown in Fig. 9.4.

When we consider image clustering of river regions based on spatial features, rivers usually have larger perimeters and lesser area compared to other land cover types. So we use the spatial parameters—SI and DI to

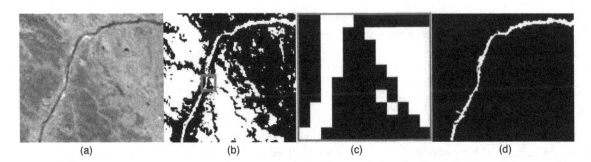

<p style="text-align:center">(a) (b) (c) (d)</p>

■ **FIGURE 9.1** (a) Before flood MODIS image; (b) clustered image; (c) subset employed for the spatial analysis of flood extraction; and (d) river extracted using region based segmentation.

Pixel coordinates	49	50	51	52	53	54	55	56	57	58	59	60
345	179	169	112	76	135	154	163	157	144	141	143	143
346	196	215	110	74	145	159	139	127	133	138	138	132
347	233	209	107	88	150	168	142	126	124	119	113	108
348	241	185	93	99	149	172	147	127	126	111	103	103
349	209	166	89	117	152	166	156	142	134	118	111	113
350	195	165	99	147	174	165	160	151	144	132	126	123
351	208	54	101	164	195	175	156	138	143	138	129	120
352	196	119	110	165	185	180	158	141	139	143	130	118
353	161	88	132	168	160	175	168	169	156	163	148	134
354	125	108	143	176	162	149	149	150	149	153	149	148

■ **FIGURE 9.2 Small portion of before-flood MODIS image.**

Pixel coordinates	49	50	51	52	53	54	55	56	57	58	59	60
345	2	2	1	1	1	2	2	2	2	2	2	2
346	2	2	1	1	2	2	1	1	1	1	1	1
347	2	2	1	1	2	2	2	1	1	1	1	1
348	2	2	1	1	2	2	2	1	1	1	1	1
349	2	2	1	1	2	2	2	2	1	1	1	1
350	2	2	1	2	2	2	2	2	2	1	1	1
351	2	2	1	2	2	2	2	1	2	1	1	1
352	2	1	1	2	2	2	2	2	1	2	1	1
353	2	1	1	2	2	2	2	2	2	2	2	1
354	1	1	2	2	2	2	2	2	2	2	2	2

■ **FIGURE 9.3 Clustered image matrix.**

Pixel coordinates	49	50	51	52	53	54	55	56	57	58	59	60
345	2	2	1	1	1	2	2	2	2	2	2	2
346	2	2	1	1	2	2	2	2	2	2	2	2
347	2	2	1	1	2	2	2	2	2	2	2	2
348	2	2	1	1	2	2	2	2	2	2	2	2
349	2	2	1	1	2	2	2	2	2	2	2	2
350	2	2	1	2	2	2	2	2	2	2	2	2
351	2	2	1	2	2	2	2	2	2	2	2	2
352	2	1	1	2	2	2	2	2	2	2	2	2
353	2	1	1	2	2	2	2	2	2	2	2	2
354	1	1	2	2	2	2	2	2	2	2	2	2

■ **FIGURE 9.4** Region-based segmented image matrix after clustering.

extract river regions. From the clustered image matrix shown in Fig. 9.3, we can observe that some of the nonwater region pixels are also classified as water pixels because of similar spectral information. From Figs. 9.3 and 9.4, we can see that in clustered image matrix, there are 31 misclassified water region pixels, out of which, 19 pixels constitute the perimeter. SI is calculated using Eq. (9.4) and it found to be 0.8531. Variance of X coordinates of misclassified region (var$[X]$) is 2.2473 and variance of Y coordinates of misclassified region (var$[Y]$) is 4.6129. Upon computing DI using Eq. (9.5), we get DI as 1.5384.

The region classified properly as a water region, has an area of 19 pixels and also a perimeter of 19 pixels. Hence, SI of this region is 1.0897 and DI equal to 1.0131. From the illustration, it is quite obvious that river regions have higher SI because of the longer perimeter and lesser area. Similarly, DI is less for river regions because of their large distance coverage. Thus, a suitable ratio of SI to DI is set as the threshold to distinguish between river regions and nonriver regions. The region segments whose SI/DI ratio is higher than the threshold are classified as river regions, and those with a lesser ratio are classified as nonriver regions.

3 METHODOLOGY

Swarm intelligence–based algorithms have become popular in recent years due to their simplicity and flexibility (Yang, 2011; Yang et al., 2011). In this section, an approach for flood detection and mapping is presented in two stages: in the first stage, GA, PSO, and FA are used for spectral-level analysis, and in the second stage, spatial information is evaluated using SI

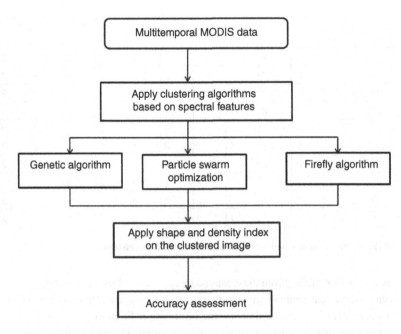

■ **FIGURE 9.5 Flowchart of proposed methodology.**

and DI. The resultant images are subsequently classified into flooded and nonflooded regions. Our proposed methodology is depicted in Fig. 9.5.

3.1 **Genetic algorithm**

The GA is an optimization technique inspired by the principles of natural evolution. It is a population-based stochastic search. In GA, a solution for a given optimization problem is evaluated using a fitness function for each individual in complex and large search spaces. Cluster centers are encoded using strings or chromosomes, and the collection of such chromosomes is termed as population. Primarily, a random population of different locations/points is initialized/created within the search space. To test the optimality of a chromosome as the best solution to the given problem, the fitness values for each chromosome of the population have to be evaluated (Senthilnath et al., 2013b).

These chromosomes are then subjected to genetic operators, such as reproduction, crossover, and mutation, so as to produce a better population. The process of reproduction, crossover, and mutation lasts for a preset number of generations. The chromosome which has the best fitness value in the final generation is the solution to a given optimization problem, though there is no guarantee that the optimality found is truly the optimal solution to the problem.

The genetic operators used in this study are (Senthilnath et al., 2013b):

1. *Reproduction.* A few chromosomes are selected from the population governed by the concept of survival of the fittest in natural genetic systems. This is usually based on the fitness of the individual. A certain fraction of the entire set of chromosomes in the population having the best fitness values is selected for the next generation.
2. *Crossover.* This is a probabilistic process which involves two parent chromosomes to generate two child chromosomes. Again, a certain fraction of child chromosomes needed for the next generation are created using this operator. In our study, single-point crossover is used. For an *l*-length cluster center value, a crossover point (a random integer) is generated in the range $[2, l-1]$. The portions of the cluster center value which are positioned to the right of the crossover point are swapped between the cluster centers of any two randomly selected parent chromosomes to produce two offspring.
3. *Mutation.* Unlike crossover, this probabilistic operator involves a single parent chromosome to generate a child chromosome for the next generation. This is controlled by a mutation probability. To create a child chromosome, small (compared to the range of search space) random numbers are added or subtracted (with equal probability) to each cluster center of the parent chromosome. While adding the random numbers, care should be taken so that the new cluster center value lies within the limits of the design variables/parameters in the search space.

The steps involved in image segmentation using GA are summarized next (Senthilnath et al., 2013b).

1. Initialize randomly a population of *n* chromosomes within *d*-dimensional cluster centers, x_{ik}, where $i = 1, 2, ..., n$ and $k = 1, 2, ..., d$.
2. For $i = 1$ to maxIterations
 - For each chromosome x_{ik},
 - Evaluate the fitness for each chromosome using Eq. (9.1).
 - Apply elitism by sorting the fitness value of the population.
 - *Reproduction*: Retain the best fitness value based on a predefined reproduction rate.
 - *Mutation*: Generate a new chromosome based on a mutation rate, perturb these chromosomes nearest to its position, and retain the best position by evaluating its fitness.
 - *Crossover*: The chromosomes selected by a predefined crossover probability undergo crossover with other chromosomes.
3. The best (fittest) solution from the population is selected as the cluster center.

4. Apply SI and DI as defined in Eqs. (9.4) and (9.5) to the GA clustered image.
5. Finally, classify the water and nonwater regions based on the threshold set for the spatial features.

3.2 Particle swarm optimization

PSO is a stochastic optimization technique inspired by the swarming behavior of bird flocks or fish. Kennedy and Eberhart (1995) developed this population-based algorithm. Some years later, PSO was applied to image segmentation by Omran et al. (2006). Results of their study revealed that PSO performed better than fuzzy C-means and K-means.

In PSO, each particle flies through the search space with a varying location and velocity. Local best (or individual best) is the solution that each particle visited so far in the search space. Global best is the overall best solution found so far by the entire swarm of particles. Each particle is evaluated based on the fitness function as mentioned in Section 2. The main characteristics associated with each particle in the swarm are: (1) x_i: current position of the particle; (2) v_i: current velocity of the particle; and (3) y_i: personal best position of the particle. These parameters vary with the iteration or time counter t.

The fitness function evaluates the local best position, which is obtained as follows (Omran et al., 2006):

$$y_i(t+1) = \begin{cases} y_i(t), & \text{if } f(x_i(t+1)) \geq f(y_i(t)) \\ x_i(t+1), & \text{otherwise.} \end{cases} \quad (9.6)$$

The global best solution takes into account all the local best solutions, as shown next:

$$y(t) \in \{y_0(t), y_1(t), y_2(t)...y_n(t)\} = \min\{f(y_0(t)), f(y_1(t)),...f(y_n(t))\} \quad (9.7)$$

where n is the size of the swarming population. The velocity and position of each particle are updated as follows (Omran et al., 2006):

$$v_{i,j}(t+1) = wv_{i,j}(t) + c_1 rand()(y_{i,j}(t) - x_{i,j}(t)) + c_2 rand()(y_j(t) - x_{i,j}(t)) \quad (9.8)$$

$$x_i(t+1) = x_i(t) + v_i(t+1) \quad (9.9)$$

where $v_{i,j}(t)$ is the jth element of velocity vector of ith particle. The first component of particle velocity is the inertia component, the second is the cognitive component, and the third is the social component. Normally, the updating of the velocity component is terminated after the maximum

number of iterations or when the velocity update is negligibly small. $y_{i,j}(t)$ is the personal best position of the particle, and $y_i(t)$ is the global best solution found in that iteration "t."

The PSO for image segmentation is summarized as shown next:

1. Initialize n particles within d-dimensional cluster centers randomly, x_{ik}, where $i = 1, 2, ..., n$ and $k = 1, 2, ..., d$.
2. For $t = 1$ to maxIterations
 - For each particle x_{ik},
 * For each pattern z_p, calculate its Euclidean distance to all the cluster centers. Each pixel intensity value or pattern is assigned to a cluster to which it has the least Euclidean distance.
 * Objective function (fitness function) is calculated using Eq. (9.1).
 - Based on the fitness value, individual best and global best solutions are updated using Eqs. (9.6) and (9.7), respectively.
 - Now cluster centers are updated with their velocity and position using Eqs. (9.8) and (9.9), respectively.
3. Apply SI and DI as defined in Eqs. (9.4) and (9.5) to the PSO clustered image.
4. Finally, classify the water and nonwater regions based on the threshold set for the spatial features.

3.3 Firefly algorithm

The FA (Yang, 2008, 2010) is also a swarm-based algorithm inspired by the flashing behavior of fireflies. This algorithm is also used to find the global optima of a given objective function or even for multiobjectives (Yang, 2013). In FA, fireflies are randomly distributed in the search space initially. Each firefly carries a luminescence quantity, known as luciferin, that emits light proportional to the fitness value. The brighter flash (better fitness value) is converted into the attraction between neighboring fireflies. The decrease in attractiveness is due to the increase in distance between fireflies. Also, a firefly will move randomly if it does not find a brighter firefly among its neighbors. In the application of the FA to image clustering, the decision variables are cluster centers. The objective function is measured using Eq. (9.1).

Based on this objective function, initially all fireflies are randomly distributed within the search space. The two steps involved in firefly algorithm are:

1. *Variation of light intensity.* The intensity level of light is related to the objective function values (Yang, 2008; Senthilnath et al., 2011). For a given maximization or a minimization problem, a firefly will attract another firefly proportional to its light intensity. Consider a swarm of

n fireflies. Let x_i denote a position for a firefly i and $f(x_i)$ represent the fitness value of x_i (Yang, 2008; Senthilnath et al., 2011).

$$I_i = f(x_i), \qquad 1 \leq i \leq n \tag{9.10}$$

where I_i stands for the brightness of firefly i for a given position x and fitness value $f(x_i)$.

2. *Firefly movement based on attractiveness.* The attractiveness of the firefly is proportional to the light intensity as perceived by other neighboring fireflies. The strength of a firefly to attract the other members of its swarm is denoted in this study as β. However, note that the term β is relative in terms of variation with the distance r_{ij} between fireflies i and j.

$$r_{ij} = \| x_i - x_j \| \tag{9.11}$$

where x_i and x_j are used to denote the location of two fireflies i and j, respectively.

The attractiveness function $\beta(r)$ can be expressed from Yang (2008) and Senthilnath et al. (2012) as

$$\beta(r) = \beta_0 e^{-\gamma r^2} \tag{9.12}$$

where β_0 is the attractiveness at $r = 0$ and γ is a fixed light absorption coefficient.

The position $x_i(t + 1)$ of a firefly i attracted to another firefly j located at x_j is updated as

$$x_i(t+1) = x_i(t) + \beta_0 e^{-\gamma r^2} [x_j(t) - x_i(t)]. \tag{9.13}$$

A more detailed explanation of the FA is given in Yang (2008) and Senthilnath et al. (2012).

The FA for image segmentation is summarized as shown next:

1. Initialize n fireflies within d-dimensional cluster centers randomly, x_{ik}, where $i = 1, 2, ..., n$ and $k = 1, 2, ..., d$.
2. Evaluate fitness value of the population using Eq. (9.1).
3. For $t = 1$ to maxIterations
 - For $i = 1$ to n
 * For $j = 1$ to n
 • if ($I_i < I_j$)
 • Move firefly i toward j using Eq. (9.13).
 • end if
 • Vary the attractiveness with distance r.

- Evaluate new results and update the value of light intensity using Eq. (9.10).
- Find the current best after ranking the fireflies.

4. Apply SI and DI as defined in Eqs. (9.4) and (9.5) to the FA clustered image.

5. Finally, classify the water and nonwater regions based on the threshold set for the spatial features.

Image clustering based solely on spectral reflectance may provide less accurate results, irrespective of the fitness function being used, as discussed in the illustrative example. This makes it necessary to consider spatial features as well. Hence, SI and DI (shape information) are used in conjunction with pixel-based clustering techniques for object extraction, which results in better segmentation.

4 PERFORMANCE EVALUATION

In this study, to assess the accuracy of the segmented image, the root mean square error (RMSE) by Naidu and Raol (2003) as a measure is used for before- and after-flood MODIS imagery. Receiver operating characteristics (ROC) error estimation methods are used for evaluating the result of during flood MODIS image.

4.1 Root mean square error

Different algorithms may be compared using their RMSE as a measure of how well they explain a given set of observations. In our study, we use RMSE as a tool for the performance evaluation of before- and after-flood river extracted images. RMSE is mathematically expressed as:

$$\text{RMSE} = \sqrt{\frac{\sum_{k=1}^{n} E_k^2}{N}}, \tag{9.14}$$

where E_k is the difference between the pixel intensity values of segmented and reference images and N is the total number of pixels in the image.

4.2 Receiver operating characteristics

The performance of a binary classifier is very well illustrated by ROC. This helps in the performance appraisal of a spectral-spatial–based method in terms of certain ROC parameters. Decision making is easy in ROC as it helps in choosing the most optimal solutions and eliminating nonoptimal ones. Some of the evaluating parameters were introduced by Fawcett (2006); of them, certain parameters, such as true positive rate, true negative rate, false positive rate, accuracy, and false discovery rate, are employed for performance evaluation in this study (Senthilnath et al., 2012).

5 RESULTS AND DISCUSSION

In this section, we present the study area and data description. Then we present the comparison of image clustering based on nature-inspired methods, GA, PSO, and FA, after applying region-based segmentation for flood assessment. Accuracy assessment of the three methods is done in terms of RMSE and ROC.

5.1 Study area and data description

The region surrounding the Krishna River near Manthralaya, Andhra Pradesh, India, is taken as the study area. This region is located between 16°38′00″N-77°09′00″W and 15°26′00″S-78°26′00″E (Fig. 9.6). The study area includes Kosigi, Sindhanur, Manthralaya, Nandavaram, Halaharvi, Yemmiganur, Kurnool, Alampur, Nandhikotkur, Gabbur, Sirvar, Manvi, Atmakur, Peddamandadi, Wanaparthy, Pebbair, Beechupalli, Gummadam, Gonegandla, Adoni, Raichur, Arsegiri, Dharur, Gadwall, Sangamvadi, Gudur, Sirugupa, and Ulindakond. The dataset obtained from MODIS (MOD09Q1) Terra surface reflectance 8-Day L3 Global 250 m satellite images are used for this purpose. The details of the dataset used in this study have been discussed in Senthilnath et al. (2012). The multitemporal data used in our study are before-flood MODIS image (Mar. 2009), during-flood MODIS image (Sep. 2009), and after-flood MODIS image (Nov. 2009).

5.2 Spectral-spatial MODIS data analysis using unsupervised methods

In this section, we discuss the effect of using unsupervised methods based on nature-inspired techniques on multitemporal MODIS data. Here MODIS data is clustered to form water and nonwater regions. After performing region-based segmentation for the river region mapping and flood evaluation, the comparison of GA-, PSO-, and FA-based clustering models is carried out. Also, these methods are compared with the conventional clustering method, namely, K-means.

5.2.1 Clustering MODIS data

All the MODIS data used for river region mapping and flood extent evaluation are clustered using three clustering techniques: GA, PSO, and FA. The pixels comprising two clusters are eventually grouped as water and nonwater regions. The only user-defined parameters in fitness function evaluation are constants w_1 and w_2. Both of these constants are set as 1.

5.2.1.1 Genetic algorithm

All the satellite data used for river mapping and flood evaluation are clustered by GA techniques as water and nonwater regions. In GA, each

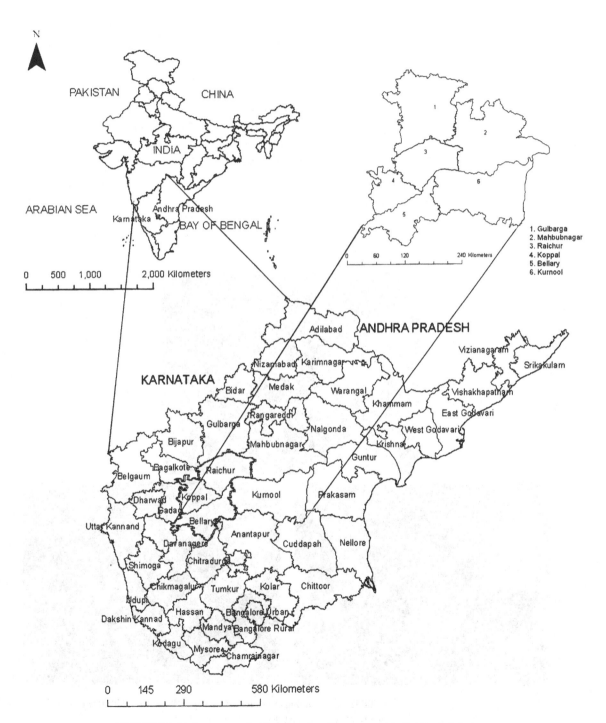

N

PAKISTAN CHINA

INDIA

ARABIAN SEA Andhra Pradesh

Karnataka BAY OF BENGAL

0 500 1,000 2,000 Kilometers

1. Gulbarga
2. Mahbubnagar
3. Raichur
4. Koppal
5. Bellary
6. Kurnool

0 60 120 240 Kilometers

ANDHRA PRADESH

Adilabad

Vizianagaram

KARNATAKA

Nizamabad Karimnagar

Srikakulam

Bidar Medak Warangal

Vishakhapatnam

Rangareddi Khammam

East Godavari

Gulbarga Nalgonda

West Godavari

Bijapur Mahbubnagar

Krishna

Belgaum Bagalkote Raichur Guntur

Dharwad Koppal Kurnool Prakasam

Gadag

Uttar Kannand Bellary

Anantapur Cuddapah Nellore

Davanagere

Chitradurga

Shimoga

Chikmagalur Tumkur Kolar Chittoor

Udupi

Hassan Bangalore Urban

Dakshin Kannad

Mandya Bangalore Rural

Kodagu Mysore Chamrajnagar

0 145 290 580 Kilometers

■ FIGURE 9.6 Study area contains 28 regions from Karnataka and Andhra Pradesh, India.

generation has 20 chromosomes, and the maximum number of generations allowed for finding the best solution to the given optimization problem is 30.

The crossover operator and the mutation operator provide search mechanisms. So the varying rates of crossover and mutation are used to improve the convergence. For the first 15 generations, we applied these rates: reproduction rate (R_r) is 0.25; crossover rate (C_r) is 0.5; and mutation rate (M_r) is 0.25. For the remaining 15 generations, we applied these rates: reproduction rate (R_r) is 0.25; crossover rate (C_r) is 0.25; and mutation rate (M_r) is 0.5 (Senthilnath et al., 2013b).

The chromosome with the best fitness value is used to cluster the image. The clustering result of before-flood MODIS image by the GA technique is shown in Fig. 9.7a. During-flood and after-flood MODIS image clustering

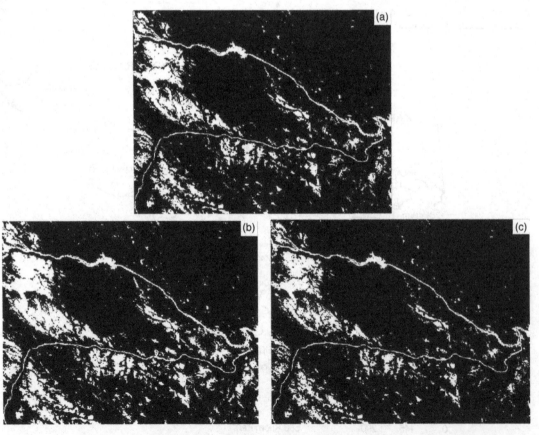

■ FIGURE 9.7 **Clustering results for before-flood (Mar. 2009) MODIS image using algorithms.** (a) GA, (b) PSO, and (c) FA (white represents water).

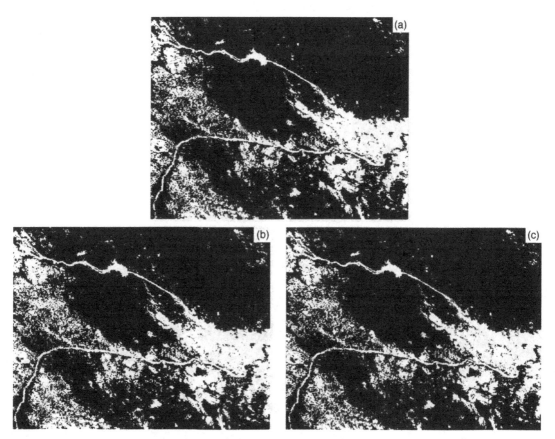

■ **FIGURE 9.8 Clustering results for during flood (Sep. 2009) MODIS image using algorithms.** (a) GA, (b) PSO, and (c) FA (white represents water).

results using GA are depicted in Figs. 9.8a and 9.9a, respectively. As can be seen from the results of clustering, many nonwater segments have been clustered as water because of their spectral resemblance to water. These nonwater features are removed by region-based segmentation.

5.2.1.2 Particle swarm optimization

In case of PSO, each iteration has 20 particles, and the maximum number of iterations allowed to find the best solution to the problem is 30. To search the optimum cluster centers, we use these parameter values: inertia factor (w) is 0.7; cognitive learning rate (C_p) is 1.5; and social learning rate (C_g) is 1.5 (Senthilnath et al., 2013b).

The best particle fitness value is used to cluster the image. The clustering result of the before-flood MODIS image by the PSO technique is shown

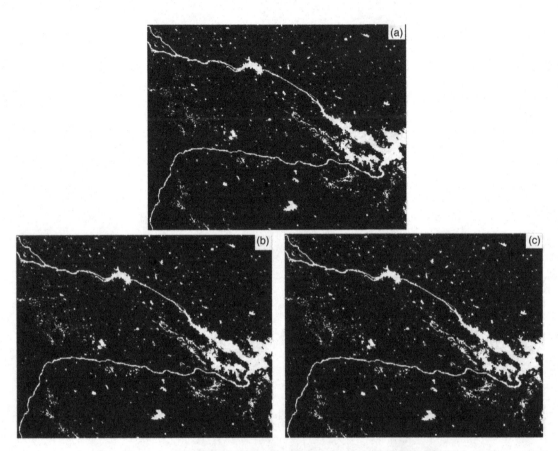

■ **FIGURE 9.9 Clustering results for after-flood (Nov. 2009) MODIS image using algorithms.** (a) GA, (b) PSO, and (c) FA (white represents water).

in Fig. 9.7b. During-flood and after-flood MODIS image clustering results using PSO are depicted in Figs. 9.8b and 9.9b, respectively.

5.2.1.3 Firefly algorithm

The fireflies are arbitrarily initialized in the search space. The parameter values used in the FA algorithm are: number of fireflies (N) is 20; attractiveness (β_0) is 1; light absorption coefficient (γ) is 1; and number of generations (T) is 30.

After the fireflies are deployed randomly within the search space, the parameter β_0 is 1, which is equivalent to the scheme of cooperative local search with the brightest firefly strongly determined the other fireflies positions, especially in its neighborhood (Senthilnath et al., 2011). The parameter value of γ is 1, which influences the light intensity variation with the increasing distance from a firefly it is attracted to (Senthilnath et al., 2011).

Table 9.1 Parameters Used for Each Population-Based Method

Methods	Parameters
Genetic algorithm	1–15 iteration: $R_r = 0.25$, $C_r = 0.5$, $M_r = 0.25$ 16–30 iterations: $C_r = 0.25$, $M_r = 0.5$
Particle swarm optimization	$w = 0.7$, $C_p = 1.5$, $C_g = 1.5$
Firefly algorithm	$\beta_0 = 1$, $\gamma = 1$

The parameter values were chosen empirically based on optimal value obtained in previous studies in the literature.

The best firefly fitness value is used to cluster the image. The clustering result of the before-flood MODIS image by the FA technique is shown in Fig. 9.7c. During-flood and after-flood MODIS image clustering results using FA are depicted in Figs. 9.8c and 9.9c, respectively.

As can be seen from the results of the three clustering methods, many nonwater segments are also clustered as water because of their spectral similarity to water. These nonwater features are removed by region-based segmentation.

Table 9.1 shows the parameters used for each population-based method. It is important to clarify that, for all techniques, we assumed a model with a population size of 20 agents and 30 iterations to reach a solution.

5.2.2 *Segmentation of clustered MODIS data*

The failure of clustering to extract water regions from the multitemporal MODIS data is overcome by segmentation. Two indices, SI and DI, are used as geometric parameters for shape extraction. Subsequently, water regions are differentiated from nonwater regions after thresholding the SI and DI values.

The significance of SI and DI thresholding can be seen in Fig. 9.10. We use different threshold values of SI and DI on the FA clustered before-flood MODIS image. Fig. 9.10a shows segmentation of the FA clustered image with an SI threshold of 2.5 and a DI threshold of 1.5. Fig. 9.10b shows the segmentation result of the FA clustered image with an SI threshold of 2.5 and a DI threshold of 0.9. Similarly, Fig. 9.10c shows the segmentation result of the FA clustered image with an SI threshold of 2.0 and a DI threshold of 1.5. Likewise, Fig. 9.10d shows the segmentation result of the FA clustered image with an SI threshold of 2.0 and a DI threshold of 0.9. These results show that the segmentation results can differ significantly with even a small variation in thresholding. As SI threshold increases, regions with smaller lengths compared to their area get eliminated from the segmented

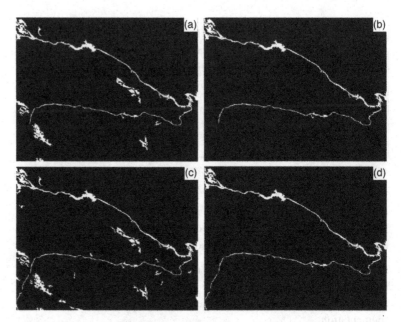

■ FIGURE 9.10 **Segmented images of Krishna River basin in Mar. 2009 using FA clustered image.** (a) SI = 2.5 and DI = 1.5; (b) SI = 2.5 and DI = 0.9; (c) SI = 2.0 and DI = 1.5; and (d) SI = 2.0 and DI = 0.9.

image. In contrast, as DI threshold increases, thick regions with smaller lengths get incorporated in the segmented image.

In the before-flood and after-flood MODIS image used in this study, to extract the river course, we use an SI threshold of 2.0 (high value) and a DI threshold of 0.9 (low value). Thus, regions with spatial indices above the threshold are extracted as water segments. The segmentation results of the before-flood MODIS image clustered by GA, PSO, and FA can be observed in Fig. 9.11a, c, and e, respectively. Fig. 9.12a, c, and e show the segmentation results of the postflood image clustered by GA, PSO, and FA, respectively.

However, for the during-flood MODIS image used for flood assessment, a threshold of 2.0 and 1.4 are set for SI and DI, respectively. The change in DI threshold is because of the larger area coverage due to the flooded region. Since the parameters in DI depend on the river area rather than length (SI), the increase in the DI threshold can be justified. The segmentation results of during-flood MODIS image clustered by GA, PSO, and FA can be observed in Fig. 9.13a, c, and e, respectively. The GA, PSO, and FA clustered before-flood MODIS images are overlaid on the original image, which are shown in Fig. 9.11b, d, and f, respectively. Similarly, the after-flood MODIS images clustered using GA, PSO, and FA are overlaid on the original image for better assessment of flood extent and are shown in

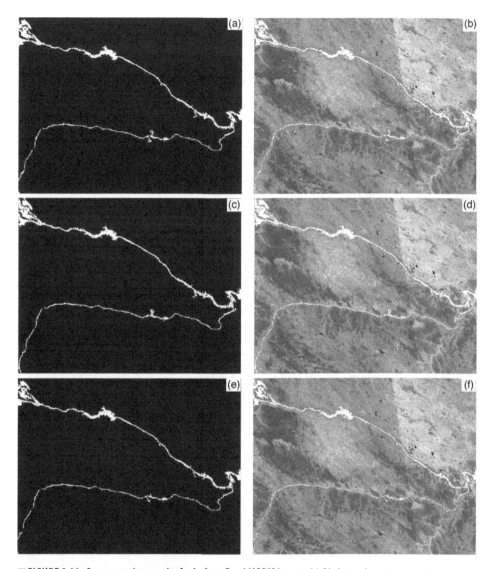

■ **FIGURE 9.11 Segmentation results for before-flood MODIS image.** (a) GA clustered image; (c) PSO clustered image; (e) FA clustered image (white represents water); (b), (d), and (f) show the overlap of (a), (c), and (e), respectively on the original MODIS image.

Fig. 9.12b, d, and f, respectively. In these images, white pixels correspond to water-covered regions.

For the during-flood MODIS images, the results of flood extraction after clustering by GA, PSO, and FA are shown in Fig. 9.13b, d, and f, respectively. The perimeter of the flooded region in these images is shown as white pixels.

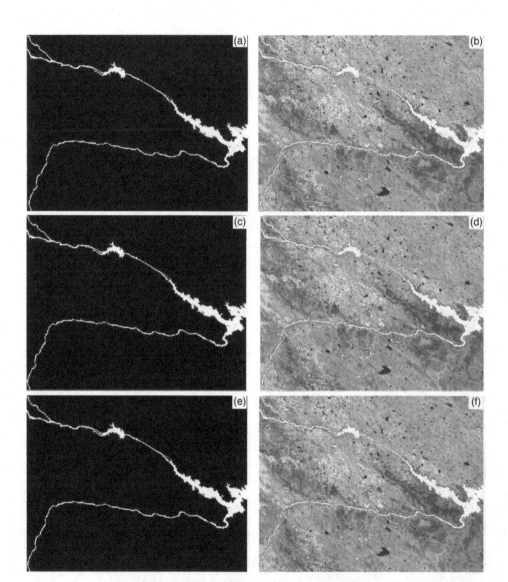

■ **FIGURE 9.12 Segmentation results for after-flood MODIS image.** (a) GA clustered image; (c) PSO clustered image; (e) FA clustered image (white represents water); (b), (d), and (f) show the overlap of (a), (c), and (e), respectively on the original MODIS image.

5.2.3 *Qualitative assessment of GA, PSO, and FA*

To assess the extraction of the Krishna River network, the resultant images after clustering by the aforementioned techniques, are tested against the ground truth image of the river. RMSE, a well-known performance measure, is calculated for the final image (after clustering and segmentation). The

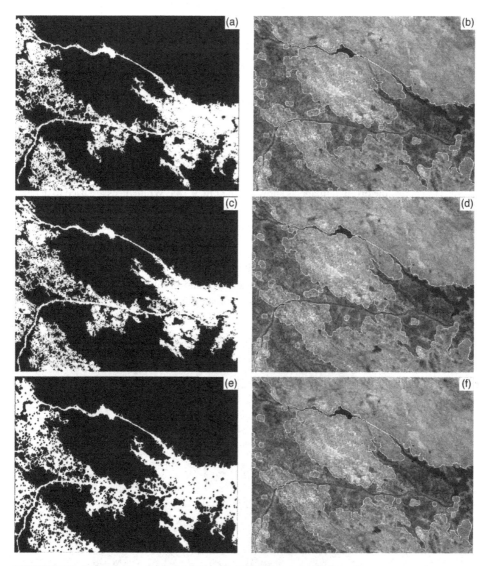

■ **FIGURE 9.13 Segmentation results for during flood MODIS image.** (a) GA clustered image;
(c) PSO clustered image; (e) FA clustered image (white represents water); (b), (d), and (f) highlight the
perimeter of (a), (c), and (e), respectively on the original MODIS image with a white line.

RMSE value is estimated to perform a qualitative assessment of the different
approaches used for extraction of the river course in before and after-flood
MODIS image. The error estimation is done for GA, PSO, and FA, and
these results are reported in Table 9.2. From the values of RMSE reported in
Table 9.2, we can deduce that FA performs better than GA and PSO.

Table 9.2 Root Mean Square Error (After Segmentation) Attained by the Four Clustering Techniques

MODIS Data	K-Means	GA	PSO	FA
Before-flood MODIS image	0.45	0.18	0.15	0.12
After-flood MODIS image	0.27	0.14	0.12	0.11

A list of cities situated in the flooded region according to the result images of during-flood MODIS image by GA, PSO, and FA is made for performance evaluation. To analyze the results, the cities listed are plotted as points in the original image as shown in the Fig. 9.14a. White discs are used to denote the cities which are not affected by flood and white discs having black dots in the center are used to represent cities affected by flood.

The cities which are reported as flooded according to GA, PSO, and FA clustering are shown as white dots in Fig. 9.14b–d, respectively. A list of flooded cities reported by GA, PSO, and FA is then compared against the list of flooded cities according to the original database.

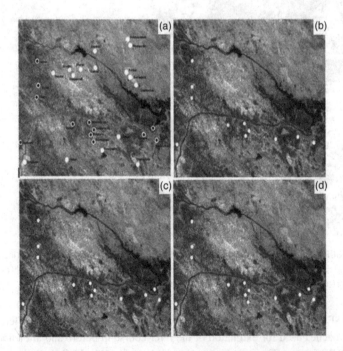

■ **FIGURE 9.14** (a) Ground truth information of the region around Krishna River basin during flood, white dots signify cities which were not flooded and white dots with black dots inside them signify cities which were flooded; (b) cities which were flooded according to flood map of GA clustered image; (c) cities which were flooded according to flood map of PSO clustered image; and (d) cities which were flooded according to flood map of FA clustered image.

Table 9.3 ROC Parameters Comparison for Flooded and Nonflooded Cities

Terms	K-Means	GA	PSO	FA
True positive	9	10	11	12
False positive	4	1	1	1
True negative	12	15	15	15
False negative	3	2	1	0

Table 9.4 Accuracy Assessment Using ROC-Based Performance-Evaluating Features

Features	K-Means	GA	PSO	FA
TPR	0.75	0.83	0.92	1
TNR	0.75	0.94	0.94	0.94
FPR	0.25	0.06	0.06	0.06
ACC	0.75	0.89	0.93	0.96
FDR	0.36	0.09	0.08	0.07

Table 9.3 shows the results of comparative analysis of GA, PSO, and FA based on ROC parameters. The performance evaluating ROC features are tabulated in Table 9.4. From Tables 9.3 and 9.4, we can observe that PSO is less error-prone compared to GA in flood evaluation. Among the three clustering methods used in this study, FA performs better than GA and PSO in segmentation of all three MODIS datasets for both river network (before and after flood) and flood extent extraction (during flood).

In all these methods, initially every cluster center picked by the population is not the best optimal point in the search space. Therefore, the selection of new cluster centers after the fitness evaluation is effectively scanned iteratively until all the particles converge to an optimal solution (ie, in the form of cluster centers). In FA, a firefly moves toward another firefly, which has a better objective function (fitness value). The distance moved by the firefly in each instance is given by the distance between the two firefly particles (r). When the value of r is large/small, the firefly will move a small/large distance. In PSO, each particle will move a distance based on its individual best and the global best, whereas in GA, each chromosome position will be moved to another using crossover and mutation.

We can analyze the rate of convergence of these multiple agents to the optimum solution, if we consider the fitness values of the agents of population for the described techniques. For this, after each iteration, the difference of the average fitness value of the population and the minimum fitness value is achieved in the entire run. This observation is presented in the form of bar graphs for GA, PSO, and FA techniques in Fig. 9.15a–c, respectively.

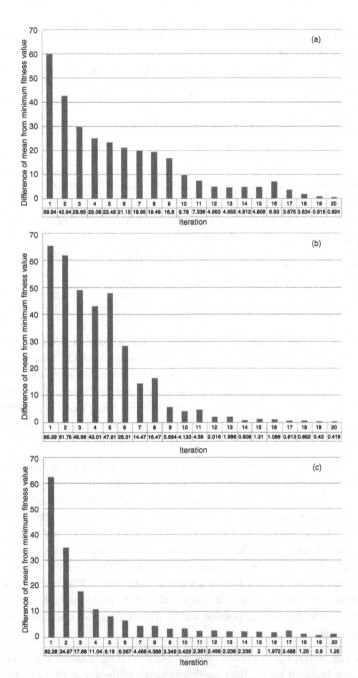

■ **FIGURE 9.15 Bar graph representing difference of the average fitness value of population and the minimum fitness value versus iterations for the three clustering techniques.** (a) GA, (b) PSO, and (c) FA.

Table 9.5 Time Complexity for All Algorithms (in Seconds)

Dataset	GA	PSO	FA
Before-flood MODIS image	86.73	30.23	37.74
During-flood MODIS image	88.77	31.31	40.01
After-flood MODIS image	80.63	29.23	39.31

From Fig. 9.15, we conclude that the rate of convergence of FA is faster, although particles in the case of PSO also end up with the best convergence.

5.3 Time complexity analysis

The time complexity of all the three population-based algorithms is derived for three dataset as shown in Table 9.5. The time complexity analysis provides a better understanding of the time taken by the algorithm to compute the outputs. The algorithms run until the iteration reaches the maximum limit (ie, the total number of generations).

The algorithms are run on a computer with an Intel core i-5 processor, 4 GB RAM on MATLAB version 7.08. The execution times in seconds taken by the algorithms for maximum generations are shown in Table 9.5. From Table 9.5, we can observe that the computation time is the least for PSO compared to the other methods. FA takes slightly more time than PSO and less time than GA for all the datasets.

5.4 Comparison of unsupervised techniques

In the literature, the conventional method such as K-means (MacQueen, 1967) is often used in image clustering. In our study, GA, PSO, and FA are compared against the conventional technique for clustering of the before-flood MODIS image.

These methods are also compared with the population-based methods used in this study: GA, PSO, and FA. While applying K-means, two classes (water and nonwater) are generated for clustering the before-flood MODIS image. After clustering, an SI value of 2.0 and a DI value of 0.9 is set as the threshold to segment the image. The performance measure like the RMSE value is used for comparison of image segmentation of the before-flood MODIS image. For K-means, RMSE is found out to be 0.45. The RMSE value for the after-flood MODIS image is 0.27. As we can observe from Table 9.2, FA performs better than GA and PSO. Since the RMSE of FA, GA, and PSO is better than K-means, we can conclude that

population-based methods are more efficient compared to conventional technique.

From Tables 9.3 and 9.4, we can observe K-means for the during-flood MODIS image. In Table 9.3, we can see that K-means have more false positives and false negatives than other population-based methods. By considering the ROC-based performance of these values, Table 9.4 shows that population-based methods perform better than K-means.

6 CONCLUSIONS

A method of river mapping and flood evaluation is proposed by utilizing the multitemporal MODIS data based on spectral and spatial features of rivers. The downside of image clustering based on spectral characteristics has been overcome by adopting region-based segmentation using geometric parameters. This combined approach has been found to be an efficient method to extract water regions from multitemporal MODIS images (before, during, and after flood).

The population-based algorithms, such as GA, PSO, and FA, have been used for image clustering, and a performance comparison has been carried out. Among these three algorithms, FA performed better than PSO and GA. Though all of these algorithms are popular in optimization for image clustering, they misclassified some of the nonwater regions as water regions. This problem is overcome by involving SI and the density index as two geometric parameters. This resulted in an efficient way of mapping of water-covered flood regions, thus providing a promising and reliable tool for assisting flood disaster mitigation systems.

This study demonstrates a novel method to analyze remote sensing data. The results are promising; however, an extension to this work is planned to analyze different fitness functions for clustering. In addition, it will also be useful to analyze hybrid optimization algorithms based on combining nature-inspired techniques and K-means.

ACKNOWLEDGMENTS

We are grateful to S.N. Omkar and V. Mani from IISc, Bangalore, India, for many useful and stimulating discussions regarding image clustering for remote sensing. Finally, we are indebted to Vikram Shenoy H., NTU, Singapore, for proofreading this chapter.

Satellite data for experimentation are distributed by the Land Processes Distributed Active Archive Center (LP DAAC), located at the US Geological Survey (USGS) Earth Resources Observation and Science (EROS) Center (lpdaac.usgs.gov).

REFERENCES

Baatz, M., Schape, A., 2000. Multi-resolution segmentation: an optimisation approach for high quality multi-scale image segmentation. In: Proceedings of the Angewandte Geographische Informationsverarbeitung, XII Beitrge Zum AGIT Symposium, pp. 12–23.

Boggess, J., 1993. Identification of Roads in Satellite Imagery Using Artificial Neural Networks: A Contextual Approach, Technical Report MSU-930815, Mississippi State University, MS.

Bosco, G., 2001. A genetic algorithm for image segmentation. In: Proceedings of IEEE 11th International Conference on Image Analysis and Processing, Italy, pp. 262–266.

Brakenridge, R., Anderson, E., 2006. MODIS-Based Flood Detection, Mapping and Measurement: The Potential for Operational Hydrological Applications. Transboundary Floods: Reducing Risks Through Flood Managementvol. 72Springer Verlag, The Netherlands, pp. 1–12.

Craig, D., Omkar, S., Senthilnath, J., 2012. Pickup and delivery problem using meta-heuristics. Expert Syst. Appl. 39 (1), 328–334.

Fawcett, T., 2006. ROC Graphs: Notes and Practical Considerations for Researchers. HP Lab, CA.

Gianinetto, M., Villa, P., Lechi, G., 2006. Post flood damage evaluation using landsat TM and ETM+ data integrated with DEM. IEEE Trans. Geosci. Remote Sens. 44 (1), 236–243.

Huang, W., Zhang, X., 2011. Projection pursuit flood disaster classification assessment method based on multi-swarm cooperative particle swarm optimization. J. Water Resource Prot. 3 (6), 415–420.

Islam, A., Bala, S., Haque, A., 2009. Flood inundation map of Bangladesh using MODIS surface reflectance data. In: 2nd International Conference on Water and Flood Management, Bangladesh.

Jarabo, A., Rosa, Z., Mata-Moya, D., Vicen, B., Maldonado, B., 2011. Spatial-range mean-shift filtering and segmentation applied to SAR images. IEEE Trans. Instrum. Meas. 60 (2), 584–736, 597.

Jiafu, L., Yan, L., Wenfeng, Z., Jing, L., 2011. Storm floods risk assessments by GA-BP: a case study of seven countries in Asia. Int. J. Adv. Comput. Technol. 3 (10), 313–329.

Kennedy, J., Eberhart, R., 1995. Particle swarm optimization. In: Proceedings of IEEE International Conference on Neural networks, Australia, vol. 4, pp. 1942–1948.

Khan, S., Hong, Y., Wang, J., Yilmaz, K., Gourley, J., Adler, R., Brakenridge, G., Policelli, F., Habib, S., Irwin, D., 2011. Satellite remote sensing and hydrologic modelling for flood inundation mapping in Lake Victoria basin: implications for hydrologic prediction in ungauged basins. IEEE Trans. Geosci. Remote Sens. 49 (1), 85–95.

MacQueen, J., 1967. Some methods for classification and analysis of multivariate observations. In: Proceedings of Fifth Berkeley Symposium on Mathematical Statistics and Probability. University of California Press, pp. 281–297.

Mancas, M., Gosselin, B., Macq, B., 2005. Segmentation using a region growing thresholding. Proc. SPIE 5672, 388–398.

McKeown, D., Harvey, W., McDermott, J., 1985. Rule-based interpretation of aerial imagery. IEEE Trans. Pattern Anal. Mach. Intell. 7 (5), 570–585.

Mingjun, S., Daniel, C., 2004. Road extraction using SVM and image segmentation. Photogramm. Eng. Remote Sens. 70 (12), 1365–1371.

Nagesh, K., Janga, R., 2007. Multipurpose reservoir operation using particle swarm optimization. J. Water Res. Plan Manag. ASCE 133 (3), 192–201.

Naidu, V.P.S., Raol, J., 2003. Evaluation of data association and fusion algorithms for tracking in the presence of measurement loss. In: Proceedings of the AIAA Guidance, Navigation, and Control Conference, Austin, TX.

Nevatia, R., Babu, K., 1980. Linear feature extraction and description. Comput. Graph. Image Process. 13 (3), 257–269.

Omkar, S., Manoj, K., Mudigere, D., Muley, D., 2007. Urban satellite image classification using biologically inspired techniques. In: Proceedings of IEEE International Symposium of Industrial Electronics, Spain, pp. 1767–1772.

Omran, M., EngelBrecht, A., Salman, A., 2006. Particle swarm optimization for pattern recognition and image processing. Stud. Comput. Intell. 34, 125–151.

Qiu, R., 2009. An improved spatial/spectral-resolution image fusion method based on IHS-MC for IKONOS imagery. In: 2nd International Congress on Image and Signal Processing, CISP'09, China, pp. 1–4.

Roberts, L., 1970. Machine perception of three-dimensional solids. Optical and Electro-Optical Image Processing. MIT Press, Cambridge, MA, pp. 159–197.

Roberts, D., Gardner, M., Funk, C., Noronha, V., 2001. Road Extraction Using Spectral Mixture and Q-Tree Filter Techniques, Technical Report, National Center for Geographical Information & Analysis, University of California, Santa Barbara.

Rogge, D., Rivard, B., Zhang, J., Sanchez, A., Harris, J., Feng, J., 2007. Integration of spatial-spectral information for the improved extraction of endmembers. Remote Sens. Environ. 110 (3), 287–303.

Sakamoto, T., Nguyen, N., Kotera, A., Ohno, H., Ishitsuka, N., Yokozawa, M., 2007. Detecting temporal changes in the extent of annual flooding within the Cambodia and the Vietnamese Mekong Delta from MODIS time-series imagery. Remote Sens. Environ. 109 (3), 295–313.

Sande, C., Jong, S., Roo, A., 2003. A segmentation and classification approach of IKONOS-2 imagery for land cover mapping to assist flood risk and flood damage assessment. Int. J. Appl. Earth Obs. Geoinf. 4 (3), 217–229.

Senthilnath, J., Omkar, S., Mani, V., 2011. Clustering using firefly algorithm: performance study. Swarm Evol. Comput. 1 (3), 164–171.

Senthilnath, J., Omkar, S., Mani, V., Nitin, K., Shreyas, P., 2013a. Crop stage classification of hyperspectral data using unsupervised techniques. IEEE J. Sel. Topics Appl. Earth Obs. Remote Sens. 6 (2), 861–866.

Senthilnath, J., Rajeswari, M., Omkar, S.N., 2009. Automatic road extraction using high resolution satellite image based on texture progressive analysis and normalized cut method. J. Indian Soc. Remote Sens. 37 (3), 351–361.

Senthilnath, J., Shenoy, H.V., Omkar, S., Mani, V., 2013b. Spectral-spatial MODIS image analysis using swarm intelligence algorithms and region based segmentation for flood assessment. In: Proceedings of the Seventh International Conference on Bio-Inspired Computing: Theories and Application, Advances in Intelligent Systems and Computing, vol. 202. Springer, India, pp. 163–174.

Senthilnath, J., Shivesh, B., Omkar, S., Diwakar, P., Mani, V., 2012. An approach to multitemporal MODIS image analysis using image classification and segmentation. Adv. Space Res. 50 (9), 1274–1287.

Shaker, A., Yan, W., 2010. Flood hazard assessment from Panchromatic satellite imagery: a case study on the Nile River. In: International Conference and Exhibition MELAHA, Cairo, Egypt.

Shamaomaa, H., Kerleb, N., Alkemab, D., 2006. Extraction of flood-modelling related base-data from multisource remote sensing imagery. In: Proceedings of the ISPRS Comm VII Symposium. Enschede, The Netherlands.

Stow, D., 2010. Geographic object-based image change analysis. Handbook of Applied Spatial Analysis, Springer, Berlin Heidelberg, pp. 565–582.

Tarabalka, Y., Benediktsson, J., Chanussot, J., 2009. Spectral-spatial classification of hyperspectral imagery based on partitional clustering techniques. IEEE Trans. Geosci. Remote Sens. 47 (8), 2973–2987.

Tilton, J., 1989. Image segmentation by iterative parallel region growing and splitting. In: International Geoscience and Remote Sensing Symposium (IGARSS), Vancouver, Canada, pp. 2235–2238.

Wilson, R., Spann, M., 1988. Image Segmentation and Uncertainty. Research Studies Press, Hertfordshire, UK, pp. 388-398.

Wu, C., Chau, K., 2006. A flood forecasting neural network model with genetic algorithm. Int. J. Environ. Pollut. 28 (3/4), 261–273.

Yang, X.S., 2008. Nature-Inspired Metaheuristic Algorithms. Luniver Press, Bristol, UK.

Yang, X.S., 2010. Firefly algorithm, stochastic test functions and design optimisation. Int. J. Bio-inspired Comput. 2 (2), 78–84.

Yang, X.S., 2011. Review of meta-heuristic and generalised evolutionary walk algorithm. Int. J. Bio-Inspired Comput. 3 (2), 77–84.

Yang, X.S., 2013. Multiobjective firefly algorithm for continuous optimization. Eng. Comput. 29 (2), 175–184.

Yang, X.S., Deb, S., Fong, S., 2011. Accelerated particle swarm optimization and support vector machine for business optimization and applications. In: Networked Digital Technologies (NDT2011), Communications in Computer and Information Science (CCIS), vol. 136, Springer, Berlin, pp. 53–66.

Zhan, X., Sohlberg, R., Townshend, J., DiMiceli, C., Carroll, M., Eastman, J., 2002. Detection of land cover changes using MODIS 250 m data. Remote Sens. Environ. 83 (1–2), 336–350.

Zhu, M., Yeh, P., 1986. Automatic road network detection on aerial photographs. In: International Conference on Computer Vision and Pattern Recognition, Miami Beach, FL, pp. 34–40.

Firefly algorithm for optimized nonrigid demons registration

S. Chakraborty*, N. Dey**, S. Samanta†, A.S. Ashour‡,§, V.E. Balas¶

**Department of CSE, Bengal College of Engineering and Technology, Durgapur, West Bengal, India;*
***Department of Information Technology, Techno India College of Technology, Kolkata, West Bengal, India;*
†*Department of Computer Science & Engineering, University Institute of Technology, Burdwan, West Bengal, India;*
‡*Department of Electronics and Electrical Communications Engineering, Faculty of Engineering, Tanta University, Tanta, Egypt;*
§*College of CIT, Taif University, Saudi Arabia; ¶Faculty of Engineering, Aurel Vlaicu University of Arad, Arad, Romania*

1 INTRODUCTION

Image processing is a wide domain that has various processes including enhancement, feature extraction, registration, segmentation, pattern matching, classification, fusion, morphology analysis, and statistical measurement (Bulsara et al., 2011). Thus, researchers are interested in studying miscellaneous image processing applications and optimization algorithms (Dey et al., 2012a,b; Sharma and Pant, 2013; Roy et al., 2014; Mathew et al., 2014; Jakšić et al., 2015; Pal et al., 2015; Nandi et al., 2015; Gospodinova et al., 2015). Typically, image registration is a significant

Bio-Inspired Computation and Applications in Image Processing. http://dx.doi.org/10.1016/B978-0-12-804536-7.00010-7

process in many applications (Chowdhury et al., 2014; Araki et al., 2015). It is the process of aligning two images that correspond to the same scene into a common coordinate system to locate a definite object, by comparing the pixel-by-pixel value of both the sensed and referenced images. These aligned images may be captured from different imaging devices or at different time instances. Moreover, since the video content is separated into multiple image frames, in video registration, each moving image (target image) is mapped with a referenced (fixed) image. Generally, the referenced image is kept fixed and is used as basis for the sensed image.

Video sequence registration involves the spatial transformation recovery and the temporal alignment recovery between the two videos. Features are extracted from every frame of the two video sequences. Afterward, the features from a frame in the first sequence are to be matched with the corresponding frame's features in the second sequence.

In the recent decades, nonrigid image registration techniques have been extended to enhance registration accuracy. Such methods are the similarity criterion (intensity-based, landmarks, surfaces) approaches, different deformable models (nonrigid models using splines, rigid/affine models, wavelets, dense/nonparametric), and regularity constraints as well as adding different constraints on the transformation.

Typically, effective motion correction requires nonrigid image registration, which facilitates more flexible matching of the local details between two images than rigid registration does. B-splines can fit the nonrigid deformations model, where a grid of fixed window size is formed to assist the mapping of the target image according to the reference image. Nonrigid image registration methods can be extensively grouped into two classes, namely the intensity-based technique and the feature-based technique (Crum et al., 2004). Feature-based techniques provide precise models without manually/automatically select the control points/features. They utilize the attribute vector model to match related features between images. Thus, the registration process can be considered a feature matching problem. To match the images, the feature-based techniques depend on a relatively small number of feature points.

In contrast, intensity-based techniques deal directly with the image intensity and measure the intensity similarity, and then adjust the transformation until the similarity measure reaches its optimal value. Thirion (1998) presented the demons algorithm as a delegate to the intensity-based techniques. It is based on the standard of intensity conservation between images as it is derived from the optical flow model. In the demons algorithm, each

pixel can have its own displacement. Conversely, in real images, accurate intensity matches do not essentially imply good registration of the underlying images. Therefore, the energy function being optimized in the intensity-based techniques suffers extensively from local minima. Demons is a representative form for the fluid registration algorithm that have different parameters, such as velocity field smoothing kernel and the alpha noise constant. Thus, it requires optimization algorithms to attain the parameter's optimal values. In addition, in the video segmentation, the relationship between frames of the two video sequences is unknown. This relationship can be achieved using all potential selections of the frame pairs from the two video sequences. This broad search scheme will lead to the optimal result, but will suffer from increased computational cost to solve this brute-force optimization.

Consequently, optimization algorithms should be employed to search for specific optimal solutions using an objective/multiobjective function. Metaheuristic algorithms, such as the particle swarm optimization (PSO), cuckoo search (CS), and firefly algorithm (FA), are high-level approaches for exploring the search spaces. Thus, in the current work, the FA is employed to optimize the velocity-smoothing kernels of demons registration.

The remaining sections are structured as follows. Section 2 includes the related works followed by the material and methods in Section 3. The proposed method and the results are introduced in Sections 4 and 5, respectively. Finally, the conclusion is presented in Section 6.

2 **RELATED WORKS**

The main goal of image/video registration is to estimate the transformation, which registers the reference image and the target image. This process can be performed by optimizing the metric function (similarity measure). The gradient descent scheme was used for medical image registrations (Brown, 1992), which considered the local optimization technique since the transformation parameters are generally nonconvex and irregular. Thus, to avoid the local minimum, these schemes require good initial values for estimation. To overcome the problem of the local minimum, Rouet et al. (2000) employed the genetic algorithm (GA), which is a powerful global optimization technique, to optimize medical image registrations. However, the GA suffers from some disadvantages, such as consuming large computation time and lacking of fine-tuning potentials. Consequently, Wachowiak et al. (2004) adapted the PSO algorithm for single-slice three-dimensional (3D)-to-3D biomedical image registration. The experimental results of optimizing the normalized mutual information similarity metric were compared

to other evolutionary strategies. The hybrid PSO method produced accurate registrations compared to the evolutionary strategies in terms of convergence. The authors demonstrated that the PSO approach along with evolutionary algorithms and local methods were functional in image registration. Klein et al. (2007) compared the performance of several optimization methods, namely the gradient descent, nonlinear conjugate gradient, quasi-Newton, simultaneous perturbation, Robbins–Monro, Kiefer–Wolfowitz, and evolution strategy of medical image registration. The optimization techniques for registration were tested on manually deformed computed tomography (CT) images of the heart, CT chest images, and magnetic resonance (MR) images. The results demonstrated that the Robbins–Monro technique was the best in several applications.

Chen et al. (2008) applied PSO to two-dimensional (2D) nonrigid image registration, which proved its effectiveness. In Mohamed and Hamza (2010), an optimized entropy-based image registration algorithm was proposed for medical image registration. The authors employed a modified instantaneous perturbation stochastic approximation algorithm in the optimization process. In Meskine et al. (2010), a GA-based rigid image registration was suggested for satellite/radar images registration. Afterward in Zheng and Tong (2011), a hybrid PSO algorithm was applied on mutual information to optimize image registration. Singhai and Singhai (2012) presented a dominant search strategy based on the GA to register satellite images. The authors applied mutual information to calculate the statistical dependence of the information redundancy between the image intensities of matching voxels in both the reference image and the floating image. The results established that this conducted approach overcame the limitation of local maxima with the desired speed and accuracy.

Bejinariu et al. (2013) suggested a parallel method for the pixel intensity-based image registration problem on multicore processors. A geometric transform consisted of two classes of bio-inspired algorithms, namely the bacterial foraging optimization algorithm and the GA, were employed. The optimal transform was applied to a target (source) image in order to align it to a reference image by maximizing a similarity measure. The mutual information was used to evaluate the image registration quality and the consumed processing time. Hwuang et al. (2013) proposed a novel approach based on discrete optimization outperforming other approaches for deformable CT that introduced the anisotropic smoothing regularizer (AnSR). Edge-detection and denoising within the demons framework were conducted. The authors used AnSR within the demons algorithm and executed pairwise registration on 2D synthetic brain magnetic resonance images with and without noise after inducing

a deformation. The results illustrated that by selecting the displacements in the deformation field, AnSR surpassed both GaSR and no regularizer in terms of the normalized sum of squared differences. Caspi et al. (2006), feature trajectories have been engaged instead of features from every frame for video registration. The authors extracted the feature points from the first frame and tracked all over the video. To improve the spatial/temporal transformation between the video sequences, the optimization problem was solved.

The foremost survey included related work on image/video registration problem for both rigid and nonrigid scenes, jointly with introduced previous studies on the optimization concept to support image registration. Consequently, it is obvious that no earlier studies used the FA in the domain of demons registration optimization.

3 MATERIAL AND METHODS

The proposed framework includes three major parts: (1) binning, (2) demons registration, and (3) use of the FA to optimize the velocity-smoothing kernels of the demons registration.

3.1 Binning

The proposed system defragmented the video content into multiple frames and then applied a binning strategy prior to the registration process in order to define the middle frame of the bin being the target frame. The binning selection strategy is executed to solve the problem created by spatiotemporal localization changes of the frames. This problem occurs during the frame registration process, where a correlation between two consecutive frames exists.

By minimizing the distance between moving/target images, registration process sensitivity is maximized. Moreover, since any miss selection of the target frames can lead to insignificant registration, thus, the current study proposed the use of a bin selection strategy for selecting the number of frames to be used as a set for registration after dividing the entire video m frames into a bin size of n to solve this mentioned problem. The target frame demotes either the middle (nth/2) or the common frame in both halves. This process is carried on until all the bins are processed.

3.2 Demons registration

To resolve the deformable image registration, the demons framework is employed as a classical optimization scheme. Through transformation, each

pixel has a displacement vector, thus the demons framework can solve the semilocal transformation problem generated by B-splines registration. The deviator displacement D between the moving image (t) and the reference (fixed image) (r) is computed using the following iterative formula:

$$D_{i,j}^n = D_{i,j}^{n-1} - \frac{\left(t_{i,j}^{n-1} - r_{i,j}^0\right)\nabla r_{i,j}^0}{|\nabla r_{i,j}^0|^2 + |\left(t_{i,j}^{n-1} - r_{i,j}^0\right)|^{2'}} \tag{10.1}$$

This iterative formula is subjected to the following initial condition:

$$D_{i,j}^0 = 0, \quad t_{i,j}^0 = \hat{t}_{i,j}, \quad r_{i,j}^0 = \hat{r}_{i,j} \tag{10.2}$$

Here, $i, j = 1, 2, 3, \ldots, N$, while the original static and moving images intensities at the corresponding pixel are represented by $\hat{t}_{i,j}$ and $\hat{r}_{i,j}$, respectively, where N is any positive integer.

3.3 **Firefly algorithm**

Metaheuristic algorithms, nature-inspired with multiple interacting agents, have vital role for contemporary global optimization algorithms, soft computing, and computational intelligence. Among the new metaheuristics, the FA has been shown to be very efficient with multimodal and global/local optimization problems.

The FA is based on the objective function that can find an optimal solution to a problem by iteratively trying to enhance a candidate solution considering a specified measure of solution quality. It was developed by Xin-She Yang (2008) based on the flashing patterns and behavior of fireflies (Yang and He, 2013). The three basic rules for the FA modern metaheuristic algorithm, based on firefly characteristics, are:

1. Fireflies are unisexual, as they move toward brighter/more attractive fireflies regardless of their sex.
2. The attractiveness is related to the brightness, while the brightness is inversely proportional to the distance among the fireflies. Thus, for any two flashing fireflies, the less bright firefly moves in the direction of the brighter one. If there is no brighter firefly than the particular one, the firefly will move randomly.
3. The objective function setting establishes the brightness of a firefly. Generally, based on the problem domain, the value of the objective function is proportional to the brightness.

The significant concerns in the FA are the attractiveness formulation and the light intensity variation. The firefly's attractiveness is proportional

to the light intensity that seen by nearby fireflies. The attractiveness function $\beta(r)$ with the distance between two adjacent fireflies, r, is given by:

$$\beta(r) = \beta_0 e^{-\gamma r^m}, \quad (m \ge 1) \tag{10.3}$$

Here, β_0 refers to the maximum attractiveness at $r = 0$ and γ denotes a fixed light absorption coefficient, which controls the decrease in light intensity. In practice, the value of γ is established by the system's characteristic length that is to be optimized within the range of 0.1–10 from the full range of $\gamma \in [0, \infty]$. Meanwhile, the distance over which the attractiveness changes significantly is known as the characteristic distance Γ. For certain characteristic, the length scale Γ is considered an optimization problem. The parameter γ can be initialized by using the following value:

$$\gamma = \frac{1}{\Gamma^m} \tag{10.4}$$

For fixed γ, the characteristic distance is:

$$\Gamma = \gamma^{-1} \to 1 \text{ when } m \to \alpha$$

The distance between any two fireflies i and j at x_i and x_j is expressed as:

$$r_{ij} = \| x_i - x_j \| = \sqrt{\sum_{k=1}^{d} \left(x_{i,k} - x_{j,k} \right)^2} \tag{10.5}$$

where $x_{i,k}$ is the spatial coordinate kth component of the x_i related to the ith firefly and d is the dimension level.

The firefly i movement is attracted to another brighter (appealing) firefly j, which is the relation between the new and old position of firefly i, given by:

$$x_i^{t+1} = x_i^t + \beta_0 e^{-\gamma r_{ij}^2} \left(x_j^t - x_i^t \right) + \alpha \varepsilon_i^t \tag{10.6}$$

where the second term due to attraction and the third term is the randomization with $\alpha \in [0, \infty]$ being the randomization parameter and represents a vector of random numbers from a Gaussian distribution/uniform distribution at time t.

Based on Yang (2008) and Yang and He (2013), the essential steps of the FA can be formulated as the subsequent pseudocode:

FIREFLY ALGORITHM
Begin
Determine the objective function $f(x)$, $x = (x_1......x_d)^{\mathrm{T}}$
Generate initial population of fireflies x_i ($i = 1,2,....,n$)
Determine the light intensity I_i at x_i by $f(x_i)$
Define the light absorption coefficient γ
 while ($t <$ MaxGeneration)
 for $i = 1$: n all n fireflies
 for $j = 1$:i all n fireflies (inner loop)
 if ($I_j > I_i$), move firefly i toward j;
 end if
 Vary the attractiveness with distance r via $exp[-\gamma r]$
Evaluate new solutions and update light intensity
 end for j
 end for i
Rank the fireflies and find current global best g.
 end while
Postprocess results and visualization.
END

4 PROPOSED METHOD

The proposed system consists mainly of two dependable phases as demonstrated in Fig. 10.1. The first phase includes the image registration process, which required dividing the video under test into frames. Afterward, the binning selection strategy is employed to select the number of frames that will be included in the registration process. To perform the registration, the second phase involves determining the optimized values of the scaling factors that are used by the velocity field smoothing kernel. The optimization process is achieved via the FA algorithm in the registration framework.

To test the proposed system performance, different videos are used, and each is divided into a total of 112 image frames. To achieve proper distance between the source and the target image, the bin size must be small. Therefore, the bin size is set to 14 in order to attain 8 bins, where the total number of 112 frames is to be divided equally, where the total number of bins is 8 (=112/14) that obtained from the target video. Since the middle frame of the bin in the proposed framework is the seventh frame (of each bin), the seventh frame is chosen as a fixed image. Subsequently, each bin is allocated as an input, and every frame is processed from those bins. The image registration using demon's algorithm (Khader and Hamza, 2012) is applied using the registration parameters depicted in Table 10.1.

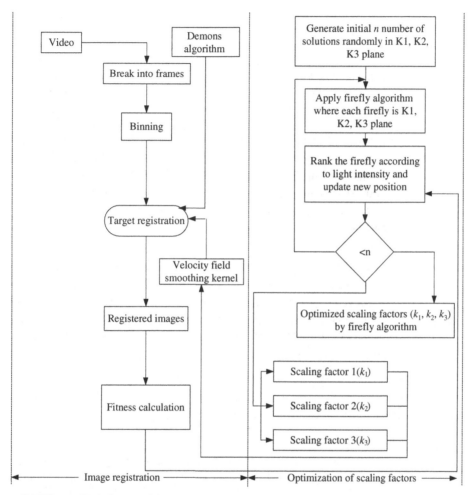

■ FIGURE 10.1 Block diagram of the proposed method.

The Gaussian low pass filter with integer coefficients is used for velocity field smoothing kernel, thus the total number of iterations used is 200. The integer values of the Gaussian filter guarantee the avoidance of errors that result from floating point operations. The same parameter default values involved for fluid registration in demons (20) is to be used for the proposed

Table 10.1 Registration Parameters Used in Demons Registration

Total number of iterations	200	
Velocity field smoothing kernel	2D filter	Sigma
	Gaussian low pass filter	10 pixels
Alpha (noise) constant	2.5 dB	

system. Thus, the Gaussian filter window size of 60 × 60, with sigma value of 10 pixels for the velocity field smoothing kernel and the value of the alpha constant value is 2.5 dB, is used.

In the proposed study, the 2D Gaussian filter for demons registration is employed with optimized velocity field smoothing kernel values using the FA. To optimize the window size (*hsize*), its values are chosen to vary from 20 to 100, where it is established experimentally that selecting window size less than 20 or greater than 100 led to erroneous registration. The parameter *hsize* can be a vector which specifies the number of rows and columns in *h*. Furthermore, the standard deviation (sigma) is optimized within the range of 0–20 while the default value of sigma is 10, where any value more than 20 led to very poor quality for the registered frames. Generally, for both parameters, the distortion increases if the parameter values used are beyond these ranges.

Finally, the correlation coefficient obtained by FA is to be used in the demons registration. The highest correlation coefficient is stored with the values of k_1, k_2, and k_3 used as a fitness function. Once the process is completed, the relationship of the registered image (e') and the original image (e) can be decided using the standard correlation coefficient (Corr) in Eq. (10.7), which is used to determine the fitness function.

$$\mathrm{Corr} = \frac{\sum_i \sum_j \left(e_{ij} - e'\right)\left(f_{ij} - f'\right)}{\sqrt{\left(\sum_i \sum_j \left(e_{ij} - e'\right)^2\right)\left(\sum_i \sum_j \left(f_{ij} - f'\right)^2\right)}} \tag{10.7}$$

Here, f and f' are the transforms of e and e', respectively. The proposed algorithm can be summed up as shown next based on the FA for optimization:

THE PROPOSED ALGORITHM

Begin
Objective function image registration $f(x)$ $x = (k_1, k_2, k_3)^T$
Generate initial population of fireflies x_i ($i = 1, 2 \ldots n$)
Light intensity Icorr$_i$ at x_i is determined by $f(x_i)$ (Eq. 10.7)
Define light absorption coefficient γ
 while (t < MaxGeneration)
 for $i = 1$ to n all n fireflies
 for $j = 1$ to i all n fireflies
 if *Ireg_corr$_j$* > *Ireg_corr$_i$*
 Move firefly i toward j;
 end if
 Attractiveness varies with distance r_{ij} via exp $[-\gamma \times r_{ij}]$

 Evaluate new solutions and update light intensity
 end for *j*
 end for *i*
Rank the fireflies and find current best.
end while
 Postprocess on the best so far results and visualization
End

Image Registration Algorithm

Begin
 For bin *i* = 1:*N*, *N* = total no. of bins
 For image *j* = 1:*M*, *M* = total number of images inside a bin
 Read the source image;
 Read the target image;
 Apply alpha (noise) constant;
 Apply velocity field smoothing kernel (k_1, k_2, k_3);
 Begin
 demons registration;
 End
 End for
 End for
End

5 RESULTS

MATLAB R2012a with 2.20 GHz Intel I third-generation computer with Microsoft Windows 7 operating system is used to implement the proposed system. The tested videos are obtained from dataset at: http://www.cipr.rpi.edu/resource/sequences/sequences/sif/yuv/sif_yuv_tennis.tgz. Meanwhile, the parameters used for FA are: the number of firefly = 10, alpha = 0.25, the randomness is 0–1 (highly random), betamn (minimum value of beta) is 0.20, and gamma (absorption coefficient) is 1. In addition, the parameters used for PSO are: inertia = 1.0, correction_factor = 2.0, swarm_size = 10, and the dimension *d* = 3. Furthermore, the number of iterations used in both algorithms is 5, 10, 15, 20, 25, 30, 35, and so on.

The original image, the source (reference, fixed) image registered, the registered image using the default parameters (velocity-smoothing kernels of demons registration), and the registered image using the optimized parameters (velocity-smoothing kernels of demons registration) are demonstrated in Fig. 10.2a–d, respectively.

By visual representation of Fig. 10.2, it is established that involving the FA for optimization has greatly enhanced the registered image quality. The same observed result is proved numerically using two image quality measurement parameters, such as structural similarity index (SSIM) and the

■ **FIGURE 10.2** (a) Target image, (b) source image, (c) registered image with default parameters, and (d) registered image with optimized parameters (k_1, k_2, and k_3).

Table 10.2 Comparison of Optimized and Nonoptimized Frameworks

Comparative Parameter	With Default Parameters	Firefly Algorithm
Correlation	0.5591	0.6108
Structural similarity index	0.2736	0.4776

correlation coefficient. Table 10.2 illustrates that the correlation has significantly changed using the FA with a value of 0.6108 compared to demons registration with the default parameters of 0.5591. Similarly, the demons registration based FA for optimization achieved SSIM value. A SSIM value of 0.4776 is achieved using the FA to attain the optimized parameters, which is greater than the framework without optimization, which have a value of 0.2736.

Fig. 10.3 illustrates the pair of the moving image and registered image. Fig. 10.3b shows that the displacement is less significant in the overlapped image of the optimized framework than in the default framework (Fig. 10.3a).

The Gaussian filter with integer window coefficients is optimized using FA. For the current experimental study, the FA-based optimization techniques converged at 25th iteration with population size of 15. The graphical depiction is illustrated in Fig. 10.4 along with the values reported in Table 10.3.

The PSO can be considered a good benchmark method. Thus, the results obtained using the FA for optimizing demons registration is compared to using the PSO algorithm. The comparison is conducted using the same

■ **FIGURE 10.3 Overlapped image of moving image with registered image.** (a) Default parameters and (b) optimized parameters.

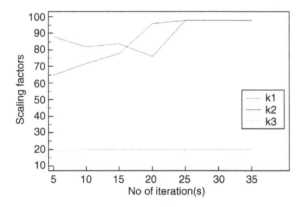

■ **FIGURE 10.4 Optimization of scaling factors using the firefly algorithm.**

Table 10.3 Optimization Using the Firefly Algorithm

No. of Iteration(s)	k_1	k_2	k_3	Obtained Maximum Fitness
5	65	88	19	0.5914
10	72	82	20	0.6027
15	78	84	20	0.6051
20	96	76	20	0.604
25	*98*	*98*	*20*	*0.6108*
30	*98*	*98*	*20*	*0.6108*
35	*98*	*98*	*20*	*0.6108*

Gaussian filter. The obtained FA results reported in Table 10.3 are compared to those attained using the PSO reported in Table 10.4.

The results obtained in Table 10.3 and Table 10.4 are shown in Fig. 10.5 to compare both results, which support the proposed claim.

Fig. 10.5 clarified that the PSO is converged after 30th iteration with the same population size of 15, showing that FA is a superior technique for

Table 10.4 Optimization Using Particle Swarm Optimization

No. of Iteration(s)	k_1	k_2	k_3	Obtained Maximum Fitness
5	93	98	20	0.6099
10	98	84	20	0.6082
15	98	98	20	0.6108
20	93	98	20	0.6098
25	95	81	20	0.6081
30	98	98	20	0.6108
35	98	98	20	0.6108

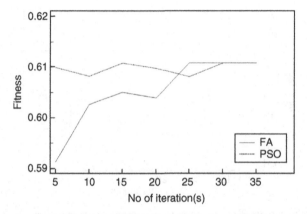

■ FIGURE 10.5 Comparative study of optimized fitness values using PSO and FA.

Table 10.5 Time Complexity of the Firefly Algorithm Versus Particle Swarm Optimization

No. of Iteration(s)	Firefly Algorithm (s)	Particle Swarm Optimization(s)
5	2,141.91	6,871.9
10	3,748.07	12,599.6
15	12,374.13	18,567
20	15,914.34	32,517.4
25	19,820.22	43,158.7
30	23,545.22	57,891
35	39,581.19	75,671.6

demons registration optimization compared to the PSO. Table 10.5 and Fig. 10.6 show the time comparison of using the FA and the PSO-based optimization framework for registration.

Visual representation of the graph in Fig. 10.6 and comparative study from Table 10.5 show that the FA is faster than the PSO. Consequently, from

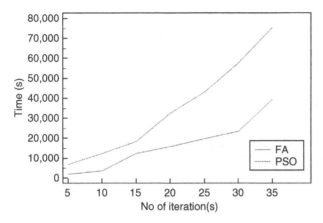

■ FIGURE 10.6 Time complexity comparison of the firefly algorithm and particle swarm optimization.

the results shown, it is established that the proposed registration approach enhanced the image quality more than the classical registration. In addition, the comparative study of the FA versus PSO proved that the FA-based optimization framework is more stable and produces superior results than the PSO-based optimization framework. In addition, the FA-based optimization framework is faster than PSO-based optimization framework. Therefore, the overall conclusion is that the FA-based optimization for demons registration is more stable and faster than the PSO-based optimization framework.

6 CONCLUSIONS

The current work proposes a method for registering video sequences based on demons registration–based FA for optimization. The suggested framework employed the Gaussian filter values for the velocity smoothing kernel scaling factors (k_1, k_2, k_3) to be optimized. The FA used the correlation coefficient as the fitness function, where the highest fitness value was stored in order to use the corresponding scaling factor values for postprocessing. The performance of the proposed FA-based framework was compared to the classic demons algorithm with default parameters without optimization, which established the superiority of the proposed system.

Moreover, comparing the proposed FA-based optimization framework to the PSO-based optimization framework demonstrated that the fitness value and scaling factors were higher in the FA than PSO. Additionally, the FA achieved faster convergence with 25 iterations than the PSO, which converged at 30 iterations. Subsequently, demons registration–based FA is a faster framework than the PSO.

ACKNOWLEDGMENT

This work was cofunded by European Union through European Regional Development Funds Structural Operational Program "Increasing of Economic Competitiveness" Priority axis 2, operation 2.1.2. Contract Number 621/2014.

REFERENCES

Araki, T., Ikeda, N., Dey, N., Chakraborty, S., Saba, L., Kumar, D., Godia, E., Jiang, X., Gupta, A., Radeva, P., Laird, J., Nicolaides, A., Suri, J., 2015. A comparative approach of four different image registration techniques for quantitative assessment of coronary artery calcium lesions using intravascular ultrasound. Comput. Methods Programs Biomed. 118 (2), 158–172.

Bejinariu, S.-I., Rotaru, F., Nita, C., Luca, R., Costin, H., 2013. Parallel image registration using bio-inspired computing. In: E-Health and Bioengineering Conference (EHB), pp. 1–4.

Brown, L., 1992. A survey of image registration technique. ACM Comput. Surv. 24, 325–376.

Bulsara, V., Bothra, S., Sharma, P., Rao, K.M.M., 2011. Low cost medical image processing system for rural/semi urban healthcare. In: IEEE Conference Publications on Recent Advances in Intelligent Computational Systems (RAICS), pp. 724–728.

Caspi, Y., Simakov, D., Irani, M., 2006. Feature-based sequence-to-sequence matching. Int. J. Comput. Vis. 68, 53–64.

Chen, Y.-W., Lin, C.-L., Mimori, A., 2008. Multimodal medical image registration using particle swarm optimization. Proc. ISDA 3, 127–131.

Chowdhury, S., Chakraborty, S., Karaa, W., Ray, R., Dey, N., 2014. Effect of demons registration on biomedical content watermarking. In: International Conference on Control, Instrumentation, Communication and Computational Technologies, pp. 509–514.

Crum, W.R., Hartkens, T., Hill, D.L.G., 2004. Non-rigid image registration: theory and practice. Br. J. Radiol. 77, 140–253.

Dey, N., Biswas, S., Roy, A.B., Das, A., Chaudhuri, S.S., 2012a. Analysis of photoplethysmographic signals modified by reversible watermarking technique using prediction-error in wireless telecardiology. In: 47th Annual National Convention of the International Conference of Intelligent Infrastructure (CSI) Kolkata, December 1–2, 2012, pp. 1–5.

Dey, N., Roy, A.B., Das, A., 2012b. Optical cup to disc ratio measurement in glaucoma diagnosis using Harris corner. In: Third International Conference on Computing Communication and Technologies 2012 (ICCCNT12), Coimbatore, Tamil Nadu, India, pp. 1–5.

Gospodinova, E., Dey, N., Domuschiev, I., Ashour, A.S., Sifaki-Pistolla, D., Gospodinova, M., 2015. Analysis of heart rate variability by applying nonlinear methods with different approaches for graphical representation of results. Int. J. Adv. Comput. Sci. Appl. 6 (8), 38–44.

Hwuang, E., Danish, S., Rusu, M., Sparks, R., Toth, R., Madabhushi, A., 2013. Anisotropic smoothing regularization (AnSR) in Thirion's demons registration evaluates brain MRI tissue changes post-laser ablation. In: 35th Annual International Conference of the IEEE Engineering in Medicine and Biology Society (EMBS), Osaka, Japan, 3–7 July, pp. 4006–4009.

Jakšić, B., Gara, B., Petrovic, M., Spalevic, P., Lazic, L., 2015. Analysis of the impact of front and back light on image compression with SPIHT method during realization of the chroma key effect in Virtual TV Studio. Acta Polytech. Hung. 12 (2), 71–88.

Khader, M., Hamza, A.B., 2012. An information-theoretic method for multimodality medical image registration. Expert Syst. Appl. 39 (5), 5548–5556.

Klein, S., Staring, M., Pluim, J.P.W., 2007. Evaluation of optimization methods for nonrigid medical image registration using mutual information and B-splines. IEEE Trans. Image Process. 16 (12), 2879–2891.

Mathew, S.P., Balas, V.E., Zachariah, K.P., Samuel, P., 2014. A content-based image retrieval system based on polar raster edge sampling signature. Acta Polytech. Hung. 11 (3), 25–36.

Meskine, F., Mezouar, M.C.E., Taleb, N., 2010. A rigid image registration based on the nonsubsampled contourlet transform and genetic algorithms. Sensors 10 (9), 8553–8571.

Mohamed, W., Hamza, A., 2010. Medical image registration using stochastic optimization. Opt. Laser. Eng. 48 (12), 1213–1223.

Nandi, D., Ashour, A.S., Samanta, S., Chakraborty, S., Salem, M., Dey, N., 2015. Principal component analysis in medical image processing—a study. Int. J. Image Mining 1 (1), 1–17.

Pal, G., Acharjee, S., Rudrapaul, D., Ashour, A.S., Dey, N., 2015. Video segmentation using minimum ratio similarity measurement. Int. J. Image Mining 1 (1), 87–94.

Rouet, J.M., Jacq, J.J., Roux, C., 2000. Genetic algorithms for a robust 3-D MR-CT registration. IEEE Trans. Inform. Technol. Biomed. 4, 126–136.

Roy, P., Chakraborty, S., Dey, N., Dey, G., Ray, R., Dutta, S., 2014. Adaptive thresholding: a comparative study. In: International Conference on Control, Instrumentation, Communication and Computational Technologies, 10–11 July, pp. 1182–1186.

Sharma, T.K., Pant, M., 2013. Enhancing different phases of artificial bee colony for continuous global optimisation problems. Int. J. Adv. Intell. Paradigms 5 (1/2), 103–122.

Singhai, R., Singhai, J., 2012. Registration of satellite imagery using genetic algorithm. In: Proceedings of the World Congress on Engineering (WCE 2012), London, UK, vol. 2, pp. 201–206.

Thirion, J.P., 1998. Image matching as a diffusion process: an analogy with Maxwell's demons. Med. Image Anal. 2, 243–260.

Wachowiak, M.P., Smolíková, R., Zheng, Y., Zurada, J.M., Elmaghraby, A.S., 2004. An approach to multimodal biomedical image registration utilizing particle swarm optimization. IEEE Trans. Evol. Comput. 8, 289–302.

Yang, X.S., 2008. Nature-Inspired Metaheuristic Algorithms. Luniver Press, Bristol, UK.

Yang, X.S., He, X., 2013. Firefly algorithm: recent advances and applications. Int. J. Swarm Intell. 1 (1), 36–50.

Zheng, L., Tong, R., 2011. Image registration algorithm using an improved PSO algorithm. ICCIC 2011, Part IV, CCIS, 234, pp. 198–203.

Chapter 11

Minimizing the mode-change latency in real-time image processing applications

P.S. Martins*, F.R. Massaro*, E.L. Ursini*, M.G. Carvalho*, J. Real**

*School of Technology, University of Campinas (UNICAMP), Limeira, São Paulo, Brazil;
**Universitat Politècnica de València, Valencia, Spain

1 INTRODUCTION

Image processing applications may benefit from multithreading in a single or multicore processor. The key concept is to partition the functionality of the application into simple tasks (or threads) and execute them concurrently, so that the total time is distributed between these tasks. The idea

Bio-Inspired Computation and Applications in Image Processing. http://dx.doi.org/10.1016/B978-0-12-804536-7.00011-9

of multithreading image processing applications on multicore systems and its gains in performance have been demonstrated by a number of authors, for example, Kika and Greca (2013), Chen et al. (2009), Stevenson et al. (2000), Squyres et al. (1998), and Saxena et al. (2015). One example of parallelization in image processing applications is the case where an image is divided into different areas and each thread is assigned to process one area.

In addition to decomposing the image processing functionality into modules that may run in parallel, it is also necessary to define the shared data items and create a controlled access through synchronization primitives (ie, it is necessary to ensure coordination and synchronization among threads to prevent anomalies such as deadlocks). Last but not least, given that the functional correctness is asserted, the algorithms have to be optimized and the system's efficiency has to be analyzed and improved.

In addition to efficiency, the new generation of image processing systems must dynamically adapt to the environment where they are deployed. One way of achieving multifunctionality and adaptivity is by organizing the system design around modes of operation. Each mode implements a well-defined system behavior, and the system transitions from one mode to another in response to changes in the surrounding context. The new active mode is customized and configured to the new operational phase and can thus deliver better performance than a general, monolithic (ie, single mode) implementation of the system functionality. Therefore, by changing modes in response to external events, the system becomes more reconfigurable and adaptive.

For example, assume an image processing application that has two modes of operation: SUNLIGHT (SLT) and OVERCAST (OVC) modes. Under sunlight conditions, the system executes the SLT mode, which is implemented by a set of threads running algorithms that are specialized to deal with this condition. Once the conditions change to cloudy (eg, on a heavily overcast or rainy day), the system dynamic and autonomously switches to the OVC mode of operation. In the OVC mode, the system loads and executes the set of threads that optimize resource usage and run specialized algorithms for this condition. During the transition between modes, the threads belonging to the SLT mode have to be eliminated and the new OVC threads have to be added. This is specified by a mode-change protocol. Such a protocol allows that some threads that are common to both modes to continue running without interference. Other modes are possible, and each mode will run the threads with the "best" algorithm for that phase of operation.

A mode of operation is defined by its behavior (ie, functionality and performance) and implemented by a task (ie, thread) set (also denoted a schedule) (Pedro, 1999). Changes in the mode of operation thus involve changing the

task set by adding, replacing, or removing tasks from the schedule, or a combination of these actions. In order to implement modal (or flexible) image processing systems with real-time capabilities, the transitions from mode to mode have to be guaranteed by offline (ie, static) schedulability analysis.

In this work, we assume the implementation of a multithreaded image processing application in a fixed-priority preemptively scheduled real-time operating system running on a single processor (Tindell et al., 1994). As we show in Section 2 in more detail, in our model any new task is introduced in the system during a mode change (or transition) with an offset (or delay) O after the start of the transition to the new mode of operation.

On one hand, offsets that are too small may increase the CPU utilization at the start of the transition to a point where the system is no longer schedulable (ie, tasks miss their deadlines). On the other hand, if offsets are assigned with large values, the latency of a mode-change may increase to the point where the mode change itself is not longer viable in terms of system performance and functionality.

The main motivation to minimize the latency of a mode change is that, during a mode change, while the system is self-configuring the task set, the application may be only "partially" delivering its critical functions. Therefore, it is reasonable to associate a deadline with a mode change. Consequently, it is of utmost importance that the latency of the system is reduced to its lowest possible value. This leads to the main concern to be addressed in this work:

We wish to find a method to automatically assign proper offsets to tasks across a mode-change so that the latency of the transition is minimized while real-time guarantees are also preserved. As a case study, we take an image processing application implemented by a set of tasks and two possible modes of operation.

We tackle the issue of "tasks across a mode-change" because previous work (Tindell et al., 1994) has already provided solutions to the schedulability of tasks running in a steady mode of operation (ie, where there is no transition). A task is said to be schedulable across a mode-change if its worst-case response time (WCRT) during the transition is less than or equal to its deadline. Real-time guarantees mean that deadlines for tasks must be fulfilled by the analysis, otherwise the system is deemed not schedulable, potentially leading to undesired critical behavior. This problem is a multiobjective optimization one that has to deal with trade-offs, as discussed later.

To our knowledge, there is currently no work in the literature that addresses such concerns. The work that is closest to ours is that by Real and Crespo

(2001), in which the authors tackle the issue of minimizing offsets. However, our goal in this work is different in that we wish to primarily minimize the worst-case latency of a mode-change.

This work offers a method to minimize the latency of a mode change (as well as tasks offsets) in a real-time system running an image processing application, whereby threads are scheduled by the fixed-priority preemptive scheduling approach. We show in Case 2 in Section 4 that the minimization of tasks offsets, as carried out by Real and Crespo (2001), does not necessarily lead to minimum mode-change latency.

Most work using genetic algorithms (GAs) in real-time systems fall outside the scope of our work, as they deal with the issue of allocating tasks to multiprocessors, such as the work by Yoo (2009) and ManChon et al. (2011). The focus of our work is on addressing the challenge of minimizing the mode-change latency and proposing a workable solution, which involves the modeling of the approach and its validation. Therefore, we do not aim to experiment with different metaheuristics or evolutionary algorithms or compare their performance.

We have opted to use GAs due to their known efficiency and simplicity. More advanced approaches could certainly be used here, but the results obtained in this work have shown that the proposed approach is feasible (ie, it is able to find solutions that satisfy the requirements defined for the problem). Therefore, we reserve the comparison analysis of metaheuristics and evolutionary algorithms to future work. The issue of mode-change latency minimization is modeled both as a single-objective and a multiobjective optimization.

In multiobjective optimization problems, the objective functions can be (and generally are) in conflict with each other. In these cases, there is a set of final solutions that correspond to different trade-offs between the objectives (ie, each of these solutions indicates, for a given value of one of the objectives, the best value that can be obtained for the remaining ones). Therefore, an infinite set of solutions can exist for a given problem, which corresponds to the infinite number of existing trade-offs among the objectives. This set of solutions for a multiobjective problem is known as the *Pareto front*, and it contains only *nondominated individuals*. Assuming that all objectives of the problem must be minimized, a given solution \vec{x} is said to dominate a solution \vec{y} of the problem $(\vec{x} \leq \vec{y})$ if and only if

$\forall\, m \in \{1,\ldots,M\}, f_m(\vec{x}) \leq f_m(\vec{y})$, and $\exists\, i \in \{1,\ldots,M\} : f_i(\vec{x}) < f_i(\vec{y})$, where M is the number of objectives to be optimized. The notion of optimality in multiobjective optimization problems states that a given solution $\vec{x}*$ belongs to

the Pareto front (or is Pareto optimal) if there is no other feasible solution \vec{x} capable of improving the value of one objective without simultaneously worsening at least one of the others.

This remainder of this chapter is organized in this way: Section 2 presents a review of earlier work. The model and approach using GA is discussed in Section 3. The case studies and the results are presented in Section 4 and discussed in Section 5. Finally, in Section 6, we present our conclusions.

2 REVIEW OF EARLIER WORK

In this section we review background as well as earlier work on the subject.

2.1 Offset minimization algorithm

An algorithm for the optimization of task's offsets across a mode change was proposed by Real and Crespo (2001). This algorithm reduces offsets for high-priority tasks and considers two scenarios in order to achieve consistency in the use of shared resources across an asynchronous mode change: increased blocking of new-mode tasks and violation of the immediate priority ceiling protocol (IPCP). The IPCP protocol ensures that lower-priority old-mode tasks sharing resources do not lock resources used by new-mode, higher-priority tasks (Real and Wellings, 1999).

There is a set of vectors used in this approach. For example, Y_r is the vector of offsets needed for consistency of shared resources; Y_{max} and Y_{min} are respectively the vectors with the maximum and the minimum offsets that can be applied to new-mode tasks, and Y_i is a vector that holds the values of the current iteration of the analysis.

The offset of the higher-priority task is reduced to a point where the system is closest to becoming unschedulable or it is *zero*. This procedure is repeated to the next lower-priority task until all tasks in the task set are covered.

2.2 Genetic algorithms

The taxonomy reported in De Corte and Sörensen (2012) divides metaheuristic frameworks into three classes: (1) local search metaheuristics, which operate on a single complete solution and iteratively improve it by making small adjustments called moves; (2) population-based metaheuristics, which operate on a set of solutions and find better solutions by combining solutions from that set into new ones; and (3) constructive metaheuristics, which build a solution by working with a single, unfinished solution and adding one solution element at a time.

We found that methods belonging to the local search metaheuristics risk being trapped in unfeasible spaces, while methods belonging to constructive metaheuristics are promising but quite difficult to calibrate and require further research. GA methods belong to the population-based metaheuristics. They are stable and produce a sure improvement without the need to calibrate parameters that do not have their own physical meaning and which therefore must be estimated empirically.

An example of application of GAs in real-time systems is the work by Briand et al. (2006). GAs were used to provide automated analysis of the schedulability of tasks during the design process as well as to test system response time to events in an effective manner once implemented.

2.3 Mode-change model

An operational mode is composed of a set of tasks. Each task is described by these attributes: worst-case response time R_i, worst-case execution time C_i (WCET), periodicity T_i, priority P_i, and deadline D_i. The mode-change model is based on the same assumptions of Real and Crespo (2001) and Pedro and Burns (1998): (1) tasks are assigned fixed priorities by the deadline monotonic scheduling algorithm and executed in a uniprocessor system; (2) tasks are not permitted to voluntarily suspend themselves during an invocation; (3) there are fixed task sets before and after the mode change; and (4) tasks are scheduled with time offsets during the mode change only. This time phasing between tasks may or may not hold after the mode change. There are two types of task offsets O_i: Y_i is measured from the start of a mode-change request (MCR) and Z_i is measured from the end of the period of the preceding old-mode task (Real and Crespo, 2001). The window x is the phasing between the MCR and the activation of task τ_i.

Fig. 11.1 illustrates the mode-change model. The system goes through three distinct stages: upon receiving an MCR, the system moves from a steady-state old mode to a mode change (transient period) and finally arrives in a steady-state new mode. The simple iterative deadline monotonic analysis (Audsley et al., 1993) equation guarantees the schedulability of tasks in the steady state. Given the current mode, an MCR and a set of tasks, the goal of the WCRT mode-change analysis is to find out whether tasks are schedulable across the transition. Inherent to the schedulability analysis is the fact that old tasks that advance through the mode-change period in order to complete interfere and suffer interference from new tasks released during the mode change.

The mode-change model is composed of five types of tasks:

- *Old mode completed tasks* $\tau_{i(o)}$ run in the old mode and are not needed in the new mode. Therefore, they need to complete during the mode

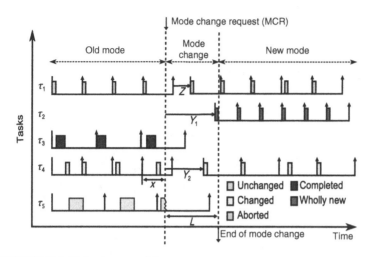

■ **FIGURE 11.1** Mode-change model.

change for data consistency and future executions. Their execution may span the whole duration of a mode change, provided only that deadlines are not missed.

- *Old mode aborted tasks* $\tau_{i(A)}$ are discarded at the beginning of the transition window. They need to be quickly eliminated in order to release resources back to the system.

- *Whole new tasks* $\tau_{i(W)}$ are introduced in the system during the transition and run in the new mode. They model the new functionality that is required by the system (eg, alarms). Furthermore, they can be introduced in the system with an offset Y_i anytime later than the MCR. From the application point of view, this class of tasks not only provides the system with a new functionality but it also caters to situations where it is required to introduce tasks as soon as the MCR occurs, as may be the case with more critical tasks.

- *Changed new* $\tau_{i(C)}$ *and unchanged new* $\tau_{i(U)}$ tasks implement the system's changed and unchanged functionality respectively. Each task in this class is always preceded by a corresponding old mode with computational time and period that may be changed during the mode change. Changed and unchanged new tasks can be introduced with an offset O_i. This condition may be necessary to allow the corresponding old-mode task to complete.

2.4 Schedulability analysis

The schedulability analysis of a mode change is divided into two parts: analysis of old-mode tasks and analysis of new-mode tasks. For the analysis of the WCRT of an old-mode task, we consider that its execution is affected

by: (1) interference from higher-priority old-mode completed tasks $Ihp_{(i)o}$; (2) interference from higher-priority aborted tasks $Ihp_{(i)A}$; (3) interference from higher-priority new-mode tasks $Ihp_{(i)N}$; and (4) interference from unchanged tasks $Ihp_{(i)U}$. By combining each of these terms, we obtain the WCRT window for an old-mode task, given by the next recurrence equation:

$$
\begin{aligned}
w_i^{n+1} = C_i + B_i + & \sum_{\forall j \in hp(i)o} \left\lceil \frac{x}{T_j} \right\rceil C_j + \\
& \sum_{\forall j \in hp(i)A} \left(\left\lfloor \frac{x}{T_j} \right\rfloor C_j + \min\left(x - \left\lfloor \frac{x}{T_j} \right\rfloor T_j, C_j \right) \right) + \\
& \sum_{\forall j \in hp(i)N} \left\lceil \frac{w_i^n - x - Y_j}{T_j} \right\rceil_0 C_j + \\
& \sum_{\forall j \in hp(i)U} \left\lceil \frac{x}{T_j} \right\rceil C_j + \left\lceil \frac{w_i^n - \lceil x/T_j \rceil T_j - Z_j}{T_j} \right\rceil_0 C_j
\end{aligned}
\tag{11.1}
$$

The notation $[\zeta]_0$ denotes a modified ceiling function that returns zero if $\zeta < 0$. B_i is the blocking time suffered from task τ_i. The initial value of w_i is set to *zero*. It can be shown that w_i either converges or exceeds some threshold, such as D_i. However, the worst case for the response task R_i, which must then be compared with the respective deadline, is given by $R_i = \max(w_i(x)) \forall x \in (0, R_i^s)$, where R_i^s is the steady-state WCRT of task τ_i. The analysis of a new-mode task is similar and can be found in Pedro and Burns (1998) or Real and Crespo (2001).

In addition to the schedulability analysis work of Pedro and Burns (1998), Real and Crespo (2004), and Tindell et al. (1992) on mode changes in uniprocessors for fixed-priority preemptive real-time systems using the deadline monotonic policy, other authors have contributed to the theme using other approaches, such as mode changes under: (1) systems with the rate-monotonic policy (Sha et al., 1988); (2) time-triggered systems (Fohler, 1993); (3) multiprocessor systems' scheduling (Nelis and Goossens, 2008; Yomsi et al., 2010); (4) uniprocessors using earliest deadline first (EDF) scheduling (Andersson, 2008; Stoimenov et al., 2009; Nelis et al., 2011), (5) multiprocessor systems with mixed-criticality constraints (Neukirchner et al., 2013; De Niz and Phan, 2014); (6) multicore real-time embedded systems (Negrean et al., 2012); and (7) temporal isolation (Fisher and Ahmed, 2011).

2.5 Definition of mode-change latency

The mode-change latency (L) is usually an important performance criterion when dealing with mode changes. We often seek to minimize the latency since during the mode change, the system may deliver only partial

functionality at the expense of more critical services, and not all tasks are yet activated in the system. Mode-change latency is defined as follows: "A window starting with the arrival of the mode-change request (MCR) and ending when the set of new-mode tasks have completed their first execution and the set of old-mode tasks have completed their last execution" (Pedro and Burns, 1998). The worst-case latency is given by Eq. (11.2):

$$L = \max(R_{i(N)} + Y_{i(N)}, R_{i(O)} - x_i) \, \forall \, \tau_i \in \tau \tag{11.2}$$

where $R_{i(N)}$ and $R_{i(O)}$ are the WCRT of the new-mode task and the WCRT of the old-mode task respectively.

3 MODEL AND APPROACH TO MINIMIZATION

The flow of the optimization process using GA is illustrated in Fig. 11.2. Each one of the steps presented is explained in detail next.

- *Initial population.* The first step is to create the initial population, which can be predetermined or randomly defined. We chose to adopt an initial random population. In this work, the population is the set of

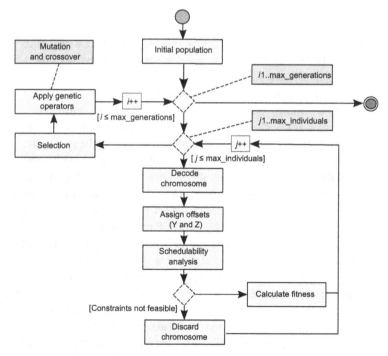

■ FIGURE 11.2 Optimization using GA.

FIGURE 11.3 Structure of a chromosome (*n* equal to the number of new-mode tasks).

offsets from all new-mode tasks. Determining an appropriate initial population for this analysis is not straightforward. Small values for offsets are not good candidates, since small offsets may lead to unschedulability. Large offsets are amenable to reduction to some extent but are far from the solution searched for. Furthermore, no relationship establishes a direct function between latency and offsets, and both offsets and latency are very application dependent.

■ *Decode chromosome.* The analysis of the problem to be optimized shows that each gene in a chromosome must correspond to an offset value O_i (*Y* or *Z*). The GA adopted in this work uses a permutation-based representation (Coello et al., 2007). Each gene is expressed in hexadecimal notation and uses 4 characters that represent an integer value between 0 and 65,535 (Fig. 11.3). A chromosome must have *n* genes, where *n* is the number of new-mode tasks across a mode change.

■ *Assign offsets (Y and Z).* Each chromosome belonging to a generation is decoded, and the values of its genes are assigned to the task offsets.

■ *Schedulability analysis.* Having assigned the offsets, the task set is submitted to the mode-change schedulability analysis.

■ *Check constraints.* The optimization process must meet constraints represented as *Co*. *Co* is a vector that uses binary notation (1 represents an active or valid constraint and 0 an inactive one). In the case study described in Sections 4.1–4.5, two constraints were used: (1) system feasibility (constraint *Co*1) (ie, all tasks meet their deadlines), where we apply the schedulability analysis ($R \leq D$) tests to discard unfeasible solutions. This analysis is based on the WCRT windows as shown in Section 2.4; (2) resource sharing via IPCP protocol (constraint *Co*2). This objective is also used to discard solutions that do not comply with the IPCP protocol when resources are shared across a mode change. In case tasks are independent, the objective is simply removed from the search (ie, by assigning *Co*2 = 0).

■ *Discard chromosome.* At the end of the analysis process, we check the constraints (system feasible and compliance with the IPCP protocol, when necessary). If the constraints are not feasible, the chromosome is discarded.

- *Calculate fitness.* Upon completion of the real-time analysis, if the constraints are met, the algorithm proceeds by calculating the fitness function as shown:

$$\text{Fitness} = \sum_{j=1}^{n} Ob_j \cdot We_j \qquad (11.3)$$

where Ob_j corresponds to the value of objective j and We_j represents its weight (ie, the relative importance of one objective j in comparison to the other ones). Fitness is the degree of aptitude of a chromosome. The smaller the fitness value is, the better is the individual within the population.

The minimization of the latency of mode changes is a multiobjective optimization problem. For example, in the case studies to be described, we used two objectives to compose the fitness function: (1) reduction of latency (objective Ob_1), using Eq. (11.2). In this case, the minimization of latency is modeled as the main, single/multiobjective GA; (2) minimization of offsets (objective Ob_2), where we use the summation of all task offsets as a measure of the degree of minimization of a candidate solution. Clearly, the lower the sum of offsets for a given solution, the better (or more fit) it is as a solution in regard to this objective. However, other objectives can also be adopted, such as minimization of the interference between tasks for a given value of latency and minimization of offsets for higher-priority tasks. The rating or the quality of the solution is represented by the fitness function, which expresses the fitness of a particular chromosome within a population. The greater the fitness (smaller value), the higher are the chances of a chromosome adapting to its environment and passing its genes to its successors.

- *Selection.* The selection process chooses the chromosomes with the highest degree of suitability for reproduction (ie, the larger the fitness of a chromosome, the greater are its chances of reproduction). The selection operator used in this work was elitist selection (Coello et al., 2007).

- *Genetic operators.* After the selection process, the selected chromosomes are recombined to a certain extent using a crossover operator. Pairs of chromosomes from a population are randomly chosen, taking into account their fitness, and then recombined, generating a new individual that inherits the genetic characteristics of both parents. The crossover operator adopted was the two-point crossover (Coello et al., 2007; De Jong, 2006). The mutation operator was also used to increase the diversity of a population of

chromosomes. The mutation and crossover probabilities were fixed at 10 and 70%, respectively, for all scenarios and case studies.

4 CASE STUDIES

This section is subdivided into five case studies:

1. Minimization of offsets (single objective)
2. Minimization of the latency (single objective)
3. Minimization of both latency and offsets (weights-based multiobjective)
4. Minimization of both the latency and the offsets (multiobjective optimization)
5. Minimization of both the latency and the offsets (multiobjective optimization) with a randomly generated task set

These case studies are set according to scenarios that are likely to be encountered in real applications. They also provide a range of possibilities with enough coverage to allow us to understand the behavior of the search in the face of its objectives and constraints. Table 11.1 shows a summary of the cases studies introduced in this section.

The case studies were performed on a hardware/software platform consisting of an Intel Core i7-2670QM CPU @ 2.20 GHz processor with installed memory (RAM) of 6.00 GB and Windows 7 Home Premium 64-bit operating system.

4.1 Case 1: Minimizing offsets

4.1.1 Definition

In this case study, the optimization was performed on a set of six generic tasks (Table 11.2) in order to minimize offsets. The goal of this case is two-fold: to demonstrate the flexibility of the approach (ie, the weights-based multiobjective GA mode-change minimization approach can also be used to minimize offsets in addition to minimizing latency), and to compare the

Table 11.1 Summary of the Case Studies

Case Study	Goal(s): to Minimize	Algorithm
1	Offsets	Single-objective GA
2	Latency	Single-objective GA
3	Latency and offsets	Weights-based multiobjective GA
4	Latency and offsets	Multiobjective NSGA-II
5	Latency and offsets using a random task set	Multiobjective NSGA-II

Table 11.2 Case 1: Set of Tasks

	Mode M1						Mode M2						
Tasks	**P**	**C**	**B**	**T = D**	**R**	**TEST**	**Tasks**	**P**	**C**	**B**	**T = D**	**R**	**TEST**
$\tau_{1(O)}$	1	10	0	100	10	OK	$\tau_{1(U)}$	1	10	0	100	10	OK
$\tau_{2(W)}$	Not active in this mode						$\tau_{2(W)}$	2	20	25	120	55	OK
$\tau_{3(O)}$	2	30	25	200	65	OK	$\tau_{3(C)}$	3	30	25	270	85	OK
$\tau_{4(O)}$	3	40	24	280	115	OK	$\tau_{4(U)}$	4	40	24	280	155	OK
$\tau_{5(O)}$	4	50	25	300	165	OK	$\tau_{5(C)}$	5	50	25	350	180	OK
$\tau_{6(O)}$	5	60	0	350	200	OK	$\tau_{6(O)}$	Not active in this mode					

Resources	**C**	**Users**	**Ceiling**	**Users**	**Ceiling**
R1	25	τ_3, τ_5, τ_6	2	τ_3, τ_5	3
R2	25	τ_5	4	τ_2, τ_5	2

GA with the algorithm by Real and Crespo (2001). This example validates both methods used to offset minimization, as the two methods lead to the same values of offsets.

We used the same task set used by Real and Crespo (2001). Table 11.2 presents two modes of operation M1 and M2; each mode of operation comprises of six tasks, τ_1 through τ_6. The CPU utilization rate is 73.1% in M1 and 66.35% in M2. Tasks share two resources, R1 and R2, as represented in the second half of Table 11.2. As there are shared resources, the IPCP was used to protect against deadlocks and transitive blocking, due to the sharing of resource R2 across the mode change. In mode M1, this resource is used by task τ_5 with ceiling priority 4. In mode M2, resource R2 is used by new-mode tasks τ_2 and τ_5 with ceiling priority 2. Note: the column "TEST" shows that the task is feasible in steady-state mode.

4.1.2 *GA configuration*

To determine the best parameters to be used in the optimization process using GA, 8 distinct scenarios (S_1, S_2, … S_8) were created (Table 11.3). Each scenario varies the size of the population and the number of generations, and was subject to 10 repetitions, to measure the accuracy of the data obtained.

Table 11.3 Case 1: Scenarios for GA Optimization

	Scenarios							
Parameters	S_1	S_2	S_3	S_4	S_5	S_6	S_7	S_8
Population	100	100	250	250	500	500	1000	1000
Generations	25	50	25	50	25	50	25	50

4.1.3 *Modeling*

The minimization of offsets was treated as a single-objective minimization problem with two constraints (ie, the schedulability of the task set across a mode change and the compliance with the IPCP protocol, due to shared resources). To achieve these objectives, the fitness function was instantiated with the weights $We = \{0, 1\}$, thus canceling the first objective (reduction of latency), and the constraints used were $Co = \{1, 1\}$ (ie, system feasibility and compliance with the IPCP protocol). The fitness function chosen was the sum of the offsets of all new-mode tasks, that is, $fitness = \Sigma\, O_i\; \forall\; i \in \tau$. The smaller the value of the sum, the better the solution found.

4.1.4 *Results*

Table 11.4 shows the summary of the sensitivity analysis for the set of 6 tasks, using the fitness function set to minimize offsets and aiming at verifying the impact of the population size and number of generations (ie. scenarios) on the minimization of offsets (ie. sum of offsets). The columns represent: (1) the scenario used for optimization; (2) the average time spent on each repetition of the scenario; (3) the lowest, highest, and average sum of offsets; and (4) the variation of the average in relation to the lowest value. As can be seen, scenario S_8 presented the smallest sum of offsets (265).

After optimization, the values of the best offsets obtained are shown in Table 11.5. The left part describes the old-mode tasks across the mode change: their deadlines D, the WCRT achieved with the GA R_2, the WCRT R_1 obtained with the algorithm of Real and Crespo (2001), variable x, and the results of the schedulability test. The right part shows the same attributes (except x) for all new-mode tasks across the transition, and it includes the offsets for each task.

The results are analyzed in Section 5.

Table 11.4 Case 1: GA Sensitivity Analysis

Scenarios	Time (min)	Sum of Offsets			
		Low	High	Average	Var. (%)
S_1	0.81	265	281	272.9	3.0
S_2	1.16	265	289	274.8	3.7
S_3	1.39	265	281	267.9	1.1
S_4	2.55	265	267	267.9	0.3
S_5	2.89	265	267	265.7	0.3
S_6	4.86	265	268	265.3	0.1
S_7	5.58	265	266	265.1	0.0
S_8	9.95	265	265	265.0	0.0

Table 11.5 Case 1: Resulting Offsets

	Old-Mode Tasks M1 → M2						New-Mode Tasks M1 → M2						
Tasks	$T = D$	R^a	R^b	x^a	x^b	TEST	Tasks	$T = D$	O^a	R^a	O^b	R^b	TEST
τ_1	100	10	10	0	0	OK	τ_1	100	0	10	0	10	OK
τ_3	200	65	65	0	0	OK	τ_2	120	195	55	195	55	OK
τ_4	280	115	115	101	101	OK	τ_3	270	0	70	0	70	OK
τ_5	300	195	195	1	1	OK	τ_4	280	70	240	70	240	OK
τ_6	350	260	260	1	1	OK	τ_5	350	0	350	0	350	OK

[a]*Algorithm of Real and Crespo (2001).*
[b]*Genetic algorithm.*

4.2 Case 2: Minimizing latency

4.2.1 *Definition*

In this case study, the optimization was performed on a set of 21 tasks (Tables 11.6 and 11.7). Table 11.6 presents mode M1 [daylight high-visibility mode (DHVM)] and Table 11.7 presents mode M2 [overcast low-visibility mode (OLVM)]. This set of tasks is composed of image processing

Table 11.6 Case 2: Set of Tasks—Mode M1

		Daylight High-Visibility Mode (DHVM) M1					
Tasks	Description	P	C	T	D	R	Test
$\tau_{1(O)}$	Contrast	1	10	1,000	50	10	OK
τ_2	Not active in this mode						
$\tau_{3(O)}$	Object recognition	12	200	2,000	1,200	742	OK
$\tau_{4(O)}$	Display update	13	5	2,000	1,400	747	OK
$\tau_{5(O)}$	Smoothing	4	10	400	400	100	OK
τ_6	Not active in this mode						
$\tau_{7(O)}$	Geometric transformations	5	20	600	450	120	OK
$\tau_{8(O)}$	Image retrieval (CBIR)	6	50	800	500	170	OK
τ_9	Not active in this mode						
$\tau_{10(O)}$	Classification	15	80	1,100	1,550	977	OK
$\tau_{11(O)}$	Image-graph representation	16	40	1,700	1,600	1,187	OK
$\tau_{12(A)}$	Tracking target	17	100	1,700	1,650	1,397	OK
$\tau_{13(O)}$	ROI selection	10	30	2,000	800	342	OK
$\tau_{14(O)}$	Object matching	11	90	3,000	900	442	OK
τ_{15}	Not active in this mode						
$\tau_{16(O)}$	Image measurement	2	20	250	60	30	OK
$\tau_{17(O)}$	Perceptual grouping	3	60	250	120	90	OK
$\tau_{18(O)}$	Edge detection	14	10	3,000	1,500	897	OK
$\tau_{19(O)}$	Steganography	7	30	4,000	590	200	OK
$\tau_{20(O)}$	Histogram equalization	8	15	20,000	600	215	OK
$\tau_{21(O)}$	Feature extraction	9	17	20,000	700	232	OK

Table 11.7 Case 2: Set of Tasks—Mode M2

Tasks	Description	Overcast Low-Visibility Mode (OLVM) M2					
		P	C	T	D	R	Test
τ_1	Not active in this mode						
$\tau_{2(W)}$	Morphological operations	1	30	2,000	50	30	OK
$\tau_{3(W)}$	Object recognition	2	20	250	60	50	OK
$\tau_{4(C)}$	Display update	3	50	250	120	100	OK
$\tau_{5(C)}$	Smoothing	4	10	400	400	110	OK
$\tau_{6(W)}$	Circular convolution	5	30	500	450	140	OK
τ_7	Not active in this mode						
τ_8	Not active in this mode						
$\tau_{9(W)}$	Correlation	6	50	500	500	190	OK
$\tau_{10(C)}$	Classification	7	80	590	590	340	OK
$\tau_{11(C)}$	Image-graph representation	8	90	800	600	440	OK
$\tau_{12(C)}$	Tracking target	9	20	800	700	460	OK
$\tau_{13(C)}$	ROI selection	10	50	1,000	800	740	OK
τ_{14}	Not active in this mode						
$\tau_{15(W)}$	Binarization	11	10	2,000	900	750	OK
$\tau_{16(C)}$	Image measurement	12	30	2,000	1,200	970	OK
$\tau_{17(C)}$	Perceptual grouping	13	10	2,000	1,400	980	OK
$\tau_{18(C)}$	Edge detection	14	10	2,000	1,500	990	OK
$\tau_{19(C)}$	Steganography	15	30	2,000	1,550	1,380	OK
$\tau_{20(C)}$	Histogram equalization	16	10	10,000	1,600	1,390	OK
$\tau_{21(C)}$	Feature extraction	17	10	10,000	1,650	1,400	OK

applications starting from low-level to intermediate- and high-level image processing operators as well. The system initially runs mode M1.

Once the conditions change and visibility turns to low, an MCR arrives and the system switches to M2. For example, following the mode-change model from Section 2.3 (Fig. 11.1), upon the start of this transition, task *tracking target* $\tau_{12(A)}$ is aborted; whole-new task *morphological operations* $\tau_{2(W)}$ is introduced in the schedule for the new mode; old-mode task *classification* $\tau_{10(O)}$ completes its execution and it is replaced by task *classification* $\tau_{10(C)}$, which has a new algorithm for feature extraction as well as new timing properties (eg, its period is changed from 1100 to 590); old-mode task *geometric transformations* $\tau_{7(O)}$ completes and it is not activated in the new mode M2.

The CPU utilization rate is 76.58% in M1 and 85.01% in M2. The goal of this study was to search for the solutions that minimize the latency. There is no concern for the resulting configuration of task's offsets in this case.

4.2.2 GA configuration

We applied the basic GA, where $We = \{1, 0\}$, thus canceling the second objective (minimization of offsets), and the constraints used were

$Co = \{1, 1\}$, that is, system feasibility and compliance with the IPCP protocol.

4.2.3 *Modeling*

This search is modeled as a single-objective optimization problem, where latency minimization is the single objective and system feasibility and compliance with PCP are treated as constraints, as in the preceding case.

4.2.4 *Results*

After optimization, the values of the best offsets obtained are shown in Table 11.8. The left part represents the old-mode tasks across a transition and their real-time attributes whereas the right part describes the new-mode tasks. In short, the processing time was 112.42 min using GA, the sum of offsets was 10,766, and the latency was 1,327. The values obtained using the algorithm of Real and Crespo (2001) are presented in Case Study 3. Note: sensitivity does not work in this case study; thus, the optimization was performed just with a population of 2000 individuals for 500 generations.

Table 11.8 Case 2: Offsets Obtained

Tasks	Old-Mode Tasks M1 → M2 M1				New-Mode Tasks M1 → M2			
	D	R	x	Test	D	O	R	Test
τ_1	50	10	0	OK	Not active in this mode			
τ_2	Not active in this mode				50	257	30	OK
τ_3	1200	742	601	OK	60	1185	50	OK
τ_4	1400	787	1	OK	120	1187	100	OK
τ_5	400	100	1	OK	400	1143	110	OK
τ_6	Not active in this mode				450	973	140	OK
τ_7	450	120	1	OK	Not active in this mode			
τ_8	500	170	1	OK	Not active in this mode			
τ_9	500	1026	190	OK				
τ_{10}	1550	1007	1	OK	590	787	340	OK
τ_{11}	1600	1197	1101	OK	600	695	440	OK
τ_{12}	1650	1407	1251	OK	700	640	460	OK
τ_{13}	800	342	251	OK	800	500	740	OK
τ_{14}	900	442	401	OK	Not active in this mode			
τ_{15}	Not active in this mode				900	199	193	OK
τ_{16}	60	30	1	OK	1200	420	272	OK
τ_{17}	120	90	1	OK	1400	397	480	OK
τ_{18}	1500	897	801	OK	1500	0	897	OK
τ_{19}	590	200	1	OK	1550	961	126	OK
τ_{20}	600	215	1	OK	1600	260	877	OK
τ_{21}	700	232	1	OK	1650	136	1191	OK

Table 11.9 Case 3: Scenarios for Optimization With GAs

Parameters	Scenarios								
	S_1	S_2	S_3	S_4	S_5	S_6	S_7	S_8	S_9
Population	500	500	500	1000	1000	1000	2000	2000	2000
Generations	100	250	500	100	250	500	100	250	500

4.3 Case 3: Minimizing latency and offsets—weights-based multiobjective

4.3.1 Definition

In this case study the optimization was performed on the same set of tasks (Tables 11.6 and 11.7). The goal of this study was to search for the solutions that minimize the worst-case latency of a mode change as the main priority and also attempt to keep offsets at minimum values, as a second priority.

4.3.2 GA configuration

As with the previous case, we have determined the best parameters for the optimization process based on nine distinct scenarios (Table 11.9). Each scenario was subject to 10 repetitions in order to measure the accuracy of the resulting data.

4.3.3 Modeling

This search is modeled as a one-objective optimization problem, where solutions that are schedulable (ie, feasible) and with lower offsets are seen as constraints. As there are no shared resources, the IPCP protocol was not necessary, thus, canceling constraint 2.

To achieve these goals, the objective function was instantiated with weights $We = \{1, 0.00001\}$. Thus, the fitness function chosen was the combination of (1) the latency of the mode change (the fitness value is captured in a decimal part) Ob_1 and (2) the sum of the offsets of all new-mode tasks (Ob_2), where the fitness value is accounted for in the fractional part. The constraints used was $Co = \{1, 0\}$, that is, system feasibility and no resource sharing.

4.3.4 Results

Table 11.10 shows the summary of the sensitivity analysis of the set of 21 tasks. The columns represent: (1) the scenario used for optimization; (2) the average time spent on each repetition of the scenario; (3) the lowest, high, average, and variation between average and lowest worst-case latency; (4) the lowest sum of offset for lowest; and (5) high worst-case latency. The minimum values were found in scenario 8.

Table 11.10 Case 3: GAS Sensitivity Analysis

Scenarios	Time (min)	Measured Latency				Σ Offsets	
		Low	**High**	**Average**	**Var. (%)**	**Low**	**High**
1	3.65	1397	1665	1475	5.6	8951	7971
2	8.21	1397	1982	1479	5.9	7533	1397
3	15.78	1397	1636	1464	4.8	7579	5600
4	6.06	1397	1453	1403	0.4	8170	9389
5	15.45	1397	1417	1399	0.1	7540	7696
6	38.06	1397	1397	1397	0.0	7585	7585
7	14.09	1397	1397	1397	0.0	7657	7657
8	31.25	1397	1397	1397	0.0	7133	7693
9	64.43	1397	1412	1399	0.1	7487	7558

After optimization, the values of the best offsets obtained are shown in Table 11.11. The left part represents the old-mode tasks across a transition and their real-time attributes whereas the right part describes the new-mode tasks.

In summary, by using GA the total processing time was 31.25 min, the sum of offsets was 7133 and the worst-case latency was 1397. Using the

Table 11.11 Case 3: Offsets Obtained

Tasks	Old-Mode Tasks M1→M2						New-Mode Tasks M1→M2					
	D	**R^a**	**R^b**	**x^a**	**x^b**	**Test**	**D**	**O^a**	**R^a**	**O^b**	**R^b**	**Test**
τ_1	50	10	10	0	0	OK	Not active in this mode					
τ_2	Not active in this mode						50	0	40	288	30	OK
τ_3	1200	1152	802	1	1	OK	60	119	50	1152	50	OK
τ_4	1400	1157	1017	1	1	OK	120	70	120	1152	100	OK
τ_5	400	200	100	1	1	OK	400	0	210	256	110	OK
τ_6	Not active in this mode						450	0	260	400	140	OK
τ_7	450	230	120	1	1	OK	Not active in this mode					
τ_8	500	310	170	1	1	OK	Not active in this mode					
τ_9	Not active in this mode						500	286	154	897	190	OK
τ_{10}	1550	1257	1137	1	1	OK	590	1546	340	816	340	OK
τ_{11}	1600	1417	1277	1	1	OK	600	1546	440	608	440	OK
τ_{12}	1650	1557	1397	1101	251	OK	700	1546	460	146	106	OK
τ_{13}	800	562	342	1	251	OK	800	1546	740	400	740	OK
τ_{14}	900	722	492	1	1	OK	Not active in this mode					
τ_{15}	Not active in this mode						900	1546	750	146	356	OK
τ_{16}	60	60	30	1	1	OK	1200	1546	970	146	866	OK
τ_{17}	120	120	90	1	1	OK	1400	1546	980	146	881	OK
τ_{18}	1500	1167	1037	1	1	OK	1500	1546	990	146	901	OK
τ_{19}	590	470	200	1	1	OK	1550	1546	1380	288	949	OK
τ_{20}	600	485	215	1	1	OK	1600	1546	1390	146	1141	OK
τ_{21}	700	532	232	1	1	OK	1650	567	1650	0	1397	OK

[a]Algorithm of Real and Crespo (2001).
[b]Genetic algorithm.

algorithm of Real and Crespo (2001), the number of analyses processed was 53,145, the processing time was 4.35 min, the sum of offsets was 16,502 and the worst-case latency was 2,936.

4.4 Case 4: Minimizing latency and offsets—multiobjective

4.4.1 Definition

In this case study the optimization was performed on the same set of tasks (Tables 11.6 and 11.7). The goal of this study was to search for the solutions that minimize both the worst-case latency of a mode-change and task offsets using a multiobjective GA.

4.4.2 GA Configuration

We applied the nondominated sorting GA II (NSGA-II), where $We = \{1, 1\}$. Thus, objectives 1 and 2 have the same weights in the optimization process. The crossover and mutation operators used for NSGA-II are the same as the ones employed in the GA. The constraints used were $Co = \{1, 0\}$ (ie, system feasibility and no resource sharing).

4.4.3 Modeling

This search is modeled as a multiobjective optimization problem, where latency and offsets are the main objectives and schedulability is a constraint. As with the previous case, since there are no shared resources, the IPCP protocol was not necessary, thus, canceling constraint 2.

4.4.4 Results

After optimization, the values of the best offsets obtained are shown in Table 11.12. The left part represents the old-mode tasks across a transition and their real-time attributes whereas the right part describes the new-mode tasks.

Fig. 11.4 shows the best frontier of nondominated solutions found during the optimization process using NSGA-II. From the solutions illustrated, three were used as a comparison in Table 11.12: NDS1, the solution that has the smallest value of mode-change latency; NDS2, an intermediate solution; and NDS3, the solution that has the smallest sum of offsets. However, any of the solutions could be used, as the criteria for selection may vary according to the premises adopted by the system designer.

4.4.5 Comparison

Table 11.13 presents a comparison among Cases 1 to 4 with latency and offset optimization using the algorithm of Real and Crespo (2001), GA, NSGA-II—S_1

Table 11.12 Case 4: Offsets Obtained with NSGA-II

Tasks	Old-Mode Tasks M1→M2						New-Mode Tasks M1→M2					
	R^a	R^b	R^c	x^a	x^b	x^c	O^a	R^a	O^b	R^b	O^c	R^c
τ_1	10	10	10	0	0	0	Not active in this mode					
τ_2	Not active in this mode						0	40	0	40	0	40
τ_3	812	812	812	601	601	601	1248	50	1248	50	480	50
τ_4	847	847	1007	601	601	1	1280	100	1280	100	1280	100
τ_5	130	130	130	1	1	1	0	140	0	140	0	140
τ_6	Not active in this mode						1024	140	512	140	512	140
τ_7	160	160	160	1	1	1	Not active in this mode					
τ_8	210	210	210	1	1	1	Not active in this mode					
τ_9	Not active in this mode						1024	190	1024	190	1024	190
τ_{10}	1107	1137	1197	1	1	1	848	340	880	340	880	340
τ_{11}	1337	1337	1347	1101	1101	1	768	440	768	440	768	440
τ_{12}	1557	1557	1557	1251	1251	1251	0	292	0	292	0	292
τ_{13}	402	402	402	251	251	251	512	740	512	740	512	740
τ_{14}	502	502	502	401	401	401	Not active in this mode					
τ_{15}	Not active in this mode						0	432	0	432	0	432
τ_{16}	60	60	60	1	1	1	0	712	0	742	0	1002
τ_{17}	120	120	120	1	1	1	0	727	0	757	0	1097
τ_{18}	1007	1007	1107	801	801	1	0	747	0	977	0	1117
τ_{19}	240	240	240	1	1	1	0	1137	0	1167	0	1257
τ_{20}	255	255	255	1	1	1	0	1187	0	1227	0	1357
τ_{21}	272	272	272	1	1	1	0	1377	0	1407	0	1467

[a]NDS1 *(lower latency).*
[b]NDS2 *(intermediate).*
[c]NDS3 *(lower offsets).*

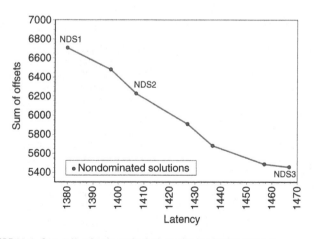

■ FIGURE 11.4 Case 4: Nondominated solutions obtained using NSGA-II.

Table 11.13 Case 4: Comparison Among Cases 1–4

Case	Algorithm	Time (min)	ΣOffsets	Latency of Mode
1	Real and Crespo (2001)	<1	265	350
1	Single-objective GA	9.95	265	350
2	Single-objective GA	112.42	10,766	1,327
2 and 3	Real and Crespo (2001)	4.35	16,502	2,936
3	Weights-based MOGA	31.25	7,133	1,397
4	NSGA-II—*NDS*1	395.08	6,704	1,380
4	NSGA-II—*NDS*2	395.08	6,224	1,407
4	NSGA-II—*NDS*3	395.08	5,456	1,467

(lowest latency), NSGA-II—S_2 (intermediate) and, NSGA-II—S_3 (lowest sum of offsets). Note: sensitivity does not work with NSGA-II. Thus, the optimization was performed just with a population of 2000 individuals for 500 generations.

4.5 Case 5: Minimizing latency and offsets— multiobjective with a random task set

4.5.1 *Definition*

In order to test the generality of the method, in this case study the minimization of latency was performed on a randomly generated task set (Brandenburg, 2015). Table 11.14 presents two modes of operation M1 and M2; each mode of operation comprises of 15 tasks, τ_1 through τ_{15}. The CPU utilization rate is 69.6% in M1 and 67.7% in M2.

Table 11.14 Case 5: Randomly Task Set Generated Using Brandenburg (2015)

	Mode M1					Mode M2					
Tasks	**P**	**C**	**T = D**	**R**	**TEST**	**Tasks**	**P**	**C**	**T = D**	**R**	**TEST**
$\tau_{1(C)}$	8	774	32,000	12,944	OK	$\tau_{1(C)}$	6	921	19,000	4,491	OK
$\tau_{2(C)}$	3	460	11,000	1,228	OK	$\tau_{2(C)}$	2	318	7,000	460	OK
$\tau_{3(C)}$	3	432	11,000	1,200	OK	$\tau_{3(C)}$	10	2,173	32,000	11,175	OK
$\tau_{4(C)}$	6	2,165	23,000	8,509	OK	$\tau_{4(C)}$	7	649	28,000	5,140	OK
$\tau_{5(U)}$	7	2,001	30,000	11,988	OK	$\tau_{5(U)}$	9	2,001	30,000	8,676	OK
$\tau_{6(C)}$	4	1,149	13,000	2,809	OK	$\tau_{6(C)}$	4	550	17,000	1,677	OK
$\tau_{7(C)}$	4	947	13,000	2,607	OK	$\tau_{7(C)}$	3	205	13,000	1,127	OK
$\tau_{8(C)}$	5	933	16,000	6,162	OK	$\tau_{8(C)}$	1	142	4,000	142	OK
$\tau_{9(O)}$	1	182	4,000	182	OK	τ_9	Not active in this mode				
$\tau_{10(C)}$	2	586	9,000	768	OK	$\tau_{10(C)}$	10	2,729	32,000	11,731	OK
$\tau_{11(C)}$	4	1,291	13,000	2,951	OK	$\tau_{11(C)}$	2	462	7,000	604	OK
τ_{12}	Not active in this mode					$\tau_{12(W)}$	5	1,751	18,000	3,428	OK
τ_{13}	Not active in this mode					$\tau_{13(W)}$	9	326	30,000	6,079	OK
τ_{14}	Not active in this mode					$\tau_{14(W)}$	8	613	29,000	5,753	OK
τ_{15}	Not active in this mode					$\tau_{15(W)}$	10	1,964	32,000	10,966	OK

Table 11.15 Case 5: Offsets Obtained With NSGA-II

Tasks	Old-Mode Tasks M1 → M2				New-Mode Tasks M1 → M2			
	R^a	R^b	X^a	X^b	O^a	R^a	O^b	R^b
τ_1	22,932	22,932	1	1	0	13,495	0	15,222
τ_2	2,150	2,150	1	1	787	441	0	1,228
τ_3	2,122	2,122	1	1	0	28,150	0	31,607
τ_4	12,432	12,614	1	4,001	952	13,192	2	15,869
τ_5	17,915	17,915	1	1	6	26,008	2227	24,734
τ_6	3,731	3,731	1	1	4	5,710	0	5,714
τ_7	3,529	3,529	1	1	2,816	1,127	1	2,786
τ_8	7,634	8,516	4,001	1	771	142	176	148
τ_9	182	182	0	0	Not active in this mode			
τ_{10}	768	910	1	1	0	28,706	256	31,907
τ_{11}	3,873	3,873	1	1	770	602	2	1,370
τ_{12}	Not active in this mode				16	10,251	0	10,267
τ_{13}	Not active in this mode				7	23,864	0	23,871
τ_{14}	Not active in this mode				3	23,542	0	23,545
τ_{15}	Not active in this mode				1	25,976	256	25,721

[a]*NDS1 (lower latency).*
[b]*NDS2 (lower offsets).*

4.5.2 *GA configuration and modeling*

The GA configuration and modeling, shown in Table 11.15, were the same used in Case Study 4.

Fig. 11.5 presents the best frontier of nondominated solutions found during the minimization using NSGA-II. From the solutions, two were used as a comparison in Table 11.15: NDS1, the solution that has the smallest value of mode-change latency; and NDS2, the solution that has the smallest sum of offsets. The value of latency for NDS1 was 28,706 and the sum of offsets 6,133; for NDS2, the latency was 32,163 and the sum of offsets 2,920. The optimization was performed with a population of 500 individuals for 300 generations.

5 DISCUSSION

We verified that the results were not significantly sensitive to parameter values of GAs (eg, mutation probability, weights, type of crossover). The exception was population and generation size, for which we conducted a sensitivity analysis that led to the most suitable values.

Case 1 (reduction of offsets—single-objective GA) validates the results of the work by Real and Crespo (2001) and vice versa, as both procedures resulted in the same minimum offsets values for the new-mode tasks. For

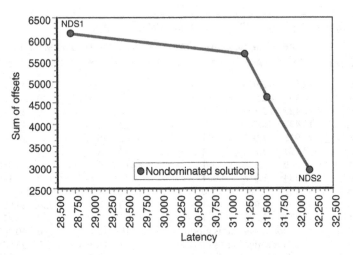

■ FIGURE 11.5 Case 5: Nondominated solutions obtained using NSGA-II.

example, in Table 11.5 we noticed that the offsets obtained by Real and Crespo (2001) O_1 were {0, 195, 0, 70, 0} and the ones from our approach O_2 were also the same.

In Case 2 (reduction of latency—single-objective GA), it is shown that the reduction to minimum offsets does not necessarily lead to a minimum worst-case mode-change latency. This aspect of the analysis was unclear before this work commenced, and it has now been quantitatively corroborated. For example, the latency obtained with the algorithm of Real and Crespo (2001) was 2936, and the one by the GA was 1327, a gain of 54.8% in reduction in the worst-case latency.

In Case 3 (reduction of latency and offsets using weights based multiobjective GA), there is an increase in the latency from 1327 to 1397 (ie, a 5.3% increase) in comparison to Case 2. However, there was a 33.74% reduction in offsets (from 10,766 to 7,133). Comparing this case with the algorithm of Real and Crespo (2001), there is a 52.4% gain in latency and 34.8% gain in offset reduction (ie, sum of offsets).

In Case 4 (reduction of latency and offsets using a multiobjective NSGA-II algorithm), seven nondominated solutions were found with NSGA-II (Fig. 11.4): the first solution had the lowest mode-change latency but a higher sum of offsets. The last solution had a higher latency and a lower sum of offsets. Therefore, in this case, it is also possible to see that the reduction of the sum of offsets caused an increase in latency. As we moved from a weights-based multiobjective GA (Case 3) to NSGA II (Case 4), there was a 1.22% decrease in the worst-case latency of the mode change

(ie, in favor of the NSGA II). However, the reduction in the sum of offsets was 6.01%. In order to further increase the generality of the method, in Case 5 we evaluated the method for randomly generated task sets. The results obtained regarding offset optimization were similar to the results from the case study presented earlier.

Based on the results and previous analysis, we ranked the solutions according to their ability to reduce worst-case mode-change latency:

1. Single-objective GA (Case 2): This was the best solution as far as lowest worst-case latency is concerned. However, the sum of offsets was larger in comparison to the other approaches.
2. Multiobjective GA (NSGA-II) to reduce the worst-case latency and sum of offsets (Case 4): NSGA-II showed to be the best choice where it is necessary to reduce worst-case latency and sum of offsets simultaneously, as it offers the system designer a set of well-balanced solutions (ie, nondominant solutions).
3. Multiobjective GA to reduce the worst-case latency and sum of offsets with weights (Case 3): This approach showed the worst results in comparison with NSGA-II and single-objective GA regarding the reduction of the worst-case latency only.

Note that our solution using GA can also accommodate the requirement of promptness as defined by Real and Crespo (2001) by defining a fitness function whereby the objective is the minimization of the sum of offsets of the higher-priority tasks of interest (ie, the ones that respond to alarms) (Section 3). It is also possible to allow the fitness function to process a mode-change deadline, such as defined by Real and Crespo (2001). In this regard, the work presented in this research may be seen as a superset of the analysis of Real and Crespo; it is a general case that can be instantiated through relatively simple adjustments to the fitness function for more specialized requirements such as promptness.

As mentioned earlier, our goal in this work is different from the work of Real and Crespo (2001) in that it lies in reducing the worst-case latency of a mode change. The assumption is that the mode change itself has a deadline, and it should be completed before this deadline. This is due to the fact that during a mode change, the system delivers its functionality and performance only partially, as the new-mode task set is not yet completely introduced.

A priori analysis of the algorithm of Real and Crespo (2001) shows that it is not easily adaptable to accomplish the minimization of mode-change latencies due to the existence of old-mode tasks and consequently the window x

in the analysis. Finding the latency is simple only if we consider changed and wholly new-mode tasks, because they all start with respect to the MCR, considering their offsets. The challenge is with the old-mode tasks and purely periodic tasks with an offset Z. With old-mode tasks, we have their R (WCRT) that depends on x. This WCRT for an old-mode task is not necessarily the time that goes farther into the transition, precisely because of x. For example, one can have an old-mode task with WCRT 100, but with $x = 90$. It could be the case that for $x = 0$, one has a slightly lower WCRT, but the task would effectively complete later with respect to the MCR than it does with $x = 90$. This issue also occurs with purely periodic tasks with an offset $Z > 0$.

Clearly, the issue of finding a global minimum continues to be a limitation of the GA approach, and more work is required (including comparison with other nonevolutionary optimization approaches) in order to establish the global minimum. However, the fact that our approach yielded the same results as the approach by Real and Crespo (2001) in Case 1 is an indication of both the correctness of the solution as well as an evidence that is has reached a global minimum.

In cases where the processor utilization was close to a schedulability threshold, minimization was possible, but the margin for minimization was also reduced. However, this may be regarded as a system configuration issue and not a weakness of the proposed approach. Given that the schedulability analysis part of this work is reasonably well established, many of the strengths of the proposed approach, including its generality, rely on the provable effectiveness of the GA itself and in the correct modeling of the problem such as presented in this work. In general, we found that the approach presented is a general and flexible tool that can be easily customized to deal with various mode-change scenarios. Examples of the minimization of several "types" of mode changes, as well as a more complete coverage of the issue of minimization of the latency of mode changes that illustrates the strengths of the proposed solution model, is beyond the scope of this work; therefore, the reader is referred to the work by Massaro (2015).

In this work we also verified that, improving the urgency for new-mode tasks (through offset reduction for higher-priority tasks) actually worsened the worst-case mode-change latency. Mode-change latency and a task's urgency (short offset) emerged as potentially conflicting requirements. To satisfy an urgency requirement, a new-mode high-priority task (ie, an alarm) must initiate early in the transition window, with a low offset. If this task has a short period, it will generate a number of releases inside the transition window; these releases constitute interference over lower-priority tasks

across the mode change, thus overextending the mode-change delay. From the perspective of latency, the ideal mode change is one that has (if possible at all) one execution of all old- and new-mode tasks inside its window. Therefore, the requirement of urgency (for new-mode tasks) moves away from the shortest possible mode-change latency by potentially forcing multiple releases of higher-priority tasks inside the transition. This effect is more accentuated as we increase the rate of latency over higher-priority (urgent) task periods (ie, L/T_i).

6 CONCLUSIONS

Mode changes are a structured way to dynamically configure real-time systems with image processing capabilities. Although there has been significant work presented for mode changes in the realm of fixed-priority scheduled systems, work on the assignment of offsets, and specifically work on the minimization of mode changes, has remained largely an open issue. In the absence of algorithms, methods and tools that automate and facilitate minimization, offset assignments have to be accomplished manually. There are at least three drawbacks of manual assignment of offsets: (1) It is manually tedious and may require detailed knowledge of the inner workings of mode-change protocols; (2) It may not lead to results that fulfill real-time systems requirements; and (3) It may not be feasible for large task sets and more complex mode-change scenarios. Therefore, the introduction of mode changes to real-time systems, and including those with image processing applications that are fixed-priority preemptive scheduled, depends on the availability of higher-level tools that allow practitioners to configure the mode change, including the minimization of the worst-case mode-change latency.

One of the most interesting findings in this work, and an attention-grabbing case, is the counterexample for the correlation between minimal offsets and minimal worst-case latencies. We have shown that an improved short offset for some tasks may seriously compromise the mode-change latency. By quickly inserting an urgent new-mode task (eg, an emergency task), old-mode tasks are pushed toward the end of the mode-change window. This is especially critical in scenarios where the old-mode tasks may be delivering functionality that is unwanted in the new mode. These ideas should be factored as design guidelines, and the designer needs to balance the requirement of urgency for some tasks across a mode change, the worst-case latency, the overall mode-change deadline, and in some cases a priority or deadline that a task may be assigned specifically for the mode change. Therefore, it may be that a not-so-small offset to an urgent task,

which yet satisfies the emergency (ie, urgency) requirement of the application may actually be a more efficient solution from a timing perspective by keeping the worst-case latency at minimum values compared to an unnecessarily (and overly) small offset that increases the overall latency unnecessarily. In conclusion, a considerable shift on emphasis in design lies in the fact that, instead of seeking for the minimum offset, the goal of the designer should be instead to *find the maximum allowable offset that satisfies the requirement of urgency while keeping the worst-case latency at a minimum value.*

Another important issue is that of shared resources or task dependencies. The model and approach we have adopted in this framework also caters to task dependencies and shared resources through the implementation of the IPCP protocol. Task precedence relationships can be accommodated in the search for minimum offsets by enforcing a search for offsets that fall within a predefined window, which ensures the fulfillment of the precedence relationships. More information about this feature of the proposed solution was demonstrated in Massaro (2015).

Evolutionary algorithms are certainly not the only way to attack this problem. Other categories of optimization algorithms and methods are combinatorial optimization, dynamic programming, gradient methods, and stochastic optimization. Therefore, decoupling the model of the problem from the model of the solution is essential. Future work should look at other approaches to optimization.

This work was introduced as a first step to overcome this challenge, by presenting a model and approach to minimization of the worst-case latency of mode changes in real-time image processing systems. Our focus was on the design of the solution from a timing perspective. This concern should be addressed early in the system's design phase before tackling its implementation. The approach chosen was based on evolutionary algorithms, due to their known ability to solve relatively complex optimization scenarios. The approach was validated by five test cases, each applying a different scenario to the optimization of latency. In general, we found that the approach presented is general and flexible in that can be easily customized to deal with various types of mode-change scenarios. These scenarios may vary from simple ones, such as the bare reduction of offsets, to more complex mode-change scenarios which may include multiple optimization objectives. Future work will consider the case of image processing applications running on multicore systems as well as the implementation of the multimode and flexible image processing application on a multithreaded platform.

REFERENCES

Andersson, B., 2008. Uniprocessor EDF scheduling with mode change. In: Proceedings of the 12th International Conference on Principles of Distributed Systems, OPODIS'08. Springer-Verlag, Berlin, Heidelberg, pp. 572–577.

Audsley, N.C., Burns, A., Richardson, M., Tindell, K., Wellings, A., 1993. Applying new scheduling theory to static priority pre-emptive scheduling. Software Eng. J. 8 (5), 285–292.

Brandenburg, B., 2015. Shedcat: the schedulability test collection and toolkit. Available from: https://github.com/brandenburg/schedcat.

Briand, L.C., Labiche, Y., Shousha, M., 2006. Using genetic algorithms for early schedulability analysis and stress testing in real-time systems. Genet. Program. Evol. Mach. 7 (2), 145–170.

Chen, L., Li, J., Zhou, J., Jiang, M., 2009. Multithreading method to perform the parallel image registration. In: International Conference on Computational Intelligence and Software Engineering, CiSE 2009, pp. 1–4.

Coello, C.A.C., Lamont, G.B., Veldhuizen, D.A.V., 2007. Evolutionary Algorithms for Solving Multi-Objective Problems. Springer-Verlag, Secaucus, NJ.

De Corte, A., Sörensen, K., 2012. Optimisation of Water Distribution Network Design: A Critical Review, Technical Report 2012016.

De Jong, K., 2006. Evolutionary Computation: A Unified Approach. MIT Press, Cambridge, MA.

De Niz, D., Phan, L., 2014. Partitioned scheduling of multimodal mixed-criticality real-time systems on multiprocessor platforms. In: 2014 IEEE 20th Symposium on Real-Time and Embedded Technology and Applications (RTAS), pp. 111–122.

Fisher, N., Ahmed, M., 2011. Tractable real-time schedulability analysis for mode changes under temporal isolation. In: 9th IEEE Symposium on Embedded Systems for Real-Time Multimedia (ESTIMedia), pp. 130–139.

Fohler, G., 1993. Realizing changes of operational modes with a pre run-time scheduled hard real-time system. In: Responsive Computer Systems. Springer, Vienna, pp. 287–300.

Kika, A., Greca, S., 2013. Multithreading image processing in single-core and multi-core CPU using Java. Int. J. Adv. Comput. Sci. Appl. 4 (9), 165.

ManChon, U., Ho, C., Funk, S., Rasheed, K., 2011. Gart: A genetic algorithm based real-time system scheduler. In: 2011 IEEE Congress on Evolutionary Computation (CEC), pp. 886–893.

Massaro, F., 2015. Configuring mode changes in fixed-priority preemptively scheduled real-time systems. Master's thesis, School of Technology, University of Campinas. Available from: http://www.bibliotecadigital.unicamp.br/document/?code=000947724

Negrean, M., Ernst, R., Schliecker, S., 2012. Mastering timing challenges for the design of multi-mode applications on multi-core real-time embedded systems. In: 6th International Congress on Embedded Real-Time Software and Systems (ERTS), Toulouse, France.

Nelis, V., Andersson, B., Marinho, J., Petters, S., 2011. Global-EDF scheduling of multi-mode real-time systems considering mode independent tasks. In: Proceedings of the 23rd Euromicro Conference on Real-Time Systems (ECRTS), pp. 205–214.

Nelis, V., Goossens, J., 2008. Mode-change protocol for multi-mode real-time systems upon identical multiprocessors. CoRR abs/0809.5238. Available from: http://arxiv.org/abs/0809.5238

Neukirchner, M., Lampka, K., Quinton, S., Ernst, R., 2013. Multi-mode monitoring for mixed-criticality real-time systems. In: Proceedings of the 9th IEEE/ACM/IFIP International Conference on Hardware/Software Codesign and System Synthesis, CODES+ISSS'13. IEEE Press, Piscataway, NJ, pp. 34:1–34:10.

Pedro, P., 1999. Schedulability of mode changes in flexible real-time distributed systems. PhD thesis, University of York.

Pedro, P., Burns, A., 1998. Schedulability analysis for mode changes in flexible real-time systems. In: Proceedings of the 10th Euromicro Workshop on Real-Time Systems, Cat. No. 98EX168, pp. 172–179.

Real, J., Crespo, A., 2001. Offsets for scheduling mode changes. In: Proceedings of the 13th Euromicro Conference on Real-Time Systems, pp. 3–10.

Real, J., Crespo, A., 2004. Mode change protocols for real-time systems: a survey and a new proposal. Real-Time Syst. 26 (2), 161–197.

Real, J., Wellings, A., 1999. Dynamic ceiling priorities and Ada 95. Ada Lett. XIX (2), 41–48.

Saxena, S., Sharma, N., Sharma, S., 2015. Multithreaded approach for registration of medical images using mutual information in multicore environment and its applications in medical imaging. Int. J. Comput. Appl. 113 (3), 23–32.

Sha, L., Rajkumar, R., Lehoczky, J., Ramamritham, K., 1988. Mode change protocols for priority-driven preemptive scheduling. Real-Time Syst. 1, 243–264.

Squyres, J.M., Lumsdaine, A., Stevenson, R.L., 1998. A toolkit for parallel image processing. In: Proceedings of the SPIE Conference on Parallel and Distributed Methods for Image Processing, pp. 69–80.

Stevenson, R., Lumsdaine, A., McCandless, B.C., 2000. Parallel and distributed algorithms for high-speed image processing. AFRL-IF-RS-TR, Rome Laboratory, Air Force Research Laboratory, Information Directorate, Rome Research Site.

Stoimenov, N., Perathoner, S., Thiele, L., 2009. Reliable mode changes in real-time systems with fixed priority or EDF scheduling. In: 2009 Design, Automation and Test in Europe Conference and Exhibition, pp. 99–104.

Tindell, K., Burns, A., Wellings, A., 1992. Mode changes in priority preemptively scheduled systems. In: Real-Time Systems Symposium, pp. 100–109.

Tindell, K., Burns, A., Wellings, A., 1994. An extendible approach for analysing fixed priority hard real-time systems. J. Real-Time Syst. 6, 133–152.

Yomsi, P., Nelis, V., Goossens, J., 2010. Scheduling multimode real-time systems upon uniform multiprocessor platforms. In: 2010 IEEE Conference on Emerging Technologies and Factory Automation (ETFA), pp. 1–8.

Yoo, M., 2009. Real-time task scheduling by multiobjective genetic algorithm. J. Syst. Software 82 (4), 619–628.

Chapter

12

Learning OWA filters parameters for SAR imagery with multiple polarizations

L. Torres, J.C. Becceneri, C.C. Freitas, S.J.S. Sant'Anna, S. Sandri

National Institute for Space Research—INPE, São José dos Campos, São Paulo, Brazil

CHAPTER OUTLINE

1 INTRODUCTION

Unlike their optical counterparts, synthetic aperture radar (SAR) sensors are usually not affected by adverse atmospheric conditions and the presence of clouds (Lee and Pottier, 2009), and can be used at either day or night. However, the visual quality of SAR images is degraded by sudden variations in image intensity with a salt-and-pepper pattern, due to a great amount of speckle, a multiplicative non-Gaussian noise, that is proportional to the intensity of the received signal (Mott, 2006).

In order to reduce speckle, one can, for instance, employ multiple looks in the generation of the complex images, but that causes degradation in spatial resolution. Another alternative is the use of filters that may, or may not,

Bio-Inspired Computation and Applications in Image Processing. http://dx.doi.org/10.1016/B978-0-12-804536-7.00012-0

take into account a model for noise. Ordered statistical filters (OSFs) (Bovik et al., 2005) are model independent and belong to the class of nonlinear filters based on order statistics (Pitas and Venetsanopoulos, 2013). Given a window around a central pixel, the result of the use of OSFs is the substitution of the central pixel value by the linear combination of the values of the pixels in the window. Model-dependent filters can also be used to reduce noise, but they are significantly more complex than their model-independent counterparts. Some important model-dependent filters used to reduce speckle are the so-called Lee filter (Lee et al., 1991, 1999) and its variations, such as the refined Lee filter (R-Lee) (Lee et al., 2006). More recent approaches on model-dependent filters for SAR include stochastic distances and nonlocal means (SDNLM) (Torres et al., 2014), based on Buades et al.'s nonlocal means methodology (Buades et al., 2005).

Computational intelligence is the name nowadays used for the area joining together neural networks, evolutionary systems, and fuzzy systems. The application of computational intelligence techniques for solving optimization problems is known as intelligent optimization. Two important intelligent optimization techniques often used in applications are genetic algorithms (GAs), based on natural selection and genetics (Holland, 1975;Goldberg, 1989), and particle swarm optimization (PSO), inspired by the collaborative behavior in nature, such as bird flocking and fish schooling (Kennedy and Eberhart, 1995).

In a previous paper (Torres et al., 2015), we introduced OWA filters, a model-independent class of filters, constructed using ordered weighted average operators (OWA) (Yager, 1988), a family of mean operators from the fuzzy sets theory domain, that perform a convex combination of a set of ordered values. In these filters, all coefficients are nonnegative and sum to 1; being they are a particular type of OSFs. In that work, we also reported the use of GAs (Holland, 1975; Goldberg, 1989) to learn the parameters (a weight vector) in a fivefold crossvalidation experiment with 50 synthetic HH intensity images, derived from a real-world scene. We used a 3×3 window and obtained better results, according to the normalized mean square error (NMSE), than with other OSFs, such as the mean and the median, but fared worse than both R-Lee and SDNM.

In this chapter we extend the work from Torres et al. (2015) and consider how to learn the OWA vectors when multiple polarizations from a SAR image are available. We investigate the use of two strategies; in the first one, one vector is learned separately for each polarization and in the second one, the weight vectors for each polarization are learned jointly. Also, instead of a 3×3 window, we make use of a 5×5 window (as done in R-Lee

and SDNM) on the same images used in Torres et al. (2015). The use of a larger window led to better results for all OSFs considered; in particular, the learned OWA filters yielded better results than both R-Lee and SDNM.

This work is organized as follows. Sections 2–4 discuss SAR images and filters, GAs, and OWA filters, respectively. Sections 5 and 6, respectively, describe our proposal to learn OWA filter operators for multiple polarizations using GAs and an experiment in SAR imagery, respectively. Section 7 is the conclusion.

2 BASIC CONCEPTS OF SAR IMAGES

Optical and SAR sensors measure the amount of energy reflected by a target in various bands of the electromagnetic spectrum. In most imaging radars, the bands use frequencies in the 2-MHz to 12.5-GHz range, with wavelengths ranging from 2.4 cm to 1 m. In this work, we used L-band images with wavelengths of [30 cm, 1 m] and frequencies of [1 MHz, 2 GHz].

SAR systems generate the image of a target area by moving along a usually linear trajectory. The pulses are transmitted in lateral looks toward the ground, in either horizontal or vertical polarizations (Richards, 2009), denoted as H and V, respectively.

The imaging can be obtained by gathering all the intensity and phase information data from the electromagnetic signal after it has been backscattered by the target in a given polarization (Lee and Pottier, 2009). Each polarization in a given a scene generates a complex image, which can be thought of as two images, one with the real and the other with the imaginary values for the pixels.

In the past, the reception of the transmitted energy was made on the same polarization of the transmission only, generating images in the HH and VV polarizations. Nowadays, with the advent of polarimetric or polarized radars (PolSAR), information about intensity and phase of the cross-signals are also obtained, generating images also in HV and VH polarizations.

The complex images from HH, VV, and HV polarizations are denoted by S_{HH}, S_{HV}, and S_{VV}. A 3×3 covariance matrix is obtained when vector [S_{HH} S_{HV} S_{VV}] is multiplied by its transposed conjugated vector [S_{HH}^{*} S_{HV}^{*} S_{VV}^{*}]$'$. The main diagonal of this matrix contains intensity values, denoted by I_{HH}, I_{HV}, and I_{VV}.

2.1 Filters for SAR imagery

Polarimetric SAR image smoothing requires preserving the target polarimetric signature (Lee and Pottier, 2009), which can be posed in this

way: (1) each element of the image should be filtered in a similar way to multilook processing by averaging the covariance matrix of neighboring pixels; and (2) homogeneous regions in the neighborhood should be adaptively selected to preserve resolution, edges, and image quality. The last requirement is a common problem in pattern recognition.

Given a window around a central pixel in a given image, a filter substitutes the value in the central pixel by a function of the values of the pixels in that window. The simplest filters do not adopt any model for the noise. Well-known examples of such filters are the mean and median filters, in which the arithmetic mean and the median are respectively used as the function to change the value in the window central pixel. The mean filter tends to reduce the speckle; however, it tends to indiscriminately blur the image (Mascarenhas, 1997). In directional means filters, only pixels in one of the 12 regions of the 6 orthogonal directions are considered (diagonals, rows, and columns), and these filters can be good alternatives for filtering, considering their simplicity (Sant'Anna and Mascarenhas, 1996). Local region filters (Sheng and Xia, 1996) also do not adopt a model for noise. The local region divides the window in eight regions based on angular position. The central pixel is replaced by the mean value of the subregion presenting the lowest variance.

The median filter is one of the main model-independent filters, reducing erratic variations by eliminating the lowest and highest pixel values (Sant'Anna and Mascarenhas, 1996). It is a particular case of order statistics filters (Bovik et al., 2005), a general class of filters in which the result of filtering is the linear combination of the values of the pixels in the window. These filters belong to the larger class of nonlinear filters based on order statistics (Pitas and Venetsanopoulos, 2013), being an application of L-estimators.

More complex filters can be built by taking the noise model into account. One of most used model-based filters is the so-called Lee filter, in which speckle reduction is based on multiplicative noise model using the minimum mean-square error criterion (Lee et al., 1991, 1999). An improved version of this filter, called scattering model-based speckle filter (also known as the R-Lee filter), was proposed in Lee et al. (2006). In this filter, a methodology is used to select neighboring pixels with similar scattering characteristics.

Buades et al. (2005) proposed a methodology well suited for decreasing additive Gaussian noise, called nonlocal means (NL-means). It uses similarities between patches as the weights of a mean filter. The stochastic distances and NL-means filter (SDNLM), proposed in Torres et al. (2014), is an adaptive nonlinear extension of the NL-means algorithm filter. In SDNLM, overlapping samples are compared using the stochastic distances between

distributions, and the *p*-values resulting from such comparisons are used to build the filter weights.

2.2 Image quality assessment for SAR images

Assessing the quality of images is a very difficult task (Wang et al., 2002). To evaluate the performance of a filter, we use image quality indices, comparing reference images with filtered ones.

The NMSE is one of the most important and widely used error measures in image processing (Baxter and Seibert, 1998). Let x be the perfect information data and y an approximation of x. Let x_j and y_j refer to values in x and y at the same coordinates (a given pixel position in the case of images). NMSE is given by

$$\text{NMSE} = \frac{\sum_{j=1}^{n}(x_j - y_j)^2}{\sum_{j=1}^{n} x_j^2}. \tag{12.1}$$

The structural similarity index (SSIM) measures the similarity between two scalar-valued images. When one of the images is regarded as of perfect quality, SSIM can be viewed as a quality measure of the other image (Wang et al., 2004). It is based on the universal image quality index proposed in Wang and Bovik (2002). SSIM takes into account three factors: (1) correlation between edges; (2) brightness distortion; and (3I) distortion contrast. Let x and y be the perfect information and an approximation, respectively. Let μ_x and μ_y be the sample means, σ_x^2 and σ_y^2 the sample variances, $Cov(x,y)$ be the sample covariance between x and y, and α_1, α_2, and α_3 be index stabilization constants. SSIM is calculated as

$$\text{SSIM} = \frac{Cov(x,y) + \alpha_1}{\hat{\sigma}_x \hat{\sigma}_y + \alpha_1} \frac{2\mu_x\mu_y + \alpha_2}{\mu_x^2\mu_y^2 + \alpha_2} \frac{2\hat{\sigma}_x\hat{\sigma}_y + \alpha_3}{\hat{\sigma}_x^2\hat{\sigma}_y^2 + \alpha_3}. \tag{12.2}$$

Other measures that can be used to evaluate SAR image quality are the equivalent number of looks (ENL), which usually is applied to intensity images in homogeneous areas, and β_p, a correlation measure between the edges of a pair of images (Moschetti et al., 2006).

3 GENETIC ALGORITHMS

GAs, first proposed in Holland (1975) (see also Goldberg, 1989), are based on Darwin's ideas on the survival of the fittest (natural selection) and Mendel's ideas about the codification of life in genes. Sets of candidate solutions

to a given problem are codified as populations of chromosomes that evolve over time, according to a fitness function that measures the quality of solutions to solve the problem at hand.

Let c be a candidate solution in a population $C = \{c_1, ..., c_k\}$, itself composed of a set of parameters to a given function sol, that models the problem to be solved. Let fit be a function that is such that $fit(sol(c))$ is proportional to the quality of $c \in C$ to solve the problem at hand. We can view c as a genotype (chromosome), $sol(c)$ as its corresponding phenotype, and fit as a fitness function.

Three operators are used in GAs to generate a new population C' from a population C (selection, crossover, and mutation), whose implementation varies according to the problem to be solved. The selection operator chooses candidates solutions in C for reproduction and is such that the fittest candidates in C have a higher probability of being selected. This process is usually performed by means of a roulette (the larger the fitness of an individual, the larger its share in the roulette wheel) or a set of tournaments (at each tournament, a set of individuals are chosen at random from the population and the winner is selected for reproduction). Moreover, different forms of elitism can be used, such as forcing the best candidate in C to remain in the new population C'.

The crossover operator creates two new candidate solutions by mixing the genotypes of two selected parent candidate solutions. In the usual procedure, a position in the chromosome is somehow chosen and the codification of each parent is divided in two, one part containing the information from the beginning of the chromosome up to the chosen position and the other part containing the rest. Two sibling chromosomes are created mixing the information from the parents; the first sibling is composed by the first part of parent one and the second part of parent two, whereas the second sibling is composed by the first part of parent two and the second part of parent one.

The mutation operator has the power to change the new candidate solutions. In the usual mutation procedure, considering chromosomes with n positions, each position has a small amount of probability (called the mutation rate) of being chosen for mutation. When the chromosome is a binary string, the mutation consists simply in replacing the bit value by its complement.

The first initial population can be obtained at random or tailored, and the stop criterion is usually a fixed number of iterations. The choice of selection, crossover, and mutation operators for a GA should provide it with a

good equilibrium between exploration and exploitation of the search space of the problem at hand.

4 OWA FILTERS

OWA filters are a particular type of OSF, where all coefficients are nonnegative and sum to 1 (Torres et al., 2015). They are based on ordered weighted average operators (Yager, 1988), an important family of aggregation operators proposed in the context of fuzzy sets theory.

Formally, an OWA operator is a mapping $f: R^n \rightarrow R$, associated with a weight vector $w = [w_1...w_n]^t$, which is such that:

1. $w_i \in [0,1]$
2. $\Sigma_i w_i = 1$
3. $f(a_1, ..., a_n) = \Sigma_i w_i \times b_i$, where b_i, is the jth largest a_i in $(a_1, ..., a_n) \in R^n$.

The reordering step (3) distinguishes OWA operators from other families of weighted means; a given w_i is not necessarily associated with the ith argument of f, but with the ith largest of the arguments of f. For instance, given $w = [0.4 \ 0.3 \ 0.2 \ 0.1]^t$, $f(1,2,4,3) = 3$, with $b_1 = 4$, $b_2 = 3$, $b_3 = 2$, and $b_4 = 1$.

Some well-known OWA operators are the min, max, median, and mean, which are obtained with the OWA vectors w_{min}, w_{max}, w_{med}, and w_{mean}, respectively. For $n = 3$, $w_{min} = [0 \ 0 \ 1]^t$, $w_{max} = [1 \ 0 \ 0]^t$, $w_{med} = [0 \ 1 \ 0]^t$, and $w_{mean} = [\frac{1}{3} \ \frac{1}{3} \ \frac{1}{3}]^t$.

OWA operators perform a convex combination of a set of ordered values; they thus implement an ordered statistics on the original values. OWA filters are created from OWA operators by applying OWA weight vectors in the values inside a sliding window over a given image (Torres et al., 2015).

An OWA filter for a $m \times m$ window has $n = m^2$ elements in its associated weight vector. For example, considering a 3×3 (respectively 5×5) window, the weight vectors for an OWA filter will have 9 (respectively 25 positions), which will be applied on the elements of the window, disposed as a tuple according to a predefined rule. Let $v(r_0, s_0)$ denote the value of a pixel at coordinates (r_0, s_0) in a given image I. Let us consider an OWA filter and a 3×3 window in I with the center at coordinates (r, s). The corresponding tuple of a_i's in the definition of OWA is given as $(v(r - 1, s - 1), v(r - 1, s), v(r - 1, s + 1), v(r, s - 1), v(r, s), v(r, s + 1), v(r + 1, s - 1), v(r + 1, s), v(r + 1, s + 1))$, when the tuple is obtained from the window by appending the rows in a topwise manner (Fig. 12.1).

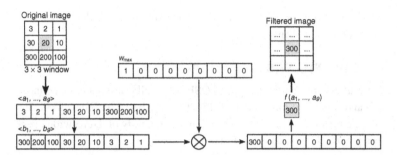

■ **FIGURE 12.1** Application of OWA w_{max} filter on the central pixel of a 3×3 window.

5 LEARNING OWA FILTERS FOR MULTIPLE POLARIZATION WITH GAs

In a previous paper (Torres et al., 2015), we considered how to learn OWA filters for a single polarization (HH). In the experiments, we used both GAs and PSO. However, these optimization approaches yielded similar results and did not show significant differences in computational cost. For this reason, we opted to only report the GA results and to dedicate our efforts in the remainder of the project to GA use only.

Here we are interested in learning OWA filters with GAs when we have a set of simulated SAR images from multiple polarizations of the same scene. In our approach, first we estimate all the parameters of the distribution associated to the various regions in a given image. Using these parameters, a set of simulated images is then randomly created, which is then partitioned in two sets, one for training and one for testing. The best weight vector found by applying a GA on a training set is subsequently used on its corresponding test set for evaluation. As a fitness function, we take the mean values of the quality index over the set of simulated images (Section 2.2). Selection is done using roulette (Section 3). Note that, since the weight vectors sum up to 1, mutation and crossover are not straightforward.

When the usual crossover operator is applied on two chromosomes encoding weight vectors, more often than not, of the two new elements of the population, one will sum up to a value higher than 1, whereas the other will sum up to a value lower than 1. In the approach we adopted, after crossover, we just normalize the values in the new chromosomes, by dividing them by the sum of the weights.

In our problem, mutation is such that a change in any given position (by complementation or otherwise) makes the weight vector become no longer normalized. In preparing the paper for Torres et al. (2015), we tested a few

operators for mutation, and the main ones (A, Bl, and Br) are described next. In all cases, the mutation rate is not applied for each position but for the chromosome as a whole. Given a chromosome selected for mutation, we randomly select a position $1 \leq p \leq n$, considering a uniform distribution.

- When mutation operator A is used, the value in position p is multiplied by the mutation rate. The difference is then divided by $n - 1$ and added to each of the remaining positions.
- When mutation operator Br is used (respectively Bl), the chromosome is considered as a ring; we add the value in p with the value of its neighbor to the right (respectively left), and the neighbor receives value 0.

Let us suppose sets of training images of k different polarizations are available and that a $m \times m$ window is used on each, associated with weight vectors containing $n = m^2$ positions. We have investigated the use of two strategies, named S1 and S2, to learn the weight vectors for the k polarizations:

- In S1, k GAs are run independently, one for each polarization, with weight vectors containing n positions.
- In S2, a single GA is run, with the weight vector containing $k \times n$ positions; when the weight vector is learned, it is split in k parts, one for each polarization, and the vectors are applied on the corresponding polarization images.

Strategy S2 requires a more complex way of dealing with the GA than S1: even though selection, mutation, and crossover remain basically the same, we have to ensure consistency, with each of the k parts of the chromosome adding up to 1 (Fig. 12.2).

6 EXPERIMENTS

In Torres et al. (2015), we conducted a series of experiments using a fragment of a phantom described in Saldanha (2013) (Fig. 12.3). GAs were used to learn the weight vector for HH polarization using a 3×3 window, with a dataset consisting of 50 synthetic images, simulated using the parameters for Wishart distribution estimated in Silva et al. (2013) for an area in the Brazilian Amazon region. Each simulated image has 240×240 pixels and was generated with one look.

In that work, for each experiment, we performed a fivefold crossvalidation, using 40 images for training and 10 for testing in each fold. The elements in the initial population in each experiment were chosen at random. As fitness function for each fold in each parametrization, we took the mean of the quality of the resulting filtered images, according to index NMSE

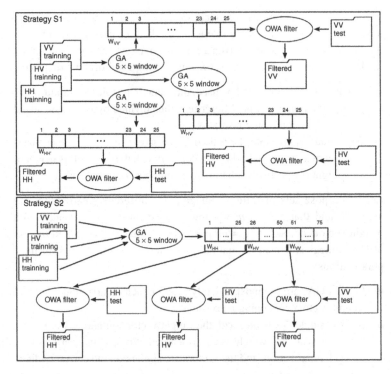

■ FIGURE 12.2 Strategies S1 and S2.

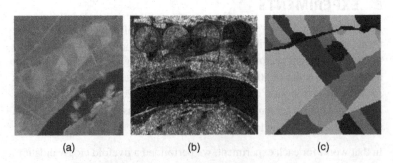

■ FIGURE 12.3 Images derived from a scene in Bebedouro in Brazil. (a) Landsat RGB composition, (b) SAR L-band RGB composition, and (c) phantom false color composition. *(Parts a and b, source: Silva et al., 2013; Part c, source: Saldanha, 2013).*

(Section 2.2). We also verified the quality of the filtered images in the test sets, according to SSIM.[a]

Using NMSE, we verified that standard OSFs ranged from reasonably good values as the mean (0.1208) and the median (0.1950), whereas others fared very poorly, as the minimum (0.8088) and the maximum (4.9466). The use of a GA to learn the best weight vector in OWA filters outperformed those other OSFs (0.1159), but the results were worse than those obtained by both R-Lee (0.0791) and SDNM (0.0787) filters. (The unfiltered images obtained a NMSE of 0.9971.) The use of SSIM produced basically the same ordering as NMSE. (Only min. and max. were inverted.)

In Torres et al. (2015), selection was done by roulette, and 2 mutation operators were addressed (A and Br, the latter called B in that work), 2 mutation rates (.2 and .8), 3 population sizes (18, 36, and 72 chromosomes), 2 possibilities for the number of generations (10 and 30), and 3 seeds for random numbers (2, 70 and 271). There was no significant difference in the results with respect to the different seeds; they differ only on the fourth decimal place. The results were also quite similar in relation to the number of generations and number of elements in the population used; as expected, the results are better when these parameters are larger, but they demand a larger amount of computational time. Mutation operator A outperformed the Br counterpart.[b]

In the present work, we considered not only the intensity images used in Torres et al. (2015), derived from polarization HH, but also those from the corresponding polarizations HV and VV. Considering that both model-based filters in R-Lee and SDNM use a 5×5 window, we have here enlarged the window and considered the weight vectors of 25 elements in each polarization instead of 9 as in the 5×5 window. Note that for strategy S2, the vectors had 75 positions (25 for each polarization). The new experiments were also performed with five folds and used strategies A, Bl, and Br.

We performed a series of small experiments with various parametrizations, including the same ones used with 3×3 window on HH, and verified the

[a]Note that NMSE always yield positive values SSIM ranges in the $[-1,1]$ interval; thus here NMSE should be minimized and SSIM should be maximized.

[b]Note that in strategy A, the smaller the mutation rate (ie, the closest it is to 0), the smaller is the probability that a chromosome suffers mutation, but the more the mutation procedure changes the original weight vector. On the contrary, when the mutation rate is large (ie, close to 1), a larger amount of chromosomes will suffer mutation, but with a rather small effect on each one of them. For this reason, a large mutation rate like .8 can be successful with mutation operator A. In strategy B, mutation simply tends to make the chromosome closer to w_{max} for Br and closer to w_{min} or Bl (this tendency does not occur only when $p = n$).

Table 12.1 NMSE and SSIM Mean for 50 Images (Truncated); With GA Filters Learned Using Fivefold Crossvalidation

	NMSE				SSIM			
	HH	**HV**	**VV**	**Agg**	**HH**	**HV**	**VV**	**Agg**
Unfiltered	0.997	0.074	1.025	1.008	0.068	0.084	0.053	0.068
OWA-GA-2	0.063	0.063	0.122	0.083	0.166	0.177	0.125	0.156
OWA-GA-1	0.064	0.063	0.123	0.083	0.166	0.178	0.124	0.156
Mean	0.064	0.063	0.124	0.084	0.166	0.178	0.124	0.156
SDNLM	0.078	0.074	0.119	0.091	0.166	0.177	0.126	0.157
R-Lee	0.079	0.075	0.125	0.093	0.155	0.167	0.124	0.149
Median	0.153	0.153	0.203	0.170	0.123	0.131	0.099	0.118
Min	0.927	0.928	0.934	0.930	0.001	0.001	0.000	0.000
Max	9.754	9.868	9.590	9.737	0.024	0.026	0.019	0.023

same characteristics as in the previous experiments: changing the seeds and increasing both the number of generations and the number of chromosomes in a population did not have a great impact in the results. Also, mutation operator A outperformed Bl and Br.

Table 12.1 brings the comparison of the filters, using the same handling of the data (fivefold crossvalidation with 10 simulated images in each fold), according to the mean of indices NMSE and SSIM on the test images, but considering a 5×5 window. The rows in the tables are ordered (apart from the results obtained with unfiltered images) according to the best NMSE, considering the three polarizations altogether, using the arithmetic mean. The standard deviation (not shown here) remained below 10^{-5} in all experiments. In Table 12.1 and in the remainder of this text, we call OWA-GA-1 (respectively OWA-GA-2) to the OWA filter obtained with strategy S1 (respectively S2). For both OWA-GA-1 and OWA-GA-2, we report the experiments performed considering a population of 18 individuals, 20 generations, mutation operator A, mutation rate .2, and seed 77. In both filters, the fitness function in each fold is the mean of the application of the indices on the training images, considering the three polarizations. Column "Agg" in Table 12.1 refers to the application of the indices on the test images in each fold, obtained from the aggregation of the filtered intensity bands from each of the three polarizations, with the OWA filter learned in the training images corresponding to that fold.

For NMSE, the lower the results, the better; we see in Table 12.1 that the best mean results for NMSE are obtained with OWA-GA-2 and OWA-GA-1, considering the polarizations both individually and globally.[c] For SSIM,

[c]The results for SDNLM were obtained with a parametrization that yielded the best results considering only HH (Torres et al., 2015). Better results can surely be obtained with a more suitable parametrization.

the higher results, the better; we see in Table 12.1 that SDNLM fared better than all other filters. We note, however, that SSIM was not used to generate the weights; better results can surely be obtained for this index by OWA-GA-1 and OWA-GA-2, when it is used as fitness function in a GA.

We took our best OWA filter (OWA-GA-2) and then selected the simulated image that produced the best NMSE. Fig. 12.4 presents both the unfiltered image and the filtered images obtained with the methods considered here. We note that the images produced by OWA-GA-1 and OWA-GA-2 not only

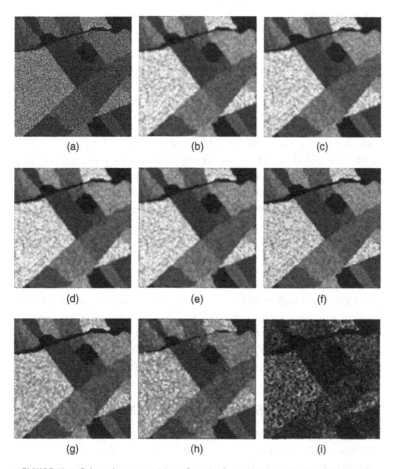

■ FIGURE 12.4 False color composition of results from the same simulated images, for HH, HV, and VV polarizations, with mean NMSE and SSIM from the polarizations inside parentheses. (a) Unfiltered (0.9991, 0.0699); (b) OWA-GA-1 (0.0600, 0.1648); (c) OWA-GA-2 (0.0792, 0.1586); (d) mean (0.0863, 0.1504); (e) SDNLM (0.0912, 0.1579); (f) R-Lee (0.0953, 0.1509); (g) median (0.1700, 0.1159); (h) min (0.9270, 0.0010); and (i) max (0.96841, 0.0234).

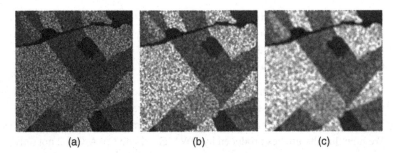

(a) (b) (c)

■ **FIGURE 12.5** **Images corresponding to the same HH simulated image, with NMSE and SSIM inside parentheses.** (a) Unfiltered (0.9833, 0.0693), and using OWA filters learned with (b) 3 × 3 (0.1094, 0.1407), and (c) 5 × 5 (0.0610, 0.1714) windows.

obtained a lower NMSE but are visually superior to those obtained with both complex filters; SDNLM produces a blurred image, and the R-Lee filter yields a pixelated image.

In order to compare the results obtained here with those in our previous work, we ran the GA with the same parameters as in Torres et al. (2015) (seed 2, a population with 72 individuals, 30 generations, mutation operator A with mutation rate .2), but using a 5 × 5 instead of a 3 × 3 window. Then we applied the obtained filter on the same simulated image that fared better in Torres et al. (2015). The difference between using different window sizes is illustrated in Fig. 12.5. We note that the image produced by the OWA-GA with the 5 × 5 window instead of the 3 × 3 reduced the noise significantly while still preserving the structures in the image.

The machine used in all experiments has these specifications: Intel i7, CPU 2.60 GHz, RAM with 16 GB, Windows 10, Fortran with Force 2.0 compiler. The overall computation for the 5 folds and 20 generations, considering all seeds, was of 3169 s for OWA-GA-S1 and 3154 s for OWA-GA-S2. Using 10 generations in both OWA-GA-1 and OWA-GA-2, computational time was reduced by half but the results produced were slightly worse.

7 CONCLUSIONS AND FUTURE WORK

Here we have investigated the learning of parameters for OWA filters (weight vectors), to reduce speckle in multiple polarization SAR images. This work extended a previous one (Torres et al., 2015) in which 3 × 3 windows were used on HH intensity images. We applied a 5 × 5 window (as done with model-dependent filters R-Lee and SDNM) on the same images used in the previous paper. We have also enlarged our scope by using multiple polarizations. We used two strategies to learn the weight vectors by the use of GAs:

in strategy S1, a vector is learned separately for each polarization; in strategy 2, the weight vectors for each polarization are learned jointly. A third strategy was also studied but abandoned because it proved much inferior to the other ones: the images from the different polarizations were previously merged, and a single-weight vector is learned which is then used on all images. The use of a larger window on the OWA filters led to better results for all OSFs considered. In particular, the learned OWA filters yielded better results than all other alternatives, both quantitatively and visually.

Our results point to directions for future research. SDNLM and R-Lee filters use full polarimetric images, whereas only intensity images were used for the OWA filters. It is expected that for complex images, the OWA filters will lead to even better results, albeit with a consequent higher computational cost. Also, in our experiments, the initial populations were chosen at random. It is possible that using other types of initial populations could lead to better results. One alternative would be to insert in the initial population some weight vectors of basic OWA operators, such as the means and the median that had good performance in the experiments.

In the future, we also intend to use more sophisticated types of neighborhoods, as discussed in Sandri and Silva (2015). We also intend to verify the quality of our approach, according to other indices, either independently or as a multiobjective problem, considering Pareto frontiers.

ACKNOWLEDGMENTS

The authors are thankful to CNPq for financial support (Projeto Universal 487032/2012-8) and are also indebted to Alejandro Frery for discussions on filters for SAR imagery.

REFERENCES

Baxter, R., Seibert, M., 1998. Synthetic aperture radar image coding. MIT Lincoln Laboratory J. 11 (2), 121–158.

Bovik, A., Huang, T., Munson, D., 2005. A generalization of median filtering using linear combinations of order statistics. IEEE Trans. Acoustics Speech Signal Process. 31 (6), 1342–1349.

Buades, A., Coll, B., Morel, J.M., 2005. A review of image denoising algorithms, with a new one. Multiscale Model. Simul. 4 (2), 490–530.

Goldberg, D.E., 1989. Genetic Algorithms in Search, Optimization, and Machine Learning. Addison-Wesley, Reading, MA.

Holland, J.H., 1975. Adaptation in Natural and Artificial Systems. University of Michigan Press, Ann Arbor, MI.

Kennedy, J., Eberhart, R.C., 1995. Particle swarm optimization. In: Proceedings of the IEEE International Conference on Neural Networks, Piscataway, NJ, pp. 1942–1948.

Lee, J.-S., Grunes, M.R., de Grandi, G., 1999. Polarimetric SAR speckle filtering and its implication for classification. IEEE Trans. Geosci. Remote Sens. 37 (5), 2363–2373.

Lee, J.-S., Grunes, M.R., Mango, S.A., 1991. Speckle reduction in multipolarization, multifrequency SAR imagery. IEEE Trans. Geosci. Remote Sens. 29 (4), 535–544.

Lee, J.-S., Grunes, M.R., Schuler, D.L., Pottier, E., Ferro-Famil, L., 2006. Scattering-model-based speckle filtering of polarimetric SAR data. IEEE Trans. Geosci. Remote Sens. 44 (1), 176–187.

Lee, J.-S., Pottier, E., 2009. Polarimetric radar imaging: from basics to applications. Optical Science and Engineering Taylor & Francis, Boca Raton, FL.

Mascarenhas, N., 1997. An overview of speckle noise filtering in SAR images. In: 1st Latin-American Seminar on Radar Remote Sensing—Image Processing Techniques, pp. 71–79.

Moschetti, E., Palacio, M.G., Picco, M., Bustos, O.H., Frery, A.C., 2006. On the use of Lee's protocol for speckle-reducing techniques. Latin Am. Appl. Res. 36 (2), 115–121.

Mott, H., 2006. Remote Sensing With Polarimetric Radar. John Wiley & Sons, Hoboken, NJ.

Pitas, I., Venetsanopoulos, A.N., 2013. Nonlinear Digital Filters: Principles and Applications. Springer Science - Business Media, New York.

Richards, J., 2009. Remote Sensing With Imaging Radar, Signals and Communication Technology. Springer Science - Business Media, New York.

Saldanha, M.F.S., 2013. Um segmentador multinível para imagens SAR polarimétricas baseado na distribuição Wishart. PhD thesis, São José dos Campos, INPE.

Sandri, S., Silva, Jr., G., 2015. A study on edge detection algorithms modified by non-standard neighbourhood configurations for use in sar imagery. In: Lopes, B., Perciano, T. (Eds.), Learning and Inferring. Festschrift for Alejandro C. Frery on the Occasion of His 55th Birthday. College Publications, Milton Keynes, UK, pp. 153–165.

Sant'Anna, S.J.S., Mascarenhas, N., 1996. Comparação do desempenho de filtros redutores de "speckle." In: VIII SBSR, pp. 871–877.

Sheng, Y., Xia, Z.-G., 1996. A comprehensive evaluation of filters for radar speckle suppression. In: IGARSS, vol. 3, pp. 1559–1561.

Silva, W.B., Freitas, C.C., Sant'Anna, S.J.S., Frery, A.C., 2013. Classification of segments in PolSAR imagery by minimum stochastic distances between Wishart distributions. IEEE J. Sel. Topics Appl. Earth Obs. Remote Sens. 6 (3), 1263–1273.

Torres, L., Becceneri, J.C., Freitas, C.C., Sant'Anna, S.J.S., Sandri, S., 2015. OWA filters for SAR imagery. In: Proceedings of the La-CCI'15, Curitiba, Brazil, pp. 1–6.

Torres, L., Sant'Anna, S.J.S., Freitas, C.C., Frery, A.C., 2014. Speckle reduction in polarimetric SAR imagery with stochastic distances and nonlocal means. Pattern Recogn. 47 (1), 141–157.

Wang, Z., Bovik, A.C., 2002. A universal image quality index. IEEE Signal Process. Lett. 9 (3), 81–84.

Wang, Z., Bovik, A.C., Lu, L., 2002. Why is image quality assessment so difficult? In: IEEE International Conference on Acoustics, Speech, & Signal Processing, vol. 4, Orlando, FL, pp. 3313–3316.

Wang, Z., Bovik, A.C., Sheikh, H.R., Simoncelli, E.P., 2004. Image quality assessment: from error visibility to structural similarity. IEEE Trans. Image Process. 13 (4), 600–612.

Yager, R., 1988. On ordered weighted averaging aggregation operators in multi-criteria decision making. IEEE Trans. Syst. Man Cybern. 18, 183–190.

Chapter

13

Oil reservoir quality assisted by machine learning and evolutionary computation

M.C. Kuroda*, A.C. Vidal*, J.P. Papa**

*University of Campinas (UNICAMP), Institute of Geosciences, Campinas, São Paulo, Brazil;
**Department of Computing, São Paulo State University, Bauru, São Paulo, Brazil*

1 INTRODUCTION

The geological characterization of petroleum reservoirs in subsurface depends on the combination of different rock parameters (eg, porosity and lithotype) and structural features that guarantee the oil or gas accumulation. These predictions are usually conducted by the analysis of two main types of data: well source, consisting mainly of well logs and drill cuttings, and

285

Bio-Inspired Computation and Applications in Image Processing. http://dx.doi.org/10.1016/B978-0-12-804536-7.00013-2

seismic data, which represent images of the subsurface that do not allow a good identification of rock properties due to the lack of resolution. For this reason, many risks are involved in oil and gas exploration.

With the aim of decreasing economic and environmental risks, this study presents an alternative workflow to convert seismic images into rock properties through bio-inspired machine learning techniques. For this purpose, we show the design of robust geological models that allow the identification of the best reservoir location for exploration and well drilling. Unlike most other studies, we detail all the steps of the algorithm as well as the decisions regarding parameters that may change according to the dataset used.

This study describes the area that is being evaluated, the structural description of the study area, the methods of machine learning used to predict sandstone and porosity properties, and the identification of the best reservoir areas to be exploited.

2 FIELD DESCRIPTION

The study area is part of an oil producer basin in Brazil. It is a passive continental margin–type basin formed during the breakup of the Gondwana supercontinent that separated the South American and African plates in the Mesozoic (Milani and Thomaz, 2000). The energy resulting from this opening reactivated discontinuities that overprinted the preexisting ones of the basement rocks, defining new directions and rift style (Matos, 2000). The study area (Fig. 13.1) exemplifies a wedge-shaped graben area characterized by continental sedimentation of conglomeratic layers, sand, silt and shale, deposited by alluvial, fluvial, deltaic, and lacustrine systems that constitute

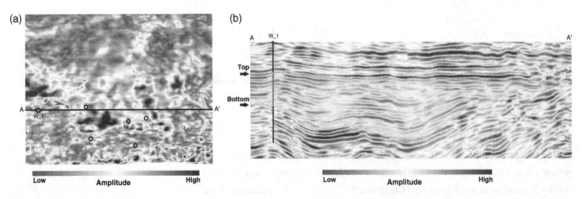

■ **FIGURE 13.1** (a) Image of the reservoir top and six wells identified by *circles*. Wells w_1 and w_2 *(black)* were used to illustrate the results, and (b) the image of seismic section line AA' that crosses well w_1. The interval of interest is the volume between the top and bottom of one depositional sequence highlighted in gray.

(a)

(b)

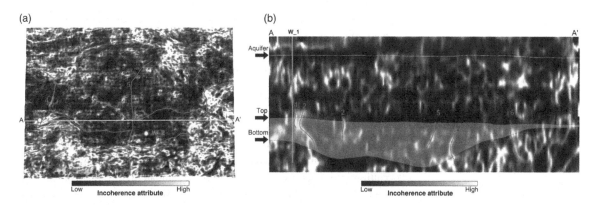

■ **FIGURE 13.2** (a) Seismic attribute incoherence visualized at the top of the reservoir and (b) in line AA′ that crosses well W_1. The main faults are highlighted by *black* and *white lines*. Fault 1 represents the main fault of the basin edge. Associated with it, other normal faults as 2 and 3 were defined, as well as the relief faults 4, 5, 6, and 7. Note that the main faults do not connect with the upper Aquifer.

the Continental Megasequence (Chang et al., 1992; Matos, 2000; Milani and Thomaz, 2000).

During tectonic activities, extensional movements created the main fault, which is associated with the edge of the basin, and several fractures, normal and relief faults (Fig. 13.2). The main fault is dozens of kilometers long, and its expressive vertical slip can exceed 5 km (fault 1 of Fig. 13.2). There is little evidence of this set of faults in the overlying sequence, characterized by a shaly facies that seals the top of the reservoir. Indeed, immediately above the top, the expressive layer with low values of seismic attribute incoherence marks the end of the fault extension, thus corroborating the hypothesis of no connecting layers in the units above by faults (Fig. 13.2b). We can also conclude that the stratigraphic features enable the accumulation of hydrocarbons, thus characterizing a reservoir.

3 DATABASE

The dataset used to characterize the field is composed of three different sources. The first of them are well logs (Fig. 13.5), obtained locally every 0.2 m by tools inserted into the wells. It is considered the *hard data* since the logs represent the direct information from the rock. The second dataset is made of drill cuttings, which provide the lithological classification by visual analysis of the rocky material extracted during drilling. It can be used as a guide to predict rock facies or electrofacies. Finally, the three-dimensional (3D) seismic data, obtained by means of the reflection of acoustic waves, is considered indirect information. These data are sampled into intervals of 2 or 4 ms (Fig. 13.1) and converted into depth domain that can vary from 6 to

25 m, depending on the lithology and petrophysical parameters of the rock, being more sparse than the well log data. Therefore, although the seismic data can cover a large 3D area, they have poor resolution, impacting the quality of the prediction of geological parameters.

For this study, the available data encompass well log information from six wells with mean thickness of 500 m and seismic amplitude data covering 80 km^2. The well logs include information about gamma ray (GR), density (RHOB), sonic (DT), and neutron porosity (NPHI). From these data, porosity, shale volume, and acoustic impedance (AI) were calculated. The drill cutting information was also available to validate the results with description of shale (38%), conglomerate (16%), silt (3%), carbonate (less than 1%), and sandstone (43%). In order to discuss the results, wells 1 and 2 were chosen.

The seismic image data were originally processed into 4 ms, and we also improved its vertical resolution in 1 ms by kriging (for more information, see Doyen, 2007) to enhance details of the study area. Besides this information, seismic attributes were also used. These data are related to any calculation done in the original seismic amplitude, and it is very important in geological interpretation because of the different sensibilities of each one (Chopra and Marfurt, 2007). In this study, 37 different seismic attributes were extracted at the well log scale (calculated by the mean of the four nearest signals from each well point) in order to predict lithological types and porosity in a 3D grid. The dataset of seismic attributes is described in Table 13.1.

4 METHODS

This chapter suggests the use of different bio-inspired machine learning techniques to characterize lithological types and porosity and further assessment of the reservoir quality for well drilling planning. The first step was the interpretation of faults. Working with two different kinds of data (well logs and seismic images), these techniques help the integration of information and prediction of properties by nonlinear correlations. The flowchart of Fig. 13.3 resumes the proposed procedure.

The first objective is the qualitative interpretation of faults that can compartmentalize the reservoir and limit accumulation. After that, the lithology estimation from electrofacies at the well log scale was performed by self-organizing map (SO). With these results and information of core and cutting data, it was possible to extrapolate to the seismic scale by the genetic algorithm (GA) and probabilistic neural network (PNN).

Table 13.1 List of Seismic Attributes Available to Predict Facies and Porosity at the Seismic Scale

Number	Seismic Attribute
1	3D mix
2	Amplitude envelope
3	Automatic gain control
4	Band pass filter (6–60 Hz)
5	Colored inversion
6	Decomp_spectral_10Hz.Euc
7	Decomp_spectral_20Hz.Euc
8	Decomp_spectral_30Hz.Euc
9	Decomp_spectral_40Hz.Euc
10	Decomp_spectral_50Hz.Euc
11	Decomp_spectral_60Hz.Euc
12	Decomp_spectral_70Hz.Euc
13	Decomp_spectral_80Hz.Euc
14	Envelope balancing
15	Exponential gain
16	Fault moment filter
17	FX deconvolution
18	FXY deconvolution
19	Gaussian XY smoother
20	Acoustic impedance
21	Incoherence
22	Instantaneous phase
23	Instantaneous frequency
24	Loop reconvolution
25	Peak spectral frequency
26	Phase rotation
27	Recursive inversion
28	Scalar math
29	Structure oriented median
30	Sparse spike deconvolution
31	Sparse spike deconvolution 3D
32	Sweetness
33	Time variant ZPD
34	Trace equalization
35	Trapezoid filter
36	Velocity
37	Zero phase deconvolution

In parallel, porosity was also predicted by GA and generalized regression neural networks (GRNN). These results were analyzed and compared to the lithological distribution in order to better estimate the reservoir volume and the spatial distribution of each lithology as well as to identify the reservoir position and possible areas for well drilling (Fig. 13.3).

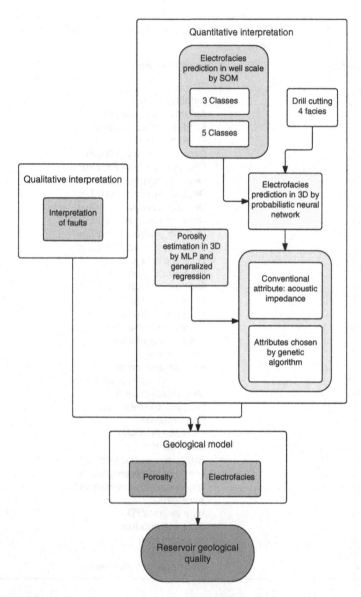

■ FIGURE 13.3 Flowchart for the definition of water injection sites.

4.1 Self-organizing map

The SOM is an unsupervised method used for classification purposes that can help the interpretation of data with no or sparse previous information (Kohonen, 2001; Vesanto et al., 2000). SOM maps the input data onto a bidimensional lattice composed by nodes. The association of nodes and the

input data is performed by the Euclidean distance between prototype vectors (or weights) of nodes and the input samples. In a competitive training, the weight with the smaller distance represents the input, and the winner node and its neighborhood are updated to be closer to the input sample. As such, the method allows the topological preservation of the map that can be visually evaluated by the U-matrix that shows the distance among nodes, and by the distribution map of each variable (Vesanto et al., 2000).

4.2 **Genetic algorithm**

Because of the variety of seismic attributes, it is necessary to apply an optimizer to guarantee that the best set of data will be chosen to predict lithology into the 3D volume. Hence, we chose the GA to define the best set of data. The technique has been widely applied in geophysical problems: for example, lithology estimation (Rivera et al., 2002), porosity (Duan et al., 2014), and well log properties (Dorrington and Link, 2004).

We used the global optimizer GA in this study to select the best set of seismic attributes aiming at predicting electrofacies and porosity. As the name suggests, GA is based on evolution theories, in which genes represent variables or coordinates in a space domain, and chromosomes, also called individuals, represent samples or points on that space. The goal of the optimizer is to find the quasibetter chromosome that minimizes an objective function represented by the multilayer perceptron neural network and PNN. For this purpose, an initial population (the group of possible solutions to the problem) is randomly selected to start the iterations (Mitchell, 1998).

The update of a population is performed by a randomly tournament selection that chooses a number of chromosome pairs and elects the ones with smallest performance index [ie, minimum square error (MSE)] in this study from each pair. The error is provided by ANN-MLP and PNN algorithms, by dataset not used during the algorithm training. These individual choices are updated by reproduction and mutation, creating a new population. In reproduction, the algorithm sets two individuals to survive to the following generation and 80% of the population to crossover. The used crossover function is the scattered, which creates a random binary vector and associates the number "1" to the first parent and "0" to the second one in order to combine their genes and thus generate an offspring.

In order to improve the population, the best set of 20% of individuals from the previous iteration is kept to replace the worst individuals of the last iteration, defined by migration. All these updates generate independent individuals that allow wide possible combinations, avoiding local minimum solutions. Table 13.2 summarizes the chosen parameters for GA.

Table 13.2 Parameters Used in Seismic Attribute Selection by the GA Algorithm

Parameter		Parameter	
Fitness function	MLP and PNN	Number of generations	100
Fitness limit	$5*10^{-5}$	Select type	Tournament
Population type	Binary	Crossover	80%
Number of variables	37	Crossover function	Scattered
Number of individuals	50	Migration	20%
		Mutation	2%

4.3 Multilayer perceptron neural network

One of the techniques used to predict porosity was the supervised method called multilayer perceptron (MLP), which consists of neurons or nodes associated with synaptic weights and bias. These neurons are connected in groups, forming layers. At least one of these layers is a hidden layer. During the training step, weights are updated by a nonlinear activation function, which is able to learn the complex relation between seismic attributes and porosity. Due to this powerful ability, the method is one of the most widely used types of neural networks in the geosciences (Poulton, 2001).

In order to predict porosity from seismic attributes by means of MLP, the sigmoid activation function was chosen, since it is a continuous differentiable and positive function, which generates normal network outputs. As a supervised method, the network reaches a desired learning performance when the difference between the porosity output and the real value is satisfactory, calculated by MSE. This parameter is used as input to GA as a decision criterion. Many tests were developed to set the best activation function and number of neurons of the network architecture (Tables 13.3 and 13.4).

The method propagates the calculated neuron porosity forward while adapting MSE errors and weights, and also improves network performance. Therefore, the correction is initialized in the output layer, where the current prediction error is calculated, and it is backpropagated along all layers (Poulton, 2001). MLP fitness is calculated by crossvalidation, which is described by Dorrington and Link (2004) and Hampson et al. (2001) as a "one-out approach."

In order to avoid overtraining, the database is divided into three parts: training, validation, and testing processing. The testing dataset represents the chosen well to be classified. Such information is used to confirm the final

Table 13.3 MLP Parameters Used in Seismic Attribute Selection by the GA Algorithm

Parameter		Parameter	
Fitness function	Sigmoid	Increment ratio of learning	0.05
Fitness limit	$5*10^{-5}$	Decrement ratio of learning	0.01
Hidden neurons	3	Max error increment	0.04
Train algorithm	Levenberg–Marquartdt Backpropagation	Validation	Crossvalidation
Epochs number	300	Error function	MSE
Momentum ratio	0.9		

Table 13.4 MLP Training Functions

Abbreviation Name	Training Function	Abbreviation Name	Training Function
Trainlm	Levenberg–Marquardt backpropagation	Traincgb	Conjugate gradient backpropagation with Powell–Beale restarts
Trainbfg	BFGS quasi-Newton method	Traincgf	Conjugate gradient backpropagation with Fletcher–Reeves updates
Trainrp	Resilient backpropagation	Traincgp	Conjugate gradient backpropagation with Polak-Ribiére updates
Trainscg	Scaled conjugate gradient backpropagation	Trainoss	One-step secant backpropagation

solution of the network, and it is not used in the processing step of network training. The training data is used for learning, and it is responsible for adjusting the weights of the neural network. In turn, the validation set is used to verify the accuracy of the training step.

After training the neural network, the well classified by the algorithm is then compared to the porosity well log data, and a MSE is calculated for each well. The final response of the chromosome classification is the mean value error of the trained well (MSE_m). When GA ends the search for the best set of seismic attributes to predict porosity, the chosen attributes are then analyzed to be combined and trained once again by the algorithm. First, we

retrain MLP, but do not use the testing data in crossvalidation any longer. At this time, the conventional partitioning into three subsets (training, validation, and testing) is used, respecting the same neural network architecture of layers previously chosen.

In regard to the tests concerning GA, the Levenberg–Marquardt backpropagation function was used. It calculates the Jacobian matrix to approach the second-order training speed without having to compute the Hessian matrix, thus having a good convergence. However, its limitation is related to the performance that is a mean or sum of squared errors (Hagan and Menhaj, 1994; Haykin, 2008).

4.4 Probabilistic and generalized regression neural networks

In this study, the PNN was applied to predict electrofacies together with GA, and GRNN was used to predict porosity. The difference between them is that PNN performs the classification of discrete targets whereas GRNN performs prediction of continuous targets. According to Cigizoglu and Alp (2006), the advantages of using PNN and GRNN instead of MLP is that they are faster to train, they do not need an iterative training, and they do not require many parameters. Additionally, they are relatively insensitive to outliers; on the other hand, they are slower for classifying new samples and require more storage memory than MLP. The biggest advantage of the use of these alternative methods in this study is that PNN and GRNN require fewer samples than MLP (Specht, 1991). This skill decreases the impact of error prediction due to the sparse well log information in the field.

As a neural network, these methods are based on connected neurons or nodes, divided into layers. But in contrast to MLP, PNN and GRNN work with the conventional feed-forward procedure, approximating any arbitrary function between input and output vectors directly from the training data (Specht, 1991; Specht and Shapiro, 1991; Cigizoglu and Alp, 2006; Haykin, 2008). The regression is performed by the computation of the radial basis function (RBF), which has only one parameter to be set: the sigma value (σ) that determines the spread of the Gaussian function.

The PNN and GRNN networks have four layers:

1. *Input layer.* This layer is composed of N neurons associated with each predictor variable or class. Before the input layer starts, the range of the class values is initialized by subtracting the mean and dividing by the interquartile range.

2. *Hidden layer.* Each neuron computes the Euclidean distance between the test sample and the hidden neurons and also applies the RBF kernel function using the defined σ value.
3. *Pattern layer/summation layer.* This layer is different for PNN and GRNN. In regard to PNN, there is a pattern neuron for each class to be classified, and the weight of the hidden layer is activated in the neuron of the class that it represents. With respect to GRNN, there are two neurons: the denominator and the numerator summation unit. The first adds up the weight values of the hidden neurons, and the other adds up the weight values multiplied by the actual target value for each hidden neuron.
4. *Decision layer.* For PNN, the decision layer compares the weighted values and chooses the largest one as the sample class. In regard to GRNN, the decision layer divides the values of the numerator by denominator, and the result is used as the predicted target value.

5 RESULTS AND DISCUSSION

5.1 Prediction of electrofacies at the well scale

The SOM technique was applied in six wells in order to find different patterns in these well log data: AI, gamma ray, density, effective porosity, and clay volume. The SOM classifier was trained 100 times with Euclidean distance as the distance function, in order to evaluate the best number of classes. In these training the algorithm clustered the dataset into 19 classes 20 times, for which the smallest error was computed (Fig. 13.4). The Davies–Bouldin index was the parameter used to find the best set of classes (Fig. 13.5a).

Comparing the clustering of the U-matrix (Fig. 13.5b) with the map distribution of variables used in the training step and with the maximum drill

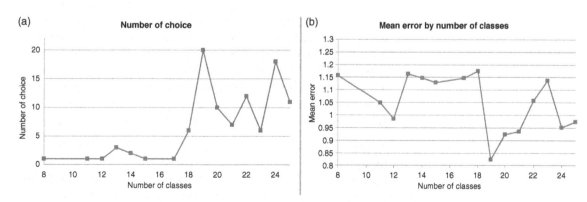

■ **FIGURE 13.4 Results of SOM training for facies classification.** (a) The number of times the classes were chosen by the algorithm and (b) the mean error of Davies–Bouldin index. Considering these results, the dataset was clustered into 19 classes.

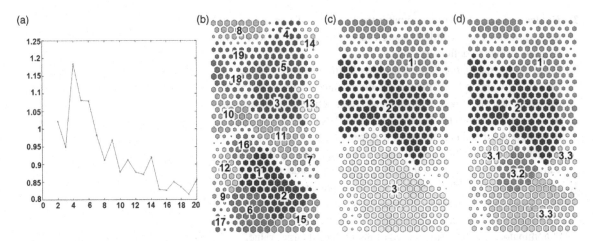

■ **FIGURE 13.5 Results of SOM training.** (a) Davies–Bouldin index clustered the U-matrix into 19 classes (b), which was posteriorly clustered into (c) three and (d) five classes, according to drill cutting information and analysis of well logs and petrophysical parameters. In (c) number 1 is shale, 2 conglomerates, and 3 sandstone. In (d) 1 represents shale, 2 conglomerate, 3.1 poor reservoirs, 3.2 regular reservoirs, and 3.3 good reservoirs.

cutting label of each clustering, we divided these 19 clusters into 3 and 5 classes, as illustrated in Fig. 13.5c and d. In these classifications, the lithology silt was ignored due to a small sampling, as cited in Section 3, and considered as shale due to similarity in flow behavior.

In regard to the electrofacies prediction, 9752 samples were analyzed. They generated a map with size of 32 × 15 neurons. The comparison error between drill cutting description and predicted electrofacies was 0.10 for 3 classes. The quantization (0.627) and topographic errors (0) highlighted the quality of the grouping by SOM.

The groups clustered by SOM were also identified according to each variable used in the training step. As described by Figs. 13.6 and 13.5c, group 1 has the values of maximum density, gamma ray end clay volume, and minimum effective and total porosity, thus characterizing the shaly lithology (no reservoir). Group 2 of Fig. 13.5c shows moderate values of gamma ray, density, AI, clay volume, and total porosity, thus representing conglomerates, while group 3 shows lower values of gamma ray, density, AI, and clay volume and the biggest values of effective and total porosity, thus characterizing sandstone (reservoir).

The third clustering, illustrated by Fig. 13.5d, details the quality of reservoir rocks. Analyzing Figs. 13.5 and 13.6, facies 3.1, 3.2, and 3.3 have increasing values of effective and total porosity and decreasing values of clay and density, which can be interpreted as poor, regular, and good reservoirs, respectively. Considering Fig. 13.6, it is clear that the distribution of gamma rays is linearly correlated to clay volume, and effective and total porosity are very similar to density values. The only variable that does not show a linear

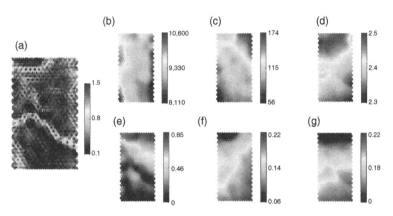

■ FIGURE 13.6 **Map distribution of each variable for training the SOM algorithm.** (b) Acoustic impedance, (c) gamma ray, (d) density, (e) clay volume, (f) effective porosity, (g) total porosity. All variables were analyzed in order to calculate the U-matrix in (a).

correlation among others is AI. Although there is no correlation of SOM results and AI, it is widely known in the literature that this attribute helps in the identification of different lithologies (Leiphart and Hart, 2001; Avadhani et al., 2006; Chopra and Marfurt, 2007). It suggests that a nonlinear correlation exists, and indeed, the SOM training without AI decreased the ratio of drill cutting matching and shows instable results, as shown in Fig. 13.7.

Figs. 13.8 and 13.9 show the result of electrofacies prediction into 3 and 5 clustering and the major well logs of well 1 and 2. Well 2 has more sandstone in the drill cutting description. Although the classification into

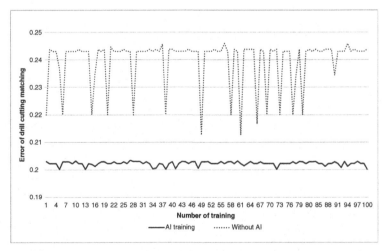

■ FIGURE 13.7 **SOM training error for data including acoustic impedance** *(continuous line)* **and without it** *(dotted line).* Although there is no linear correlation between AI and other variables, the use of AI increases the training of eletrofacies.

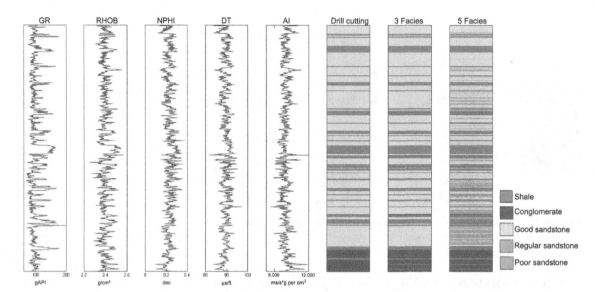

■ **FIGURE 13.8 Description of well 1.** Gamma ray *(GR)*, density *(RHOB)*, neutron porosity *(NPHI)*, sonic *(DT)*, acoustic impedance *(AI)*, drill cutting description, and prediction of 3 facies and 5 facies.

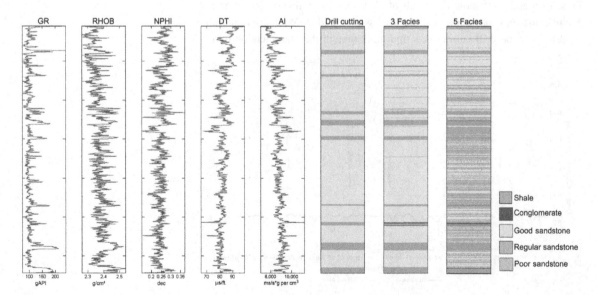

■ **FIGURE 13.9 Description of well 2.** Gamma ray *(GR)*, density *(RHOB)*, neutron porosity *(NPHI)*, sonic *(DT)*, seismic acoustic impedance *(AI)*, drill cutting description, and prediction of 3 facies and 5 facies.

3 classes, of wells 1 and 2, looks similar to the drill cutting description, the detailed reservoir facies classification into 5 classes is prefered. This last classification shows the interbedded of good and regular sandstone, allowing the identification of best intervals of each kind of reservoir. As shown in Figs. 13.8 and 13.9, the best sandstone of well 1 and 2 is at the top. Below it the quantity of lower-quality reservoirs, shale and conglomerate, increases.

5.2 Prediction of electrofacies into 3D grid

We created four models for electrofacies prediction at the grid scale, with two different datasets: facies calculated by SOM (described in Section 5.1) and drill cutting facies. After 50 iterations of GA, different seismic attributes were chosen by PNN. We selected the attributes that were more often chosen by the algorithm (Table 13.5).

The AI is the most common attribute used for lithology and porosity estimation because its values are directly associated with rock characteristics (Chopra and Marfurt, 2007). However, the correlation between the desired rock property and AI is not always the best one. However, the correlation between the desired rock property and AI is not always the best one, as shown in Table 13.5. For this study, the combination of AI with other seismic data, such as phase rotation and spectral decomposition, improved the results of electrofacies prediction in more than 8% of cases.

The choice of the GA, as described in Table 13.5, highlight two kind of seismic attributes used for rock characterization. Zeng and Backus (2005) show that 90 degree phase seismic data are better than the zero-phase data to thin-bed interpretation and lithology prediction for clastic formations, as well as spectral decomposition and sparse spike deconvolution data, used for sand thickness estimation (Chopra and Marfurt, 2007). The band pass

Table 13.5 3D-Facies Scenario Description

	Models	Attributes	Matching	GA Error
DC1	4 Facies defined by drill cutting description	AI	0.8764	—
FI	3 Facies defined by SOM	AI	0.8482	—
DC2	4 Facies defined by drill cutting description		0.9	0.0015
F2	5 Facies defined by SOM	Band pass filter (6–60 Hz), spectral decomposition 10 Hz Gaussian smoother XY, acoustic impedance, velocity cube	0.93	0.0051

filter seismic attribute removes unwanted frequencies and emphasizes the signal with certain frequencies. As such, it can be used to remove noise from the environment as well as the Gaussian smoother XY (Arrell et al., 2008). Among the selected attributes, the velocity cube is the most correlated to AI because it is associated with the rock density, which can also give information of lithology and porosity (Berge and Bonner, 2002).

Figs. 13.10 and 13.11 compare the drill cutting description and the results of electrofacies prediction for well 1 and 2. Examining the results of electrofacies prediction, it is possible to determine that the electrofacies DC2 have more shale facies than described on drill cutting (Fig. 13.10). This implies that the electrofacies volume calculated by multiattributes would have less sandstone than expected, generating prediction errors of the reservoir capacity of the field. For this reason, DC2 was discarded. The other electrofacies (DC1 and F1, and F2) show correlation with drill cutting and electrofacies predicted at the well log scale, although there are more thin layers in the electrofacies predicted by well logs than by seismic attributes. According to the results, the 5 SOM electrofacies predicted by multiattributes (F2) were used to calculate the distribution map of the facies in the field (Fig. 13.11).

Fig. 13.12 shows the distribution of good, regular, and poor sandstone for line BB' that crosses well W2. It is possible to determine that the higher concentration of good sandstone is at the top of the study area, and the higher the depth, the lower the reservoir quality.

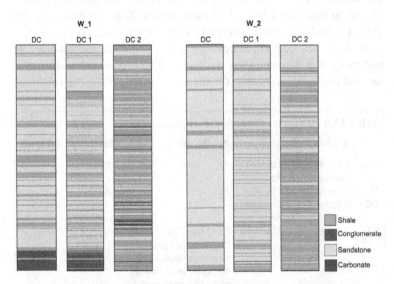

■ FIGURE 13.10 Drill cutting *(DC)* prediction at the seismic scale determined by acoustic impedance *(DC 1)* and multiattributes *(DC 2)*, for well 1 and 2, respectively.

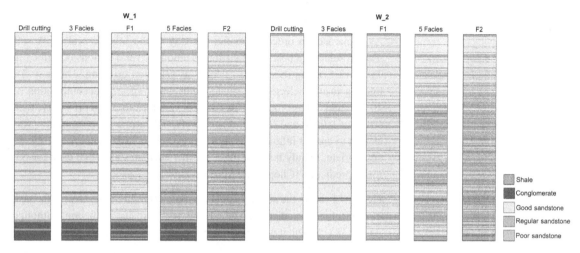

■ **FIGURE 13.11 Comparison of well log facies prediction for well 1 and 2.** From left to right: drill cutting, 3 SOM facies predicted at the well scale, 3 PNN facies prediction using acoustic impedance *(F1)*, 5 SOM facies predicted at the well scale, and 5 PNN facies prediction using multiattributes *(F2)*.

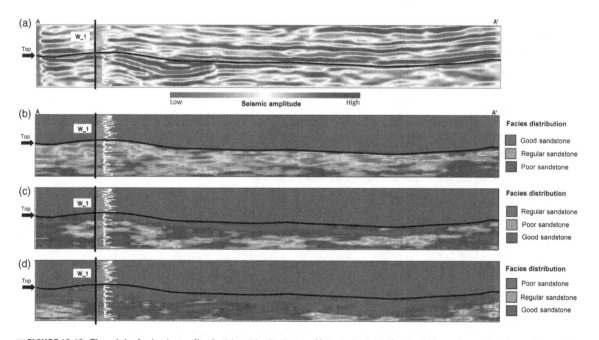

■ **FIGURE 13.12 The original seismic amplitude.** (a) and the distribution of facies in the detail of section AA′ according to the higher probability of being (b) good sandstone, (c) regular sandstone, and (d) poor sandstone in the cube with higher resolution calculated by indicator kriging. The gamma ray well log shows the lower values associated with the best reservoir and higher values to the poor sandstone.

5.3 Prediction of porosity into the 3D grid

As explained, in order to predict porosity at the seismic scale, GA was used to select the best set of attributes among several options described in Table 13.1, using the results of MLP as selection criterion. The best GA training results selected the seismic attributes "spectral decomposition of 40 Hz" and "phase rotation" as the best variables to predict porosity, with errors of 0.0648 and 0.0649, respectively. This same set of attributes was chosen to predict lithology, as shown previously. Such choice is considered appropriate, mainly because these seismic attributes are often used for porosity prediction (Chopra and Marfurt, 2007).

Fig. 13.13 shows the set of seismic attributes chosen by the GA for the task of electrofacies prediction, well cutting, and porosity prediction. Although AI was not chosen, it was used because of its relevance in the description of

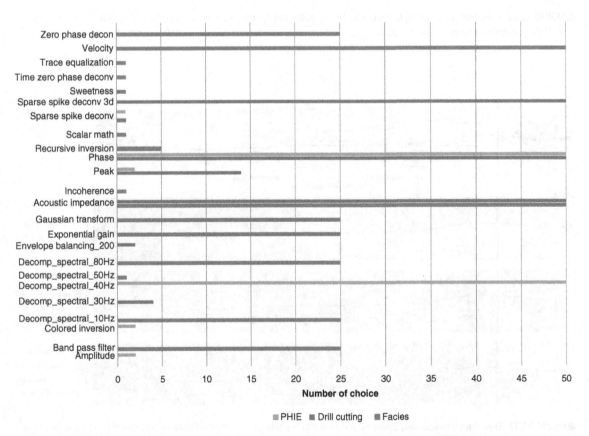

■ FIGURE 13.13 Selected seismic attributes by GA for the prediction of porosity *(PHIE)*, drill cutting, and facies. Phase rotation and acoustic impedance were the attributes more frequently chosen by the algorithm.

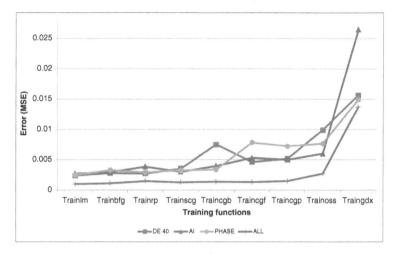

■ FIGURE 13.14 MSE error, considering different training function for porosity extrapolation, using spectral decomposition of 40 Hz *(DE 40)*, acoustic impedance *(AI)*, phase rotation *(PHASE)*, and all variables.

geological features, as mentioned before (Leiphart and Hart, 2001; Avadhani et al., 2006; Chopra and Marfurt, 2007).

Regarding the task of porosity prediction by MLP using as input the AI seismic attribute, the best MLP training algorithm was the Levenberg–Marquardt backpropagation (Fig. 13.14). After defining the training function, other tests were conducted to identify the best number of neurons (Fig. 13.15). The training steps with AI and phase rotation were the ones

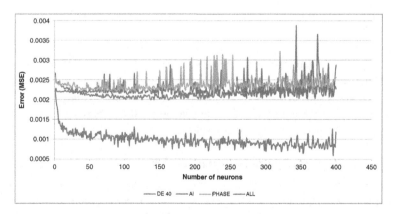

■ FIGURE 13.15 MSE error considering a different number of neurons for porosity extrapolation using spectral decomposition of 40 Hz *(DE 40)*, acoustic impedance *(AI)*, phase rotation *(PHASE)*, and all variables.

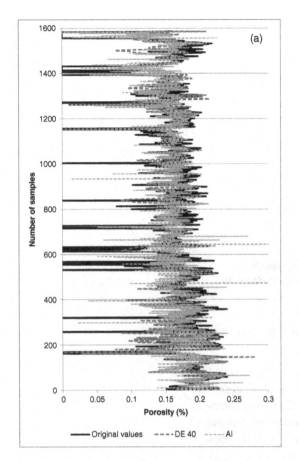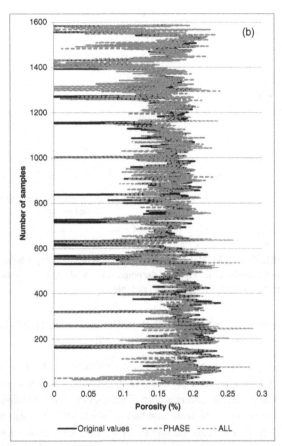

■ **FIGURE 13.16** Comparison of the results concerning MLP porosity prediction by spectral decomposition of 40 Hz *(DE 40)*, acoustic impedance *(AI)*, both variables in graph (a); phase rotation *(PHASE)*, and all variables in graph (b).

that yielded more error variations, considering the number of neurons. Moreover, the combination of all variables led to the smallest errors in both tests. The results of porosity extrapolation are illustrated in Fig. 13.16. Indeed, the MLP training with the combination of all variables was closer to the original values than the other results.

5.3.1 3D porosity prediction by GRNN

The GRNN algorithm was also employed to predict porosity, using parameters defined in Section 4.4. The training of spectral decomposition of 40 Hz and phase rotation attributes (with MSE errors of 0.013) achieved constant values of porosity. However, better results were obtained using AI and the combination of all variables (with MSE error of 0.0141 and 0.0076,

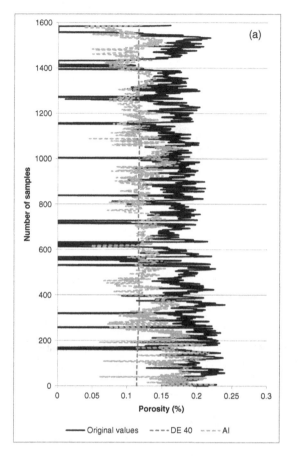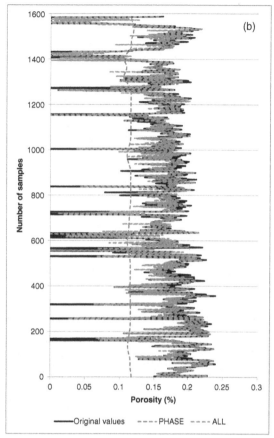

■ FIGURE 13.17 Comparison of the results of GRNN porosity prediction by spectral decomposition of 40 Hz *(DE 40)*, acoustic impedance *(AI)*, in graph (a); phase rotation *(PHASE)*, and all variables in graph (b).

respectively), although the first variable showed low similarity with the original porosity values (Fig. 13.17).

The porosity prediction by MLP and GRNN using all variables (spectral decomposition of 40 Hz, AI and phase rotation) resulted in similar values. In order to compare these results, the crossplot (Fig. 13.18) shows that the MLP prediction was a little better, with a 65% correlation. Therefore, this method was chosen to predict porosity in the field.

The distribution of porosity (Fig. 13.19) showed similar results compared to the seismofacies distribution, yielding higher values at the top of the study area.

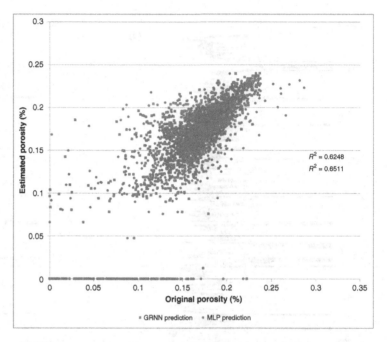

■ FIGURE 13.18 Crossplot of the estimated porosity calculated by GRNN and MLP algorithms, using all seismic attributes. The MLP prediction was a little better, with a 65% correlation.

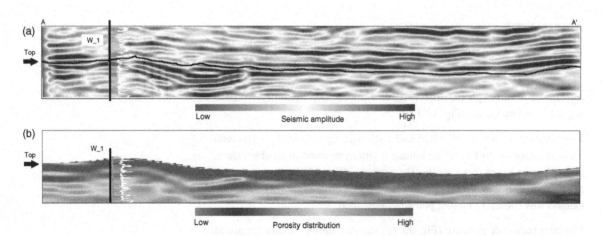

■ FIGURE 13.19 Details of the seismic amplitude (a) and the distribution of porosity in section AA' (b). The higher values of porosity at the top of the reservoir are associated with the good and regular sandstone previously predicted. The gamma ray well log is highlighted for well W_1.

5.4 **Geological analysis**

We created a map of reservoir thickness that allows the identification of the best regions (Fig. 13.20). The southwest section shows the highest expression of good reservoir facies with thickness greater than 100 m and a large spread of moderate thickness between the wells (Fig. 13.20a). Sandstone of good quality more frequently occurs at the top of the study area, with significant volume south of well W1. Another region is north of well W2, but the reservoir rock is thinner (Fig. 13.20b). The same analysis that produced the thickness map was applied to porosity distribution, which revealed that the best portion of the block is the southwestern, thus corroborating the result obtained from the facies thickness study (Fig. 13.20).

Besides of the study of reservoir facies thickness and porosity, the connectivity of the reservoir facies is very important to determine reservoir quality, guaranteeing the flow during exploitation. The results revealed that the region near well W1 can be used for exploitation, since it is connected with the largest volume of reservoir facies.

In order to determine the best location for well drilling, the information on the reservoir thickness, porosity, good-quality reservoir distribution, and reservoir facies connectivity was combined, and two areas in the southwestern region of well W1 were depicted with the best properties (Fig. 13.21).

Considering Fig. 13.21, it is possible to conclude that the quality facies prediction by SOM in well logs was indispensable in delimiting the area of the reservoir. Among many possible regions of thicker reservoir facies (Fig. 13.20a), the two best regions were highlighted by the detailed classification of the neural network SOM, which improved the information that was not available in the core description data. Besides, well W1 can be used as a pilot extraction well, since it is the well nearest to the chosen area and also showed a good reservoir facies thickness.

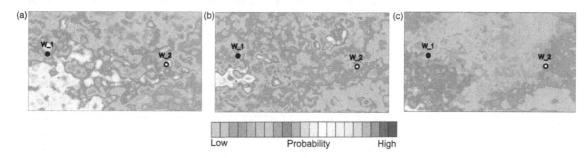

■ **FIGURE 13.20 Thickness.** (a) Regular reservoir facies, (b) good reservoir facies, and (c) porosity higher than 12%.

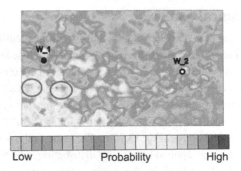

■ **FIGURE 13.21** **Image of the reservoir thickness considering the top of the interval of interest.** The *circles* highlight the identified areas of reservoir.

6 CONCLUSIONS

This study presents a workflow that combines geological interpretation and computational bio-inspired machine learning techniques to define the geological quality of a reservoir for the drilling a new well in a Brazilian sand field. The database used in this study yielded a nonlinear correlation between AI, porosity, and core description, which led us to apply computational methods to find the best way to use these basic data to reach our objective of identifying a reservoir in the study area. Supervised (MLP, GRNN, and PNN) and unsupervised neural networks (SOMs) were combined with GA to provide the best set of seismic attributes.

The first classification was the electrofacies definition into well logs by SOM in order to discriminate reservoir facies. The classification into five classes enabled the identification of reservoir quality (poor, regular, and good sandstone), which was not possible from core descriptions only, thus improving the accuracy of local decision rules. Furthermore, the predicted electrofacies and information about the core description were used as input for the classification of the whole seismic image by PNN and GA. The same process was performed to predict porosity by GA combined with GRNN and MLP, which demonstrated better results. It is important to mention that due to the low number of wells, the basis for the results was seismic data, especially AI. The best results from different computational methods were chosen by the analysis of correlation between input data and prediction and the peer geological review that guaranteed their effectiveness. The performance of MLP and GRNN was very similar, although the choice of attributes by GA was conducted with MLP only. Considering that the GRNN algorithm has only one free parameter to be set, it can be a good option to construct a porosity model.

The results helped identify two promising areas. These areas are shown by well W1, which shows favorable lithologic conditions for a good reservoir (high-quality sandstone). Moreover, the sandstone thickness in both areas is good, the volumes of good sandstone are the highest, and the porosity distribution indicates high connectivity values in both areas. Therefore, well W1 can be used as a pilot well in the sandstone layers near the top because of its connectivity to the main reservoir.

The results obtained in this study show that the accuracy of facies prediction is very important to refine geological characteristics obtained in the field. Hence, it is indispensable for deciding on the best place for drilling. Moreover, although AI is a consecrated seismic attribute to predict reservoir properties, the use of seismic multiattributes yields better results. However, it is not good enough for every set of attributes, revealing that the combination with seismic imaging needs to be conducted carefully, as well as tested using well information to evaluate the accuracy of the seismic attributes.

ACKNOWLEDGMENTS

The authors would like to thank Drillinginfo, Schlumberger, and Roxar for providing the programs used in this study. The first author also thanks CAPES for financial support.

REFERENCES

Arrell, K., Wise, S., Wood, J., Donoghue, D., 2008. Spectral filtering as a method of visualizing and removing striped artefacts in digital elevation data. Earth Surf. Process. Landforms 33, 943–961.

Avadhani, V.L.N., Anandan, B., Thattacherry, B.J., Murthy, K.S., Gariya, B.C., Dwivedi, A.K., 2006. Acoustic impedance as a lithological and hydrocarbon indicator—a case study from Cauvery Basin. Leading Edge 25 (7), 854–858.

Berge, P.A., Bonner, B.P., 2002. Seismic velocities contain information about depth, lithology, fluid content, and microstructure. In: Symposium on the Application of Geophysics to Engineering and Environmental Problems, Las Vegas, NV.

Chang, H.K., Howsman, R.O., Figueiredo, A.M.F., Bender, A.A., 1992. Tectonics and stratigraphy of the East Brazil Rift System. Tectonophysics 213, 97–138.

Chopra, S., Marfurt, K.J., 2007. Seismic Attributes for Prospect Identification and Reservoir Characterization. Society of Exploration Geophysicists, Tulsa, OK, p. 456.

Cigizoglu, H.K., Alp, M., 2006. Generalized regression neural network in modelling river sediment yield. Adv. Eng. Software 37, 63–68.

Dorrington, K.P., Link, C.A., 2004. Genetic-algorithm/neural-network approach to seismic attribute selection for well-log prediction. Geophysics 69 (1), 212–221.

Doyen, P., 2007. Seismic Reservoir Characterization: An Earth Modelling Perspective. CGGVeritas, London, p. 255.

Duan, Y., Pan, B., Han, X., Zhang, H., Yang, X., 2014. Porosity calculation of tight sand gas reservoirs with GA_CM hybrid optimization log interpretation method. J. Geosci. Environ. Prot. 2, 92–98.

Hagan, M.T., Menhaj, M.B., 1994. Training feedforard techniques with the Marquardt algorithm. IEEE Trans. Neural Netw. 5 (6), 989–993.

Hampson, D.P., Schuelke, J.S., Quirein, J.A., 2001. Use of multiattribute transforms to predict log properties from seismic data. Geophysics 66 (1), 220–236.

Haykin, S., 2008. Neural Networks: A Comprehensive Foundation, second ed. Bookman, McMaster University, Hamilton, Ontario, Canada, p. 900.

Kohonen, T., 2001. Self-Organizing Maps. Springer Series in Information Sciences, vol. 30. Springer, Berlin, Heidelberg, New York, p. 501.

Leiphart, D.J., Hart, B.S., 2001. Comparison of linear regression and a probabilistic neural network to predict porosity from 3-D seismic attributes in Lower Brushy Canyon channeled sandstones, southeast New Mexico. Geophysics 66 (5), 1349–1358.

Matos, R.M.D., 2000. Tectonics evolution of the Equatorial South Atlantic. In: Mohriak, W., Talwani, M. (Eds.), Atlantic Rifts and Continental Margins. Geophysical Monograph vol. 115, pp. 331–354.

Milani, E.J., Thomaz, F.A., 2000. Sedimentary basins of South America. In: Cordani, U.G., Milani, E.J., Thomaz, F.A., Campos, D.E. (Eds.), Tectonics Evolution of South America. International Geological Congress, vol. 31, pp. 389–449.

Mitchell, M., 1998. An Introduction to Genetic Algorithms. MIT press, London, England.

Poulton, M.M., 2001. Multi-layer perceptrons and back-propagation learning. Computational Neural Networks for Geophysical Data Processing: Handbook of Geophysical Exploration, vol. 30, Elsevier, Tucson, EUA, Chapter 3.

Rivera, N., Ray, S., Chan, A., Jensen, J., 2002. Well-log feature extraction using wavelets and genetic algorithms. In: AAPG Annual Meeting, Houston, TX, pp. 1–13.

Specht, D.F., 1991. A general regression neural network. IEEE Trans. Neural Netw. 2 (6), 568–576.

Specht, D.F., Shapiro, P.D., 1991. Generalization accuracy of probabilistic neural networks compared with back-propagation networks. In: International Joint Conference on Neural Networks, Seattle, WA.

Vesanto, J., Himberg, J., Alhoniemi, E., Parhankangas, J., 2000. SOM Toolbox for Matlab 5, Technical Report A57, Helsinki University of Technology, p. 59.

Zeng, H., Backus, M.M., 2005. Interpretative advantages of 90 phase wavelets: part 2—seismic applications. Geophysics 70 (3), C17–C24.

Chapter

14

Solving imbalanced dataset problems for high-dimensional image processing by swarm optimization

J. Li, S. Fong

Department of Computer and Information Science, University of Macau, Macau SAR, China

1 INTRODUCTION

Multimedia data and image data are two important parts of data engineering. But we often face the imbalance problem in multimedia and image datasets, which makes research difficult. Say we want to use satellite images to detect a volcanic eruption on Earth. In the dataset of 1000 images, there may only be 30 or fewer images containing magma; the rest of the images are normal rocks. This challenge is widely known as the imbalanced dataset problem, which causes confusion in classification models. The model lacks of training by the images containing magma which belongs to the minority class sample, but becomes overly trained with the normal data. In another example, consider the imbalance ratio of 41 to 896 in the detection of oil spills in satellite radar images, in which the majority class of negative look-alike samples occupy almost 96% while the rest are positive examples of oil slicks in the image (Kubat et al., 1998).

Bio-Inspired Computation and Applications in Image Processing. http://dx.doi.org/10.1016/B978-0-12-804536-7.00014-4

If volcanic activity occurs in a satellite image, this event may contribute just a few characteristics reflecting the natural disaster in the many pixels of an image. Therefore, we need to select the proper characteristics from the image dataset to improve classification performance.

These problems indicate that it is important to reduce the imbalanced ratio of imbalanced datasets;selecting only the useful features from image datasets is equally important. In other words, processing imbalanced high-dimensional dataset consists of two parts. Our proposed algorithms for rebalancing datasets is first to obtain a credible classification performance, then apply feature selection, so that robust and meaningful accuracy can help swarms effectively verify the searched results in each iteration to reduce the dimensions of the dataset.

2 DATASET AND EXPERIMENT

The three datasets used in our experiment are downloaded from the UCI Machine Learning Repository (Lichman, 2013). They are: Optical Recognition of Handwritten Digits Data (shortened to optical digits dataset), Statlog Landsat Satellite (satellite image dataset), and Libras Movement Dataset (Libras move dataset). All of them are pixel datasets ranging from static images to video frames. In our experiment, the data imbalance ratios between majority-class datasets and minority-class datasets are 1:9.1, 1:9.3, and 1:14.0. The number of features are 64, 36, and 90. Fig. 14.1 shows samples where only one class is tested; the rest are learned.

From the perspective of data mining, when we build a classification model using an imbalanced dataset compared to the original dataset, sometimes we can get a very good accuracy. This might be an illusion because the

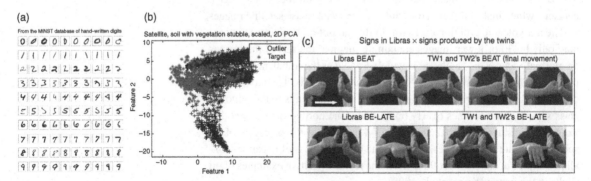

■FIGURE 14.1 Samples of testing image datasets used in our experiments. (a) Digits, (b) Statlog, and (c) Libras. *(Courtesy: images from UCI machine learning repository, https://archive.ics.uci.edu/ml/datasets.html)*

other performance index, called Kappa statistics, is very low. Most of the time Kappa falls to almost zero. Sometimes it may become a negative value depending on how imbalanced the data are. From the confusion matrix, it could be seen that most of the misclassified errors come from the tests of minority data of negative class. That means if we use all the negative class datasets as testing datasets, the accuracy of the trained classification model will be very low. The classifier was undertrained with the negative class data. Thus when discussing imbalanced dataset, a highly accurate classification result is meaningless. The Kappa index should be looked into as well.

In our proposed method, high but false accuracy is prone to happen. This suggests that it is necessary to fix the imbalanced problem first before feature selection. As long as the imbalanced problem is not solved, the high accuracy is incorrect, even if other preprocessing techniques were applied, such as feature selection. The low Kappa still would affect the improved accuracy brought about by feature selection. Therefore, the imbalanced problem associated with the dataset must be fixed first, to achieve a reliable value of Kappa. After that is done, other preprocessing methods designed for enhancing the accuracy can be applied.

As shown in Fig. 14.2 the experiment consists of two main parts: rebalancing the dataset and feature selection. They both operate by using the swarm intelligence (SI) algorithm, powered by particle swarm optimization (PSO) (Kennedy, 2011) or the bat algorithm (Yang, 2010). The classification algorithms will validate the local best results which are found from the search

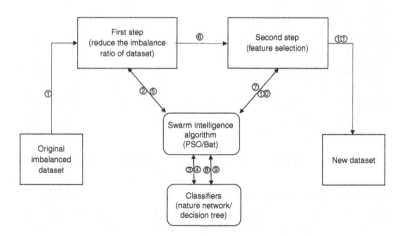

■ FIGURE 14.2 Block diagram of the experiment design.

space by each iteration of particles or bats, and they return the performance to the swarms for a comparison of the conditions and current best solution. This continues until the maximum iteration is reached.

Kappa is an alternative measure of computing classification performance in response to the consistency of a testing dataset. Thus it is an important index that tells us how to judge whether the classification accuracy is within a confidence level. Sometimes Kappa is interpreted as the reliability of the classifier model. As the Kappa value is higher, the accuracy is more credible. The range of Kappa values (or just Kappa) is between -1 and 1. Three levels of Kappa are used to estimate the credibility of classification accuracy (Li et al., 2015a):

1. Kappa ≥ 0.75: strong consistency, high credible accuracy
2. $0.4 \leq$ Kappa < 0.75: the confidence of the accuracy is mediocre
3. Kappa < 0.4: accuracy is not credible

Our experiment was aimed at the datasets having binary classes. We use PSO and bat algorithms to optimize the two parameters selection of synthetic minority oversample technique (SMOTE) (Chawla et al., 2002), which is a frequently used oversampling methods with high performance. The core idea of SMOTE is using the K-NN algorithm to understand the spatial structure of the target minority class data and synthesize the extra target samples into the original dataset to rebalance the dataset. However, there are two key parameters of SMOTE, the suitable value of K of K-NN and the number of synthesized minority data (K and S, respectively stand for these two parameters). Thus, the target in first step is to find the best K and S. The neural network and decision tree are the classifiers which we choose to measure and verify the objectives in terms of fitness in every generation with swarm algorithms. In general, we only focus on the accuracy to measure whether the two parameters are best globally. But here due to the specificity of imbalanced dataset, we also need to ensure that the Kappa is also as large as possible to ensure that the result is credible. Meanwhile in the experiment we use a harsh 10-fold crossvalidation to test the dataset. To keep the experiment consistent, we use the same two swarm algorithms and classification algorithms in the second part of the feature selection.

Fig. 14.3 presents the principle and concept of rebalancing the imbalanced data in terms of a flowchart for the first part of the experiment. The rebalancing is about using optimization to improve the SMOTE method by finding the optimal values of the two key parameter values. Whenever the search agents (in particles in PSO) or bats try a new solution, it is hoped that through the classifiers of the neural network and decision tree, the new

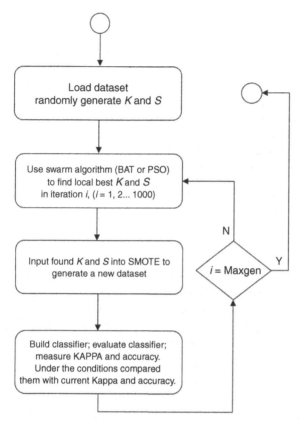

■ **FIGURE 14.3** Flowchart of rebalancing.

method can find a local best of K and S. At the same time, it aims at improving the performance and accuracy of Kappa. We then use the performance indicators to compare with the conditions, with the iterative processing to find the globally best K and S so to improve the values of and accuracy of Kappa. In the computation, each of the parameters of SMOTE, N and S, has its own step interval. The maximum of S is the ratio between the majority class and the minority class. The minimum value of S is 100%. The maximum and minimum values of K, respectively are the number of instances of the minority class and 2. For instance, if a dataset has two labels, the number of the majority class's instance is 1000 and the minority label has only 10 instances, the maximum value of S can increase to 9000%. That means the minority class sample can grow as large as 100,000 times, and it has to increase from 20 at least. The range of K is between 2 and 10 (Li et al., 2015b). There are two updated conditions in the rebalancing

step: we know that when Kappa is in the scope bounded from 0.4 to 1, the results of classification are deemed significant. Therefore, the two conditions are: the value of Kappa statistics must fall in the credible area (≥ 0.4), and the program needs to improve the classification accuracy. Hence if the program tries to increase the value of accuracy, the corresponding Kappa value should be at least 0.4. The value 0.4 is a minimum threshold which is adjustable. When the user requires a much stronger classifier, the minimum threshold can be used. In general, Kappa and accuracy are consistent; Kappa increases while accuracy rises, and vice versa, except when very imbalanced data are used as the training dataset.

In the next step, the same SI algorithm is used for the feature selection. The swarm feature selection achieved good results in processing high-dimensional dataset (Fong et al., 2014). The dataset has already been rebalanced. So the accuracy generated is credible with a satisfactory level of Kappa guaranteed. Thus, in this step, unlike the first step, the program only needs to pay attention to the change of accuracy without worrying about the Kappa. Meanwhile the update condition is very simple. In each iteration, the new features subset will replace the current best one if the new accuracy is higher than the old one. The classification algorithm used in this step should be the same as the one used in step 1 for consistency.

As a benchmark for comparison, a popular rebalancing algorithm called the Class balancer is used to fix the three imbalanced datasets. The algorithm is coupled with feature selection by correlation-based feature selection (Cfs), and the classifier's decision tree and neural network are used as fitness functions for the swarm search method. The Class balancer is a traditional algorithm to even all the class distributions in the dataset to a complete balance. It works by dividing the majority class data which are near the boundary of the two classes into the minority class to achieve the balance of the dataset in quantity. Meanwhile Cfs is also a traditional feature selection algorithm that provides good performance.

The programs are coded in MatLAB version 2014a. The computing environment is a PC workstation with a CPU: E5-2670 V2 @2.50 GHz and RAM: 128 GB.

3 ANALYSIS AND CONCLUSIONS

Through the experiment, we obtain two kinds of results from the datasets using our methods. First, both the accuracy and Kappa have been improved; second, Accuracy reduces a little, but Kappa has a big increase. All the classification performance results are shown in Tables 14.1–14.3. As for the

Table 14.1 Performance Comparison Between the Classification Algorithms for the Image Dataset Called Optical Digits

Data Name	Optical Digits										
Algorithms	Posi-tive	Nega-tive	Accura-cy (%)	Kap-pa (%)	Selected Features (64)	Imbalance Ratio (Maj/Min) (%)	Dimen-sion (%)	Preci-sion	Re-call	F-Mea-sure	ROC Area
DT	554	5066	96.99	82.70	64	10.94	100.00	0.97	0.97	0.97	0.91
FS-SMOTE-PSO-DT	3274	5066	97.55	94.87	36	64.63	56.25	0.98	0.98	0.98	0.98
FS-SMOTE-BAT-DT	4742	5066	97.84	95.67	34	93.60	53.13	0.98	0.98	0.98	0.98
CB-CFS-DT	2810	2810	92.12	84.24	16	100.00	25.00	0.93	0.92	0.92	0.93
PN	554	5066	90.14	0.00	64	10.94	100.00	0.81	0.90	0.86	0.85
FS-SMOTE-PSO-PN	4454	5066	86.66	73.63	51	87.92	79.69	0.89	0.87	0.87	0.90
FS-SMOTE-BAT-PN	3584	5066	83.34	67.49	26	70.75	40.63	0.88	0.83	0.83	0.88
CB-CFS-PN	2810	2810	90.00	80.01	16	100.00	25.00	0.90	0.90	0.90	0.94

Table 14.2 Performance Comparison Between the Classification Algorithms for the Image Dataset Called Satellite Image

Data Name	Satellite Image										
Algorithms	Posi-tive	Nega-tive	Accura-cy (%)	Kappa (%)	Selected Features (64)	Imbalance Ratio (Maj/Min) (%)	Dimen-sion (%)	Preci-sion	Re-call	F-Mea-sure	ROC Area
DT	626	5809	91.89	52.53	36	10.78	100.00	0.92	0.92	0.92	0.76
FS-SMOTE-PSO-DT	7918	5809	93.67	87.03	8	136.31	22.22	0.94	0.94	0.94	0.94
FS-SMOTE-BAT-DT	5690	5809	92.59	85.18	20	97.95	55.56	0.93	0.93	0.93	0.92
CB-CFS-DT	3218	3218	80.27	60.54	12	100.00	33.33	0.82	0.80	0.80	0.81
PN	626	5809	90.27	0.00	36	10.78	100.00	0.82	0.90	0.86	0.85
FS-SMOTE-PSO-PN	5646	5809	87.35	74.73	25	97.19	69.44	0.88	0.87	0.87	0.90
FS-SMOTE-BAT-PN	6272	5809	89.44	78.77	35	107.97	97.22	0.90	0.89	0.89	0.91
CB-CFS-PN	3218	3218	85.04	70.08	12	100.00	33.33	0.85	0.85	0.85	0.89

method which combines the Class balancer and Cfs for processing, the imbalanced dataset is worse than the one generated by our method in general. The results show two general situations. But compared to our method, the benchmarking method yields poorer results, and they are unstable across different classifiers and swarm search methods.

Table 14.3 Performance Comparison Between the Classification Algorithms for the Image Dataset Called Libras Movement

Data Name	Libras Movement										
Algorithms	Posi-tive	Neg-ative	Accura-cy (%)	Kappa (%)	Selected Features (64)	Imbalance Ratio (Maj/Min) (%)	Dimen-sion (%)	Preci-sion	Recall	F-Mea-sure	ROC Area
DT	24	336	96.39	70.41	90	7.14	100.00	0.96	0.96	0.96	0.70
FS-SMOTE-PSO-DT	281	336	95.79	91.51	65	83.63	72.22	0.96	0.96	0.96	0.96
FS-SMOTE-BAT-DT	205	336	92.79	84.55	26	61.01	28.89	0.93	0.93	0.93	0.94
CB-CFS-DT	3218	3218	84.23	68.45	15	100.00	16.67	0.92	0.91	0.91	0.89
PN	24	336	96.11	72.00	90	7.14	100.00	0.97	0.96	0.96	0.93
FS-SMOTE-PSO-PN	140	336	96.85	92.49	51	41.67	56.67	0.97	0.97	0.97	0.97
FS-SMOTE-BAT-PN	170	336	96.44	92.05	45	50.60	50.00	0.97	0.96	0.96	0.90
CB-CFS-PN	3218	3218	91.37	82.74	15	100.00	16.67	0.92	0.91	0.91	0.89

Figs. 14.4–14.6 present the results of accuracy, Kappa, imbalance ratio (majority/minority), and dimension (%) of the three datasets. In general, the decision tree has better imbalanced dataset processing ability than the neural network. However, after the datasets have been processed by the methods, the accuracy and Kappa of the decision tree can be improved in both, while the value of Kappa gets a huge promotion at a little drop in accuracy of the neural network. Meanwhile we know that having high accuracy but low Kappa is meaningless. So the little decrease of accuracy is reasonable and acceptable.

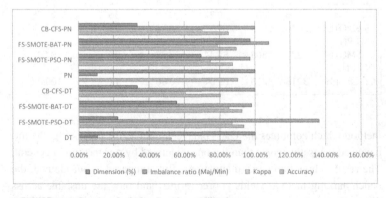

■ FIGURE 14.4 Results of rebalancing the satellite image.

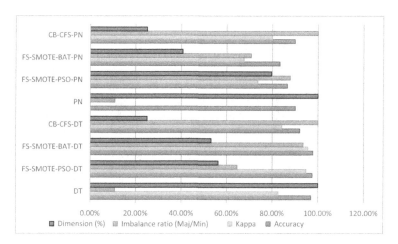

■ FIGURE 14.5 Result of rebalancing the optical digits.

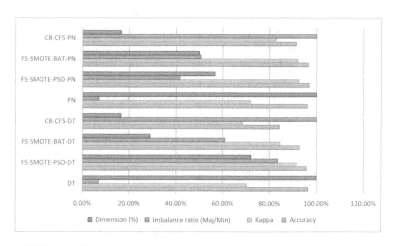

■ FIGURE 14.6 Results of rebalancing the Libras movement.

Compared with CB-CFS method, this method seems to be effective in solving the imbalance problem, although it was outperformed when neural network was used over the optical digits dataset. In view of the overall results, our method is observed to be generally better than CB-CFS by significantly increasing the Kappa value and maintaining a high accuracy.

From the imbalance ratio we observe the results in average values shown in Fig. 14.7. It is easy to notice the shape and trend of the imbalance ratio is almost the same as the Kappa value, in addition to the points on CB-CFS

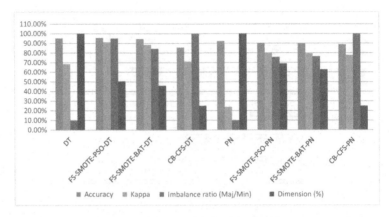

■ **FIGURE 14.7** Average results of rebalancing the three datasets.

methods. At the same time, the dimension trend in the two parts of the two classifiers are the same, which follows the shape of accuracy. But the decision tree results are better than the right part of neural network. However, the scale of original data should be kept as constant as possible when we are trying to obtain a higher accuracy. Thus, on this point, the methods with the neural network are better than the decision tree, and CB-FS methods change most of the original dataset, which is shown in Figure 14.7.

We can conclude from this experiment that the FS-SMOT-PSO-DT method is the best, and the other FS-SMOTE-swarm methods also have a big improvement for imbalanced datasets. What's more, from the perspective of classification algorithms, the decision tree is better than the neural network with imbalanced datasets. Our program is shown to be effective and useful in parameter selection of SMOTE and feature selection by using SI algorithms. SI algorithms avoid choosing parameters blindly; rather, they follow the optimization goal and progressively and heuristically find an optimal feature subset for performance refinement.

REFERENCES

Chawla, N.V., Bowyer, K.W., Hall, L.O., Kegelmeyer, W.P., 2002. SMOTE: "synthetic minority over-sampling technique". J. Artif. Intell. Res. 16, 321–357.

Fong, S., Deb, S., Yang, X.S., Li, J., 2014. Feature selection in life science classification: metaheuristic swarm search. IT Professional 16 (4), 24–29.

Kennedy, J., 2011. Particle swarm optimization. Encyclopedia of Machine Learning. Springer, New York, NY, pp. 760–766.

Kubat, M., Holte, R.C., Matwin, S., 1998. Machine learning for the detection of oil spills in satellite radar images. Mach. Learn. 30 (2–3), 195–215.

Li, J., Fong, S., Mohammed, S., Fiaidhi, J., 2015a. Improving the classification performance of biological imbalanced datasets by swarm optimization algorithms. J. Supercomput., 1–21.

Li, J., Fong, S., Zhuang, Y., 2015. Optimizing SMOTE by metaheuristics with neural network and decision tree. In: 3rd International Symposium on Computational and Business Intelligence (ISCBI), 2015, IEEE, pp. 26–32.

Lichman, M., 2013. UCI Machine Learning Repository. University of California, School of Information and Computer Science, Irvine, CA. Available from: http://archive.ics.uci.edu/ml

Yang, X.S., 2010. A new metaheuristic bat-inspired algorithm. Nature Inspired Cooperative Strategies for Optimization (NICSO 2010). Springer, Berlin, Heidelberg, pp. 65–74.

Retinal image vasculature analysis software (RIVAS)

B. Aliahmad, D.K. Kumar

Biosignals Group, School of Electrical and Computer Engineering, RMIT University, Melbourne, VIC, Australia

CHAPTER OUTLINE

Bio-Inspired Computation and Applications in Image Processing. http://dx.doi.org/10.1016/B978-0-12-804536-7.00015-6

1 INTRODUCING RIVAS

Retinal vasculature can be observed in eye fundus images and allows for direct examination of a number of diseases. It is the only section of the human cardiovascular system that can be viewed in vivo. It also has a number of morphological and physiological similarities with other microvasculatures, such as in the ones in brain. Eye fundus imaging is used for ophthalmology tests and is also used extensively as a screening window for noninvasive and in vivo assessment of the risk of cerebrovascular pathology and cardiovascular diseases.

Retinal vasculature is an indicator of a number of health-related parameters. Changes to vasculature have been found to be associated with aging (Azemin et al., 2012), hypertension (Hubbard et al., 1999; Nguyen and Wong, 2006), diabetes (Wong et al., 2002; Ikram et al., 2006), and smoking (Yanagi et al., 2014) and have been identified as an indicator of risk of stroke (Kawasaki et al., 2011). The vasculature shape and diameter is also affected by insufficient reception of oxygen to the tissue as a result of diabetes mellitus. This damage to retina is known as diabetic retinopathy (DR). DR leads to some pathologies, such as damage to the blood vessels, microaneurysms, development of new fragile vessels around the macula (neurovasculature) and hemorrhages. These pathologies result into vision impairment and cause changes to the appearance of the retina as well as the morphology and complexity of the vascular network.

So far eye fundus image analysis largely has been performed manually by grading experts or ophthalmologists. However, the outcomes can be subjective and dependent on the expertise of the examiner. Therefore, there has been a need for automating the analysis of eye fundus images. Research groups and companies have attempted to identify suitable feature sets that are associated with a disease condition and can be measured automatically.

Retinal vessel parameters associated with a disease condition can be classified as either local or global according to their characteristics and whether they correspond to a local entity (eg, a vessel segment or cross-section) or summarize the entire image. Some of the local features include arteriolar and venular diameter as indicators of hypertension (Wong et al., 2004a), stroke (Wang et al., 2002), diabetes mellitus (Wong et al., 2002), and coronary heart disease; vessel tortuosity and branching angle as indicators of cardiovascular diseases (Cheung et al., 2011) and diabetes (Sasongko et al., 2010), respectively. Global features include fractal dimension (FD) as a measure of the complexity of the entire retinal vasculature. The alteration in this parameter has been shown to be associated with aging (Azemin et al., 2012), early DR (Cheung et al., 2009), and stroke (Baker et al., 2008; Kawasaki et al., 2011).

Retinal image analysis is now widely used for quantification of different aspect of geometrical attributes of retinal vessel and characterization of the biomarkers associated with systemic diseases. This is important for disease risk assessment, monitoring disease progression, and as a marker of therapeutic efficacy. Depending on the type and severity of retinopathy, quantification of the retinal vascular parameter can be erroneous, time consuming, and expensive. Without a proper measurement tool, it may require extensive expert knowledge and manual supervision. To overcome these problems, retinal image vasculature assessment software (RIVAS) has been developed. This comprehensive software package is based on MATLAB, the Math-Works, Inc., platform. This software is suitable for automatic measurement and analysis of retina vascular parameters in both human and mouse retina flat-mounts. The software package is designed to be user-friendly, robust, and suitable for automatic analyzes of retinal images.

2 KEY FEATURES OF RIVAS

The key features of the software are discussed next.

2.1 Preprocessing and image enhancement

A high-quality retinal image is required for reliable automatic analysis as well as correct diagnosis through visual examination. However, often the retinal images may be degraded by a large luminosity variations (uneven illumination) and poor vessel-to-background contrast. The degradation happens in most cases due to natural curvature of the surface of retina, a small and nondilated pupil, involuntarily eye movements, and blurred lens of the eye as a result of disease, such as cataract. Therefore, image enhancement is an essential preprocessing step which has to be performed prior to every analysis. RIVAS provides a range of enhancement options, from histogram equalization to adaptive color selection, which can be chosen through drop-down menus. It also features edge enhancement techniques for improving the vessel-to-background contrast as well as smoothing filters to remove background noise.

2.2 Image segmentation (extraction of vascular network, skeletonization, vessel to background ratio)

Image segmentation is also known as binerization. A binarized image has two values for the pixels, 1 and 0, corresponding to white and black color respectively. Binerization is the process of partitioning the image into two groups of black and white pixels corresponding to the background and vascularized area respectively. Segmentation is an important step in most analyses where extraction of the vascular network is required for applications

such as vessel diameter measurement and fractal analysis and obtaining the branching angles.

In RIVAS, after the preprocessing step, image segmentation is performed by application of the Gabor wavelet, as a filter matched to retinal vessels, over different orientations and scales as proposed by Soares et al. (2006). The filter was employed at five different scales of 4, 5, 6, 7, and 8, and maximum modulus of the response was obtained over 18 equally separated angles starting from 0 to 170 degree. The Gabor wavelet was used and defined as:

$$\psi = e^{ik_0 x} e^{-0.5|Ax|^2} \tag{15.1}$$

where

$$A = diag[\varepsilon^{-0.5}, 1], \quad \varepsilon > 1 \tag{15.2}$$

This is a 2×2 diagonal matrix corresponding to the elongation in any direction with ε being the elongation factor; k_0 is the vector of horizontal and vertical frequencies. The optimum values for ε and k_0 were obtained according to the work of Soares et al. (2006) and were set to 4 and [0, 3], respectively. This process resulted into an enhanced grayscale image in which the intensities along cross-section of the vessels had a Gaussian-like profile and the vessels were highlighted in white on a dark background as a three-dimensional (3D) surface. This Gabor enhanced image was then fed into a support vector machine (SVM) for binerization.

The SVM was trained using the DRIVE (Staal et al., 2004) and STARE (Hoover et al., 2000) dataset of manually labeled nonmydriatic retinal images. The DRIVE database consists of 40 images, 7 of which present mild early DR. It contains manual segmentations of retinal vessels performed by trained observers. The images in this database are of size 768×584 pixels (8 bits color resolution) and were captured in nonmydriatic form using Canon CR5, 3CCD at a 45-degree field of view (FOV). The STARE database consists of 20 digitized images, half of which contain pathology that obscures the appearance of the blood vessel in some part of the image. The images were taken by a TopCon TRV-50 fundus camera at 35-degree FOV and digitized to 700×605 pixels, 8 bits per color channel. It also contains manually segmented images performed by two independent observers.

Both of these datasets have been made freely available online and have been established as ground truth for validation of studies on vessel segmentation. The images from these datasets were enhanced following the previously discussed procedure, and the 3D surfaces of retinal vasculatures were extracted. These enhanced images and manually segmented labels were used to train the SVM classifier for image segmentation.

RIVAS also generates the skeleton of the binarized images, as this is required for a number of applications, such as estimation of fractal dimension and approximation of the vessel center lines. It is a morphological operation on the binary image which refers to the process of obtaining a single-pixel version of the vascular network corresponding to a line that is equidistant from vessel boundaries (vessel centerline).

One global measure of the retina vasculature is the extent of the coverage of the retina by the vessels. For this purpose, RIVAS provides an index for vessel-to-background ratio (V/B), which is defined as the ratio of the area (number of pixels in white) covered by vessels to the background area (number of pixels in black) within a fixed square-size region of interest. It is a useful parameter for monitoring abnormal growth of the vascularized region and the presence of neovascularization as a complication of DR.

2.3 Automatic measure of optic nerve head parameters (center, rim, best fitting circle, and color)

Optic nerve head measurement is an important clinical indicator for ophthalmologists. RIVAS allows for automatic measurement of the optic nerve head parameters and includes the detection of the center point, boundary (rim), and cup-to-disk ratio as well as the best-fitting circle/oval to the boundary. These parameters are important for detecting and monitoring glaucoma because the cup-to-disk ratio is used as a key index to assess the progression of the disease. This measurement can also be used to assess for of papilledema, a condition caused by increased intracranial pressure which leads to swelling of the disk boundary.

Color of the retinal cup and optic disc are other important features that are observed by experts. However, there has been limited work on quantifying the color of the eye fundus images, which may be attributed to the lack of robust tools available for evaluating the color. To overcome this, RIVAS provides adaptive color analysis of the optic disk and the cup. A healthy perfused neuroretinal tissue appears as in pinkish orange with a donutlike disk. Any change in the color of the optic disk can be an indication of a pathological condition, such as advanced glaucoma and ischemic optic neuropathy.

2.4 Vessel diameter measurement (individual, LDR, vessel summary-CRAE, CRVE)

Studies have revealed that variation in the retinal vascular diameter can be associated with early pathological disease symptoms (Ikram et al., 2013). For instance, for middle-aged persons (45–64), retinal arteriolar narrowing has been shown to be associated with incidence of diabetes, independent

of known risk factors (Wong et al., 2002). Elsewhere, significantly wider summary retinal arteriolar and venular caliber has been reported in patients aged 45–84 with mild and no DR (Kifley et al., 2007; Wong et al., 2006) and has been used for analysis of the progression of retinopathy in type 1 cases (Wong et al., 2004b; Klein et al., 2004). It is an important parameter which could be used in the future to monitor disease progression and assess the risk of retinopathy and other complications (Ikram et al., 2013).

Measurement of vessel diameter requires locating and tracking the vessel edges. The accuracy of the measurements is largely dependent on the precision of vessel edges and the tracking process. RIVAS has a set of robust algorithms for automatic location of the edges and tracking the boundaries using the entire image or a region that the examiner can select. The software is designed to overcome the problem with vessel center-light reflection and multimodal behavior of cross-section profiles because of the camera flash light. It provides a range of options for accurate quantification of individual vessel diameters at any point as well as the average value along a vessel segment. Individual vessel diameter can be obtained within a vessel segment of choice and by placement of the cursor close to a desired vessel boundary. In RIVAS, vessel diameter was measured by taking the shortest distance between two vessel edge points (Euclidian distance) normal to vessel centerline. The location of edge points was identified using two different algorithms. One was based on tracking vessel boundaries and application of an active contour model to fit vessel boundaries. The second approach followed a novel vessel profile analysis technique and classification of the pixels in vessel cross-section profiles into edge versus nonedge pixel candidates using a machine learning technique.

In the first method, in order to locate the edge points, the image was filtered by second partial derivatives of two-dimensional (2D) second-order Gaussians along x and y directions to obtain the Hessian matrix $H(x, y)$ corresponding to each image intensity $I(x, y)$ in the coordinates of (x, y) as in (15.3). This method discriminates vessels with tubular structure from the background image and provides local information regarding second-order structures around each pixel.

$$H(x, y) = \begin{bmatrix} f_{xx} & f_{xy} \\ f_{yx} & f_{yy} \end{bmatrix} \quad (15.3)$$

where:

$$f_{xx} = f_{xx}(x, y) = I(x, y) * \frac{\partial^2}{\partial x^2}\left(\exp\left(-\left(\frac{x^2 + y^2}{2\sigma^2}\right)\right)\right) \quad (15.4)$$

$$f_{yy} = f_{yy}(x, y) = I(x, y) * \frac{\partial^2}{\partial y^2} \left(\exp\left(-\left(\frac{x^2 + y^2}{2\sigma^2} \right) \right) \right) \qquad (15.5)$$

$$f_{yx} = f_{xy} = f_{xy}(x, y) = I(x, y) * \frac{\partial}{\partial x \, \partial y} \left(\exp\left(-\left(\frac{x^2 + y^2}{2\sigma^2} \right) \right) \right) \qquad (15.6)$$

and "*" represents the "convolution" operation.

In this case, the spreading factor "σ" of the Gaussian kernel was set to 4 in order to match the maximum vessel size inside the selected region of interest (ROI). The eigenvalues of Hessian matrix (λ_1, λ_2) and their corresponding eigenvectors (v_1, v_2) were calculated in each coordinate (x, y). Assuming $\lambda_1 \geq \lambda_2$, for a coordinate inside the vessel, the orientations of eigenvectors corresponding to small eigenvalues (v_2) show the direction along the vessels, while the orientation of the ones relating to large eigenvalues (v_1) present the normal direction. However, for a pixel outside the vessel area, this trend is opposite (Xiaofang et al., 2010), providing a good feature for differentiating vessels from nonvessel pixels near the boundaries. The sum of the two eigenvectors was calculated, and the direction of the resultant vector was obtained as in (15.7).

$$\theta = \left| \tan^{-1} \frac{v_{Ty}}{v_{Tx}} \right| \qquad (15.7)$$

where v_{Tx} and v_{Ty} are the vector sums of the two eigenvectors decomposed into x and y directions. The coordinates between the points corresponding to maximum change in θ were considered as edge locations and used for tracking the vessel boundary. The maximum changes in θ was found by obtaining the magnitude of the gradient vectors at each point, as in (15.8).

$$|\nabla \theta| = \sqrt{\left(\frac{\partial \theta}{\partial x} \right)^2 + \left(\frac{\partial \theta}{\partial y} \right)^2} \qquad (15.8)$$

Therefore, $|\nabla \theta|$ was used to differentiate vessels from nonvessel pixels and to locate seed points (edge candidates) for the tracking process. Due to the presence of image artifacts, central light reflex (CLR), and variation in image contrast in some areas along a vessel boundary (especially for arteries), the maximum intensity change may not be always clear. This may lead to some discontinuities in the magnitude of the gradient vectors along vessel edges. Therefore, linear interpolation had to be applied onto the edge candidates to obtain an estimate of vessel boundaries. This estimate was further improved using the ribbon of twins active contour model proposed by Al-Diri et al. (2009). The boundaries were considered as the points where

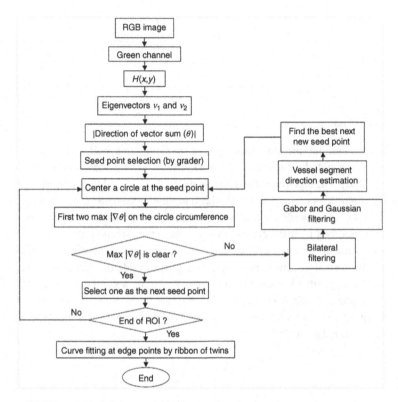

■ FIGURE 15.1 Block diagram of the vessel tracking process.

the two ribbons converged. Fig. 15.1 shows the block diagram of the boundary detection. The vessel centerline was defined as the average between the two tracked edges. Minimum Euclidean distance between the boundaries was picked as the normal line-to-vessel centerline (Fig. 15.2). The length of this line was considered an estimate of vessel diameter.

The second method used in RIVAS for automatic diameter measurement was based on pixel classification using linear discriminant analysis (LDA). LDA is a supervised classifier and thus unsuitable for some automatic processing applications. RIVAS employs a modified LDA in which the classifier is trained automatically prior to each diameter measurement. This technique does not require profile modeling and addresses the limitations of other techniques in the presence of edges with sharp transitions and kickpoints present on the cross-section profile.

LDA is a method for data classification and dimensionality reduction (Wijaya et al., 2011). It optimizes class separability by maximizing the ratio

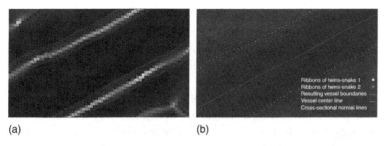

(a) (b)

■ **FIGURE 15.2** **Demonstration of vessel tracking outcome.** (a) Gradient magnitude image
and tracking circles, (b) implementation of ribbons of twins (Al-Diri et al., 2009) and illustration of
boundary, vessel centre line and cross-sectional normal lines.

of interclass to intraclass variances and is suitable for applications with un-
equal sample sizes. Assuming a dataset containing a total number of L class-
es with N_C samples in each class, based on the Fisher's equation (15.9), the
optimum projection matrix W can be obtained by maximizing Eq. (15.9):

$$J(W) = \frac{W^T S_b W}{W^T S_w W} \qquad (15.9)$$

where S_b and S_w are the interclass and intraclass scatter matrices, respec-
tively. The scatter matrices were defined as:

$$S_b = \sum_{C=1}^{L} N_C (\mu_C - \bar{X})(\mu_C - \bar{X})^T \qquad (15.10)$$

$$S_w = \sum_{C=1}^{L} \sum_{i=1}^{N_C} \left(x_i^C - \mu_C \right)\left(x_i^C - \mu_C \right)^T \qquad (15.11)$$

where $\mu_C = (1/N_C)\sum_{i=1}^{N_C} x_i^C$, $\bar{X} = (1/N)\sum_C N_C \mu_C$, and T stands for the "trans-
pose" matrix.

The next step was to automatically train the LDA to classify the vessel
profile into the three clusters, the first cluster corresponding to the vessel
surface and the second and third clusters corresponding to the background
at either side of the vessel trunk. This was performed using a novel cluster
analysis, based on the sharp transitions on the vessel profile corresponding
to the edges (Zhou et al., 1994; Lowell et al., 2004; Gao et al., 2000). The
tracking part in the first method was used only to find the normal-to-vessel
centerline with respect to the tracking direction and to record the vessel
cross-section profiles. In order to obtain vessel diameter, three points on
the vessel cross-section profile were defined as the initial critical points to
obtain the LDA training sets. According to the Gaussian model of vessel

profile (Zhou et al., 1994; Lowell et al., 2004), it is confirmed that generally the background points have high intensity values while the points on the surface of the vessels contain lower intensities except for the CLR area. Therefore, locations of the lowest minima in intensity which correspond to the vessel region were marked as the first required critical point. The two highest maxima at both sides of this point were labeled as the two other points, each corresponding to one background region at the left and the right side of the vessel. Given the three non-collinear points, it is possible to draw a circle that passes through all three, by joining the vertices to form a triangle; as the perpendicular bisectors of the chords always pass through the center of a circle which includes those vertices. This automatically obtained bounding circle was used as the basis for cluster analysis and classification of the local extremums to automatically train the LDA. Fig. 15.3 shows an example of a vessel cross-section profile with CLR and the bounding circle.

From the center of this circle, a radial line was connected to each detected point. Starting from 0 degree and rotating anticlockwise, all the angles $(\theta_1, \theta_2, ..., \theta_n)$ between the two consecutive radial lines were obtained

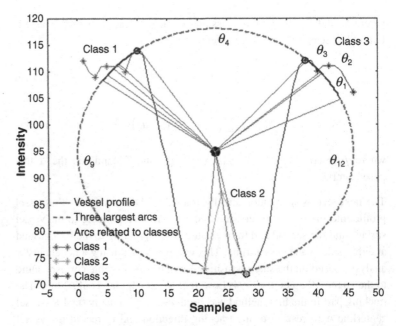

■ **FIGURE 15.3 Obtaining the training classes for a sample vessel profile.** The extremums related to the three classes are shown with asterisks θ_4, θ_9, and θ_{12} represent the first three largest angles separating the three detected classes.

sequentially and sorted from the largest to the smallest value. The first three largest angles corresponding to the largest arcs on the circle were considered as the boundaries separating the three training classes (eg, θ_4, θ_9, and θ_{12} in Fig. 15.3). All the extrema that fell within the same section between the two boundary-arcs were categorized as the same class. Group 1 and 3 were considered as the maxima and minima relating to the background at either side of the vessel and group 2 to the extremums corresponding to the trunk as shown by asterisks in a unique color (Fig. 15.3). In order to increase the number of training samples for more accurate cluster analysis, all the points on the vessel profile within the distance between the two horizontally farthest extremums of each class were considered as members of that class and used as training samples.

A generalization of the Fisher's LDA (1936) was applied to the intensities of retinal vessel cross-section profiles after the mean value was subtracted, in order to classify them into three major regions based on their physical location on the intensity profile (vessel or background). The decision boundaries were used to highlight the midpoints between the maximum and minimum intensities corresponding to the vessel edges and measure the diameter based on the definition of 50% intensity change, according to Gang et al. (2002). Let the matrix $X = [X^1, X^2, X^3]$ denote the 2D training data (intensities vs samples) where X^C ($C = 1, 2, 3$) represent the vector set belonging to the class C obtained earlier. Considering \bar{X}_C as the matrices of size 2×1 representing for the class sample means, the pooled estimate of the corresponding 2×2 sample scatter matrices was calculated according to Seber (1984), as follows:

$$S_{p_{2\times2}} = \frac{\sum_{C=1}^{3}(N_C - 1)S_C}{\sum_{C=1}^{3}(N_C - 1)} \qquad (15.12)$$

where $S_C = \sum_{i=1}^{N_c}(x_i^C - \bar{X}_C)(x_i^C - \bar{X}_C)^T/(N_C - 1)$, $(C = 1, 2, 3)$ is the sample scatter matrix of size 2×2. N_C is the number of samples available in each dimension of the class C.

Eq. (15.12) is valid due to the robustness of linear discriminant function to unequal scatter matrices and the assumption of the existence of similarity among the three sample scatter matrices (Seber, 1984). The resulting three discriminant functions were calculated as in (15.13).

$$L_C(x) = \log \pi_C - \frac{1}{2}X_C^T S_p^{-1} X_C + \bar{X}_C^T S_p^{-1} x, \quad (C = 1, 2, 3) \qquad (15.13)$$

where $\pi_1 = \pi_2 = \pi_3 = 1/3$ were defined as the prior probabilities of each training group while ignoring the class proportions.

In order to measure the diameter, the intensity versus sample plane of the vessel profile was padded with training points and classified according to the largest value of $L_C(x) - \log \pi_C$ as the decision rule. The decision boundaries D_{ij}, $(i, j) \in [(1, 2), (2, 3), (1, 3)]$ corresponding to three classes were obtained using (15.14).

$$D_{ij}(x) = L_i(x) - L_j(x) \qquad (15.14)$$

The horizontal distance between the two points where the decision boundaries crossed the vessel profile was considered the vessel diameter, as shown in Fig. 15.4.

The output also can provide the mean, median, and standard deviation of all the measured diameters along with the length-to-diameter ratio (LDR). The LDR parameter was defined as the ratio of the length of a vessel segment between two branching points to the average diameter of the segment. It shows the prospective relationship between retinal vessel diameters and risk of hypertension.

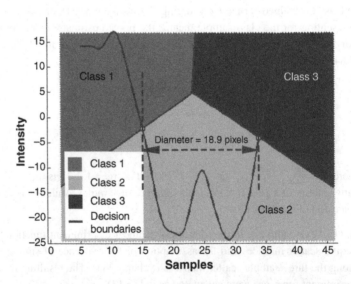

■ **FIGURE 15.4 Example of RIVAS output showing a vessel cross-section profile with classified padded intensity values and the decision boundaries between the classes.** The horizontal distance between the two points where the decision boundaries cross the vessel edges (approximately at 50% intensity change) was considered as the diameter (18.9 pixels in this example).

However, most clinicians find the individual vessel diameter (referred to as 'vessel caliber') not a repeatable measure of the vasculature properties, and prefer the summarization of the diameter over all the major vessels. For this purpose, RIVAS is designed to measure the central retinal artery equivalent (CRAE) and central retinal vein equivalent (CRVE), known as the vessel summary diameter, as well as the arteriolar-to-venular ratio (AVR = CRAE/CRVE). The measurement is based on the 6 biggest arterioles and venules within a circular region equivalent to 0.5–1 disc diameters from the disc margin (Zone B). The summary formula was adopted from the work by Knudtson et al. (2003), a revised version of the Parr–Hubbard formulas. This modified version is more robust, independent of image scale, and easier to implement.

2.5 Fractal dimension [binary and differential (3D) box-count, Fourier, and Higuchi's]

FD has been employed by a number of studies for quantification of retinal vasculature complexity as a self-similar and semifractal object. It gained importance in the characterization of the vasculature pattern before and after disease incidence. For instance, the study of early DR shows that increase in retinal vascular FD was significantly associated with increasing odds of retinopathy (Cheung et al., 2009). In type 1 diabetes patients, the study found that persons with lower FDs were more likely to have proliferative retinopathy (Grauslund et al., 2010).

FD was first introduced by Benoit Mandelbrot (1983) by drawing attentions to the length of the coastline of Great Britain. He argued that the length of the coastline can have different interpretations depending on the estimation method. Mandelbrot suggested measuring the degree of complexity by evaluating how fast the length would increase with respect to a reduction in scale (Jürgens et al., 1992). There are many established techniques for FD calculation, including binary box-counting, differential 3D box-counting (Sarkar and Chaudhuri, 1994), Fourier fractal (Azemin et al., 2011), and Higuchi's method. All of these are incorporated in RIVAS, which allows for automated measurement of these values from the eye fundus images.

Binary box-counting FD is a special form of Mandelbrot's fractal dimension that is frequently used for analysis of any structure in the plane or space. The technique is the one which has been employed by most studies for retinal image analyses. This method is applicable to binary images and requires superimposition of a mesh grid with varying size on either the segmented image or its skeletonized version.

Differential 3D box-counting (Sarkar and Chaudhuri, 1994) is a modification of binary box-counting, with the advantage that it is applicable to grayscale images and does not require image segmentation or binarization; therefore, it is suitable for automatic image analyses. The technique is based on the binary box-counting, but instead the image is covered by a grid of 3D boxes with varying side lengths.

Fourier FD (FFD) is the estimation of the fractal properties of the data by considering the spectral properties and is also known as Spectrum FD (SFD). It is mathematically obtained from the Fourier transform of an image and calculated from an exponent relation between the power spectrum of the Fourier transform of the image and the frequency variable (Russ, 1994). FFD is invariant to geometrical transforms and provides good computational and noise performance compared to other FD methods. An algorithm specially designed for eye fundus images was developed by Azemin et al. (2011), and this has been incorporated in RIVAS.

Higuchi (1988) measured the FD of a set of points in the form of a one-dimensional (1D) time series. When it comes to image processing, the 1D data sequence can be extracted by scanning the image and recording the grayscale intensities values along a direction. RIVAS provides different scanning paths and several direction options including horizontal, vertical, radial, and circular using concentric circles centered at the optic disc and macula center.

2.6 Analysis of the branching angle (total number, average, max, min, SD, acute angle, vessel tortuosity)

Changes in retinal vascular geometry can be indicative of the progression of a disease complication affecting retina. This includes larger arteriolar branching angle and increased tortuosity which are of clinical importance in the study of the severity of diabetic retinopathy. According to Sasongko et al., they can be associated with a longer duration of diabetes and higher A1C respectively. RIVAS features comprehensive branching angle analysis options: total number of branch points, individual and average values of the angles (both acute and nonacute), and vessel tortuosity defined as the actual path length of the vessel segment divided by the Euclidian distance between the two end points of the segment. The software also provides the statistical information, such as mean, median, minimum, maximum, and standard deviation of the measured values. Without RIVAS and a good automatic technique, measurement of such parameters would not have been possible. Fig. 15.5 shows an application of RIVAS for analysis of the branching angles using a human retina (RGB fundus image).

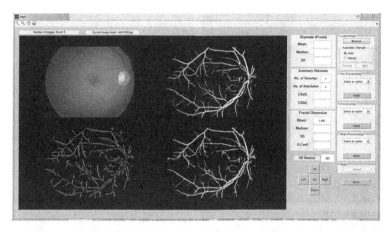

■ FIGURE 15.5 Application example: analysis of branching angle using RIVAS and a snapshot from the main window.

2.7 Detection of the area of neovascularization and avascularized region in a mouse model

A mouse model with oxygen-induced retinopathy allows for investigation of proliferative DR and retinopathy of prematurity in humans. The parameters of interest in the study of retinal flat-mounts include measurement of the total area of the retina, quantification of the extent of vasoobliteration and neovascularized area as well as analysis of avascular regions. So far the current techniques have relied on the application of the Lasso tool; the techniques are based in Adobe Photoshop or other similar programs (Connor et al., 2009). However, such methods require extensive user intervention and are prone to human error. RIVAS enables automatic quantification of such parameters without the need for human intervention. The result of all the analyses are provided by graphical representation (Figs. 15.5–15.7) and saved in an Excel sheet and/or comma-separated values (.csv) files.

3 APPLICATION EXAMPLES

RIVAS has been employed in a number of studies for automatic quantification of retina vascular parameters. It has been validated against state-of-the-art techniques to ensure the accuracy, reliability, consistency, and repeatability of the measurements. The advantages of RIVAS—that it is fully automatic and able to process both rat/mouse and human retina images—have been of great interest to ophthalmologists. Some examples of its intended applications are as follows.

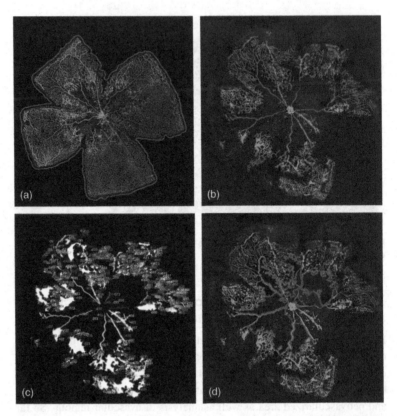

■ **FIGURE 15.6 Analysis of mouse retinal flat-mounts (oxygen-induced retinopathy).**
(a) Measurement of the total area of retina, (b, c) detection of the main vessel boundaries and areas of neovascularization, and (d) detection of the avascularized area.

3.1 Relationship between diabetes and grayscale fractal dimensions of retinal vasculature (Aliahmad et al., 2014b)

Diabetes mellitus results in a number of alterations to the retinal vascular morphology caused by endothelial damage and dysfunction. These alterations, which are referred to as a type of DR, will lead to an increase in complexity of retinal vascular network, evidenced by changes in vessel diameter, lengths, tortuosity, branching angles and also by neovascularization. FD is a measure of complexity; it can be used to estimate the retinal vascular complexity, and repeated measures examine the associated changes over a period and thus help to monitor the disease.

RIVAS was employed to quantify the relationship between diabetes and grayscale fractal dimensions of retinal vasculature in an Indian population

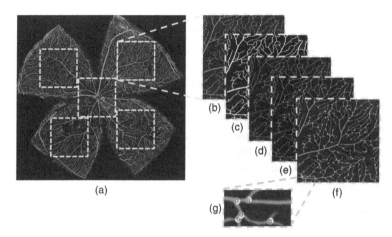

■ **FIGURE 15.7** **Automatic measurement of vascular parameters in mouse retinal flat-mounts.** (a) Selection of the region of interest (ROI), (b) selected ROI, (c) ROI segmentation, (d) skeletonized image, (e) detection of branch points, (f) measurement of acute angle, and (g) example of detected acute angles.

with mild nonproliferative DR (NPDR). It was hypothesized that FD would increase as result of the increases in vascular complexity seen in NPDR. Thus RIVAS could be used to examine the associated changes for early diagnosis of microvascular pathology.

This was a cross-sectional study comprising 189 optic disc (OD) centered retinal images of healthy and diabetic individuals aged 14–73 years with type 2 diabetes and NPDR.

Grayscale box-counting FD was considered as the FD of choice to overcome the problems associated with image segmentation and enable a fully automated FD analysis without requiring any manual supervision.

Statistical analysis of variance (ANOVA) indicated that the average FD of diabetic patients was significantly higher 2.4403 ($p < 0.001$, 95% CI 2.4335–2.4471) compared to that of the control group (2.4227, $p < 0.001$, 95% CI 2.4201–2.4252). This study revealed that the alterations in FD preceded the onset of NPDR and that RIVAS could be an effective tool for early detection and risk assessment of DR. This could not have been achieved without a fully automated eye fundus image analysis software.

3.2 10-year stroke prediction (Aliahmad et al., 2014a)

Change in retinal vasculature is associated with stroke event due to presence of a number of physiological and embryological similarities between retina

and cerebral vasculature (Patton et al., 2005; Baker et al., 2008). These changes, which mainly include focal retinal arteriolar narrowing, arteriovenous nicking, microaneurysms, and hard exudates, reflect pathophysiological processes affecting the morphology and complexity of the retinal vasculature pattern. In this work a new methodology was introduced to measure the FD of retinal images to predict an episode of stroke event. The study was validated on retinal image sets from the Blue Mountains Eye Study, a population-based study conducted in a suburban region west of Sydney, Australia. Using RIVAS, Higuchi's FD was measured along concentric circles (FDC) centered at optic disk center and compared against SFD and box-counting (BC) dimension.

Nonparametric statistical Kruskal–Wallis analysis revealed FDC to be a better predictor of stroke compared with SFD and BC with overall lower median value for the cases compared to the control group. With the help of real-time and automated analysis of the eye fundus images, large populations could be studied to help people recognize their risk of disease. This is feasible only when the analysis can be performed automatically and in real time.

3.3 Visualization of fine retinal vessel pulsation (Kumar et al., 2013)

Retinal vessels undergo a number of physiologic variations during the cardiac cycle as a result of changes in blood volumetric flow entering the ophthalmic vascular system in the peak systolic and diastolic phase. These variations, also known as normal pulsatile features, include spontaneous venous pulsation in the optic disk region, venous pulsation in other areas, arteriolar pulsation, serpentine movements, and mechanical coupling between two vessels (Moret et al., 2011b). Understanding the pulsatile feature in the retina could be of benefit for the study of intracranial pressure, papilledema, and measurement of pulse wave velocity as indicators of retinal arterial stiffness.

In this work RIVAS was used to visualize and quantify retinal vessel pulsation during a cardiac cycle. The objective was to (1) provide a method to improve the examiner's ability to observe fine pulsatile features and (2) to obtain an overall trend for variation of arteriolar and venular caliber across one cardiac cycle.

Data were collected using a modified eye fundus imaging system. A Canon CR1 nonmydriatic fundus camera equipped with 15.1 megapixel Canon EOS 50D was integrated with a standard 3-lead electrocardiogram (ECG) monitoring system to trigger the camera at 8 distinct points within the R-R

interval. Each patient was connected to the system, and his/her ECG was monitored in real time. A total of 9 images were taken for each subject with the first and last one synchronized with the QRS peaks. All the images were aligned to get an image sequence free of eye movement and were corrected for uneven illumination. This was followed by development of a technique for vesselness mapping of retinal image sequence (VMRS) in which the vessel boundaries were highlighted in white on a black background to maximize the vessel-to-background contrast. For more information on the technique, please refer to Kumar et al. (2013).

RIVAS and VMRS allow graders to better observe retinal vessel pulsation over a larger region of interest and in a finer vessels compared to state-of-the-art principal component analysis filtering (Moret et al., 2011a). RIVAS enables simultaneous measurement of individual vessel diameters along selected vessel segments and therefore the quantification of vessel caliber change across the cardiac cycle. The software and the techniques may later find other applications, such as for accurate measurement of pulse wave velocity and early detection of associated diseases using noninvasive fundus imaging.

3.4 Automated measurement of vascular parameters in mouse retinal flat-mounts (Aliahmad et al., 2015)

RIVAS has been successfully tested for automatic measurement of vascular geometric parameters in adult C57BL/6J mouse retinas and to define a baseline characteristic for the control samples with no retinopathy. In this study, retinal flat-mounts were stained with fluorophore-conjugated isolectin B4 and imaged using the confocal microscopy technique, following the protocol approved by the institutional animal care and use committee (St. Vincent's AEC protocol SABC 001) on the use of animals in ophthalmic and vision research. Analyses were done based on a number of novel algorithms specific to RIVAS. At first image segmentation was performed using the SVM classifier and an adaptive learning scheme. The pixels were classified into vessels and background classes (Fig. 15.7c) with vessels shown in white (equivalent to binary value of 1) and the background in black (binary value of 0). This was then followed by skeletonization and extraction of a number of candidate pixels corresponding to the vessel centerline (Fig. 15.7d). This image was then used as a mask to highlight the overall vascular network structure and as the basis for detection of the location of bifurcation (branch) points and crossovers. Vessel bifurcations and crossovers were automatically differentiated using a novel "backward morphological shrinking" algorithm (Fig. 15.7e). The images were partitioned into five nonoverlapping square regions, centered on the optic disk

and each retinal quadrant (Fig. 15.7a). Vascular parameters including the branching angles (Fig. 15.7e and f), both acute value and count, V/B ratio, and binary box-count fractal dimension were obtained for each region and compared.

The study found that for control data, the fractal dimension and the V/B ratio of the optic disk regions were similar to those of the retinal quadrants. The optic disk area has less branch points and mean acute angle compared to retinal quadrants. One advantage of using RIVAS for the study of retinal vascular disease is that along with other conventional vascular parameters, it provides detailed analysis of branching angles (including the total number and individual and average values), manual measurement of which would have not been possible. In the future, the technique can be applied to study the mouse and rat models with oxygen-induced retinopathies and to analyze vascular loss, vessel regrowth, neovascular formation, and vascular regression as seen in DR. The outcome of this study was presented at the ARVO annual meeting in 2015 (Denver, Colorado, USA).

REFERENCES

Al-Diri, B., Hunter, A., Steel, D., 2009. An active contour model for segmenting and measuring retinal vessels. IEEE Trans. Med. Imaging 28, 1488–1497.

Aliahmad, B., Kumar, D.K., Hao, H., Unnikrishnan, P., Che Azemin, M.Z., Kawasaki, R., Mitchell, P., 2014a. Zone specific fractal dimension of retinal images as predictor of stroke incidence. Sci. World J. 2014, 7.

Aliahmad, B., Kumar, D.K., Sarossy, M., Chan, E., Wijngaarden, P.V., 2015. Automated measurement of vascular parameters in mouse retinal flat-mounts. Invest. Ophthalmol. Vis. Sci. 56, 3324.

Aliahmad, B., Kumar, D.K., Sarossy, M.G., Jain, R., 2014b. Relationship between diabetes and grayscale fractal dimensions of retinal vasculature in the Indian population. BMC Ophthalmol. 14, 152.

Azemin, M.Z., Kumar, D.K., Wong, T.Y., Kawasaki, R., Mitchell, P., Wang, J.J., 2011. Robust methodology for fractal analysis of the retinal vasculature. IEEE Trans Med. Imaging 30, 243–250.

Azemin, M.Z.C., Kumar, D.K., Wong, T.Y., Wang, J.J., Mitchell, P., Kawasaki, R., Wu, H., 2012. Age-related rarefaction in the fractal dimension of retinal vessel. Neurobiol. Aging 33, 194.e1–194.e4.

Baker, M.L., Hand, P.J., Wang, J.J., Wong, T.Y., 2008. Retinal signs and stroke: revisiting the link between the eye and brain. Stroke 39, 1371–1379.

Cheung, N., Donaghue, K.C., Liew, G., Rogers, S.L., Wang, J.J., Lim, S.W., Jenkins, A.J., Hsu, W., Li Lee, M., Wong, T.Y., 2009. Quantitative assessment of early diabetic retinopathy using fractal analysis. Diabetes Care 32, 106–110.

Cheung, C.Y., Zheng, Y., Hsu, W., Lee, M.L., Lau, Q.P., Mitchell, P., Wang, J.J., Klein, R., Wong, T.Y., 2011. Retinal vascular tortuosity, blood pressure, and cardiovascular risk factors. Ophthalmology 118, 812–818.

Connor, K.M., Krah, N.M., Dennison, R.J., Aderman, C.M., Chen, J., Guerin, K.I., Sapieha, P., Stahl, A., Willett, K.L., Smith, L.E.H., 2009. Quantification of oxygen-induced retinopathy in the mouse: a model of vessel loss, vessel regrowth and pathological angiogenesis. Nat. Protocols 4, 1565–1573.

Gang, L., Chutatape, O., Krishnan, S.M., 2002. Detection and measurement of retinal vessels in fundus images using amplitude modified second-order Gaussian filter. IEEE Trans. Biomed. Eng. 49, 168–172.

Gao, X.W., Bharath, A., Stanton, A., Hughes, A., Chapman, N., Thom, S., 2000. Quantification and characterisation of arteries in retinal images. Comput. Methods Prog. Biomed. 63, 133–146.

Grauslund, J., Green, A., Kawasaki, R., Hodgson, L., Sjølie, A.K., Wong, T.Y., 2010. Retinal vascular fractals and microvascular and macrovascular complications in type 1 diabetes. Ophthalmology 117, 1400–1405.

Higuchi, T., 1988. Approach to an irregular time series on the basis of the fractal theory. Phys. D 31, 277–283.

Hoover, A., Kouznetsova, V., Goldbaum, M., 2000. Locating blood vessels in retinal images by piecewise threshold probing of a matched filter response. IEEE Trans. Med. Imaging 19, 203–210.

Hubbard, L.D., Brothers, R.J., King, W.N., Clegg, L.X., Klein, R., Cooper, L.S., Sharrett, A.R., Davis, M.D., Cai, J., 1999. Methods for evaluation of retinal microvascular abnormalities associated with hypertension/sclerosis in the Atherosclerosis Risk in Communities Study. Ophthalmology 106, 2269–2280.

Ikram, M.K., Cheung, C.Y., Lorenzi, M., Klein, R., Jones, T.L.Z., Wong, T.Y., NIH/JDRF Workshop on Retinal Biomarker for Diabetes Group, 2013. Retinal vascular caliber as a biomarker for diabetes microvascular complications. Diabetes Care 36, 750–759.

Ikram, M.K., Janssen, J.A., Roos, A.M., Rietveld, I., Witteman, J.C., Breteler, M.M., Hofman, A., Van Duijn, C.M., De Jong, P.T., 2006. Retinal vessel diameters and risk of impaired fasting glucose or diabetes: the Rotterdam study. Diabetes 55, 506–510.

Jürgens, H., Saupe, D., Peitgen, H.O., 1992. Fractals for the Classroom: Part One Introduction to Fractals and Chaos. Springer, New York, NY.

Kawasaki, R., Che Azemin, M.Z., Kumar, D.K., Tan, A.G., Liew, G., Wong, T.Y., Mitchell, P., Wang, J.J., 2011. Fractal dimension of the retinal vasculature and risk of stroke: a nested case-control study. Neurology 76, 1766–1767.

Kifley, A., Wang, J.J., Cugati, S., Wong, T.Y., Mitchell, P., 2007. Retinal vascular caliber, diabetes, and retinopathy. Am. J. Ophthalmol. 143, 1024–1026.

Klein, R., Klein, B.E., Moss, S.E., Wong, T.Y., Hubbard, L., Cruickshanks, K.J., Palta, M., 2004. The relation of retinal vessel caliber to the incidence and progression of diabetic retinopathy: XIX: the Wisconsin Epidemiologic Study of Diabetic Retinopathy. Arch. Ophthalmol. 122, 76–83.

Knudtson, M.D., Lee, K.E., Hubbard, L.D., Wong, T.Y., Klein, R., Klein, B.E., 2003. Revised formulas for summarizing retinal vessel diameters. Curr. Eye Res. 27, 143–149.

Kumar, D.K., Aliahmad, B., Hao, H., Che Azemin, M.Z., Kawasaki, R., 2013. A method for visualization of fine retinal vascular pulsation using nonmydriatic fundus camera synchronized with electrocardiogram. ISRN Ophthalmol. 2013, 9.

Lowell, J., Hunter, A., Steel, D., Basu, A., Ryder, R., Kennedy, R.L., 2004. Measurement of retinal vessel widths from fundus images based on 2-D modeling. IEEE Trans. Med. Imaging 23, 1196–1204.

Mandelbrot, B.B., 1983. The Fractal Geometry of Nature. Henry Holt and Company, New York, NY.

Moret, F., Lagrèze, W.A., Poloschek, C.M., Bach, M., 2011a. Visualization of fundus vessel pulsation using principal component analysis. Invest. Ophthalmol. Vis. Sci. 52, 1339.

Moret, F., Poloschek, C.M., Lagreze, W.A., Bach, M., 2011b. Visualization of fundus vessel pulsation using principal component analysis. Invest. Ophthalmol. Vis. Sci. 52, 5457–5464.

Nguyen, T.T., Wong, T.Y., 2006. Retinal vascular manifestations of metabolic disorders. Trends Endocrinol. Metab. 17, 262–268.

Patton, N., Aslam, T., Macgillivray, T., Pattie, A., Deary, I.J., Dhillon, B., 2005. Retinal vascular image analysis as a potential screening tool for cerebrovascular disease: a rationale based on homology between cerebral and retinal microvasculatures. J. Anat. 206, 319–348.

Russ, J.C., 1994. Fractal Surfaces. Plenum Press, New York, NY.

Sarkar, N., Chaudhuri, B.B., 1994. An efficient differential box-counting approach to compute fractal dimension of image. IEEE Trans. Syst. Man Cybern. 24, 115–120.

Sasongko, M.B., Wang, J.J., Donaghue, K.C., Cheung, N., Benitez-Aguirre, P., Jenkins, A., Hsu, W., Lee, M.L., Wong, T.Y., 2010. Alterations in retinal microvascular geometry in young type 1 diabetes. Diabetes Care 33, 1331–1336.

Seber, G.A.F., 1984. Discriminant analysis. Multivariate ObservationsJohn Wiley & Sons, Inc., New York, NY.

Soares, J.V.B., Leandro, J.J.G., Cesar, R.M., Jelinek, H.F., Cree, M.J., 2006. Retinal vessel segmentation using the 2-D Gabor wavelet and supervised classification. IEEE Trans. Med. Imaging 25, 1214–1222.

Staal, J., Abramoff, M.D., Niemeijer, M., Viergever, M.A., Van Ginneken, B., 2004. Ridge-based vessel segmentation in color images of the retina. IEEE Trans. Med. Imaging 23, 501–509.

Wang, J., Mitchell, P., Sherry, L., Smith, W., Wong, T., Klein, R., Hubbard, L., Leeder, S., 2002. Generalized retinal arteriolar narrowing predicts 5-year cardio-vascular and cerebro-vascular mortality: findings from the Blue Mountains Eye Study. Invest. Ophthalmol. Vis. Sci. 43, 4396.

Wijaya, I.G.P.S., Uchimura, K., Koutaki, G., 2011. Human face security system using alternative linear discriminant analysis based classifier. In: 17th Korea-Japan Joint Workshop on Frontiers of Computer Vision (FCV), 9–11 February 2011, pp. 1–6.

Wong, T.Y., Islam, F.M.A., Klein, R., Klein, B.E.K., Cotch, M.F., Castro, C., Sharrett, A.R., Shahar, E., 2006. Retinal vascular caliber, cardiovascular risk factors, and inflammation: the Multi-Ethnic Study of Atherosclerosis (MESA). Invest. Ophthalmol. Vis. Sci. 47, 2341–2350.

Wong, T.Y., Klein, R., Sharrett, A.R., Duncan, B.B., Couper, D.J., Klein, B.E., Hubbard, L.D., Nieto, F.J., 2004a. Retinal arteriolar diameter and risk for hypertension. Ann. Intern. Med. 140, 248–255.

Wong, T.Y., Klein, R., Sharrett, A.R., Schmidt, M.I., Pankow, J.S., Couper, D.J., Klein, B.E., Hubbard, L.D., Duncan, B.B., Investigators, A., 2002. Retinal arteriolar narrowing and risk of diabetes mellitus in middle-aged persons. JAMA 287, 2528–2533.

Wong, T.Y., Shankar, A., Klein, R., Klein, B.E.K., 2004b. Retinal vessel diameters and the incidence of gross proteinuria and renal insufficiency in people with type 1 diabetes. Diabetes 53, 179–184.

Xiaofang, Z., Wenwen, D., Tusheng, L., Bi, L., 2010. A method of retinal vessel width measurement. In: Second International Conference on Computer and Automation Engineering (ICCAE), 26–28 February 2010, pp. 443–446.

Yanagi, M., Misumi, M., Kawasaki, R., Takahashi, I., Itakura, K., Fujiwara, S., Akahoshi, M., Neriishi, K., Wong, T.Y., Kiuchi, Y., 2014. Is the association between smoking and the retinal venular diameter reversible following smoking cessation? Invest. Ophthalmol. Vis. Sci. 55, 405–411.

Zhou, L., Rzeszotarski, M.S., Singerman, L.J., Chokreff, J.M., 1994. The detection and quantification of retinopathy using digital angiograms. IEEE Trans. Med. Imaging 13, 619–626.

Index

Printed in the United States
By Bookmasters